HAGAR

HAGAR

BY

MARY JOHNSTON

Edited with an Introduction by
MARJORIE SPRUILL WHEELER

UNIVERSITY PRESS OF VIRGINIA

Charlottesville and London

THE UNIVERSITY PRESS OF VIRGINIA
This edition Copyright © 1994 by the Rector and Visitors
of the University of Virginia

First published 1994

Hagar first published 1913

Library of Congress Cataloging-in-Publication Data
Johnston, Mary, 1870–1936.
　Hagar / by Mary Johnston ; edited with an introd. by Marjorie
Spruill Wheeler.
　　p. cm.
　Reprint. Previously published: Boston : Houghton Mifflin, 1913.
　Includes bibliographical references.
　ISBN 0-8139-1526-0
　1. Women authors, American—Fiction.　2. Women—Southern States—
Fiction.　I. Wheeler, Marjorie Spruill.　II. Title.
PS2142.H34　1994
813'.52—dc20　　　　　　　　　　　　　　　　　　　　　93-42067
　　　　　　　　　　　　　　　　　　　　　　　　　　　　CIP

Printed in the United States of America

CONTENTS

Introduction by Marjorie Spruill Wheeler vii

I.	THE PACKET-BOAT	1
II.	GILEAD BALM	8
III.	THE DESCENT OF MAN	19
IV.	THE CONVICT	30
V.	MARIA	45
VI.	EGLANTINE	57
VII.	MR. LAYDON	70
VIII.	HAGAR AND LAYDON	82
IX.	ROMEO AND JULIET	92
X.	GILEAD BALM	104
XI.	THE LETTERS	116
XII.	A MEETING	132
XIII.	THE NEW SPRINGS	143
XIV.	NEW YORK	154
XV.	LOOKING FOR THOMASINE	170
XVI.	THE MAINES	184
XVII.	THE SOCIALIST MEETING	194
XVIII.	A TELEGRAM	208
XIX.	ALEXANDRIA	221

CONTENTS

XX.	MEDWAY	231
XXI.	AT ROGER MICHAEL'S	244
XXII.	HAGAR IN LONDON	257
XXIII.	BY THE SEA	266
XXIV.	DENNY GAYDE	275
XXV.	HAGAR AND DENNY	284
XXVI.	GILEAD BALM	300
XXVII.	A DIFFERENCE OF OPINION	313
XXVIII.	NEW YORK AGAIN	323
XXIX.	ROSE DARRAGH	332
XXX.	AN OLD ACQUAINTANCE	341
XXXI.	JOHN FAY	351
XXXII.	RALPH	360
XXXIII.	GILEAD BALM	372
XXXIV.	BRITTANY	382

INTRODUCTION

In 1913 Mary Johnston, the author of extremely popular historical romances including the best-selling novel of 1900, *To Have and to Hold,* astonished her readers with the publication of *Hagar.*[1] In this novel, the only one of her twenty-three books with a contemporary setting, Johnston offered a strong critique of traditional attitudes toward woman's role, particularly in the South, and a ringing endorsement of the feminist movement. The story of an aristocratic southern girl who, endowed with intelligence and a strong sense of justice, casts aside the "dead past's hand, cold and heavy" (373) and devotes herself to the then highly controversial "Woman Movement," *Hagar* was hardly what Johnston's readers expected.

Mary Johnston was a very private person, who generally declined to be interviewed or quoted in the press;[2] yet an image of her had been firmly established in the few newspaper and magazine portraits she had permitted after *Prisoners of Hope* (1898) and, especially, *To Have and to Hold* catapulted her to fame and fortune.[3] According to these articles Johnston was all that a "high-bred" girl of the South should be. She was "slender and fragile" but possessing "wondrous strength and sweetness." One reporter gushed over "the graceful contour of her features," which brought to mind "famous miniatures on ivory by the old masters"; the way she "carries herself with that high-bred air that gives her a distinctive charm in any assembly"; and her "quiet and fashionable" dress, appropriate for a "charming woman" who respects "every propriety."[4] Another praised her devotion to her family; as the eldest of five children, Mary Johnston took over her mother's role as mistress of the household and traveling companion to her father

following the mother's death when Mary was nineteen. Certainly, observed the reporter, "she has been satisfied with the consequent love of the members of her family—more satisfied, one may feel justified in saying, than with the fame which has come with the publication of her novels."[5] They lavished praise upon Johnston's "charming home" and "her ideal life in Sunny Alabama," where Major John W. Johnston's business interests had taken them when Mary was sixteen. A *New York Times* reporter described Johnston's devotion to her native Virginia, "many illustrious names of that State being those of her ancestors," and traced Johnston's lineage back two centuries or more, including, of course, her relationship to the famous Confederate general Joseph Eggleston Johnston.[6]

Between the publication of *To Have and to Hold* and of *Hagar*, Johnston produced two more historical romances, *Audrey* (1902) and *Sir Mortimer* (1904); a play, "The Goddess of Reason" (1907), which was performed in Boston and New York with the famous stage actress Julia Marlowe in the leading role; and the first of her "history" novels, *Lewis Rand* (1908). These contributed to Johnston's status as a successful writer and did nothing to contradict the romanticized genteel and southern image of her that her readers cherished. Furthermore, shortly before *Hagar* appeared in 1913, Johnston's highly acclaimed Civil War novels, *The Long Roll* (1911) and *Cease Firing* (1912), were published. In these books, undertaken partly as a memorial to her Confederate ancestors, Johnston insisted that the war was fought gallantly and in defense of noble ideals rather than for the preservation of slavery.[7] Readers responded enthusiastically to her realistic and stirring portrayals of Civil War battles: Margaret Mitchell told a friend that while writing her own Civil War novel she "felt so childish and presumptuous for even trying to write about that period when she [Johnston] had done it so beautifully, so powerfully—better than anyone can ever do it, no matter how hard they try."[8] A builder of monuments to the Confederate dead of stone as well as of words, Johnston seemed to be a loyal and traditional daughter of the South: in Vicksburg in 1907 for the dedication of a memorial she had helped to erect to her father and his company, Mary Johnston

sat on the platform like a proper southern lady while "a General Lee" read the address she had written for the occasion.⁹

Yet those who had been paying attention to the writer as well as to her writings were aware that in recent years Mary Johnston had publicly aligned herself with the feminist movement. Having returned to Virginia with her family in 1902 and established residence in Richmond, Johnston developed close friendships with Ellen Glasgow and Glasgow's sister Cary Glasgow McCormick, Lila Meade Valentine, Kate Langley Bosher, Lucy Randolph Mason, and a number of other Virginia women who were becoming increasingly interested in the suffrage movement. In the spring of 1909 they began meeting quietly at Glasgow's home to consider forming a suffrage movement.¹⁰ When Johnston returned to Richmond from Europe that autumn, she "very quickly threw in her lot" with the conspirators. In November 1909 an "explosion" resulted when news of their meetings reached the city's newspapers. Looking back, Johnston recalled, "One can hardly understand the shock of surprise, of more or less indignant incredulity with which Richmond received the intimation that within her walls were women who wished votes."¹¹

The group formed the Equal Suffrage League of Virginia with Valentine as president and Johnston an officer and active worker. For the first time in her life, Johnston set aside her natural reticence and joined Valentine as a public lecturer and organizer, even taking elocution lessons to enhance her persuasive powers.¹² Crisscrossing the state on speaking tours, they appeared in homes and churches and before civic clubs, organizing local chapters in towns, cities, and—whenever they were permitted—on college campuses.¹³ Glasgow, who had departed for New York following Cary's death in 1911, was amazed at their persistence. "You and Mary are wonders," she wrote to Valentine in 1912. "I can look on and admire, but I can't hope to emulate you. I suppose a part of it is that you both have your roots still clinging to Virginia and I haven't. I've been plucked up root and branch."¹⁴

The suffragists wrote pamphlets, sought support from political

leaders and the press, and launched a petition drive to persuade the Virginia House of Delegates to adopt a suffrage amendment to the state constitution. In the winter of 1912 Johnston delivered a highly publicized address to the legislature that was printed and distributed throughout the country by the National American Woman Suffrage Association (NAWSA). Johnston's home at 110 East Franklin Street in Richmond became, according to her sister Elizabeth Johnston, "a sort of rendezvous for those of like minds," where "local workers" and "out-of-town visitors or organizers," joined Johnston's old "literary friends," sitting around her "Chippendale table in the sunny east dining room with its crimson draperies," plotting (in the words of William Blake, one of Mary's favorite poets) how to "build a New Jerusalem in this pleasant land."[15]

With Johnston as chair of the legislative committee, the Virginia suffrage leaders also promoted a broad spectrum of reforms in addition to suffrage, including better housing for workers, prison reform, wage and hour legislation, the abolition of sweatshops, an end to child labor, and increased access to higher education for the women of the state.[16] Their radical image was enhanced by their close association with organized labor, something unusual among southern suffragists. The Board of Directors of the Equal Suffrage League passed resolutions expressing support for trade union organization "whenever and wherever it struggles to raise the standard of living for wage earners and improve the conditions under which they work." They also urged labor unions to "keep their working sisters constantly in mind in their own struggles" and "help them secure as quickly as possible a share in the making and enforcement of laws for their own protection." Johnston and Valentine further outraged many of their acquaintances by addressing labor conventions in person.[17]

The two women stopped short of endorsing socialism, however, though both of them were privately sympathetic. In 1910 Johnston had confided to her diary that "from the evolutionists and other thinkers I have passed at last to the sociologists, and

about this time I began to read what came my way about Socialism. If I know anything about my own evolutionary process, I will sooner or later find myself identified with the Movement."[18] In 1912 Johnston, however, refused the request of a Socialist Party of Virginia official to endorse his movement publicly, saying, "To enter the papers—or to try to enter them—on this other issue, would, I think, be disastrous to my immediate cause without doing much good to yours."[19] Though the Virginia suffragists learned, as Valentine wrote, "the necessity of quiet, educational propaganda with an entire elimination of the spectacular for the present at least" and under her leadership eschewed some of the "newer methods" of suffrage promotion including parades and street speaking, Johnston participated in such events in other states.[20]

Indeed, as word spread among suffrage leaders of Johnston's "coming-out" for the cause, national as well as regional leaders of the woman suffrage movement welcomed Johnston with open arms, at once recognizing the value of such a celebrity to the movement. Alice Stone Blackwell, editor of the NAWSA's organ, the *Woman's Journal,* invited Johnston to be a contributing editor. Johnston agreed but expressed fear that her views would be too "radical" for the paper. Johnston also accepted an invitation to serve on the NAWSA Literature Committee. And she purchased life memberships in the NAWSA for herself and two of her sisters, Elizabeth and Eloise, who lived with her and also were supporters of the cause. Johnston was inundated with requests to write and to speak on suffrage. She published a lengthy article on the movement, "The Woman's War," in the April 1910 *Atlantic Monthly.*[21]

Invitations for speaking engagements came from all over the nation, but Mary Johnston was particularly sought after by suffragists in the southern states, where the movement experienced the greatest opposition and the least success. The New Orleans–based Southern States Woman Suffrage Conference (SSWSC) persuaded her to lend her name to the organization as an honor-

ary vice president.[22] Beleaguered suffragists in Alabama, an antisuffrage stronghold, hung her portrait in their headquarters and claimed her as one of their own. The president of the Alabama Equal Suffrage Association, Pattie Ruffner Jacobs, held a tea for Johnston in Birmingham; the newspapers reported that Johnston, "with her exquisite diction," offered advice based on her experience in Virginia.[23] Baltimore suffrage leader Edith Houghton Hughes thanked her for her visit, saying, "You brought us all in all about two hundred members who came over to our side because of your presentation of the subject and also because of *you* yourself—Heroine worship is very much to the fore since you came.... Many of the conservative people have opened their ears to the cause on discovering that a true southern woman of your stamp was an adherent."[24] Johnston accepted invitations to address the state legislatures of West Virginia and Tennessee as well as a national conference of governors. The Nashville *Democrat* observed "that a young Southern woman of Miss Johnston's type, rearing, and environment should become an ardent advocate of equal suffrage is one of the most marked evidences of the growth of the sentiment. A speech from such a source before the Tennessee legislature twenty-five years ago would hardly have been conceivable."[25]

As such effusions indicate, Johnston was extremely valuable to the suffrage movement precisely because she was at home in two worlds that were often thought to be irreconcilable. She was both a respected—indeed, revered—southern lady and an advocate for women's rights. By her own admission she was a devoted daughter of the South; in 1905 she wrote to a friend, "In spite of all reason and merely [as] an ingrained and hereditary matter, Virginia (and incidentally the entire South) is my country, and not the stars and stripes but the stars and bars is my flag."[26] Yet she was one of the most famous and influential of the tiny band of southern women willing to assume the leadership of this cause—once anathema to virtually all white southerners.[27]

Fellow Virginian and novelist Thomas Nelson Page, who

lamented Johnston's views on suffrage and particularly her support for woman suffrage by federal amendment, regarded such views unthinkable for "any one, man or woman, who is in the least familiar with the history of suffrage in Virginia and in other States of the South."[28] Like Page, many southern men and women considered the woman suffrage movement an affront to the cherished notion that men should provide for and guide women, who, in turn, with their virtue and trust, inspired men to rule wisely and well. They also considered advocacy of a federal woman suffrage amendment tantamount to treason against the South, as it signified acquiescence to federal authority in regard to suffrage and an abandonment of state sovereignty—for which southern heroes had fought and died. They regarded northern leaders of the woman suffrage movement, who had been demanding a federal amendment since Congress failed to include women in the Fifteenth Amendment during Reconstruction, as enemies of the South, seeking to "pervert the tastes of our women, [and] persuade them to abandon their old ideals." And they believed southern suffragists like Johnston were naively endangering "Southern Civilization" through their foolish meddling in politics.[29]

In what many suffrage opponents regarded as a cultural battle to save southern values following the defeat of the southern nation, the traditional southern lady had a separate but crucial role to play as preserver and transmitter of culture, rearing the future champions of the South: as one minister insisted in his often quoted "Mission of Woman," southern women must not try to "imitate a Washington, or a Lee, or a Jackson, but . . . to rear, and train, and educate, and mould the future Washingtons, and Lees, and Jacksons of the South, to protect and preserve the sacred rights of woman as well as of man."[30]

Mary Johnston, recalled her sister Elizabeth, endured "vicious" personal attacks from antisuffragists in Virginia who launched a "bitter whispering campaign against [the] personal integrity" of the suffragists. As a writer "already in the public eye," Mary Johnston "received most of the poisoned arrows," said Elizabeth. But

the barbs did not greatly disturb Johnston, who "took it as part of the day's work," though she "greatly deplored the depths to which her [antisuffrage] sisters ... and brothers ... would stoop." Rather than lessening her suffrage activities, said Elizabeth, the criticism just "spurred them on."[31]

Indeed, Johnston recognized that as suffragists, she and her associates were definitely in the minority among southern women. But she called upon them to look to the future rather than the past and to become a part of this great movement that would one day be looked upon in a far different light. Speaking to a group of potential converts, Johnston said:

> I have heard that certain foolish women are ashamed of our company. You may be sure that Patrick Henry would not have been ashamed of it. Fifty years from now when the history books glorify this period as they will glorify it, when the statues are raised, when the pictures are painted, when music and art and literature hymn the coming of woman into her own, which would you rather be?—Would you rather be the woman who can say to her children and grandchildren, to the youth of that time "Yes I was there! I was a soldier in the War of Independence!" Or would you rather be the woman who must say—and say to free women—"No, the liberty nerve must have been dead in me. I can see now that it was all glorious, but I couldn't see it then."

She concluded: "The Southern woman has pride,—oh she has pride! ... [and] when it comes really to her aid, she will become a suffragist."[32]

How did all this happen? How did Mary Johnston, reared in a traditional, upper-class southern home, become a champion of the woman's movement? How did a young woman who, as she recalled, grew up in "a virtual battle cloud, an atmosphere of war stories, of continued reverence to the men and to the deeds of that giant struggle" to preserve the "Southern Way of Life" be-

come a sworn enemy of the traditional role of woman—a role which defenders of Southern Civilization considered to be one of its cornerstones?[33] Why and how did she break free from the provincial attitudes typically associated with young women of her background? The answer is to be found in *Hagar*. For though there are many topics explored in this fascinating book, its central theme is clearly the intellectual and moral development of a young, southern, aristocratic girl—much like Mary Johnston—who undergoes an expansion of consciousness and conscience that leads to her avid embrace of the "Woman Movement."

The book is not an autobiography. Mary Johnston's family and, even more significantly, Johnston herself did not consider it as such. Her great-nephew, John W. Johnston, says that though "most of the other members of the family, apart from Eloise and Elizabeth, were somewhat scandalized by her espousals," neither he nor Eloise and Elizabeth recognized specific events or characters in *Hagar* that correspond to reality in "May's" life.[34] There was no ancestral home like Gilead Balm with which Mary Johnston had an enduring connection. There were no real-life counterparts to Colonel Ashendyne or "Old Miss," the domineering and intractable grandparents who remained significant even into Hagar's adult life. And there was no Ralph Coltsworth. Mary's father, Major John W. Johnston, a lawyer, businessman, and civil engineer, was a leader in the economic transformation of the New South, moving from president of the Kanawha Canal Company to president of the Georgia Pacific Railroad Company, with interests in the Tennessee Coal and Iron Company—unlike Colonel Ashendyne, his wealth destroyed by the war, who resented innovation and struggled to hold on in the old, rural, plantation manner. After attaining financial success Johnston chose to settle not in an avant-garde, "kitchenless" flat in New York City but in a sprawling mountain retreat, Three Hills, that she had built for herself and her sisters in the Virginia mountains of her youth. And obviously there was no John Fay, as Mary Johnston remained single throughout her life. Furthermore, it would be unthinkable

for Johnston to refer to the novel as autobiographical when it described Hagar in such glowing terms! She would recoil at the thought.[35]

However, without question *Hagar* is largely drawn from Johnston's own experiences. Until age sixteen Mary Johnston lived in Buchanan, Virginia, a small community on the James River in the foothills of the Blue Ridge Mountains and visited often at the sulphur-springs resorts in the mountains. Like Hagar, she roamed freely in the woods and hills, developing the quasi-religious love for nature that would last all of her life. As a child Mary was frail and had numerous health problems including debilitating headaches much like those suffered by Maria in *Hagar*. As a result she was educated at home and was largely self-taught—voraciously consuming her father's library. She did attend a "finishing school," Mrs. Roy's School in Atlanta, perhaps the model for Eglantine, but was there for only three months before being sent home for reasons of health. After her mother's death in 1889, Mary, much like Hagar, accompanied her father on his "convalescent tour" of Europe, visiting England, Scotland, Ireland, France, and Italy, the first of her many European tours. The family also began spending summers at Cobb's Island in Virginia, where Mary nearly perished in a boating accident similar to the one described near the end of *Hagar*.[36]

In 1892, when Mary was twenty-two, her father's business interests required the family to move to New York, where they lived (particularly after financial reverses in 1895) in a manner closely resembling the lifestyle of the Powhatan Maines in *Hagar*. Mary, who had already begun to write short stories, secretly began submitting them to magazines for publication, driven in part by the desire to contribute to the family finances, just as one of Hagar's motives was to contribute to the Green-Dale family's finances. One of Mary's short stories, written largely in a quiet corner of Central Park, grew into the novel *Prisoners of Hope*. As was the case in *Hagar*, its acceptance came as a complete surprise to the author's family, who were unaware that Mary had even attempted to publish. Its success led to a contract for *To Have and to Hold*.

Having appeared serially in the *Atlantic Monthly,* this novel sold 60,000 copies in advance and 135,000 during the first week after publication, making Johnston one of the most celebrated American women of her day. As a result Mary Johnston was able to provide very well not only for herself but for her family.[37]

After 1902 the family moved to Richmond but continued to spend considerable time abroad. They spent the winter of 1904 in Nassau and traveled in Sicily, Switzerland, France, Scotland, and England where Mary met a number of famous writers.[38] In all her travels, but especially in New York and London, Johnston was exposed to a great deal that was out of the usual realm of experience of a young southern woman. This included the intense suffering resulting from industrialization and urbanization, the hardships and even violence that accompanied labor's efforts to attain better conditions, and the ideas and actions of reformers on both sides of the Atlantic who were searching for solutions to these new and pressing social problems. Like Hagar, Mary Johnston was impressed by the efforts of middle- and upper-class reformers like the settlement workers at Henry Street in New York and Toynbee Hall in London as well as of labor union leaders but came to believe with the American Socialist party and the Fabians of London that alleviation of suffering was not enough—that capitalism itself must go.[39]

In 1905 Major Johnston died, causing Mary—who was extremely devoted to him—to suffer a prolonged illness. While recovering, she had the first of her "psychic" experiences, which became more frequent over the years. Since losing her faith in conventional religion at around twenty-five and withdrawing her membership in the Baptist church, she had been searching for an alternative religious experience and became—like Hagar—increasingly fascinated by mysticism. By 1907 she had become quite interested in Eastern religions; she began having lengthy conversations with Ellen Glasgow about the Upanishads, as well as Spinoza and Kant; the two women agreed that their common goal was "to merge the self in the Larger Self and All," reminiscent of Hagar's religious quest and belief that in the new century the

barriers between the material and spiritual worlds would be overcome and a "Fourth Dimension" reached. She read extensively on astrology, numerology, and various occult sciences and visited the Psychic Bookshop in London. She was especially drawn to a mystical belief system known as Theosophy, which closely resembled the religious beliefs expressed by Hagar; but she refused to become formally affiliated with Theosophists or any other group.[40]

In 1909 Johnston's travels took her again to Europe; but this time she went beyond Europe, into Egypt, which also provided material for *Hagar*.[41] This was also the year in which Johnston became actively involved in the suffrage movement, with which she had become more familiar while in England. And this too provided her with experiences—such as the open-air speeches at Cooper Union—that are reflected in *Hagar*.

In addition to these obvious similarities in experiences between the author and the protagonist of *Hagar,* there are also striking similarities between Mary Johnston and Hagar in physical appearance, temperament, and taste. Contemporaries described Johnston much as Johnston described Hagar: delicate in appearance but strong; not beautiful in the conventional manner but possessing a certain elegance and dignity that inspired admiration and interest. "For all her plainness," said Hagar's friend Sylvie Maine, "Hagar's got distinction" (59). And later to Hagar, "You've got something that makes people ask who you are" (61). Though by no means antisocial, Johnston enjoyed spending considerable time alone, reading and, of course, writing. Hagar described herself to Rachel Bolt as one of those people "to whom solitude means as much as food or sleep" (26).[42]

Johnston was often described in her lifetime as she is now, as multidimensional or enigmatic; Hagar said of herself, "I can be opposites" (287). Charlotte Perkins Gilman once wrote to Johnston: "You fascinating person. You always make me think of an eagle, delicately masquerading as a thrush—so soft and gentle and kind—and with big *sweepingnesses* in back of it all."[43] Ralph Coltsworth, recognizing Hagar's intensity beneath her serenity, called her "you dark, rich thing with wings" (369). Both Johnston

and Hagar were "philosophers" who felt compelled to take to the streets as "crusaders" (Denny's description, 285) and "Brahmins" who felt they must not just point the way for the masses through their writings but must "take wallet and staff and go with the mass upon the day's march, encouraging, lifting, helping, pointing forward, bearing with the others," which "is a nobler thing than to run ahead upon your own path and cry back to the throng, 'Why are you not here as well'" (286–87). Both had a passion for globe-trotting (264) but began to feel it "irresponsible, brushing life with moth wings" (261), and had a desire to, in Hagar's words, "grow in my native forest and serve in my own place" (261). The similarities between author and protagonist extend even to their mutual distaste for shopping![44]

Indeed, as one of her literary critics, Lawrence G. Nelson, has said, *Hagar* comes the closest of any of her novels to "telling the truth of the inner life" of Mary Johnston.[45] Great-nephew John W. Johnston agrees, saying, "*Hagar* expresses many of May's personal thoughts, ideas, and views" and can be considered "autobiographical in that it reflects her feelings and personality."[46] Still, readers must never lose sight of the fact that *Hagar* was written largely as a work of propaganda, as a contribution to the "Woman Movement," and that whatever deductions about the inner life of Mary Johnston we choose to make from this novel are made at some risk.

By the time she wrote *Hagar,* Mary Johnston had become (according to C. Ronald Cella, author of the most extensive treatment of Johnston and her canon) "determined to be much more than just an 'entertainer.'" And though she recognized that her "continued prosperity depended upon continued popularity," she "began to seek ways to please herself and at the same time meet tactful but insistent requests by her editors, publishers, and reviewers that she stay with the subject matter and techniques which had first made her a popular success." Her Civil War novels, which reflected this new commitment to producing works of enduring value, were critically acclaimed, which must have been quite satisfying. By the time they were published, however, Johns-

ton had again expanded her goals, having become convinced that she had a moral obligation to use her talents as a writer—and her influence with the public—to promote the great cause of women's rights.[47]

In *Hagar* Johnston describes this emerging commitment—Hagar's and her own. In a quiet corner of Westminster Abbey, Hagar reflects upon her success as a writer; she is pleased that her feverish desire to do "better work, and always better work," born of insecurity, was now stilled, and that her mind now "swept with wider wings." She "had a strange passion for the future, for all that might become." And as the world struggled to find its way, those who had seen the light must help to guide the way for others (264). "Power," she wrote, "lay in community of understanding, Public Opinion, community of understanding, minds moving in a like direction, power resulting, power to accomplish mighty and mightier things" (265). Thinking of all those buried near where she sat (perhaps in "Poet's Corner"), she thought that "many who lay there . . . saw the light and had tried to bring the mass of their being to follow; many had ennobled the world-mind, one this way and one that; each had brought to the vast granary his handful of wheat." Like them, Hagar told herself, she must "do your best to ennoble Public Opinion" (265).

So *Hagar* is a curious blend of intellectual autobiography, propaganda, and fiction, a work in which the author draws freely on her own experience but claims all of the liberties in the depiction of real places and events that are claimed both by polemicists and novelists. Clearly Johnston intended for her readers to have, through Hagar, the "consciousness-raising experiences" (to borrow a modern term) experienced by Johnston herself, embellished as needed for maximum effect.

Hagar is depicted as a young innocent, intellectually curious and endowed with an inborn sense of justice. As she moves through life, her eyes are opened, despite the best efforts of the adults in her life to shield her from corrupting influences and experiences and to compel her to accept society and the human

condition with all its injustices rather than try to change it—an attitude which Johnston suggests is particularly prevalent in the South. We see how the reading of forbidden books and chance encounters with outsiders stimulate young Hagar to think critically about the world around her and to question the authority of tradition. As Hagar explains to Denny Gayde in chapter 25: "My own sharp inner struggle was for intellectual and spiritual freedom. I had to think away from concepts with which the atmosphere in which I was raised was saturated. I had to think away from creeds and dogmas and affirmations made for me by my ancestors. I had to think away from the idea of a sacrosanct Past and the virtue of Immobility. . . . I had to think away from a concept of woman that the future can surely only sadly laugh at" (284–85).

Hagar's travels in the northern United States and abroad contribute to this "inner struggle" as she encounters conditions and ways of thinking that further undermine her provincial upbringing. Upon arrival in New York, we see her recoil in astonishment and horror as she observes with unjaded eyes the ugliness and misery of urban poverty, which contrasts sharply with the rustically charming rural poverty of the South that "did not seem to hurt" so much. We see her slowly grasp the magnitude of the problems produced by modern capitalism and the impossibility of any individual or individuals—including the well-meaning settlement workers—to alleviate the suffering, much less to rectify the economic injustices that cause the suffering.

As the book progresses, a new consciousness and new commitments emerge in Hagar, and she discovers a new way of living. For Johnston does not just condemn the old; she offers alternatives—to Hagar and to her readers. Just as the Colonel, Old Miss, Serena, Mrs. LeGrand, and Ralph offer examples of the models to be rejected, new models are proffered in the "New Women" and "New Men" Hagar encounters: "Roger Michael," the British woman writer and Fabian who visits Eglantine and later introduces Hagar to her circle of writers and reformers in London; Elizabeth Eden and Marie Caton, the settlement workers who happened to stray south to one of Virginia's sulphur springs and,

back in New York, introduce Hagar to socialist and feminist literature; the Josslyns, who are the first to demonstrate to Hagar that a new kind of marriage—of equals and friends—exists; Rose Darragh and Denny Gayde, "Socialist Agitator" and "Socialist Editor," who also offer a new model for a marriage of equals and committed partners working for a cause; and finally, John Fay, the New Man—the metaphorical bridge builder, who will forge such a marriage with Hagar. When Hagar warns him that she plans to "work on through life for the fairer social order" and that "the Woman Movement has me for keeps," this ideal man replies, "I'm aware. I'm going to help you" (390). And by locating Hagar in the kitchenless apartment building in New York, where domestic tasks like cooking and laundry are provided by professionals, Johnston also endorses the search among reformers for new domestic arrangements that would free women for careers.[48]

The lingering influence of Johnston's background—traditional, southern, and aristocratic—are nevertheless evident at times in *Hagar*. For example, Johnston has Hagar living in this feminist apartment building with her childhood playmates as servants! Thomasine Dale, granddaughter of the overseer, Mr. Green, is her secretary, and Mary Magazine, daughter of Gilead Balm's black housekeeper, Car'line, is her "tidy coloured maid" (345). Johnston's failure to confront the race issue stands out in sharp contrast to her repeated attacks on class prejudice. Hagar seems never to consider inviting Mary Magazine to join herself, Miss Serena, and Thomasine on the proposed New York excursions that so horrified Serena: "I wonder when Ashendynes and Dales and Greens began to 'do things' . . . together! The bottom rail's on top with a vengeance these days!" (307). Even when Johnston condemns society for keeping young women in the dark on matters sexual owing to an absurd and dangerous conspiracy to preserve their innocence and propriety—even when she endorses "the Movement to tell the young girl" (219–20)—her language is incredibly delicate and restrained and full of euphemisms as she painstakingly avoids words such as "venereal disease," "prostitution," and even "divorce."

Yet Johnston does not avoid these issues. Clearly she is attempting to alter "Public Opinion" on the "Woman Question" in addition to and beyond the question of suffrage. In *Hagar* (and in her suffrage speeches), Johnston raises many issues that were not to be discussed in polite society and promulgates ideas that were quite advanced—indeed, radical—in 1913. In innumerable passages Johnston labors to convince the reader of the injustice of women holding an auxiliary and subordinate role in society. With limited opportunities for education and employment, women are denied the opportunity to discover their full potential. Indeed, such conditions encourage women to become petty and selfish, squeezing the men who provide for them so hard that they have to squeeze other men, and making it difficult for women to be friends with one another owing to their competition for men. And, worst of all, women are forced into conformity by being forced into economic dependence. They are compelled to enter into and stay in marriages—often bad marriages—for want of alternatives.

Hagar clearly reveals the influence upon Johnston of her good friend Charlotte Perkins Gilman, author of *Women and Economics* (1898),[49] as Johnston drives home the point that economic independence is the key to woman's equality, dignity, and happiness. Indeed, Johnston, like Gilman, compares marriage to prostitution, in that both wives and prostitutes are dependent for their support on their ability to please men. Rachel Bolt (whose son was born blind from the venereal disease brought home by his errant father) recounts the horrors of her "married life" to Hagar: how her husband "treated me like a slave, bought for one purpose, wanted for one purpose, kept for one purpose," and how the prostitutes ("those others ... who made him pay them") he patronized "were freer than I." "He would have said," she continues, "that he paid me, too.... Perhaps it's true. I only know that I am going to have Betty [their daughter] taught to support herself" (218). Indeed, though it is unclear what Johnston intended in choosing the name "Hagar" for her protagonist and her novel, one possible explanation is that she saw the case of the biblical slave Hagar, taken by

Abraham for purposes of procreation and then mistreated, as a metaphor for all womanhood.[50]

Johnston insists, through Rachel, that there are "hosts of marriages that without any very high ideal are fit and decent enough" and that there are "noble lovers—men and women—and noble marriages." But, she continues, "I'm only saying that the other kind, the kind that's not fit nor clean nor decent and anything but noble, is so frequent and commonplace that it is rather laughable and altogether sardonic and devilish to kneel down and worship as we do the Institution of Staying Together—Staying Together at any price, even when evidently the only clean thing to do would be to Stay Apart" (217). Economic independence, Johnston is saying, gives women options, to choose whom to marry or not to marry at all, and if married unwisely, the option to leave! And Johnston defends the single woman, insisting that she also can contribute much to society and find happiness and should not be considered an aberrant or failed form of womanhood (365–66).

Johnston makes her point concerning the pivotal importance of economic autonomy most clearly through Hagar's own experience. Obviously the entire plot of the book takes a crucial turn when Hagar discovers an ability to write and to attain financial independence by selling her stories and is able to travel, live, and think as she wishes. Yet even after Hagar is an adult and comes back to visit at Gilead Balm, her family withdraws its emotional support when its members discover her unorthodox views on women's rights. But Hagar is saved from the necessity of conforming to their demands by the fact that she is not dependent upon them for financial support.

Hagar's grandfather is accustomed to commanding the obedience of the women in his family. He opposed the Married Women's Property Act in his state, believing that money only encourages independence in women, an attitude he considered "the most intolerable feature of this intolerable latter age!" (300). Hagar's father is also frustrated by her willfulness: "If you couldn't write—couldn't earn," he said, "you'd trot along quietly enough! The pivotal mistake was letting women learn the alpha-

bet" (261). The showdown occurs when the Ashendyne family learns of Hagar's involvement with the woman suffrage movement. Angrily and unanimously the family denounces the movement as vulgar and an affront to the Bible and "the chivalry of our Southern men" and demands that Hagar renounce the cause. For a moment, just a moment, Hagar reels from the sting of this disapproval, feeling "trapped." But, "then she realized that she was not trapped, and she smiled." Unlike the other women of her family, indeed the vast majority of women, Hagar had an "alternative life," "an inner freedom," derived from her "ability to work." "The Hagar Ashendyne appearing to others upon this porch was not chained there," wrote Johnston, "was not riveted to Gilead Balm. Next week, indeed, she would be gone" (313–18).

To a lesser extent Johnston, as Hagar, promotes socialism, using fiction to further a cause she was unwilling publicly to embrace as Mary Johnston, suffragist. Her endorsement of socialism is enthusiastic but vague. Hagar loved British Socialist William Morris's *News from Nowhere* (1890), which obviously had a major impact on her thinking,[51] though the adult Hagar agrees with Denny Gayde that Morris's brand of socialism was but an "oversimplified dream" (353). Hagar acknowledges that she does not know exactly what must be done, that "she has no clear vision" of the country that would come, nor does she "wish a rigid mind, posturing before one altar-piece" (353). Her socialism is the gradual, voluntary, somewhat elitist version of socialism that reflects the influence of the Fabians. But she is truly outraged at the disparity between rich and poor in her country (as in England), the hold of the new moneyed aristocracy upon the nation, and the callousness toward the suffering of other human beings that she sees exhibited every day. And, as she indicates through *Hagar*, Johnston is convinced that individual acts of charity, mild reforms, and even trade unionism can provide only partial solutions; far more sweeping changes are necessary—and forthcoming.

In *Hagar* Johnston is astoundingly confident that both socialism and female independence will triumph in the twentieth century, once Public Opinion has found its way—with her help and that

of other reformers. These changes she sees as both inevitable and long-range, embraced by different people at different times, and she seems to view the unenlightened around her with an attitude of patience and amused tolerance.

Indeed, *Hagar* reflects the optimism of many reformers of the pre–World War I era, when both political parties embraced Progressive reforms, when socialism—some versions of it at least—was respectable or at least tolerated in the urban centers of the North, when the woman suffrage movement at home and abroad was flourishing and on the brink of success. This optimistic tendency was strengthened in Johnston's case by the optimism that was part of her religious vision; she believed human beings, having evolved for "aeons," were about to make another epochal shift, rising from the "human plane" to another plane. They were only just beginning to see hints of the new and better life that was coming—of the "Fourth Dimension."[52] The task of reformers, she believed, was to facilitate that change, to make people better, more moral, with a stronger sense of community and justice; this done, people would voluntarily change their ways, making possible the coming of socialism and justice for all men and women.

And clearly Johnston does not want the battle for change to seem hopeless but to stimulate her readers to action as well as thought. Indeed, for her, as for Hagar, the Woman Movement was "a metaphysical adventure—a love-quest if you will . . . a passion of the mind." And as she learned to "think freely, and largely," she must, "under pain of being false . . . act freely and largely, (and) live freely and largely." And she must not "be silent when silence betrays the whole" (292–93).

Curiously enough, Mary Johnston did not expect *Hagar* to generate as strong a reaction as it did. As she was still "deep in proof," she wrote to Lila Meade Valentine: "I've finished *Hagar*. . . . [It] is a quiet, not-long or ambitious story, but I think some portion of it at any rate is good. Boston [her publisher] says it's 'at once elevated and tranquilizing'—which sounds a little as though it might be

soporific!"[53] But *Hagar* elicited a strong response. Advertised as "a wise, powerful, and effective study of one of the greatest questions of the day" written "with the imaginative understanding, the romantic fervor and richness of style of which the author is master,"[54] it sold very well and was reviewed extensively. Indeed, Johnston's clipping service supplied her with more than three hundred reviews.[55]

As one might expect, the reviews were mixed and reflected the reviewers' attitudes toward the "Woman Question."[56] The *Woman's Journal* was enthusiastic, predicting that *Hagar* would "stimulate the fast growing suffrage movement in the South."[57] A review in the *Nation* suggested that "Miss Johnston" had produced the *Uncle Tom's Cabin* of the suffrage movement, having struck more fire than the feminist novels of Ellen Glasgow or Elizabeth Robins.[58]

Other reviewers, including the *Literary Digest*, praised Johnston's newfound seriousness of purpose, saying, "This time she has discarded the purely romantic type and the seriously historical and has woven her story around the 'New Woman' and the Feminist revolt.... Unlike so many novels, it is not the love interest alone that thralls the reader. Its power grows more and more apparent as the theme develops. Feminism has never had a more human exposition."[59] The *Saturday Review* of London praised *Hagar* for its realism: "It is a little lacking in humor; but it is real. Hagar is a type of woman that does actually exist. She lives before us, and Miss Johnston has achieved a notable success in presenting us with such a lifelike figure."[60] A reviewer for the *Outlook* stressed *Hagar*'s importance as a "revolutionary story of personal experience." "While many readers will dissent from some of its conclusions," observed the reviewer, "there will be few to deny its ability or its significance. It is a report of the revolution now going on in society as it took possession of a woman and transformed her life."[61]

Other reviewers, who appeared to be antifeminist if not misogynistic, were not so kind, in fact, not kind at all. One reviewer, Brian Hooker, wrote in *Bookman:* "Miss Johnston had really no

story to tell, unless it be of the inner growth and conviction of a feminist. She has a thesis to maintain, of which she never for an instant loses sight, and toward which she bends every effort of her arts." Lacking any sympathy for young Hagar or Maria ("the one is priggish and the other fretful"), Hooker dismissed the idea that they are "intolerably repressed," saying, "Their false position results not inherently from the subjection of woman but extraneously from a special arrangement of characters and circumstances."[62] Helen Bullis, the reviewer for the *New York Times*, who seems to have been as hostile to feminism and her turbulent, reformist era in general as Colonel Ashendyne, came to the same conclusion as Hooker: "It is no less true of Miss Johnston's book than of many other feminist tracts, that their authors confuse the ills which women suffer because they are women with the ills which they suffer because they are not voters. And the natural result of this confusion is the fallacy that all ills are immediately remediable, a fallacy responsible for much of the misdirected energy, frantic legislation, all-around unrest, that characterize our opening century."[63] A reviewer for the *Boston Evening Transcript* thought "comic" the idea that John Fay would give up his bridge building in South America to marry Hagar and work for the women's movement;[64] another critic declared it inevitable that "little Hagar," the "suffraget superwoman," would marry a "desiccated man."[65]

Unfortunately, many of those who reviewed *Hagar* favorably also insisted that the book suffered as a novel because "it had too many of the qualities of a tract" and was "too evidently written for the Cause." As Ronald Cella has concluded, this seemed to be the consensus among contemporary critics, "that *Hagar* failed because it sacrificed adequate development of the plot and characters to the interests of arguing for the cause."[66] Reviewers compared *Hagar* frequently and unfavorably to *To Have and to Hold*, often (like E.F.E. of the *Boston Evening Transcript*) suggesting that Johnston return to writing historical romance: "Novels of the present, and novels of problems, are obviously not Miss Johnston's forte. She writes with a ready and a facile pen, but it is much readier and

more facile in the telling of such romantic tales as 'To Have and to Hold' and 'Audrey.' "[67]

Hence it is particularly ironic that the very quality contemporary reviewers found objectionable about *Hagar*–that it was a feminist novel, obviously written in service to the movement—is what makes it especially interesting to the modern reader, while the historic romance such as *To Have and to Hold* that Johnston's contemporaries so admired has declined drastically in critical stature. And it is indeed fortunate, for the countless scholars and students of today who wish to understand the ideology of the women's rights movement in the opening years of the twentieth century, that Johnston was so "ready" and "facile" at describing the condition of woman that made her—and many other women of her era—turn to feminism.

Johnston received encouragement from her friends, of course. Charlotte Perkins Gilman liked *Hagar* very much, admiring that "strong growing woman . . . who pushed on through things." She hoped that Johnston would continue to write such books. "I feel as if, having established your high reputation on historical novels, you were now doing far and better work. People won't like it as well, of course—but keep on."[68]

Unfortunately, however, Johnston believed that she could not "keep on," at least not writing novels that spoke out on hotly debated contemporary issues. She canceled plans to write two sequels to *Hagar,* fearing that controversy over the books might actually hurt the cause.[69] Johnston also had to concern herself with the financial prospects of her novels. She supported herself and her sisters through her writing, and though it was distasteful and frustrating, she had to consider popular response. Indeed, to a certain extent Johnston was trapped by the very economic self-sufficiency that had liberated Hagar! The ability to write freed Hagar from having to conform to her family's demands that she renounce feminism. Yet Johnston was constrained from writing in overt support of feminism by the yoke of financial independence.

The publication of *Hagar* coincided with a period of particular financial pressure in Johnston's life. Between 1911 and 1913 she

and her sisters had purchased forty acres of land in Bath County, Virginia, near Warm Springs, and constructed their large country home, Three Hills. They moved into it in May 1913, and she finished writing *Hagar* there the following summer.[70] It soon became apparent that in order to maintain this dream home, Johnston was going to have to maintain a high level of literary productivity, producing a commercially successful novel every year. By 1914 Johnston was writing anxiously to her publishers about advances. By 1915 the Johnstons decided to rent out Three Hills and spend the winter in New York. And soon thereafter they turned it into a summer resort and began taking in paying guests, mostly friends and acquaintances. Mary Johnston's letters and diaries reveal, as Cella has said, "preoccupation with the commercial prospects for her works and at the same time a resentment that she had to be concerned."[71]

This financial pressure also forced Johnston to curtail her suffrage activities. In the fall of 1913 she wrote to Valentine that she could not go to New Orleans for the organizational meeting of the Southern States Woman Suffrage Conference; "with all who are dependent on me, I must feel security of livelihood a primary duty." Indeed, she predicted, "it all means that I'll be almost entirely out of the active field this winter . . . [while] the rest of you are toiling."[72] Johnston also had to reduce her monetary contribution to the cause.[73] As the war cut into her sales abroad and raised prices at home, her financial troubles mounted. In October 1917 she told Valentine that she could not give at all to the year's suffrage work; she was having difficulty even meeting "necessary expenses" and was in "Dire Straights."[74] By the year's end she had withdrawn almost completely from active suffrage work.

There is some indication that Johnston was not unhappy at having to withdraw from active campaigning, though she clearly regretted her inability to support the movement financially. She had little taste for the intramural fighting over strategy and tactics that increased as the suffrage movement grew. It made her uncomfortable that white suffragists in Virginia, seeking their own enfranchisement, felt it necessary to point out that suffrage re-

strictions that disfranchised most black men would also disqualify most black women. "I think that as women we should be most prayerfully careful," she wrote to Valentine, "lest in the future, that women—whether coloured women or white women who are merely poor, should be able to say that we had betrayed their interests and excluded them from freedom."[75] And Johnston resigned from the SSWSC owing to her repugnance for its president's racist "utterances" that were "so opposed to [her] own moral and mental convictions, silent and expressed."[76] As was evident in *Hagar* (342), Johnston was never as offended by the methods of the "militants" of the National Woman's party as were most southern suffragists, who objected to their picketing and other "unladylike" conduct, and she attempted to promote harmony between the NWP and the NAWSA.[77] And as America entered the war, Johnston found herself philosophically separated from other women's rights advocates who pledged themselves to the war effort and distanced themselves from their prewar support of peace movements. Calling herself a "conscientious objector," she refused requests to work for the Woman's Committee of the Council of National Defense for Virginia, as well as for George Creel's jingoistic Committee on Public Information.[78]

Yet it was clear that Mary Johnston did not want to give up writing for the cause of women's rights or to renege on her commitment to use her talents to instruct and guide "Public Opinion." Ever the "Idealist-Realist" like Hagar, she found a way to reconcile her need to make money and her inner compulsion to serve humanity through her writing. She accomplished this by retreating to the safety of the past. According to Ronald Cella, Johnston "subtly introduced arguments for just treatment of women into novels which focused upon other causes." In *The Witch* (1914), *The Fortunes of Garin* (1915), and *The Wanderers* (1917), works that were "almost as heavily laden with message as *Hagar* but more palatable to her audience because set in the past," she promoted religious and intellectual freedom and, especially in *The Wanderers*, women's rights.[79] All were modestly successful.

Again Johnston nearly lost her audience with *Foes* (1918),

Michael Forth (1919), and *Sweet Rocket* (1920), novels dominated by her "mystical" beliefs, and with *Silver Cross* (1922), a modernistic experiment. But though she was never as successful in the marketplace as she had been early in her career, she regained much of her following with *1492* (1922), *Croatan* (1923), and *The Great Valley* (1926). In these works she returned to the methods and historical focus that initially made her popular, though the characters were at once "physical and geographical pioneers" and "pioneers in the exploration of psychic reality and spiritual truth."[80] In *The Slave Ship* (1923), she used the safety of the past to promote racial justice.[81]

In all of her work after *Hagar*, whether historical romances written for a popular audience, works permeated with the mysticism that so perplexed her audience, or stylistic experiments undertaken for her own satisfaction, Johnston never failed to include social or moral instruction or to make an effort to elevate and promote human tolerance and justice. For as Edward Wagenknecht, the literary critic who in Johnston's opinion best understood her work, including the mysticism, wrote shortly before her death in 1936, "many who are not mystics at all" have come to realize "that unless some far-reaching changes can be made to take place in the stuff of human nature itself, we can hardly hope to avoid destruction."[82]

Thus, we have but one *Hagar*, sans sequels. After 1913 Mary Johnston concluded that if she wished to retain her audience, her livelihood, and her influence, she could not afford the luxury of open advocacy of the contemporary feminist movement in her novels: she would continue to address the issues of justice and freedom and feminism, but more indirectly and discreetly.

Hagar's uniqueness, however, makes us value it all the more. With a clarity and directness (despite the refined language) that comes from addressing the issues of her own time, Johnston helps us understand the motives and dreams of the women like herself who risked much to work for women's rights. That the book was written "for the Cause" only enhances its appeal to students of the women's rights movement. For we can see not only why Johns-

ton became a feminist, but how she hoped to convince others to follow her lead.

As we read *Hagar* we gain insight into the women's movement from the vantage point of one of its most thoughtful and articulate participants. Johnston takes us with her on her odyssey from traditional girl to independent woman, exposing us to feminist and antifeminist arguments and helping us to understand how difficult it was to break with family, friends, and tradition and create new and more constructive relationships among women and between the two sexes. Johnston also makes it clear that the vote was only part of the larger agenda of the early twentieth-century women's rights movement: a weapon in a larger struggle for equality and justice and for recognition of women as autonomous individuals who are free to develop as they should choose. "She wants the vote to use as a lever, and so do I, and so do you," said Marie Caton to Hagar, speaking of one of their coworkers. "But behind all that, in the place where I myself live.... I am fighting to be myself! I am fighting for that same right for the other woman! I am fighting for plain recognition of an equal humanity!" (331). And clearly many of these feminists, including Johnston, were convinced that economic independence was the key to woman's autonomy and dignity, essential for intellectual and spiritual freedom, and at least as important as political equality.

Hagar speaks also to the problems of our own day. As Johnston predicted, America now celebrates the achievements of the suffragists. Yet women still fight for self-determination and against the stifling effects of convention and discrimination, still struggle to create new kinds of relationships that will serve their needs and desires, and still seek economic justice, which perpetually eludes them. With her strong sense of justice and social responsibility, her patience with humanity—flawed though it is—and her optimism, Mary Johnston offers encouragement to those in any era who struggle to see clearly through veils of tradition and to find new and better ways of living.

Marjorie Spruill Wheeler

NOTES

1. C. Ronald Cella, *Mary Johnston* (Boston: Twayne Publishers, 1981), 13, 22, 81; Mary Johnston, *Hagar* (Boston and New York: Houghton Mifflin Company, 1913).

2. Cella, *Mary Johnston*, 13.

3. Mary Johnston, *Prisoners of Hope* (Boston: Houghton Mifflin, 1898); Mary Johnston, *To Have and to Hold* (Boston: Houghton Mifflin, 1900). *To Have and to Hold*, by far her most popular novel, was about the women of Jamestown. It sold more than 500,000 copies and was twice produced as a film (Edward T. James and Janet Wilson James, eds., *Notable American Women*, 3 vols. [Cambridge: Harvard University Press, 1971], 2:282).

4. Annie Kendrick Walker, "Mary Johnston in Her Home," *New York Times*, 24 March 1900, p. 181.

5. "Mary Johnston," ibid., 19 March 1902, p. 198.

6. Anne Kendrick Walker, "Mary Johnston in Her Home," ibid., 24 March 1900, p. 181.

7. Cella, *Mary Johnston*, 43–76.

8. Mitchell quoted in Anne Goodwyn Jones, *Tomorrow Is Another Day: The Woman Writer in the South, 1859–1936* (Baton Rouge and London: Louisiana State University Press, 1981), 183–84.

9. Cella, *Mary Johnston*, 54.

10. For information on the creation of the Equal Suffrage League of Virginia, see Elizabeth Johnston, draft of a biography of Mary Johnston, 1953 (Mary Johnston Papers, acc. no. 3588, University of Virginia Library), contains some material written by Mary Johnston and copied from her diary and other materials written by Elizabeth; Charlotte Jean Sheldon, "Woman Suffrage and Virginia Politics, 1909–1920" (M.A. thesis, University of Virginia, 1969), 11–16; Trudy J. Hanmer, "A Divine Discontent: Mary Johnston and Woman Suffrage in Virginia" (M.A. thesis, University of Virginia, 1972), 7–9; and Lloyd C. Taylor, Jr., "Lila Meade Valentine: the FFV as Reformer," *Virginia Magazine of History and Biography* 4 (1954): 481–82.

11. Elizabeth Johnston, draft biography, Johnston Papers; Taylor, "Lila Meade Valentine," 481.

12. Hanmer, "Divine Discontent," 16.

13. Presidents of women's colleges were fearful about allowing such questionable activity on their campuses. Officials at Sweet Briar and Randolph-Macon in Lynchburg feared allowing Johnston to speak to their students if the subject was suffrage (Elizabeth Lewis to Mary Johnston, 3 April 1911, Johnston Papers). Lucy Somerville Howorth, the daughter of the president of the Mississippi suffragists,

Nellie Nugent Somerville, was a student at Randolph-Macon at the time. She recalls gleefully that the students "finagled an invitation to her [Johnston] to come and speak on American literature... and explained to her what the situation was. So she devoted about two sentences to the development of American literature and then made her suffrage speech" (Constance Ashton Myers interview with Lucy Somerville Howorth, June 20, 22, 23, 1975, Monteagle, Tenn., p. 22, no. 4007, Southern Oral History Collection, Southern Historical Collection, Wilson Library, University of North Carolina, Chapel Hill).

14. Ellen Glasgow to Lila Meade Valentine, 1 July 1912, Lila Meade Valentine Papers, Virginia Historical Society, Richmond. Though Ellen Glasgow promoted feminism through her writing, she was drawn into the organized suffrage movement primarily by her sister Cary. After Cary's death in 1911, Ellen moved to New York where she lived until 1916, and was no longer active in the suffrage movement (Marjorie R. Kaufman, "Ellen Glasgow," in *Notable American Women* 2:44–49).

15. Elizabeth Johnston, draft biography, Johnston Papers.

16. Ibid., 108; Elizabeth D. Coleman, "Penwoman of Virginia's Feminists," *Virginia Calvacade,* Winter 1956, p. 9.

17. Taylor, "Lila Meade Valentine," 483; Hanmer, "Divine Discontent," 18–19. The resolution is quoted in Mary Johnston, "Speech, Labor Convention, 1911," Johnston Papers.

18. In Lila Meade Valentine's papers there is a small notebook in her handwriting containing notes on various writers on socialism and aesthetics. On Mary Johnston's socialist views, including this quotation, see Elizabeth Johnston, draft biography, 108, 109, Johnston Papers.

19. Mary Johnston to B. M. Dutton, Virginia Socialist party leader, n.d., Johnston Papers. This letter contains a lengthy discussion of her views on socialism and women's rights.

20. Quotation from letter from Lila Meade Valentine to Mrs. Townsend, 7 April 1914, Virginia Suffrage Papers, Virginia State Library and Archives. See also Sheldon, "Woman Suffrage and Virginia Politics," 40. Unlike most Virginia suffragists, Johnston participated in the famous, or infamous, suffrage parade in 1913 during Wilson's inauguration, when the suffragists were abused by the crowd (Hanmer, "Divine Discontent," 38).

21. Alice Stone Blackwell to Mary Johnston, 10, 24 Aug. 1910, Johnston Papers. On the Literature Committee, see Mary Ware Dennett to Mary Johnston, 30 April, 23 May 1910, Myra Strawn Habstrom to Mary Johnston, 23 Aug. 1910, ibid.; on life memberships, see Harriet Taylor Upton to Mary Johnston, 29 April 1910, ibid.; Mary Johnston, "The Woman's War," *Atlantic Monthly,* April 1910, pp. 559–70.

22. Mary Johnston to Lila Meade Valentine, 29 Sept. 1913, Valentine Papers.

23. See "Mrs. Solon Jacobs Hostess at Tea" and other clippings in Scrapbook, Pattie Ruffner Jacobs Papers, Birmingham Public Library, Birmingham, Ala.

24. Edith Houghton Hughes to Mary Johnston, 5 Feb. 1911, Johnston Papers.

25. Clipping from the Nashville *Democrat,* Jan. 1913, Scrapbook, Laura Clay Papers, King Library, University of Kentucky, Lexington.

26. Mary Johnston to Otto Kyllman, 1 Feb. 1905, cited in Jones, *Tomorrow Is Another Day,* 186.

27. For a full description of these southern leaders and Johnston's role in the regional movement, see Marjorie Spruill Wheeler, *New Women of the New South: The Leaders of the Woman Suffrage Movement in the Southern States* (New York and Oxford: Oxford University Press, 1993). For more information on Johnston and her suffrage career, see Marjorie Spruill Wheeler, "Mary Johnston, Suffragist," *Virginia Magazine of History and Biography* 100 (Jan. 1992): 99–118.

28. Quotation from an antisuffrage leaflet, "Thomas Nelson Page . . . Warns against Legislative Ratification of the Woman Suffrage Amendment," National American Woman Suffrage Association Papers, Manuscripts Division, Library of Congress, Washington, D.C. Page and Johnston disagreed particularly on the issue of whether woman's famous "indirect influence" was powerful or powerless. See John R. Roberson, ed., "Two Virginia Novelists on Woman's Suffrage: An Exchange of Letters between Mary Johnston and Thomas Nelson Page," *Virginia Magazine of History and Biography* 64 (1956): 286–90.

29. See Wheeler, *New Women of the New South,* chap. 1, "The Southern Lady, Hostage to 'the Lost Cause.'" Quotations from antisuffrage pamphlet by James Callaway, Editor, Macon (Ga.) *Telegraph,* 1919; a widely circulated reprint from the Richmond *Evening Journal* (4 May 1915) attacked southern suffragists as illogical creatures accustomed to having their way but with no understanding of the practical realities that made enfranchising women dangerous. Both flyers are in the Clay Papers.

30. Albert Bledsoe, "Mission of Woman," *Southern Review,* Oct. 1871, pp. 923–42.

31. Elizabeth Johnston, draft biography, 107–8, Johnston Papers.

32. Johnston, "The Woman Movement in the South," Suffrage Speeches, 1910–11, ibid.

33. Cella, *Mary Johnston,* 17.

34. I am grateful to Captain John W. Johnston, whose father was the son of Mary Johnston's sister Anne, for information concerning Johnston and her family's interpretation of *Hagar.* John Johnston spent nearly every summer at Three Hills until

he was seventeen. As his grandmother, Anne Johnston, Mary's sister, had died back in 1901, Mary, Eloise, and Elizabeth were "more like collective grandmothers ... than great aunts" to him and his brother (John W. Johnston to Marjorie Spruill Wheeler, 27 Aug. and 16 Oct. 1993). "May" was a family nickname.

35. The best sources of biographical information on Johnston other than her papers at the University of Virginia are Cella, *Mary Johnston,* especially pp. 11–31, and "Mary Johnston," in *Notable American Women* 2:282–84.

36. Cella, *Mary Johnston,* 13–20; *Notable American Women* 2:282–83; "Mary Johnston," *New York Times,* 29 March 1902, p. 198; John W. Johnston to Marjorie Spruill Wheeler, 27 Aug. 1993.

37. Cella, *Mary Johnston,* 21–22.

38. Ibid., 11–12, 22–23.

39. Johnston's views on the political issues of her day are clearly revealed in her suffrage speeches in the Johnston Papers; for her views on socialism in particular, see Elizabeth Johnston, draft biography, 108–9; Mary Johnston to B. M. Dutton, n.d., to Lila Meade Valentine, 19 Aug. 1912, Johnston Papers.

40. Cella, *Mary Johnston,* 27–31; Elizabeth Johnston, draft biography, 101–5, Johnston Papers. See also Edward Wagenknecht's essay, "The World and Mary Johnston," *Sewanee Review* 44 (April–June 1936): 188–206; according to Elizabeth Johnston, Mary "liked it better than anything that had been written about her of late years," particularly in that he understood the "mystical development" in her work.

41. Cella, *Mary Johnston,* 11.

42. For the fullest description of Johnston's appearance and temperament, see Elizabeth Johnston, draft biography, 110–13, Johnston Papers.

43. Jones, *Tomorrow Is Another Day,* 186.

44. See Elizabeth Johnston's description of Mary including that she detested shopping, which she considered a "boring, fatiguing matter!" Eloise Johnston "took from Mary all distracting practical matters such as housekeeping, management of servants, and shopping." They had the perfect "Mary and Martha" relationship (Elizabeth Johnston, draft biography, 109–11, Johnston Papers).

45. Lawrence G. Nelson, "Mary Johnston and the Historic Imagination," in R. C. Simonini, Jr., ed., *Southern Writers: Appraisals in Our Time* (Charlottesville: University Press of Virginia, 1964), p. 71.

46. John W. Johnston to Marjorie Spruill Wheeler, 27 Aug. 1993.

47. Cella, *Mary Johnston,* 22–27, quotations from p. 24.

48. The idea of constructing special apartment buildings for working women

and their families became popular in America in the 1890s after it was introduced by reformers including Johnston's friend Charlotte Perkins Gilman. In her *Women and Economics: A Study of the Economic Relation between Men and Women as a Factor in Social Evolution* (Boston: Small, Maynard, 1898), she insisted that such women needed both day care and a cooked-food service and suggested that female entrepreneurs would find it quite rewarding if they would build apartments that offered such conveniences. See Dolores Hayden, *Redesigning the American Dream: The Future of Housing, Work, and Family Life* (New York and London: W. W. Norton, 1984), 89–90, and Dolores Hayden, *The Grand Domestic Revolution: A History of Feminist Designs for American Homes, Neighborhoods, and Cities* (Cambridge, Mass.: MIT Press, 1981), 182–205.

49. Charlotte Perkins Gilman, *Women and Economics.*

50. For the story of Hagar, see Genesis 16; for another interpretation of Johnston's choice of the title *Hagar,* see Anne Goodwyn Jones, *Tomorrow Is Another Day,* 202–3.

51. British Socialist William Morris's *News from Nowhere* (1890) was a utopian novel which established him as a "revered" figure among American socialists. He urged the adoption of a new pattern of social relations between men and women of equality and friendship as well as sexual love (Mari Jo Buhle, *Women and American Socialism, 1870–1920* [Urbana: University of Illinois Press, 1981], 260, 280; see also Norman and Jeanne MacKenzie, *The Fabians* [New York: Simon and Schuster, 1977]).

52. See Wagenknecht, "The World and Mary Johnston." He discusses how this philosophy permeates her work.

53. Mary Johnston to Lila Meade Valentine, 26 Aug. 1913, Valentine Papers.

54. Advertisement reprinted in Coleman, "Penwoman of Virginia's Feminists," 9.

55. Cella, *Mary Johnston,* 26–27.

56. Ibid., 27.

57. "Mary Johnston Has New Book," *Woman's Journal,* 25 Oct. 1913, p. 2.

58. *Nation* 97, no. 2522 (30 Oct. 1913), 410.

59. *Literary Digest* 47 (15 Nov. 1913): 95A.

60. "Novels," review of Mary Johnston's *Hagar, Saturday Review of Politics, Literature, Science, and Art* (London), 116 (Nov. 15, 1913): 623; cited in Jones, *Tomorrow Is Another Day,* 187.

61. "Five New Novels by Women," *Outlook,* 15 Nov. 1913, pp. 570–72.

62. Brian Hooker, "Twelve Books of the Month," *Bookman* 38 (Dec. 1913): 426–28.

63. Helen Bullis, "A Feminist Novel," *New York Times* 6, sec. 18 (2 Nov. 1913): 591.

64. E.F.E., "Mary Johnston's Feminist Novel," *Boston Evening Transcript,* 25 Oct. 1913, pt. 3, p. 8.

65. "A Submerged Novel," *Independent* 76 (30 Oct. 1913): 219.

66. Cella, *Mary Johnston,* 81.

67. E.F.E., *Boston Evening Transcript,* 25 Oct. 1913, pt. 3, p. 8.

68. Jones, *Tomorrow Is Another Day,* 187–88.

69. Cella, *Mary Johnston,* 27.

70. Hanmer, "A Divine Discontent," 38–39, 49.

71. Mary Johnston to Lila Meade Valentine, Oct. 1915, Johnston Papers; Capt. John W. Johnston to Marjorie Spruill Wheeler, 16 Oct. 1993; Cella, *Mary Johnston,* 24. According to Captain Johnston, the sisters operated Three Hills as an "elite and exclusive summer resort" with a "delightful and select clientele" which included many intellectuals and celebrities in all fields, where guests "dressed" for supper which featured "stimulating conversations" along with fine food "served on English china with Tiffany engraved silver." This very successful operation continued for many years after Johnston's death until Elizabeth finally sold Three Hills in 1954 or 1955.

72. Mary Johnston to Lila Meade Valentine, 29 Sept. 1913, Valentine Papers.

73. Ibid., 8 Aug. 1914.

74. Ibid., 27 Oct. 1917.

75. Ibid., 5 Jan. 1913 and Oct. 1915.

76. Mary Johnston to Lila Meade Valentine, Oct. 1915. Johnston Papers.

77. Mary Johnston to Lila Meade Valentine, 1 June 1915, Valentine Papers; Mary Johnston to Lila Meade Valentine, ca. 1914, Johnston Papers. Alice Stone Blackwell invited Johnston by telegram to an "informal peace conference to promote harmony between national association congressional union Boston September 17," 9 Sept. 1914, Johnston Papers.

78. Hanmer, "Divine Discontent," 49–50. Valentine was the first person in Virginia to speak on the street for recruits (clipping, n.d., Valentine Papers).

79. Cella, *Mary Johnston,* 27.

80. Ibid., 27–31, 96–104. Literary critic Edward Wagenknecht disagrees with the common verdict on *Foes,* considering it Johnston's "masterpiece" ("The World and Mary Johnston," 193). On the combination of purpose in these later historical romances, see *Notable American Women* 2:283.

81. Mary Johnston, *The Slave Ship* (Boston: Little, Brown, and Company, 1924). Her last three novels—*The Exile* (1927), the only "futuristic" work in her canon; *Miss Delicia Allen* (1933); and *Drury Randall* (1934)—were not widely read.

82. Wagenknecht, "The World and Mary Johnston," 198.

HAGAR

HAGAR

CHAPTER I

THE PACKET-BOAT

"*Low Braidge!*"

The people on deck bent over, some until heads touched knees, others, more exactly calculating, just sufficiently to clear the beams. The canal-boat passed beneath the bridge, and all straightened themselves on their camp-stools. The gentlemen who were smoking put their cigars again between their lips. The two or three ladies resumed book or knitting. The sun was low, and the sycamores and willows fringing the banks cast long shadows across the canal. The northern bank was not so clothed with foliage, and one saw an expanse of bottom land, meadows and cornfields, and beyond, low mountains, purple in the evening light. The boat slipped from a stripe of gold into a stripe of shadow, and from a stripe of shadow into a stripe of gold. The negro and the mule on the towpath were now but a bit of dusk in motion, and now were lit and, so to speak, powdered with gold-dust. Now the rope between boat and towpath showed an arm-thick golden serpent, and now it did not show at all. Now a little cloud of gnats and flies, accompanying the boat, shone in burnished armour and now they put on a mantle of shade.

A dark little girl, of twelve years, dark and thin, sitting aft on the deck floor, her long, white-stockinged legs folded decorously under her, her blue gingham skirt spread out, and

her Leghorn hat upon her knees, appealed to one of the reading ladies. "Aunt Serena, what is 'evolution'?"

Miss Serena Ashendyne laid down her book. "'Evolution,'" she said blankly, "'what is evolution?'"

"I heard grandfather say it just now. He said, 'That man Darwin and his evolution' —"

"Oh!" said Miss Serena. "He meant a very wicked and irreligious Englishman who wrote a dreadful book."

"Was it named 'Evolution'?"

"No. I forget just what it is called. 'Beginning' — No! 'Origin of Species.' That was it."

"Have we got it in the library at Gilead Balm?"

"Heavens! No!"

"Why?"

"Your grandfather would n't let it come into the house. No lady would read it."

"Oh!"

Miss Serena returned to her novel. She sat very elegantly on the camp-stool, a graceful, long-lined, drooping form in a greenish-grey delaine picked out with tiny daisies. It was made polonaise. Miss Serena, alone of the people at Gilead Balm, kept up with the fashions.

At the other end of the long, narrow deck a knot of country gentlemen were telling war stories. All had fought in the war — the war that had been over now for twenty years and more. There were an empty sleeve and a wooden leg in the group and other marks of bullet and sabre. They told good stories, the country gentlemen, and they indulged in mellow laughter. Blue rings of tobacco-smoke rose and mingled and made a haze about that end of the boat.

THE PACKET-BOAT

"How the gentlemen are enjoying themselves!" said placidly one of the knitting ladies.

The dark little girl continued to ponder the omission from the library. "Aunt Serena —"

"Yes, Hagar."

"Is it like 'Tom Jones'?"

"'Tom Jones'! What do you know about 'Tom Jones'?"

"Grandfather was reading it one day and laughing, and after he had done with it I got it down from the top shelf and asked him if I might read it, and he said, 'No, certainly not! it is n't a book for ladies.'"

"Your grandfather was quite right. You read entirely too much anyway. Dr. Bude told your mother so."

The little girl turned large, alarmed eyes upon her. "I don't read half as much as I used to. I don't read except just a little time in the morning and evening and after supper. It would *kill* me if I could n't read —"

"Well, well," said Miss Serena, "I suppose we shall continue to spoil you!"

She said it in a very sweet voice, and she patted the child's arm and then she went back to "The Wooing O't." She was fond of reading novels herself, though she liked better to do macramé work and to paint porcelain placques.

The packet-boat glided on. It was almost the last packet-boat in the state and upon almost its last journey. Presently there would go away forever the long, musical winding of the packet-boat horn. It would never echo any more among the purple hills, but the locomotive would shriek here as it shrieked elsewhere. Beyond the willows and sycamores, across the river whose reaches were seen at intervals, gangs

of convicts with keepers and guards and overseers were at work upon the railroad.

The boat passing through a lock, the dark little girl stared, fascinated, at one of these convicts, a "trusty," a young white man who was there at the lock-keeper's on some errand and who now stood speaking to the stout old man on the coping of masonry. As the water in the lock fell and the boat was steadily lowered and the stone walls on either hand grew higher and higher, the figure of the convict came to stand far above all on deck. Dressed hideously, in broad stripes of black and white, it stood against the calm evening sky, with a sense of something withdrawn and yet gigantic. The face was only once turned toward the boat with its freight of people who dressed as they pleased. It was not at all a bad face, and it was boyishly young. The boat slipped from the lock and went on down the canal, between green banks. The negro on the towpath was singing and his rich voice floated across —

"For everywhere I went ter pray,
I met all hell right on my way."

The country gentlemen were laughing again, wrapped in the blue and fragrant smoke. The captain of the packet-boat came up the companionway and passed from group to group like a benevolent patriarch. Down below, supper was cooking; one smelled the coffee. The sun was slipping lower, in the green bottoms the frogs were choiring. Standing in the prow of the boat a negro winded the long packet-boat horn. It echoed and echoed from the purple hills.

The dark little girl was still staring at the dwindling lock. The black-and-white figure, striped like a zebra, was there

yet, though it had come down out of the sky and had now only the green of the country about and behind it. It grew smaller and smaller until it was no larger than a black-and-white woodpecker — it was gone.

She appealed again to Miss Serena. "Aunt Serena, what do you suppose he did?"

Miss Serena, who prided herself upon her patience, put down her book for the tenth time. "Of whom are you speaking, Hagar?"

"That man back there — the convict."

"I did n't notice him. But if he is a convict, he probably did something very wicked."

Hagar sighed. "I don't think *anybody* ought to be made to dress like that. It — it smudged my soul just to look at it."

"Convicts," said Miss Serena, "are not usually people of fine feelings. And you ought to take warning by him never to do anything wicked."

A silence while the trees and the flowering blackberry bushes went by; then, "Aunt Serena —"

"Yes?"

"The woman over there with the baby — she says her husband got hurt in an accident — and she's got to get to him — and she has n't got any money. The stout man gave her something, and I *think* the captain would n't let her pay. Can't I — would n't you — can't I — give her just a little?"

"The trouble is," said Miss Serena, "that you never know whether or not those people are telling the truth. And we are n't rich, as you know, Hagar. But if you want to, you can go ask your grandfather if he will give you something to give."

The dark little girl undoubled her white-stockinged legs, got up, smoothed down her blue gingham dress, and went forward until the tobacco-smoke wrapped her in a fragrant fog. Out of it came, genially, the Colonel's voice, rich as old madeira, shot like shot silk with curious electric tensions and strains and agreements, a voice at once mellifluous and capable of revealments demanding other adjectives, a voice that was the Colonel's and spoke the Colonel from head to heel. It went with his beauty, intact yet at fifty-eight, with the greying amber of his hair, mustache, and imperial; with his eyes, not large but finely shaped and coloured; with his slightly aquiline nose; with the height and easy swing of his body that was neither too spare nor too full. It went with him from head to foot, and, though it was certainly not a loud voice nor a too-much-used one, it quite usually dominated whatever group for the moment enclosed the Colonel. He was speaking now in a kind of energetic, golden drawl. "So he came up to me and said, 'Dash it, Ashendyne! if gentlemen can't be allowed in this degenerate age to rule their own households and arrange their own duels —'" He became aware of the child standing by him, and put out a well-formed, nervous hand. "Yes, Gipsy? What is it you want now?"

Hagar explained sedately.

"Her husband hurt and can't get to him to nurse him?" said the Colonel. "Well, well! That's pretty bad! I suppose we must take up a collection. Pass the hat, Gipsy!"

Hagar went to each of the country gentlemen, not with the suggested hat, but with her small palm held out, cupped. One by one they dropped into it quarter or dime, and each, as his coin tinkled down, had for the collector of bounty a

drawling, caressing, humorous word. She thanked each gentleman as his bit of silver touched her hand and thanked with a sedate little manner of perfection. Manners at Gilead Balm were notoriously of a perfection.

Hagar took the money to the woman with the baby and gave it to her shyly, with a red spot in each cheek. She was careful to explain, when the woman began to stammer thanks, that it was from her grandfather and the other gentlemen and that they were anxious to help. She was a very honest little girl, with an honest wish to place credit where it belonged.

Back beside Miss Serena she sat and studied the moving green banks. The sun was almost down; there were wonderful golden clouds above the mountains. Willow and sycamore, on the river side of the canal, fell away. Across an emerald, marshy strip, you saw the bright, larger stream, mirror for the bright sky, and across it in turn you saw limestone cliffs topped with shaggy woods, and you heard the sound of picks against rock and saw another band of convicts, white and black, making the railroad. The packet-boat horn was blown again,—long, musical, somewhat mournfully echoing. The negro on the towpath, riding sideways on his mule, was singing still.

"Aunt Serena — "

"Yes, Hagar."

"Why is it that women don't have any money?"

Miss Serena closed her book. She glanced at the fields and the sky-line. "We shall be at Gilead Balm in ten minutes.— You ask too many questions, Hagar! It is a very bad habit to be always interrogating. It is quite distinctly unladylike."

CHAPTER II

GILEAD BALM

AT the Gilead Balm landing waited Captain Bob with a negro man to carry up to the house the Colonel's portmanteau and Miss Serena's small leather trunk. The packet-boat came in sight, white and slow as a deliberate swan, drew reflectively down the shining reach of water, and sidled to the landing. The Colonel shook hands with all the country gentlemen and bowed to the ladies, and the country gentlemen bowed to Miss Serena, who in turn bent her head and smiled, and the captain said good-bye, and the Colonel gave the attendant darky a quarter, and the woman with the baby came to that side of the boat and held for a moment the hand of the dark little girl, and then the gangplank was placed and the three Ashendynes passed over to the Colonel's land. The horn blew again, long, melodious; the negro on the towpath said, "Get up!" to the mule. Amid a waving of hands and a chorus of slow, agreeable voices the packet-boat glided from the landing and proceeded down the pink water between the willows and sycamores.

Captain Bob, with his hound Luna at his heels, greeted the returning members of the family: "Well, Serena, did you have a pleasant visit? Hey, Gipsy, you've grown a week! Well, Colonel?"

The Colonel shook hands with his brother. "Very pleasant

time, Bob! Good old-time people, too good for this damned new-fangled world! But —" he breathed deep. "I am glad to get home. I am always glad to get home. Well? Everything all right?"

"Right as a trivet! The Bishop's here, and Mrs. LeGrand. Came on the stage yesterday."

"That's good news," said the Colonel. "The Bishop's always welcome, and Mrs. LeGrand is most welcome."

The four began to walk toward the house, half a mile away, just visible among great trees. The dark little girl walked beside the hound, but the hound kept her nose in Captain Bob's palm. She was fond of Hagar, but Captain Bob was her god. As for Captain Bob himself, he walked like a curious, unfinished, somewhat flawed and shortened suggestion of his brother. He was shorter than the Colonel and broader; hair, nose, eyes, mouth were nothing like so fine; carriage and port were quite different; he lacked the *cachet*, he lacked the *grand air*. For all that, the fact that they were brothers was evident enough. Captain Bob loved dogs and hunting, and read the county newspaper and the sporting almanac. He was not complex. Ninety-nine times out of a hundred he acted from instinct and habit, and the puzzling hundredth time he beat about for tradition and precedent. He was good-natured and spendthrift, with brains enough for not too distant purposes. Emotionally, he was strongest in family affection. "Missed you all!" he now observed cheerfully. "Gilead Balm's been like a graveyard."

"How is mother?" asked Miss Serena. She was picking her way delicately through the green lane, between the evening primroses, the grey-green delaine held just right. "She

wrote me that she burned her hand trying the strawberry preserves."

"It's all right now. Never saw Old Miss looking better!"

The dark little girl turned her dark eyes on Captain Bob. "How is my mother?"

"Maria? Well, I should say that she was all right, too. I have n't heard her complain."

"Gad! I wish she would complain," ejaculated the Colonel. "Then one could tell her there was nothing to complain about. I hate these women who go through life with a smile on their lips and an indictment in their eyes — when there's only the usual up and down of living to indict. I had rather they would whine — though I hate them to whine, too. But women are all cowards. No woman knows how to take the world."

The dark little girl, who had been walking between the Colonel and Captain Bob, began to tremble. "Whoever else's a coward, my mother's not —"

"I don't think, father, you ought —"

Captain Bob was stronger yet. He was fond of Gipsy, and he thought that sometimes the family bore too hardly on Maria. Now and then he did a small bit of cloudy thinking, and when he did it he always brought forth the result with a certain curious clearing of the throat and nodding of the head, as though the birth of an idea was attended with considerable physical strain. "No, Colonel," now he said, "you ought n't! Damn it, where'd we be but for women anyhow? As for Maria — I think you're too hard on Maria. The chief trouble with Maria is that she is n't herself an Ashendyne. Of course, she can't help that, but I think it is a pity. Always

did think that men ought to marry at least fifth or sixth cousins. Bring women in without blood and traditions of people they've got to live with — of course, there's trouble adapting. Seen it a score of times. Maria's just like the rest when they're not cousins. Ought somehow to be cousins."

"Bob, you are a perfect fool," remarked the Colonel.

He walked on, between the primroses, his hands behind him, tall and easy in his black, wide-skirted coat and his soft black hat. The earth was in shadow, but the sky glowed carnation. Against it stood out the long, low red-brick house of Gilead Balm. At either gable end rose pyramidal cedars, high and dark against the vivid sky. In the lane there was the smell of dewy grass, and on either hand, back from the vine-draped rail fences, rolled the violet fields. Somewhere in the distance sounded the tinkling of cow bells. The ardent sky began to pale; the swallows were circling above the chimneys of Gilead Balm, and now the silver Venus came out clear.

The little girl named Hagar lagged a little going up the low hill on which the house stood. She was growing fast, and all journeys were exciting, and she was taking iron because she wasn't very strong, and she had had a week of change and had been thinking hard and was tired. She wanted to see her mother, and indeed she wanted to see all at Gilead Balm, for, unlike her mother, she loved Gilead Balm, but going up the hill she lagged a little. Partly it was to look at the star and to listen to the distant bells. She was not aware that she observed that which we call Nature with a deep passion and curiosity, that beauty was the breath of her nostrils, and that she hungered and thirsted after the righteousness of

knowledge. She only came slowly, after many years, into that much knowledge of herself. To-day she was but an undeveloped child, her mind a nebula just beginning to spiral. In conversation she would have applied the word "pretty" indiscriminately to the flushed sky, the star, the wheeling swallows, the yellow primroses. But within, already, the primroses struck one note, and the wheeling swallows another, and the sky another, and the star another, and, combined, they made a chord that was like no other chord. Already her moments were distinguished, and each time she saw Gilead Balm she saw, and dimly knew that she saw, a different Gilead Balm.

She climbed the hill a little stumblingly, a dark, thin child with braided, dusky hair. She was so tired that things went into a kind of mist — the house and the packet-boat and the lock and the convict and the piping frogs and the cat-tails in a marsh and the word "evolution." . . . And then, up on the low hilltop, Dilsey and Plutus lit the lamps, and the house had a row of topaz eyes; — and here was the cedar at the little gate, and the smell of box — box smell was always of a very especial character, dark in hue, cool in temperature, and quite unfathomably old. The four passed through the house gate and went up the winding path between the box and the old, old blush roses — and here was the old house dog Roger fawning on the Colonel — and the topaz eyes were growing bigger, bigger. . . .

"I am glad to get home," said Miss Serena, in front. "It's curious how, every time you go from home, something happens to cure you of a roving disposition."

Captain Bob laughed. "Never knew you had a roving

disposition, Serena! Luna here, now,—Luna's got a roving disposition — have n't you, old girl?"

"Luna," replied Miss Serena with some asperity, "Luna makes no effort to alter her disposition. I do. Everybody's got tendencies and notions that it is their bounden duty to suppress. If they don't, it leads to all kind of changes and upheavals. — And that is what I criticize in Maria. She makes no effort, either. It's most unfortunate."

The Colonel, in front of them all, moved on with a fine serenity. He had taken off his hat, and in the yet warm glow the grey-amber of his hair seemed fairly luminous. As he walked he looked appreciatively up at the evening star. He read poetry with a fine, discriminating, masculine taste, and now, with a gesture toward the star, he repeated a line of Byron. Maria and her idiosyncrasies troubled him only when they stood actually athwart his path; certainly he had never brooded upon them, nor turned them over in his hand and looked at them. She was his son's wife — more, he was inclined to think, the pity! She was, therefore, Ashendyne, and she was housed at Gilead Balm. He was inclined to be fond of the child Hagar. As for his son — the Colonel, in his cooler moments, supposed, damn it! that he and Medway were too much alike to get on together. At any rate, whatever the reason, they did not get on together. Gilead Balm had not seen the younger Ashendyne for some years. He was in Europe, whence he wrote, at very long intervals, an amiable traveller's letter. Neither had he and Maria gotten on well together.

The house grew large, filling all the foreground. The topaz eyes changed to a wide, soft, diffused light, pouring from

windows and the open hall door. In it now appeared the figures of the elder Mrs. Ashendyne, of the Bishop, and Mrs. LeGrand, coming out upon the porch to welcome the travellers.

Hagar took her grandmother's kiss and Mrs. LeGrand's kiss and the Bishop's kiss, and then, after a few moments of standing still in the hall while the agreeable, southern voices rose and fell, she stole away, went up the shallow, worn stairway, turned to the left, and opened the door of her mother's room. She opened it softly. "Uncle Plutus says you've got a headache."

Maria's voice came from the sofa in the window. "Yes, I have. Shut the door softly, and don't let us have any light. But I don't mind your sitting by me."

The couch was deep and heaped with pillows. Maria's slight, small form was drawn up in a corner, her head high, her hands twisted and locked about her knees. She wore a soft white wrapper, tied beneath her breast with a purple ribbon. She had beautiful hair. Thick and long and dusky, it was now loosened and spread until it made a covering for the pillows. Out from its waves looked her small face, still and exhausted. The headache, after having lasted all day, was going away now at twilight. She just turned her dark eyes upon her daughter. "I don't mind your lying down beside me," she said. "There's room. Only don't jar my head —" Hagar lay carefully down upon the couch, her head in the hollow of her mother's arm. "Did you have a good time?"

"Yes. . . . Pretty good."

"What did you do?"

"There was another little girl named Sylvie. We played in the hayloft, and we made willow baskets, and we cut paper dolls out of a 'Godey's Lady's Book.' I named mine Lucy Ashton and Diana Vernon and Rebecca, and she did n't know any good names, so I named hers for her. We named them Rosalind and Cordelia and Vashti. Then there was a lady who played backgammon with me, and I read two books."

"What were they?"

"One was 'Gulliver's Travels.' I did n't like it altogether, though I liked some of it. The other was Shelley's 'Shorter Poems.' Oh" — Hagar rose to a sitting posture — "I liked that better than anything I've *ever* read —"

"You are young to be reading Shelley," said her mother. She spoke with her lips only, her young, pain-stilled face high upon the pillows. "What did you like best?"

Hagar pondered it. "I liked the 'Cloud,' and I liked the 'West Wind,' and I liked the 'Spirit of Night' —"

Some one tapped at the door, and then without waiting for an answer opened it. The elder Mrs. Ashendyne entered. Hagar slipped from the sofa and Maria changed her position, though very slightly. "Come in," she said, though Mrs. Ashendyne was already in.

"Old Miss," as the major part of Gilead Balm called her, Old Miss crossed the room with a stately tread and took the winged chair. She intended tarrying but a moment, but she was a woman who never stood to talk. She always sat down like a regent, and the standing was done by others. She was a large woman, tall rather than otherwise, of a distinct comeliness, and authoritative — oh, authoritative from her black

lace cap on her still brown, smoothly parted hair, to her low-heeled list shoes, black against her white stockings! Now she folded her hands upon her black stuff skirt and regarded Maria. "Are you better?"

"Yes, thank you."

"If you would take my advice," said Mrs. Ashendyne, "and put horseradish leaves steeped in hot water to your forehead and the back of your neck, you would find it a great relief."

"I had some lavender water," said Maria.

"The horseradish would have been far better. Are you coming to supper?"

"No, I think not. I do not care for anything. I am not hungry."

"I will have Phœbe fetch you a little thin chipped beef and a beaten biscuit and a cup of coffee. You must eat. — If you gave way less it would be better for you."

Maria looked at her with sombre eyes. At once the fingers slipped to other and deeper notes. "If I gave way less. . . . Well, yes, I do give way. I have never seen how not to. I suppose if I were cleverer and braver, I should see —"

"What I mean," said Old Miss with dignity, "is that the Lord, for his own good purposes, — and it is *sinful* to question his purposes, — regulated society as it is regulated, and placed women where they are placed. No one claims — certainly I don't claim — that women as women do not see a great deal of hardship. The Bible gives us to understand that it is their punishment. Then I say take your punishment with meekness. It is possible that by doing so you may help earn remission for all."

"There was always," said Maria, "something frightful to me in the old notion of whipping-boys for kings and princes. How very bad to be the whipping-boy, and how infinitely worse to be the king or prince whose whipping-boy you were!"

A red came into Mrs. Ashendyne's face. "You are at times positively blasphemous!" she said. "I do not at all see of what, personally, you have to complain. If Medway is estranged from you, you have probably only yourself to thank —"

"I never wish," said Maria, "to see Medway again."

Medway's mother rose with stateliness from the winged chair. "When it comes to statements like that from a wife, it is time for old-fashioned people like myself to take our leave. — Phœbe shall bring you your supper. Hagar, you had better come with me."

"Leave Hagar here," said the other.

"The bell will ring in ten minutes. Come, child!"

"Stay where you are, Hagar. When the bell rings, she shall come."

The elder Mrs. Ashendyne's voice deepened. "It is hard for me to see the mind of my son's child perverted, filled with all manner of foolish queries and rebellions."

"Your son's child," answered Maria from among her pillows, "happens to be also my child. His family has just had her for a solid week. Now, pray let me have her for an hour." Her eyes, dark and large in her thin, young face, narrowed until the lashes met. "I am perfectly aware of how deplorable is the whole situation. If I were wiser and stronger and more heroic, I suppose I should break through it. I suppose

I should go away with Hagar. I suppose I should learn to work. I suppose I should somehow keep us both. I suppose I might live again. I suppose I might . . . even . . . get a divorce —"

Her mother-in-law towered. "The Bishop shall talk to you the first thing in the morning —"

CHAPTER III

THE DESCENT OF MAN

A POOL of June sunlight lay on the library floor. It made a veritable Pool of Siloam, with all around a brown, bank-like duskiness. The room was by no means book-lined, but there were four tall mahogany cases, one against each wall, well filled for the most part with mellow calf. Flanking each case hung Ashendyne portraits, in oval, very old gilt frames. Beneath three of these were fixed silhouettes of Revolutionary Ashendynes; beneath the others, war photographs, *cartes de visite*, a dozen in one frame. There was a mahogany escritoire and mahogany chairs and a mahogany table, and, before the fireplace, a fire-screen done in cross-stitch by a colonial Ashendyne. The curtains were down for the summer, and the dark, polished floor was bare. The room was large, and there presided a pleasant sense of unencumbered space and coolness.

In the parlour, across the hall, Miss Serena had been allowed full power. Here there was a crocheted macramé lambrequin across the mantel-shelf, and a plush table-scarf worked with chenille, and fine thread tidies for the chairs, and a green-and-white worsted "water-lily" mat for the lamp, and embroidery on the piano cover. Here were pelargoniums and azaleas painted on porcelain placques, and a painted screen — gladioli and calla lilies, — and autumn leaves mounted on the top of a small table, and a gilded milking

stool, and gilded cat-tails in decalcomania jars. But the Colonel had barred off the library. "Embroider petticoat-world to the top of your bent — but don't embroider books!"

The Colonel was not in the library. He had mounted his horse and ridden off down the river to see a brother-in-law about some piece of business. Ashendynes and Coltsworths fairly divided the county between them. Blood kin and marriage connections, — all counted to the seventeenth degree, — traditional old friendships, old acquaintances, clients, tenants, neighbours, the coloured people sometime their servants, folk generally, from Judge to blacksmith, — the two families and their allies ramified over several hundred square miles, and when you said "the county," what you saw were Ashendynes and Coltsworths. They lived in brick houses set among green acres and in frame houses facing village streets. None were in the least rich, a frightful, impoverishing war being no great time behind them, and many were poor — but one and all they had "quality."

The Colonel was gone down the river to Hawk Nest. Captain Bob was in the stable yard. Muffled, from the parlour, the doors being carefully closed, came the notes of "Silvery Waves." Miss Serena was practising. It was raspberry-jam time of year. In the brick kitchen out in the yard Old Miss spent the morning with her knitting, superintending operations. A great copper kettle sat on the stove. Between it and the window had been placed a barrel and here perched a half-grown negro boy, in his hands a pole with a paddle-like crosspiece at the further end. With this he slowly stirred, round and round, the bubbling, viscous mass in the copper kettle. Kitchen doors and windows were wide, and in came the hum

of bees and the fresh June air, and out floated delectable odours of raspberry jam. Old Miss sat in an ample low chair in the doorway, knitting white cotton socks for the Colonel.

The Bishop — who was a bishop from another state — was writing letters. Mrs. LeGrand had taken her novel out to the hammock beneath the cedars. Upstairs, in her own room, in a big four-poster bed, lay Maria, ill with a low fever. Dr. Bude came every other day, and he said that he hoped it was nothing much but that he could n't tell yet: Mrs. Ashendyne must lie quiet and take the draught he left, and her room must be kept still and cool, and he would suggest that Phœbe, whom she seemed to like to have about her, should nurse her, and he would suggest, too, that there be no disturbing conversation, and that, indeed, she be left in the greatest quiet. It seemed nervous largely — "Yes, yes, that's true! We all ought to fight more than we do. But the nervous system is n't the imaginary thing people think! She is n't very strong, and — wrongly, of course — she dashes herself against conditions and environment like a bird against glass. I don't suppose," said Dr. Bude, "that it would be possible for her to travel?"

Maria lay in the four-poster bed, making images of the light and shadow in the room. Sometimes she asked for Hagar, and sometimes for hours she seemed to forget that Hagar existed. Old Miss, coming into the room at one of these times, and seeing her push the child from her with a frightened air and a stammering "I don't know you" — Old Miss, later in the day, took Hagar into her own room, set her in a chair beside her, taught her a new knitting-stitch, and explained that it would be kinder to remain out of her mother's

room, seeing that her presence there evidently troubled her mother.

"It troubles her sometimes," said Hagar, "but it does n't trouble her most times. Most times she likes me there."

"I do not think you can judge of that," said her grandmother. "At any rate, I think it best that you should stay out of the room. You can, of course, go in to say good-morning and good-night. — Throw the thread over your finger like that. Mimy is making sugar-cakes this morning, and if you want to you can help her cut them out."

"Grandmother, please let me go *four* times a day —"

"No. I do not consider it best for either of you. You heard the doctor say that your mother must not be agitated, and you saw yourself, a while ago, that she did not seem to want you. I will tell Phœbe. Be a good, obedient child! — Bring me the bag yonder, and let's see if we can't find enough pink worsted for a doll's afghan."

That had been two days ago. Hagar went, morning and evening, to her mother's room, and sometimes Maria knew her and held her hands and played with her hair, and sometimes she did not seem to know her and ignored her or talked to her as a stranger. Her grandmother told her to pray for her mother's recovery. She did not need the telling; she loved her mother, and her petitions were frequent. Sometimes she got down on her knees to make them; sometimes she just made them walking around. "O God, save my mother. For Jesus' sake. Amen." — "O God, let my mother get well. For Jesus' sake. Amen." — She had finished the pink afghan, and she had done the dusting and errands her grandmother appointed her. This morning they had let her arrange

the flowers in the bowls and vases. She always liked to do that, and she had been happy for almost an hour — but then the feeling came back. . . .

The bright pool on the library floor did not reach to the bookcases. They were all in the gold-dust powdered umber of the rest of the room. Hagar standing before one of them, first on a hassock, and then, for the upper shelves, on a chair, hunted something to read. "Ministering Children" — she had read it. "Stepping Heavenward" — she had read it. "Home Influence" and "Mother's Recompense" — she had read them. Mrs. Sherwood — she had read Mrs. Sherwood — many volumes of Mrs. Sherwood. In after life it was only by a violent effort that she dismissed, in favour of any other India, the spectre of Mrs. Sherwood's India. "Parent's Assistant and Moral Tales" — she knew Simple Susan and Rosamond and all of them by heart. "Rasselas" — she had read it. "Scottish Chiefs" — she had read it. The forms of Wallace and Helen and Murray and Edwin flitted through her mind — she half put out her hand to the book, then withdrew it. She was n't at all happy, and she wanted novelty. Miss Mühlbach — "Prince Eugene and His Times" — "Napoleon and Marie Louise" — she had read those, too. "The Draytons and the Davenants" — she half thought she would read about Olive and Roger again, but at last she passed them by also. There was n't anything on that shelf she wanted. She called it the blue and green and red shelf, because the books were bound in those colours. Miss Serena's name was in most of these volumes.

The shelf that she undertook next had another air. To Hagar each case had its own air, and each shelf its own air,

and each book its own air. "Blair's Rhetoric" — she had read some of that, but she did n't want it to-day. "Pilgrim's Progress" — she knew that by heart. "Burke's Speeches" — "Junius" — she had read "Junius," as she had read many another thing simply because it was there, and a book was a book. She had read it without much understanding, but she liked the language. Milton — she knew a great part of Milton, but to-day she did n't want poetry. Poetry was for when you were happy. Scott — on another day Scott might have sufficed, but to-day she wanted something new — so new and so interesting that it would make the hard, unhappy feeling go away. She stepped from the hassock upon the chair and began to study the titles of the books on almost the top shelf. . . . There was one in the corner, quite out of sight unless you were on a chair, right up here, face to face with the shelf. The book was even pushed back as though it had retired — or had been retired — behind its fellows so as to be out of danger, or, perhaps, out of the way of being dangerous. Hagar put in her slender, sun-browned hand and drew it forward until she could read the legend on the back — "The Descent of Man." She drew it quite forth, and bringing both hands into play opened it. "By Charles Darwin." She turned the leaves. There were woodcuts — cuts that exercised a fascination. She glanced at the first page: "He who wishes to decide whether man is the modified descendant of some preëxisting form —"

Hagar turned upon the chair and looked about her. The room was a desert for solitude and balmy quiet. Distantly, through the closed parlour doors, came Miss Serena's rendering of "Monastery Bells." She knew that her grandfather

was down the river, and that her grandmother was making raspberry jam. She knew that the Bishop was in his room, and that Mrs. LeGrand was out under the cedars. Uncle Bob did not count anyway — he rarely asked embarrassing questions. She may have hesitated one moment, but no more. She got down from the chair, put it back against the wall, closed the bookcase door, and taking the "Descent of Man" with her went over to the old, worn horsehair sofa and curled herself up at the end in a cool and slippery hollow. A gold-dust shaft, slipping through the window, lit her hair, the printed page, and the slim, long-fingered hand that clasped it.

Hagar knew quite well what she was doing. She was going to read a book which, if her course were known, she would be forbidden to read. It had happened before now that she had read books under the ban of Gilead Balm. But heretofore she had always been able to say that she had not known that they were so, had not known she was doing wrong. That could not be said in this case. Aunt Serena had distinctly told her that Charles Darwin was a wicked and irreligious man, and that no lady would read his books. . . . But then Aunt Serena had unsparingly condemned other books which Hagar's mind yet refused to condemn. She had condemned "The Scarlet Letter." When Gilead Balm discovered Hagar at the last page of that book, there had ensued a family discussion. Miss Serena said that she blushed when she thought of the things that Hagar was learning. The Colonel had not blushed, but he said that such books unsettled all received notions, and while he supported her he was n't going to have Medway's child imbibing damned anarchical sentiments of

any type. Old Miss said a number of things, most of which tended toward Maria. The latter had defended her daughter, but afterwards she told Hagar that in this world, even if you did n't think you were doing wrong, it made for all the happiness there seemed to be not to do what other people thought you ought not to do. . . . But Hagar did n't believe yet that there was anything wrong in reading "The Scarlet Letter." She had been passionately sorry for Hester, and she had felt — she did not know why — a kind of terrified pity for Mr. Dimmesdale, and she had loved little Pearl. She had intended asking her mother what the red-cloth letter that Hester Prynne wore meant, but it had gone out of her mind. The chapter she liked best was the one with little Pearl playing in the wood. . . . Perhaps Aunt Serena, having been mistaken about that book, was mistaken, too, about Charles Darwin.

Neither now nor later did she in any wise love the feel of wrong-doing. Forbidden fruit did not appeal to her merely because it was forbidden. But if there was no inner forbidding, if she truly doubted the justice or authority or abstract rightness of the restraining hand, she was capable of attaining the fruit whether forbidden or no. There was always the check of great native kindliness. If what she wanted to do was going — no matter how senselessly — to trouble or hurt other people's feelings, on the whole she would n't do it. In the case of this June day and the "Descent of Man" the library was empty. She only wanted to look at the pictures and to run over the reading enough to see what it was about — then she would put it back on the top shelf. She was not by nature indirect or secretive. She preferred to go

straightforwardly, to act in the open. But if the wall of not-agreed-in objection stood too high and thick before her, she was capable of stealing forth in the dusk and seeking a way around it. Coiled now in the cool hollow of the sofa, half in and half out of the shaft of sunshine, she began to read.

The broad band of gold-dust shifted place. Miss Serena, arrived at the last ten minutes of her hour and a half at the piano, began to play "Pearls and Roses." Out in the brick kitchen Old Miss dropped a tablespoonful of raspberry jam into a saucer, let it cool, tasted, and pronounced it done. The negro boy and Mimy between them lifted the copper kettle from the stove. Upstairs in Gilead Balm's best room the Bishop folded and slipped into an addressed envelope the last letter he was going to write that morning. Out under the cedars Mrs. LeGrand came to a dull stretch in her novel. She yawned, closed the book, and leaned back against the pillows in the hammock.

Mrs. LeGrand was fair and forty, but only pleasantly plump. She had a creamy skin, moderately large, hazel eyes, moderately far apart, a small, straight nose, a yielding mouth, and a chin that indubitably would presently be double. She was a widow and an orphan. Married at nineteen, her husband, the stars of a brigadier-general upon his grey collar, had within the year fallen upon some one of the blood-soaked battle-grounds of the state. Her father, the important bearer of an old, important name, had served the Confederacy well in a high civil capacity. When the long horror of the war was over, and the longer, miserable torture of the Reconstruction was passing, and a comparative ease and pale dawn of prosperity rose over the state, Mrs. LeGrand looked about her

from the remnant of an old plantation on the edge of a tidewater town. The house was dilapidated, but large. The grounds had Old Neglect for gardener, but they, too, were large, and only needed Good-Care-at-Last for complete rehabilitation. Mrs. LeGrand had a kind of smooth, continuous, low-pressure energy, but no money. "A girls' school," she murmured to herself.

When she wrote, here and there over the state, it was at once seen by her correspondents that this was just the thing for the daughter of a public man and the widow of a gallant officer. It was both ladylike and possible. . . . That was some years ago. Mrs. LeGrand's School for Young Ladies was now an established fact. The house was repaired, the grounds were trim, there was a corps of six teachers, with prospects of expansion, there were day pupils and boarding pupils. Mrs LeGrand saw in her mind's eye long wing-like extensions to the main house where more boarding pupils might be accommodated. . . . She was successful, and success agreed with her. The coat grew sleek, the cream rose to the top, every angle disappeared; she was warmly optimistic, and smooth, indolent good company. In the summer-time she left Eglantine and from late June to September shared her time between the Springs and the country homes of kindred, family connections, or girlhood friends. She nearly always came for a fortnight or more to Gilead Balm.

Now, leaning back in the hammock, the novel shut, her eyes closed, she was going pleasantly over to herself the additions and improvements to be carried out at Eglantine. From this her mind slipped to her correspondence with a French teacher who promised well, and thence to certain

letters received that week from patrons with daughters. One of these, from a state farther south, spoke in highest praise of Mrs. LeGrand's guardianship of the young female mind, of the safe and elegant paths into which she guided it, and of her gift generally for preserving dew and bloom and ignorance of evil in her interesting charges. Every one likes praise and no one is so churlish as to refuse a proffered bouquet or to doubt the judgment of the donor. Mrs. LeGrand experienced from head to foot a soft and amiable glow.

For ten minutes longer she lay in an atmosphere of balm, then she opened her eyes, drew her watch from her white-ribbon belt, and glancing at it surmised that by now the Bishop might have finished his letters. Upon this thought she rose, and paced across the bright June grass to the house. "Pearls and Roses" floated from the parlour. Her hand on the doorknob, Mrs. LeGrand paused irresolutely for a moment, then lightly took it away and crossed the hall to the library. A minute later the Bishop, portly and fine, letters in his hand, came down the stairs, and turned toward this room. The mail-bag always hung, he remembered, by the library escritoire. Though he was a large man, he moved with great lightness; he was at once ponderous and easy. Miss Serena at the piano could hardly have heard him pass the door, so something occult, perhaps, made her ignore the *da capo* over the bar of "Pearls and Roses" which she had now reached. She struck a final chord, rose, closed the piano, and left the parlour.

CHAPTER IV

THE CONVICT

"My dear Bishop!" exclaimed Mrs. LeGrand; "won't you come here and talk to this little girl?"

"To Hagar?" answered the Bishop. "What is the trouble with Hagar? Have you broken your doll, poor dear?" He came easily across to the horsehair sofa, a good man, by definition, as ever was. "What's grieving you, little girl?"

"I think that it is Hagar who may come to grieve others," said Mrs. LeGrand. "I do not suppose it is my business to interfere, — as I should interfere were she in my charge at Eglantine, — but I cannot but see in my daily task how difficult it is to eradicate from a youthful mind the stain that has been left by an improper book —"

"An improper book! What are you doing, Hagar, with an improper book?"

The Bishop put out his hand and took it. He looked at the title and at the author's name beneath, turned over a dozen pages, closed the book, and put it from him on the cold, bare mahogany table. "It was not for this that I christened you," he said.

Miss Serena joined the group.

"Serena," appealed Mrs. LeGrand, "*do* you think Hagar ought to be allowed to contaminate her mind by a book like that?"

Miss Serena looked. "That child! — She's been reading Darwin!"

A slow colour came into her cheeks. The book was shocking, but the truly shocking thing was how absolutely Hagar had disobeyed. Miss Serena's soul was soft as wax, pliant as a reed to the authorities her world ranged before her. By an inevitable reaction stiffness showed in the few cases where she herself held the orb of authority. To be disobeyed was very grievous to her. Where it was only negligence in regard to some command of her own, — direction to a servant, commands in her Sunday-School class, — she had often to put up with it, though always with a swelling sense of injury. But when things combined, when disobedience to Serena Ashendyne was also disobedience to the constituted authorities, Miss Serena became adamant.

Now she looked at Hagar with a little gasp, and then, seeing through the open door the elder Mrs. Ashendyne entering from the kitchen, she called to her. "Mother, come here a moment!" . . .

"If she had said that she was sorry," pronounced the Bishop, "you might forgive her, I think, this time. But if she is going to harden her heart like that, you had best let her see that all sin, in whatever degree, brings suffering. And I should suit, I think, the punishment to the offence. Hagar told me only yesterday that she had rather read a book than gather cherries or play with dolls, or go visiting, or anything. I think I should forbid her to open any book at all for a week."

Behind Gilead Balm, beyond the orchard and a strip of meadow, sprang a ridge of earth, something more than a hill, something less than a low mountain. It was safe, dry, warm,

and sandy, too cut-over and traversed to be popular with snakes, too within a stone's throw of the overseer's house and the overseer's dogs to be subject to tramps or squirrel-hunting boys, just wooded enough and furrowed with shallow ravines to make it to children a romantic, sprite-inhabited region. When children came to Gilead Balm, as sometimes, in the slow, continuous procession through the houses of a people who traditionally kept "open house," they did come, Hagar and they always played freely and alone on the homeward-facing side of the ridge. When the overseer's grandchildren, too, came to visit him, they and Hagar played here, and sometimes Mary Magazine, Isham and Car'line's ten-year-old at the Ferry, was allowed to spend the day, and she and Hagar played together on the ridge. Hagar was very fond of Mary Magazine.

One day, having completed her circle of flower dolls before her companion's was done, she leaned back against the apple tree beneath which the two were seated and thoughtfully regarded the other's down-bent brown face and "wrapped" hair. "Mary Magazine, you could n't have been named 'Mary Magazine.' You were named Mary Magdalene."

"No'm," said Mary Magazine, a pink morning-glory in one hand and a blue one in the other. "No'm. I'm named Mary Magazine. My mammy done named me for de lady what took her cologne bottle somebody give her Christmas, an' poured it on her han' an' rubbed Jesus' feet."

When Mary Magazine did n't come to Gilead Balm and no children were staying in the house, and the overseer's grandchildren were at their home on the other side of the county, Hagar might — provided always she let some one

know where she was going — Hagar might play alone on the ridge. To-day, having asked the Colonel if she might, she was playing there alone.

"Playing" was the accepted word. They always talked of her as "playing," and she herself repeated the word.

"May I go play awhile on the ridge?"

"I reckon so, Gipsy. Wear your sunbonnet and don't get into any mischief."

At the overseer's house she stopped to talk with Mrs. Green, picking pease in the garden. "Mahnin', Hagar," said Mrs. Green. "How's yo' ma this mahnin'?"

"I think she's better, Mrs. Green. She laughed a little this morning. Grandmother let me stay a whole half-hour, and mother talked about *her* grandmother, and about picking up shells on the beach, and about a little boat that she used to go out to sea in. She said that all last night she felt that boat beneath her. She laughed and said it felt like going home. — Only" — Hagar looked at Mrs. Green with large, wistful eyes — "only home's really Gilead Balm."

"Of course it is," said Mrs. Green cheerfully. She sat down on an overturned bucket between the green rows of pease, and pushed back her sunbonnet from her kind, old wrinkled face. "I remember when yo' ma came here jest as well. She was jest the loveliest thing! — But of course all her own people were a good long way off, and she was a seafarer herself, and she could n't somehow get used to the hills. I've heard her say they jest shut her in like a prison. . . . But then, after a while, you came, an' I reckon, though she says things sometimes, wherever you are she feels to be home. When it comes to being a woman, the good Lord has to get

in com-pensation somewhere, or I don't reckon none of us could stand it. — I'm glad she's better."

"*I'm* glad," said Hagar. "Can I help you pick the pease, Mrs. Green?"

"Thank you, child, but I've about picked the mess. You goin' to play on the ridge? I wish Thomasine and Maggie and Corker were here to play with you."

"I wish they were," said Hagar. Her eyes filled. "It's a very lonesome day. Yesterday was lonesome and to-morrow's going to be lonesome —"

"Have n't you got a good book? I never see such a child for books."

Two tears came out of Hagar's eyes. "I was reading a book Aunt Serena told me not to read. — And now I'm not to read *anything* for a whole week."

"Sho!" exclaimed Mrs. Green. "What did you do that for? Don't you know that little girls ought to mind?"

Hagar sighed. "Yes, I suppose they ought. . . . I wish I had now. . . . It's so lonesome not to read when your mother's sick and grandmother won't let me go into the room only just a little while morning and evening."

"Have n't you got any pretty patchwork nor nothin'?"

Hagar standing among the blush roses, looked at her with sombre eyes. "Mrs. Green, I hate to sew."

"Oh!" exclaimed Mrs. Green. "That's an awful thing to say!"

She sat on the overturned bucket, between the pale-green, shiny-podded peavines, her friendly old face, knobbed and wrinkled like a Japanese carving, gleaming from between the faded blue slats of her sunbonnet, and she regarded the

child before her with real concern. "I wonder now," she said, "if you're goin' to grow up a rebel? Look-a-here, honey, there ain't a mite of ease and comfort on that road."

"That's what the Yankees called us all," said Hagar. "'Rebels.'"

"Ah, I don't mean 'rebel' that-er-way," said Mrs. Green. "There's lonelier and deeper ways of rebellin'. You don't get killed with an army cheerin' you, and newspapers goin' into black, and a state full of people, that were 'rebels' too, keepin' your memory green, — what happens, happens just to you, by yourself without any company, and no wreaths of flowers and farewell speeches. They just open the door and put you out."

"Out where?"

"Out by yourself. Out of this earth's favour. And, though we may n't think it," said Mrs. Green, "this earth's favour is our sunshine. It's right hard to go where there is n't any sunshine. . . . I don't know why I'm talking like this to you — but you're a strange child and always were, and I reckon you come by it honest!" She rose from among the peavines. "Well, I've been baking apple turnovers, and they ain't bad to picnic on! Suppose you take a couple up on the ridge with you."

There grew, on the very top of the ridge, a cucumber tree that Hagar loved. Underneath was a little fine, sparse grass and enough pennyroyal to make the place aromatic when the sunshine drew out all its essence, as was the case to-day. Over the light soil, between the sprigs of pennyroyal, went a line of ants carrying grains of some pale, amber-clear substance. Hagar watched them to their hill. When, one by one,

they had entered, a second line of foragers emerged and went off to the right through the grass. In a little time these, too, reappeared, each carrying before her a tiny bead of the amber stuff. Hagar watched, elbows on ground and chin on hands. She had a feeling that they were people, and she tried giving them names, but they were so bewilderingly alike that in a moment she could not tell which was "Brownie" and which "Pixie" and which "Slim." She turned upon her back and lying in the grass and pennyroyal saw above her only blue sky and blue sky. She stared into it. "If the angels were sailing like the birds up there and looking down — and looking down — we people might seem all alike to them — all alike and not doing things that were very different — all alike. . . . Only there are our clothes. Pink ones and blue ones and white ones and black ones and plaid ones and striped ones — " She stared at the blue until she seemed to see step after step of blue, a great ladder leading up, and then she turned on her side and gazed at Gilead Balm and, a mile away, the canal and the shining river.

She could see many windows, but not her mother's window. She had to imagine that. Lonesomeness and ennui, that had gone away for a bit in the interest of watching the ants, returned full force. She stood up and cast about for something to break the spell.

The apple turnovers wrapped in a turkey-red, fringed napkin, rested in a small willow basket upon the grass. Hagar was not hungry, but she considered that she might as well eat a turnover, and then that she might as well have a party and ask a dozen flower dolls. Her twelve years were as a moving plateau — one side a misty looming landscape of the

mind, older and higher than her age would forecast; on the other, green, hollow, daisy-starred meadows of sheer childhood. Her attention passed from side to side, and now it settled in the meadows.

She considered the grass beneath the cucumber tree for a dining-room, and then she grew aware that she was thirsty, and so came to the conclusion that she would descend the back side of the ridge to the spring and have the party there. Crossing the hand's breadth of level ground she began to climb down the long shady slope toward a stream that trickled through a bit of wood and a thicket, and a small, ice-cold spring in a ferny hollow. The sun-bathed landscape, river and canal and fields and red-brick Gilead Balm with its cedars, and the garden and orchard, and the overseer's house sank from view. There was only the broad-leaved cucumber tree against the deep blue sky. The trunk of the cucumber tree disappeared, and then the greater branches, and then the lesser branches toward the top, and then the bushy green top itself. When Hagar and the other children played on the ridge, they followed her lead and called this side "the far country." To them — or perhaps only to Hagar — it had a clime, an atmosphere quite different from the homeward-facing side.

When she came to the spring at the foot of the ridge she was very thirsty. She knelt on a great sunken rock, and, taking off her sunbonnet, leaned forward between the fern and mint, made a cup of her hands and drank the sparkling water. When she had had all she wished, she settled back and regarded the green, flowering thicket. It came close to the spring, filling the space between the water and the wood, and it was a

wild, luxuriant tangle. Hagar's fancy began to play with it. Now it was a fairy wood for Thumbelina — now Titania and Oberon danced there in the moonlight — now her mind gave it height and hugeness, and it was the wood around the Sleeping Beauty. The light-winged minutes went by and then she remembered the apple turnovers. . . . Here was the slab of rock for the table. She spread the turkey-red napkin for cloth, and she laid blackberry leaves for plates, and put the apple turnovers grandly in the middle. Then she moved about the hollow and gathered her guests. Wild rose, ox-eye daisy, Black-eyed Susan, elder, white clover, and columbine — quite a good party. . . . She set each with due ceremony on the flat rock, before a blackberry-leaf plate, and then she took her own place facing the thicket, and after a polite little pause, folded her hands and closed her eyes. "We will say," she said, "a silent Grace."

When she opened her eyes, she opened them full upon other eyes — haggard, wolfishly hungry eyes, looking at her from out the thicket, behind them a body striped like a wasp. . . .

"I did n't mean to scare you," said the boy, "but if you ever went most of two days and a night without anything to eat, you 'd know how it felt."

"I never did," said Hagar. "But I can imagine it. I wish I had asked Mrs. Green for *five* apple turnovers." As she spoke, she pushed the red fringed napkin with the second turnover toward him. "Eat that one, too. I truly don't want any, and the flowers are never hungry."

He bit into the second turnover. "It seems mean to eat up your tea-party, but I'm 'most dead, and that's the truth —"

Hagar, sitting on the great stone with her hands folded in

her lap and her sunbonnet back on her shoulders, watched her suddenly acquired guest. He would not come clear out of the thicket; the tangled growth held him all but head and shoulders. "I believe I've seen you before," she said at last. "About two weeks ago grandfather and Aunt Serena and I were on the packet-boat. Were n't you at the lock up the river? The boat went down and down until you were standing 'way up, just against the sky. I am almost sure it was you."

He reddened. "Yes, it was me." Then, dropping the arm that held the yet uneaten bit of turnover, he broke out. "I did n't run away while I was a trusty! I would n't have done it! One of the men lied about me and said dirty words about my people, and I jumped on him and knocked his head against a stone until he did n't come to for half an hour! Then they did things to me, and did what they called degrading me. 'No more trustying for you!' said the boss. So I run away — three days ago." He wiped his forehead with his sleeve. "It seems more like three years. I reckon they 've got the dogs out."

"What have they got the dogs out for?"

"Why, to hunt me. I — I —"

His voice sunk. Terror came back, and will-breaking fear, a chill nausea and swooning of the soul. He groaned and half rose from the thicket. "I was lying here till night, but I reckon I'd better be going —" His eyes fell upon his body and he sank back. "O God! I reckon in hell we 'll wear these clothes."

Hagar stared at him, faint reflecting lines of anxiety and unhappiness on her brow, quiverings about her lips. "Ought

you to have run away? Was it right to run away?" The colour flooded her face. It was always hard for her to tell of her errors, but she felt that she and the boy were in somewhat the same case, and that she ought to do it. "I did something my aunt had told me not to do. It was reading a book that she said was wicked. I can't see yet that it was wicked. It was very interesting. But the Bishop said that he did n't christen me for that, and that it was a sin. And now, for a whole week, grandmother says that I'm not to read any book at all — which is very hard. What I mean is," said Hagar, "though I don't feel yet that there was anything wicked in that book (I did n't read much of it), I feel perfectly certain that I ought to obey grandmother. The Bible tells you so, and I believe in the Bible." Her brow puckered again. "At least, I believe that I believe in the Bible. And if there was n't anybody in the house, and the most interesting books were lying around, I would n't — at least I think I would n't — touch one till the week is over." She tried earnestly to explain her position. "I mean that if I really did wrong — and I reckon I'll have to say that I ought n't to have disobeyed Aunt Serena, though the Bible does n't say anything about aunts — I'll take the hard things that come after. Of course" — she ended politely — "your folks may have been mistaken, and you may not have done anything wrong at all —"

The boy bloomed at her. "I'll tell you what I did. I live 'way out in the mountains, the other end of nowhere. Well, Christmas there was a dance in the Cove, and I went, but Nancy Horn, that had promised to go with me, broke her word and went with Dave Windless. There was a lot of apple

THE CONVICT

jack around, and I took more'n I usually take. And then, when we were dancing the reel, somebody — and I'll swear still it was Dave, though he swore in the court-room it was n't — Dave Windless put out his foot and tripped me up! Well, Nancy, she laughed. . . . I don't remember anything clear after that, and I thought that the man who was shooting up the room was some other person, though I did think it was funny the pistol was in my hand. . . . Anyhow, Dave got a ball through his hip, and old Daddy Jake Willy, that I was awful fond of and would n't have hurt not for a still of my own and the best horse on the mountain, he got his bow arm broken, and one of the women was frightened into fits, and next week when her baby was born and had a harelip she said I'd done it. . . . Anyhow the sheriff came and took me — it was about dawn, 'way up on the mountain-side, and I still thought it was another man going away toward Catamount Gap and the next county where there was n't any Nancy Horn — I thought so clear till I fired at the sheriff and broke his elbow and the deputy came up behind and twisted the pistol away, and somebody else threw a gourd of water from the spring over me. . . and I come to and found it had been me all the time. . . . That's what I did, and I got four years."

"Four years?" said Hagar. "Four years in — in jail?"

"In the penitentiary," said the boy. "It's a worse word than jail. . . . I know what's right and wrong. Liquor's wrong, and the Judge said carrying concealed weapons was wrong, and I reckon it is, though there is n't much concealment when everybody knows you're wearing them. . . . Yes, liquor's wrong, and quarrels might go off just with some

words and using your fists if powder and shot were n't right under your hand, tempting you. Yes, drinking's wrong and quarreling's wrong, and after I come to my senses it did n't need no preacher like those that come round Sundays to tell me that. But I tell you what's the whole floor space of hell wronger than most of the things men do and that's the place the lawyers and the judges and the juries send men to!"

"Do you mean that they ought n't to — to do anything to you? You *did* do wrong."

"No, I don't mean that," said the boy. "I've got good sense. If I did n't see it at first, old Daddy Jake Willy came to the county jail three or four times, and he made me see it. The Judge and the lawyer could n't ha' made me see it, but *he* did. And at last I was willing to go." His face worked. "The day before I was to go I was in that cell I'd stayed in then two months and I looked right out into the sunshine. You could see Old Rocky Knob between two bars, and Bear's Den between two, and Lonely River running down into the valley between the other two, and the sun shining over everything — shining just like it's shining to-day. Well, I stood there, looking out, and made a good resolution. I was going to take what was coming to me because I deserved it, having broken the peace and lamed men and hurt a woman, and broken Daddy Jake's arm and fired at the sheriff. I had n't meant to do all that, but still I had done it. So I said, 'I'll take it. And I won't give any trouble. And I'll keep the rules. If it's a place to make men better in, I'll come out a better man. I'll work just as hard as any man, and if there's books to study I'll study, and I'll keep the rules and try to help other people, and when I come out, I'll be young still

THE CONVICT 43

and a better man."'" He rose to his full height in the thicket, the upper half of his striped body showing like a swimmer's above the matted green. He sent out his young arms in a wide gesture at once mocking and despairing, but whether addressed to earth or heaven was not apparent. "You see, I did n't know any more about that place than a baby unborn!"

With that he dropped like a stone back into the thicket and lay dumb and close, with agonized eyes. Around the base of the ridge out of the wood came the dogs; behind them three men with guns.

... One of the men was a jolly, fatherly kind of person. He tried to explain to Hagar that they were n't really going to hurt the convict at all — she saw for herself that the dogs had n't hurt him, not a mite! The handcuffs did n't hurt him either — they were loose and comfortable. No; they were n't going to do anything to him, they were just going to take him back. — He had n't hurt her, had he? had n't said anything disagreeable to her or done anything but eat up her tea-party? — Then that was all right, and the fatherly person would go himself with her to the house and tell the Colonel about it. Of course he knew the Colonel, everybody knew the Colonel! And "Stop crying, little lady! That boy ain't worth it."

The Colonel's dictum was that the country was getting so damned unsettled that Hagar must not again be let to play on the ridge alone.

Old Miss, who had had that morning a somewhat longish talk with Dr. Bude, stated that she would tell Mary Green to send for Thomasine and Maggie and Corker. "Dr. Bude

thinks the child broods too much, and it may be better to have healthy diversion for her in case —"

"In case —!" exclaimed Miss Serena. "Does he really think, mother, that it's serious?"

"I don't think he knows," answered her mother. "I don't think it is, myself. But Maria was never like anybody else —"

"Dear Maria!" said Mrs. LeGrand. "She should have made such a brilliant, lovely woman! If only there was a little more compliance, more feminine sweetness, more — if I may say so — unselfishness —"

"Where," asked the Bishop, "is Medway?"

Mrs. Ashendyne's needles clicked. "My son was in Spain, the last we heard: studying the painter Murillo."

CHAPTER V

MARIA

THOMASINE and Maggie and Corker arrived and filled the overseer's house with noise. They were a blatantly healthful, boisterous set, only Thomasine showing gleams of quiet. They wanted at once to play on the ridge, but now Hagar would n't play on the ridge. She said she did n't like it any more. As she spoke, her thin shoulders drew together, and her eyes also, and two vertical lines appeared between these. "What you shakin' for?" asked Corker. "Got a chill?"

So they played down by the branch where the willows grew, or in the old, disused tobacco-house, or in the orchard, or about a haystack on a hillside. Corker wanted always to play robbers or going to sea. Maggie liked to jump from the haystack or to swing, swing, swing, holding to the long, pendant green withes of the weeping willow, or to climb the apple trees. Thomasine liked to make dams across the streamlet below the tobacco-house. She liked to shape wet clay, and she saved every pebble or bit of bright china, or broken blue or green glass with which to decorate a small grotto they were making. She also liked to play ring-around-a-rosy, and to hunt for four-leaved clovers. Hagar liked to play going to sea, but she did not care for robbers. She liked to swing from the willows and to climb a particular apple tree which she loved, but she did not want to jump from the haystack, nor to climb all trees. She liked almost everything that Thomasine

liked, but she was not so terribly fond of ring-around-a-rosy. In her own likings she found herself somewhat lonely. None of the three, though Thomasine more than the others, cared much for a book. They would rather have a sugar-cake any day. When it came to lying on the hillside without speaking and watching the clouds and the tree-tops, they did not care for that at all. However, when they were tired, and everything else failed, they did like Hagar to tell them a story. "Aladdin" they liked — sitting in the shadow of the haystack, their chins on their hands, Thomasine's eyes still unconsciously alert for four-leaved clovers, Corker with a June apple, trying to determine whether he would bite into it now or wait until Aladdin's mother had uncovered the jewels before the Sultan. They liked "Aladdin" and "Queen Gulnare and Prince Beder" and "Snow White and Rose Red."

And then came the day that they went after raspberries. That morning Hagar, turning the doorknob of her mother's room, found the door softly opened from within and Phœbe on the threshold. Phœbe came out, closing the door gently behind her, beckoned to Hagar, and the two crossed the hall to the deep window. "I would n't go in this mahnin' ef I were you, honey," said Phœbe. "Miss Maria done hab a bad night. She could n't sleep an' her heart mos' give out. Oh, hit's all right now, an' she's been lyin' still an' peaceful since de dawn come up. But we wants her to sleep an' we don' want her to talk. An' Old Miss thinks an' Phœbe thinks too, honey, dat you'd better not go in this mahnin'. Nex' time Old Miss 'll let you stay twice as long to make up for it."

MARIA

Hagar looked at her large-eyed, "Is my mother going to die, Aunt Phœbe?"

But old Phœbe put her arms around her and the wrinkles came out all over her brown face as they did when she laughed. Phœbe was a good woman, wise and old and tender and a strong liar. "Law, no, chile — What put dat notion in yo' po' little haid? No, indeedy! We gwine pull Miss Maria through, jes' as easy! Dr. Bude he say he gwine do hit, and what Dr. Bude say goes for sho! Phœbe done see him raise de mos' dead. Law, no, don' you worry 'bout Miss Maria! An' de nex' time you goes in de room, you kin stay jes' ez long ez you like. You kin sit by her er whole hour an' won't nobody say you nay."

Downstairs Captain Bob was sitting on the sunny step of the sunny back porch, getting a thorn out of Luna's paw. "Hi, Gipsy," he said, when Hagar came and stood by him; "what's the matter with breakfast this morning?"

"I don't know," said Hagar. "I have n't seen grandmother to-day. Uncle Bob —"

"Well, chicken?"

"They'd tell you, would n't they, if my mother was going to die?"

Captain Bob, having relieved Luna of the thorn, gave his attention fully to his great-niece. He was slow and kindly and unexacting and incurious and unimaginative, and the unusual never occurred to him before it happened. "Maria going to die? That's damned nonsense, partridge! Have n't heard a breath of it — is n't anything to hear. Nobody dies at Gilead Balm — has n't been a death here since the War. Besides, Medway's away. — Must n't get notions in your

head — makes you unhappy, and things go on just the same as ever." He pulled her down on the step beside him. "Look at Luna, now! She ain't notionate — are you, Luna? Luna and I are going over the hills this morning to find Old Miss's guineas for her. Don't you want to go along?"

"I don't believe I do, thank you, Uncle Bob."

Mrs. LeGrand came out upon the porch, fresh and charming in a figured dimity with a blue ribbon. "Mrs. Ashendyne and Serena are talking to Dr. Bude, and as you men must be famished, Captain Bob, I am going to ring for breakfast and pour out your coffee for you —"

In the hall Hagar appealed to her. "Mrs. LeGrand, can't I go into grandmother's room and hear what Dr. Bude says about my mother?" But Mrs. LeGrand smiled and shook her head and laid hands on her. "No, indeed, dear child! Your mother's all right. You come with me, and have your breakfast."

The Bishop appearing at the stair foot, she turned to greet him. Hagar, slipping from her touch, stole down the hall to Old Miss's chamber and tried the door. It gave and let her in. Old Miss was seated in the big chair, Dr. Bude and the Colonel were standing on either side of the hearth, and Miss Serena was between them and the door.

"Hagar!" exclaimed Miss Serena. "Don't come in now, dear. Grandmother and I will be out to breakfast in a moment."

But Hagar had the courage of unhappiness and groping and fear for the most loved. She fled straight to Dr. Bude. "Dr. Bude — oh, Dr. Bude — is my mother going to die?"

"No, Bude," said the Colonel from the other side of the hearth.

Dr. Bude, an able country doctor, loved and honoured, devoted and fatherly and wise, made a "Tchk!" with his tongue against the roof of his mouth.

Old Miss, leaving the big chair, came and took Hagar and drew her back with her into the deep chintz hollows. No one might doubt that Old Miss loved her granddaughter. Now her clasp was as stately as ever, but her voice was quite gentle, though of course authoritative — else it could not have belonged to Old Miss. "Your mother had a bad night, dear, and so, to make her quiet and comfortable, we sent early for Dr. Bude. She is going to sleep now, and to-morrow you shall go in and see her. But you can only go if you are a good, obedient child. Yes, I am telling you the truth. I think Maria will get well. I have never thought anything else. — Now, run away and get your breakfast, and to-day you and Thomasine and Maggie and Corker shall go raspberrying."

Dr. Bude spoke from the braided rug. "No one knows, Hagar, what's going to happen in this old world, do they? But Nature has a way of taking care of people quite regardless and without waiting to consult the doctors. I've watched Nature right closely, and I never give up anything. Your mother's right ill, my dear, but so have a lot of other people been right ill and gotten well. You go pick your raspberries, and maybe to-morrow you can see her —"

"Can't I see her to-night?"

"Well, maybe — maybe —" said the doctor.

The raspberry patches were almost two miles away, past a number of shaggy hills and dales. A wood road led that way,

and Hagar and Thomasine and Maggie and Corker, with Jinnie, a coloured woman, to take care of them, felt the damp leaf mould under their feet. A breeze, coming through oak and pine, tossed their hair and fluttered the girls' skirts and the broad collar of Corker's voluminous shirt. The sky was bright blue, with two or three large clouds like sailing vessels with all sail on. A cat-bird sang to split its throat. They saw a black snake, and a rabbit showed a white tip of tail, and a lightning-blasted pine with a large empty bird-nest in the topmost crotch, ineffably lonely and deserted against the deep sky, engaged their attention. They had various adventures. Each of the children carried a tin bucket for berries, and Jinnie carried a white-oak split basket with dinner in it — sandwiches and rusks and a jar with milk and snowball cakes. They were going to stay all day. That was what usually they loved. It was so adventurous.

Corker strode along whistling. Maggie whistled, too, as well as a boy, though he looked disdain at her and said, "Huh! Girls can't whistle!"

"Dar's a piece of poetry I done heard," said Jinnie, —

"'Er whistlin' woman an' er crowin' hen,
Dey ain' gwine come ter no good end.'"

Thomasine hummed as she walked. She had filled her bucket with various matters as she went along, and now she was engaged in fashioning out of the green burrs of the burdock a basket with an elaborate handle. "Don't you want some burrs?" she asked Hagar, walking beside her. Thomasine was always considerate and would give away almost anything she had.

MARIA

Hagar took the burrs and began also to make a basket. She was being good. And, indeed, as the moments passed, the heavy, painful feeling about her heart went away. The doctor had said and grandmother had said, and Uncle Bob and Phoebe and every one . . . The raspberries. She instantly visualized one of the blue willow saucers filled with raspberries, carried in by herself to her mother, at suppertime. Yarrow was in bloom and Black-eyed Susans and the tall white Jerusalem candles. Coming back she would gather a big bouquet for the grey jar on her mother's table. She grew light-hearted. A bronze butterfly fluttered before her, the heavy odour of the pine filled her nostrils, the sky was so blue, the air so sweet — there was a pearly cloud like a castle and another like a little boat — a little boat. Off went her fancy, lizard-quick, feather-light.

"Swing low, sweet chariot — "

sang Jinnie as she walked.

The raspberry patches were in sunny hollows. There was a span-wide stream, running pure over a gravel bed, and a grazed-over hillside, green and short-piled as velvet, and deep woods closing in, shutting out. Summer sunshine bathed every grass blade and berry leaf, summer winds cooled the air, bees and grasshoppers and birds, squirrels in the woods, rippling water, wind in the leaves made summer sounds. It was a happy day. Sometimes Hagar, Thomasine, Maggie, Corker, and Jinnie picked purply-red berries from the same bush; sometimes they scattered and combined in twos and threes. Sometimes each established a corner and picked in an elfin solitude. Sometimes they conversed or bubbled over

with laughter, sometimes they kept a serious silence. It was a matter of rivalry as to whose bucket should first be filled. Hagar strayed off at last to an angle of an old rail fence. The berries, as she found, were very fine here. She called the news to the others, but they said they had fine bushes, too, and so she picked on with a world of her own about her. The June-bugs droned and droned, her fingers moved slower and slower. At last she stopped picking, and, lying down on a sunken rock by the fence, fell to dreaming. Her dreams were already shot with thought, and she was apt, when she seemed most idle, to be silently, inwardly growing. Now she was thinking about Heaven and about God. She was a great committer of poetry to memory, and now, while she lay filtering sand through her hands as through an hourglass, she said over a stanza hard to learn, which yet she had learned some days ago.

"Trailing clouds of glory do we come
From God, who is our home —"

When she had repeated it dreamily, in an inward whisper, the problem of why, in that case, she was so far from home engaged her attention. The "here" and the "there —" God away, away off on a throne with angels, and Hagar Ashendyne, in a blue sunbonnet here by a Virginia rail fence, with raspberry stain on her hands. *Home* was where you lived. God was everywhere; then, was God right here, too? But Hagar Ashendyne could n't see the throne and the gold steps and floor and the angels. She could make a picture of them, just as she could of Solomon's throne, or Pharaoh's throne, or Queen Victoria's throne, but the picture did n't stir anything at her heart. She was n't homesick for the court. She was

MARIA 53

homesick to be a good woman when she grew up, and to learn all the time and to know beautiful things, but she was n't homesick for Heaven where God lived. Then was she wicked? Hagar wondered and wondered. The yellow sand dropped from between her palms. . . . God in the sand, God in me, God here and now. . . . Then God also is trying to grow more God. . . . Hagar drew a great sigh, and for the moment gave it up.

Before her on the grey rail was a slender, burnished insect, all gold-and-green armour. Around the lock of the fence came, like a gold-and-green moving stiletto, a lizard which took and devoured the gold-and-green insect. . . . God in the lizard, God in the insect, God devouring God, making Himself feed Himself, growing so. . . . The sun suddenly left the grass and the raspberry bushes. A cloud had hidden it. Other cloud masses, here pearly white, here somewhat dark, were boiling up from the horizon.

Jinnie called the children together. "What we gwine do? Look like er storm. Reckon we better light out fer home!"

Protests arose. "Ho!" cried Corker, "it ain't going to be a storm. I have n't got my bucket more'n half full and we have n't had a picnic neither! Let's stay!"

"Let's stay," echoed Maggie. "Who's afraid of a little bit of storm anyhow?"

"It's lots better for it to catch us here in the open," argued Thomasine. "They're all tall trees in the wood. But *I* think the clouds are getting smaller — there's the sun again!"

The sunshine fell, strong and golden. "We's gwine stay den," said Jinnie. "But ef hit rains an' you all gets wet an' teks cold, I's gwine tell Old Miss I jus' could n't mek you

come erway! — Dar's de old cow-house at de end of de field. I reckon we kin refugee dar ef de worst comes to de worst."

While they were eating the snowball cakes, a large cloud came up and determinedly covered the sun. By the time they had eaten the last crumb, lightnings were playing. "Dar now, I done tol' you!" cried Jinnie. "I never see such children anyhow! Old Miss an' Mrs. Green jus' ought-ter whip you all! Now you gwine git soppin' wet an' maybe de lightning'll strike you, too!"

"No, it won't!" cried Corker. "The cow-house's my castle, an' we've been robbing a freight train an' the constable an' old Captain Towney and the army are after us — I'm going to get to the cow-house first!"

Maggie scrambled to her feet. "No, you ain't! I'm going to —"

The cow-house was dark and somewhat dirty, but they found a tolerable square yard or two of earthen floor and they all sat close together for warmth — the air having grown quite cold — and for company, a thunderstorm, after all, being a thing that made even train robbers and castled barons feel rather small and helpless. For an hour lightnings flashed and thunders rolled and the rain fell in leaden lines. Then the lightnings grew less frequent and vivid, and the thunder travelled farther away, but the rain still fell. "Oh, it's so stupid and dark in here!" said Corker. "Let's tell stories. Hagar, you tell a story, and Jinnie, you tell a story!"

Hagar told about the Snow Queen and Kay and Gerda, and they liked that very well. All the cow-house was dark as the little robber girl's hut in the night-time when all were asleep

save Gerda and the little robber girl and the reindeer. When they came to the reindeer, Corker said he heard him moving behind them in a corner, and Maggie said she heard him, too, and Jinnie called out, "Whoa, dere, Mr. Reindeer! You des er stay still till we's ready fer you!" — and they all drew closer together with a shudder of delight.

The clouds were breaking — the lines of rain were silver instead of leaden. Even the cow-house was lighter inside. There was no reindeer, after all; there were only brown logs and trampled earth and mud-daubers' nests and a big spider's web. "Now, Jinnie," said Corker, "you tell a ghost story."

Thomasine objected. "I don't like ghost stories. Hagar does n't either."

"I don't mind them much," said Hagar. "I don't have to believe them."

But Jinnie chose to become indignant. "You jes' hab to believe dem. Dey're true! My lan'! Goin' ter church an' readin' de Bible an' den doubtin' erbout ghosts! I'se gwine tell you er story you's got ter believe, 'cause hit's done happen! Hit's gwine ter scare you, too! Dey tell me hit scare a young girl down in de Hollow inter fits. Hit's gwine ter mek yo' flesh crawl. Sayin' ghos' stories ain't true, when everybody knows dey's true!"

The piece of ancient African imagination, traveller of ten thousand years through heated forests, was fearsome enough. "Ugh!" said the children and shivered and stared. — It took the sun, indeed, to drive the creeping, mistlike thoughts away.

Going home through the rain-soaked woodland, Hagar began to gather flowers. Her bucket of berries on her arm,

she stepped aside for this bloom and that, gathering with long stems, making a sheaf of blossoms. "What you doin' dat for?" queried Jinnie. "Dey's all wet. You'll jes' ruin dat gingham dress!" But Hagar kept on plucking Black-eyed Susans, and cardinal flowers, and purple clover and lady's-lace.

They came, in the afternoon glow, in sight of Gilead Balm. They came closer until the house was large, standing between its dark, funereal cedars, with a rosy cloud behind.

"All the blinds are closed as though we'd gone away!" said Hagar. "I never saw it that way before."

Mrs. Green was at the lower gate, waiting for them. Her old, kind, wrinkled face was pale between the slats of her sunbonnet, but her eyelids were reddened as though she had been weeping. "Yes, yes, children, I'm glad you got a lot of berries! — Corker and Maggie and Thomasine, you go with Jinnie. Mind me and go. — Hagar, child, you and me are goin' to come on behind. . . . You and me are goin' to sit here a bit on the summer-house step. . . . The Colonel said I was the best one after all to do it, and I'm going to do it, but I'd rather take a killing! . . . Yes, sit right here, with my arm about you. Hagar, child, I've got something to tell you, honey."

Hagar looked at her with large, dark eyes. "Mrs. Green, why are all the shutters closed?"

CHAPTER VI

EGLANTINE

No one could be so cross-grained as to deny that Eglantine was a sweet place. It lay sweetly on just the right, softly swelling hill. The old grey-stucco main house had a sweet porch, with wistaria growing sweetly over it; the long, added grey-stucco wings had pink and white roses growing sweetly on trellises between the windows. There were silver maples and heavily blooming locust trees and three fine magnolias. There were thickets of weigelia and spiræa and forsythia, and winding walks, and an arbour, and the whole twenty acres or so was enclosed by a thorny, osage-orange hedge, almost, though not quite so high as the hedge around the Sleeping Beauty's palace. It was a sweet place. Everyone said so — parents and guardians, the town that neighboured Eglantine, tourists that drove by, visitors to the Commencement exercises — everybody! The girls themselves said so. It was praised of all — almost all. The place was sweet. M. Morel, the French teacher, who was always improving his English, and so on the hunt for synonyms, once said in company that it was saccharine.

Miss Carlisle, who taught ancient and modern history and, in the interstices, astronomy and a blue-penciled physiology, gently corrected him. "Oh, M. Morel! We never use that word in this sense! If you wish to vary the term you might use 'charming,' or 'refined,' or 'elegant.' Besides" — she

gazed across the lawn — "it is n't so sweet, I always think, in November as it is in April or May."

"The sweetest time, I think," said Miss Bedford, who taught mathematics, geography, and Latin, "is when the lilac is in bloom."

"And when the robins nest again," sighed a pensive, widowed Mrs. Lane, who taught the little girls.

"It is 'refined' always," said M. Morel. "November or April, what is ze difference? It has ze atmosphere. It is sugary."

"Here," remarked Miss Gage, who taught philosophy — "here is Mrs. LeGrand."

All rose to greet the mistress of Eglantine as she came out from the hall upon the broad porch. Mrs. LeGrand's graciously ample form was wrapped in black cashmere and black lace. Her face was unwrinkled, but her hair had rapidly whitened. It was piled upon her head after an agreeable fashion and crowned by a graceful small cap of lace. She was ample and creamy and refinedly despotic. With her came her god-daughter, Sylvie Maine. It was early November, and the sycamores were yet bronze, the maples aflame. It was late Friday afternoon, and the occasion the arrival and entertainment overnight of an English writer of note, a woman visiting America with a book in mind.

Mrs. LeGrand said that she had thought she heard the carriage wheels. Mr. Pollock, the music-master, said, No; it was the wind down the avenue. Mrs. LeGrand, pleasantly, just condescending enough and not too condescending, glanced from one to the other of the group. "M. Morel and Mr. Pollock and you, Miss Carlisle and Miss Bedford, will,

I hope, take supper with our guest and me? Sylvie, here, will keep her usual place. I can't do without Sylvie. She spoils me and I spoil her! And we will have besides, I think, the girl that has stood highest this month in her classes. Who will it be, Miss Gage?"

"Hagar Ashendyne, Mrs. LeGrand."

Mrs. LeGrand had a humorous smile. "Then, Sylvie, see that Hagar's dress is all right and try to get her to do her hair differently. I like Eglantine girls to look their birth and place."

"Dear Cousin Olivia," said Sylvie, who was extremely pretty, "for all her plainness, Hagar's got distinction."

But Mrs. LeGrand shrugged her shoulders. She could n't see it. A little wind arising, all the place became a whirl of coloured leaves. And now the carriage wheels were surely heard.

Half an hour later Sylvie went up to Hagar's room. It was what was called the "tower room" — small and high up — too small for anything but a single bed and one inmate. It was n't a popular room with the Eglantine girls — a room without a roommate was bad enough, and then, when it was upon another floor, quite away from every one—! Language failed. But Hagar Ashendyne liked it, and it had been hers for three years. She had been at Eglantine for three years, going home to Gilead Balm each summer. She was eighteen — old for her age, and young for her age.

Sylvie found her curled in the window-seat, and spoke twice before she made her hear. "Hagar! come back to earth!"

Hagar unfolded her long limbs and pushed her hair away

from her eyes. "I was travelling," she said. "I was crossing the Desert of Sahara with a caravan."

"You are," remarked Sylvie, "too funny for words! — You and I are to take supper with 'Roger Michael'!"

A red came into Hagar's cheek. "Are we? Did Mrs. LeGrand say so?"

"Yes —"

Hagar lit the lamp. "'Roger Michael' — 'Roger Michael' — Sylvie, would n't you rather use your own name if you wrote?"

"Oh, I don't know!" answered Sylvie vaguely. "What dress are you going to wear?"

"I have n't any but the green."

"Then wear your deep lace collar with it. Cousin Olivia wants you to look as nice as possible. Don't you want me to do your hair?"

Hagar placed the lamp upon the wooden slab of a small, old-time dressing-table. That done, she stood and looked at herself with a curious, wistful puckering of the lips. "Sylvie, prinking and fixing up does n't suit me."

"Don't you like people to like you?"

"Yes, I do. I like it so much it must be a sin. Only not very many people do. . . . And I don't think prinking helps."

"Yes, it does. If you look pretty, how can people help liking you? It's three fourths the battle."

Hagar fell to considering it. "Is it? . . . But then we don't all think the same thing pretty or ugly." The red showed again like wine beneath her smooth, dark skin, "Sylvie, I'd *like* to be beautiful. I'd like to be as beautiful as Beatrix

Esmond. I'd like to be as beautiful as Helen of Troy. But everybody at Eglantine thinks I am ugly, and I suppose I am." She looked wistfully at Sylvie.

Now in the back of Sylvie's head there was certainly the thought that Hagar ought to have said, "I'd like to be as beautiful as you, Sylvie." But Sylvie had a sweet temper and she was not unmagnanimous. "I should n't call you ugly," she said judicially. "You are n't pretty, and I don't believe any one would ever call you so, but you are n't at all disagreeably plain. You've got something that makes people ask who you are. I would n't worry."

"Oh, I was n't worrying!" said Hagar. "I was only *preferring.* — I'll wear the lace collar." She took it out of a black Japanned box, and with it the topaz brooch that had been her mother's.

The visitor from England found the large, square Eglantine parlour an interesting room. The pier-glasses, framed in sallow gilt, the many-prismed chandelier, the old velvet carpet strewn with large soft roses, the claw-foot furniture, the two or three portraits of powdered Colonial gentlemen, the bits of old china, the framed letters bearing signatures that seemed to float to her from out her old United States History — all came to her like a vague fragrance from some unusual old garden. And then, curiously superimposed upon all this, appeared memorials of four catastrophic years. Soldiers and statesmen of the Confederacy had found no time in which to have their portraits painted. But Mrs. Le-Grand had much of family piety and, in addition, daguerreotypes and *cartes de visite* of the dead and gone. With her first glow of prosperity she had a local artist paint her father from

a daguerreotype. Stalwart, with a high Roman face, he looked forth in black broadcloth with a roll of parchment in his hand. The next year she had had her husband painted in his grey brigadier's uniform. Her two brothers followed, and then a famous kinsman — all dead and gone, all slain in battle. The portraits were not masterpieces, but there they were, in the pathos of the grey, underneath each a little gilt plate. "Killed at Sharpsburg." — "Killed Leading a Charge in the Wilderness." — "Killed at Cold Harbour." Upon the wall, against the pale, century-old paper, hung crossed swords and cavalry pistols, and there were framed commissions and battle orders, and an empty shell propped open the wide white-panelled door. The English visitor found it all strange and interesting. It was as though a fragrance of dried rose-leaves contended with a whiff of gunpowder. The small dining-room into which presently she was carried had fascinating prints — "Pocahontas Baptized," and "Pocahontas Married," and a group of women with children and several negroes gathered about an open grave, one woman standing out, reading the burial service. — Roger Michael was so interested that she would have liked not to talk at all, just to sit and look at the prints and mark the negro servants passing about the table. But Mrs. LeGrand's agreeable voice was asking about the health of the Queen — she bestirred herself to be an acceptable guest.

The small dining-room was separated only by an archway from the large dining-room, and into the latter, in orderly files, came the Eglantine pupils, wound about to their several tables and seated themselves with demureness. M. Morel was speaking of the friendship of France and England.

EGLANTINE 63

Roger Michael, while she appeared to listen, studied these American girls, these Southern girls. She found many of them pretty, even lovely, — not, emphatically, with the English beauty of skin, not with the colour of New England girls, among whom, recently, she had been, — not with the stronger frame that was coming in with this generation of admission to out-of-door exercise, the certain boyish alertness and poise that more and more she was seeing exhibited, — but pretty or lovely, with delicacy and a certain languor, a dim sweetness of expression, and, precious trove in America! voices that pleased. She noted exceptions to type, small, swarthy girls and large overgrown ones, girls that were manifestly robust, girls that were alert, girls that were daring, girls that were timid or stupid, or simply anæmic, girls that approached the English type and girls that were at the very antipodes — but the general impression was of Farther South than she had as yet gone in America, of more grace and slowness, manner and sweetness. Their clothes interested her; they were so much more "dressed" than they would have been in England. Evidently, in deference to the smaller room, there was to-night an added control of speech; there sounded no more than a pleasant hum, a soft, indistinguishable murmur of young voices.

"They are so excited over the prospect of your speaking to them after supper," said Mrs. LeGrand, her hand upon the coffee urn. — "Cream and sugar?"

"They do not seem excited," thought Roger Michael. — "Sugar, thank you; no cream. Of what shall I talk to them? In what are they especially interested?"

"In your charming books, I should say," answered Mrs.

LeGrand. "In how you write them, and in the authors you must know. And then your sweet English life — Stratford and Canterbury and Devonshire —"

"We have been reading 'Lorna Doone' aloud this month," said Miss Carlisle. "And the girls very cleverly arranged a little play. . . . Sylvie here played Lorna beautifully."

Roger Michael smiled across at Hagar, two or three places down, on the other side of the table. "I should like to have seen it," she said in her good, deep English voice.

"Oh," said Hagar, "I'm not Sylvie. I played Lizzie."

"This is my little cousin and god-daughter, Sylvie Maine," said Mrs. LeGrand. "And this is Hagar Ashendyne, the granddaughter of an old friend and connection of my family."

"*Hagar Ashendyne*," said Roger Michael. "I remember meeting once in the south of France a Southerner — a Mr. Medway Ashendyne."

"Indeed?" exclaimed Mrs. LeGrand. "Then you have met Hagar's father. Medway Ashendyne! He is a great traveller — we do not see as much of him as we should like to see, do we, Hagar?"

"I have not seen him," said Hagar, "since I was a little girl."

Her voice, though low, was strange and vibrant. "What's here?" thought Roger Michael, but what she said was only, "He was a very pleasant gentleman, very handsome, very cultivated. My friends and I were thrown with him during a day at Carcassonne. A month afterwards we met him at Aigues-Mortes. He was sketching — quite wonderfully."

Mrs. LeGrand inwardly deplored Medway Ashendyne's daughter's lack of *savoir-faire*. "To give herself away like

that! Just the kind of thing her mother used to do!" Aloud she said, "Medway's a great wanderer, but one of these days he will come home and settle down and we'll all be happy together. I remember him as a young man — a perfectly fascinating young man. — Dinah, bring more waffles! — Yes, if you will tell our girls something of your charming English life. We are all so interested —"

Miss Carlisle's voice came in, a sweet treble like a canary's. "The Princess of Wales keeps her beauty, does she not?"

The study hall was a long, red room, well enough lighted, with a dais holding desk and chairs. Roger Michael, seated in one of these, watched, while her hostess made a little speech of introduction, the bright parterre of young faces. Sitting so, she excercised a discrimination that had not been possible in the dining-room. Of the faces before her each was different, after all, from the other. There were keen faces as well as languorous ones; brows that promised as well as those that did not; behind the prevailing "sweet" expression, something sometimes that showed as by heat lightning, something that had depth. "Here as elsewhere," thought Roger Michael. "The same life!"

Mrs. LeGrand was closing, was turning toward her. She rose, bowed toward the mistress of Eglantine, then, standing square, with her good, English figure and her sensibly shod, English feet, she began to talk to these girls.

She did not, however, speak to them as, even after she rose, she meant to speak. She did not talk letters in England, nor English landscape. She spoke quite differently. She spoke of industrial and social unrest, of conditions among the toilers of the world. "I am what is called a Fabian," she said,

and went on as though that explained. She spoke of certain movements in thought, of breakings-away toward larger horizons. She spoke of various heresies, political, social, and other. "Of course I don't call them heresies; I call them 'the enlarging vision.'" She gave instances, incidents; she spoke of the dawn coming over the mountains, and of the trumpet call of "the coming time." She said that the dying nineteenth century heard the stronger voice of the twentieth century, and that it was a voice with a great promise. She spoke of women, of the rapidly changing status of women, of what machinery had done for women, of what education had done. She spoke of the great needs of women, of their learning to organize, of the need for unity among women. She used the words "false position" thrice. "Woman's immemorially false position." — "Society has so falsely placed her." — "Until what is false is done away with." — She said that women were beginning to see. She said that the next quarter-century would witness a revolution. "You young people before me will see it; some of you will take part in it. I congratulate you on living when you will live." She talked for nearly an hour, and just as she was closing it came to her, with a certain effect of startling, that much of the time she had been speaking to just one countenance there. She was speaking directly to the girl called Hagar Ashendyne, sitting halfway down the hall. When she took her seat there followed a deep little moment of silence broken at last by applause. Roger Michael marked the girl in green. She did n't applaud; she sat looking very far away. Mrs. LeGrand was saying something smoothly perfunctory, beflowered with personal compliments; the girls all stood; the Eglantine hostess and

EGLANTINE 67

guest, with the teachers who had been at table, passed from the platform, and turned, after a space of hallway, into the rose-carpeted big parlour.

Miss Carlisle and Miss Bedford brought up the rear. "Did n't you think," murmured the latter, "that that was a very curious speech? Now and then I felt so uneasy. — It was as though in a moment she was going to say something indelicate! Dear Mrs. LeGrand ought to have told her how careful we are with our girls."

The wind rose that night and swept around the tower room, and then, between eleven and twelve, died away and left a calm that by contrast was achingly still. Hagar was not yet asleep. She lay straight and still in the narrow bed, her arms behind her head. She was rarely in a hurry to go to sleep. This hour and a half was her dreaming-awake time, her time for romance building, her time for floating here and there, as in a Witch of Atlas boat in her own No-woman's land. She had in the stalls of her mind half a dozen vague and floating romances, silver and tenuous as mist; one night she drove one afield, another night another. All took place in a kind of other space, in countries that were not on any map. She brought imagined physical features into a strange juxtaposition. When the Himalayas haunted her she ranged them, snow-clad, by a West Indian sea. Ætna and Chimborazo rose over against each other, and a favourite haunt was a palm-fringed, flower-starred lawn reached only through crashing leagues of icebergs. She took over localities that other minds had made; when she wished to she pushed aside a curtain of vine and entered the Forest of Arden; she knew how the moonlight fell in the wood outside Athens; she entered

the pilotless boat and drove toward the sunset gate of the Domain of Arnheim. Usually speaking, people out of books made the population of these places, and here, too, there were strange juxtapositions. She looped and folded Time like a ribbon. Mark Antony and Robin Hood were contemporaries; Pericles and Philip Sidney; Ruth and Naomi came up abreast, with Joan of Arc, and all three with Grace Darling; the Round Table and the Girondins were acquainted. All manner of historic and fictive folk wandered in the glades of her imagination, any kind of rendezvous was possible. Much went on in that inner world — doubts and dreams and dim hypotheses, romance run wild, Fata Morganas, Castles in Spain, passion for dead shapes, worship of heroes, strange, dumb stirrings toward self-immolation, dreams of martyrdom, mind drenched now with this poem, now with that, dream life, dream adventures, dream princes, religions, world cataclysms, passionings over a colour, a tone, a line of verse— much utter spring and burgeoning. Eighteen years — a fluid unimprisoned mind — and no confidante but herself; of how recapitulatory were these hours, of how youth of all the ages surged, pulsed, vibrated through her slender frame, she had, of course, no adequate notion. She would simply have said that she could n't sleep, and that she liked to tell herself stories. As she lay here now, she was not thinking of Roger Michael's talk, though she had thought of it for the first twenty minutes after she had put out the lamp. It had been very interesting, and it had stirred her while it was in the saying, but the grappling hook had not finally held; she was not ready for it. She had let it slip from her mind in favour of the rose and purple and deep violin

humming of one of her romances. She had lain for an hour in a great wood, like a wood in Xanadu, beneath trees that touched the sky, and like an elfin stream had gone by knights and ladies.... The great clock down in the hall struck twelve. She turned her slender body, and the bed being pushed against the window, laid her outstretched hands upon the window-sill, and looked up, between the spectral sycamore boughs, to where Sirius blazed. Dream wood and dream shapes took flight. She lay with parted lips, her mind quiet, her soul awake. Minutes passed; a cloud drove behind the sycamore branches and hid the star. First blankness came and then again unrest. She sat up in bed, pushing her two heavy braids of hair back over her shoulders. The small clock upon the mantel ticked and ticked. The little room looked cold in the watery moonlight. Hagar was not dreaming or imagining now; she was thinking back. She sat very still for five minutes, tears slowly gathering in her eyes. At last she turned and lay face down upon the bed, her outstretched hands against the wooden frame. Her tears wet the sleeve of her gown. "*Carcassonne — Aigues-Mortes. Carcassonne — Aigues-Mortes....*"

CHAPTER VII

MR. LAYDON

THE winter was so open, so mild and warm, that a few pale roses clung to their stems through half of December. Christmas proved a green Christmas; neither snow nor ice, but soft, Indian summer weather. Eglantine always gave two weeks' holiday at Christmas. It was a great place for holidays. Right and left went the girls. Those whose own homes were too far away went with roommates or bosom friends to theirs; hardly a pupil was left to mope in the rooms that grew so still. Most of the teachers went away. The scattering was general.

But Hagar remained at Eglantine. Gilead Balm was a good long way off. She had gone home last Christmas and the Christmas before, but this year — she hardly knew how — she had missed it. In the most recently received of his rare letters her grandfather had explicitly stated that, though he was prepared to pay for her schooling and to support her until she married, she must, on her side, get along with as little money as possible. It was criminal that he had so little nowadays, but such was the melancholy fact. The whole world was going to the dogs. He sometimes felt a cold doubt as to whether he could hold Gilead Balm. He wished to die there, at any rate. Hagar had been very unhappy over that letter, and it set her to wondering more strongly than ever about money, and to longing to make it. In her return letters he suggested that she stay at

MR. LAYDON 71

Eglantine this Christmas, and so save travelling expenses. And in order that Gilead Balm might not feel that she would be too dreadfully disappointed, she said that it was very pleasant at Eglantine, and that several of the girls were going to stay, and that she would be quite happy and wouldn't mind it much, though of course she wanted to see them all at Gilead Balm. The plan was of her suggesting, but she had not realized that they might fall in with it. When her grandmother answered at length, explaining losses that the Colonel had sustained, and agreeing that this year it might be best for her to stay at Eglantine, she tried not to feel desperately hurt and despondent. She loved Gilead Balm, loved it as much as her mother had hated it. Old Miss's letter had shown her own disappointment, but — "You are getting to be a woman and must consider the family. Ashendyne and Coltsworth women, I am glad to say, have always known their duty to the family and have lived up to it." The last half of the letter had a good deal to say of Ralph Coltsworth who was at the University.

Hagar was here at Eglantine, and it was two days before Christmas, and most of the girls were gone. Sylvie was gone. The teacher whom she liked best — Miss Gage — was gone. Mrs. LeGrand, who liked holidays, too, was going. Mrs. Lane and Miss Bedford and the housekeeper were not going, and they and the servants would look after Eglantine. Besides these there would be left the books in the book-room, and Hagar would have leave to be out of doors, in the winding walks and beneath the trees, alone and whenever she pleased. The weather was dreamy still; everywhere a warm amethyst haze.

This morning had come a box from Gilead Balm. Her grandmother had filled it with good things to at and the Colonel sent his love and a small gold-piece. There was a pretty belt from Captain Bob and a hand-painted plate and a soft pink wool, shell-pattern, crocheted "fascinator" from Miss Serena. Mrs. Green sent a hemstitched handkerchief, and the servants sent a Christmas card. Through the box were scattered little sprays from the Gilead Balm cedars, and there was a bunch of white and red and button chrysanthemums. Hagar, sitting on the hearth-rug, unpacked everything; then went off into a brown study, the chrysanthemums in her lap.

Later in the morning she arranged upon the hand-painted plate some pieces of home-made candy, several slices of fruit-cake, three or four lady apples, and a number of Old Miss's exquisitely thin and crisp wafers, and with it in her hand went downstairs to Mrs. LeGrand's room, knocked at the door, and was bidden to enter. Mrs. LeGrand half-raised herself from a flowery couch near the fire, put the novel that she was reading behind her pillow, and stretched out her hand. "Ah, Hagar!—Goodies from Gilead Balm? How nice! Thank you, my dear!" She took a piece of cocoanut candy, then waved the hand-painted plate to the round table. "Put it there, dear child! Now sit down for a minute and keep me company."

Hagar took the straight chair on the other side of the hearth. The bright, leaping flame was between the two. It made a kind of softer daylight, and full in the heart of it showed Mrs. LeGrand's handsome, not yet elderly countenance, the ripe fullness of her bust, covered by a figured silk

dressing-sacque, and her smooth, well-shaped, carefully tended hands. Hagar conceived that it was her duty to think well and highly of Mrs. LeGrand, who was such an old friend of the family, and who, she knew, out of these same friendly considerations, was keeping her at Eglantine on the easiest of terms. Yes, it was certainly her duty to love and admire Mrs. LeGrand. That she did not do so caused her qualms of conscience. Many of the girls raved about Mrs. LeGrand, and so did Miss Carlisle and Miss Bedford. Hagar supposed with a sigh that there was something wrong with her own heart. To-day, as she sat in the straight chair, her hands folded in her lap, she experienced a resurgence of an old childhood dislike. She saw again the Gilead Balm library, and the pool of sunlight on the floor and the "Descent of Man," and heard again Mrs. LeGrand telling the Bishop that she — Hagar — was reading an improper book. Time between then and now simply took itself away like a painted drop-scene. Six years rolled themselves up as with a spring, and that hour seamlessly adjoined this hour.

"I'm afraid," said Mrs. LeGrand, "that you'll be a little lonely, dear child, but it won't be for long. Time flies so!"

"I don't exactly get lonely," said Hagar gravely. "You are going down the river, are n't you?"

"Yes, for ten days. My dear friends at Idlewood won't hear of my not coming. They were my dear husband's dearest cousins. Mrs. Lane and Miss Bedford, together with Mrs. Brown, will take, I am sure, the best of care of things here."

"Yes, of course. We'll get on beautifully," said Hagar. "Mr. Laydon is not going away either. His mother is ill and

he will not leave her. He says that if we like to listen, he will come over in the evenings and read aloud to us."

Mr. Laydon was teacher of Belles-Lettres at Eglantine, a well-looking young gentleman, with a good voice, and apparently a sincere devotion to the best literature. Eglantine and Mr. Laydon alike believed in the future of Mr. Laydon. It was understood that his acceptance of a position here was of the nature of a makeshift, a mere pot-boiler on his road to high places. He and his mother were domiciled with a cousin from whose doorstep you might toss a pebble into the Eglantine grounds. In the past few years the neighbouring town had begun to grow; it had thrown out a street which all but touched the osage-orange hedge.

Mrs. LeGrand made a slight motion with her hand on which was her wedding-ring, with an old pearl ring for guard. "I shall tell Mrs. Lane not to let him do that too often. I have a great esteem for Mr. Laydon, but Eglantine cannot be too careful. No one with girls in their charge can be too careful! — What is the Gilead Balm news?"

"The letter was from grandmother. She is well, and so is grandfather. They have had a great deal of company. Uncle Bob has had rheumatism, but he goes hunting just the same. The Hawk Nest Coltsworths are coming for Christmas — all except Ralph. He is going home with a classmate. Grandmother says he is the handsomest man at the University, and that if I hear tales of his wildness I am not to believe them. She says all men are a little wild at first. Aunt Serena is learning how to illuminate texts. Mrs. Green has gone to see her daughter, who has something the matter with her spine. Thomasine's uncle in New York is going to have her visit him,

and grandmother thinks he means to get Thomasine a place in a store. Grandmother says no girl ought to work in a store, but Thomasine's people are very poor, and I don't see what she can do. She's got to live. Corker has a place, but he is n't doing very well. Car'line and Isham have put a porch to their cabin, and Mary Magazine has gotten religion."

"Girls of Thomasine's station," said Mrs. LeGrand, "are beginning more and more, I'm sorry to see, to leave home to work for pay. It's spreading, too; it's not confined to girls of her class. Only yesterday I heard that a bright, pretty girl that I used to know at the White had gone to Philadelphia to study to be a nurse, and there's Nellie Wynne trying to be a journalist! A journalist! There is n't the least excuse for either of those cases. One of those girls has a brother and the other a father quite able to support them."

"But if there really is n't any one?" said Hagar wistfully. "And if you feel that you are costing a lot — " Her dreams at night were beginning to be shot with a vague but insistent "If I could write — if I could paint or teach — if I could earn money — "

"There is almost always some one," answered Mrs. LeGrand. "And if a girl knows how to make the best of herself, there inevitably arrives her own establishment and the right man to take care of her. If" — she shrugged — "if she does n't know how to make the best of herself, she might as well go work in a store. No one would especially object. That is, they would not object except that when that kind of thing creeps up higher in the scale of society, and girls who can perfectly well be supported at home go out and work for pay, it makes an unfortunate kind of precedent

and reacts and reflects upon those who do know how to make the best of themselves."

Hagar spoke diffidently. "But a lot of women had to work after the war. Mrs. Lane and General —— 's daughters, and you yourself —"

"That is quite different," said Mrs. LeGrand. "Gentlewomen in reduced circumstances may have to battle alone with the world, but they do not like it, and it is only hard fate that has put them in that position. It's an unnatural one, and they feel it as such. What I am talking of is that nowadays you see women — young women — actually choosing to stand alone, actually declining support, and — er — refusing generally to make the best of themselves. It's part of the degeneracy of the times that you begin to see women — women of breeding — in all kinds of public places, working for their living. It's positively shocking! It opens the gate to all kinds of things."

"Wrong things?"

"Ideas, notions. Roger Michael's ideas, for instance, — which I must say are extremely wrong-headed. I regretted that I had asked her here. She was hardly feminine." Mrs. LeGrand stretched herself, rubbed her plump, firm arms, from which the figured silk had fallen back, and rose from the couch. "I hope that Eglantine girls will always think of these things as ladies should. And now, my dear, will you tell Mrs. Lane that I want to see her?"

Mrs. LeGrand went away from Eglantine for ten days. Of the women teachers living in the house, all went but Mrs. Lane and Miss Bedford. All the girls went but three, and they were, first, Hagar Ashendyne; second, a pale thin girl

MR. LAYDON 77

from the Far South, a martyr to sick headaches; and third, Francie Smythe, a girl apparently without many home people. Francie was sweetly dull, with small eyes and a perpetual smile.

How quiet seemed the great house with its many rooms! They closed the large dining-room and used the small room where Roger Michael had supped. They shut the classrooms and the study-hall and the book-room, and sat in the evenings in the bowery, flowery parlour. Here, the very first evening, and the second, came Mr. Laydon with Browning in one pocket and Tennyson in the other.

Mrs. Lane was knitting an afghan of a complicated pattern. Her lips moved softly, continuously, counting. Mr. Laydon, making an eloquent pause midway of "Tithonous" caught this *One — two — three — four —* and had a fleeting expression of pain. Mrs. Lane saw the depth to which she had sunk in his esteem and flushed over her delicate, pensive face. For the remainder of the hour she sat with her knitting in her lap. But really the afghan must be finished, and so, the second evening, she placed her chair so as to face not the reader but a shadowy corner, and so knit and counted in peace. Miss Bedford neither knit nor counted; she said that she adored poetry and sighed rapturously where something seemed to be indicated. She also adored conversation and argumentation as to this or that nice point. What did Mr. Laydon think Browning really meant in "Childe Roland," and was Porphyria's lover really mad? Was Amy really to blame in "Locksley Hall"? Miss Bedford made play with her rather fine eyes and teased the fringe of the table-cover. The pale girl from the Far South — Lily was her name —

sat by the fire and now rubbed her forehead with a menthol pencil and now stroked Tipsy Parson, Mrs. LeGrand's big black cat. Francie Smythe had a muslin apron full of coloured silks and was embroidering a centre-piece — yellow roses with leaves and thorns. Francie was a great embroiderer. Hagar sat upon a low stool by the hearth, over against Lily, close to the slowly burning logs. She was a Fire-Worshipper. The flames were better to her than jewels, and the glowing alleys and caverns below were treasure caves and temples. She sat listening in the rosy light, her chin in her hands. She thought that Mr. Laydon read very well — very well, indeed.

"'Where the quiet-coloured end of evening smiles,
Miles and miles,
On the solitary pastures —'"

Midway of the poem she turned a little so that she could see the reader.

He sat in the circle of lamplight, a presentable man, well-formed, dark-eyed, and enthusiastic; fairly presentable within, too, very fairly clean, a good son, filled with not unhonourable ambitions; good, average, human stuff with an individual touch of impressionability and a strong desire to be liked, as he expressed it, "for himself"; young still, with the momentum and emanation of youth. The lamp had a rose and amber shade. It threw a softened, coloured, dreamy light. Everything within its range was subtly altered and enriched.

"'And I knew — while thus the quiet-coloured eve
Smiles to leave

MR. LAYDON 79

> To their folding, all our many tinkling fleece
> In such peace,
> And the slopes and rills in undistinguished grey
> Melt away—'"

Hagar sat in her corner, upon the low stool, in the firelight, as motionless as though she were in a trance. Her eyes, large, of a marvellous hazel, beneath straight, well-pencilled brows of deepest brown, were fixed steadily upon the man reading. Slowly, tentatively, something rich and delicate seemed to rise within her, something that clung to soul and body, something strange, sweet and painful, something that, spreading and deepening with great swiftness, suffused her being and made her heart at once ecstatic and sorrowful. She blushed deeply, felt the crimsoning, and wished to drop her head upon her arms and be alone in a balmy darkness. It was as though she were in a strange dream, or in one of her long romances come real.

> "'In one year they sent a million fighters forth,
> South and North,—
> And they built their gods a brazen pillar high
> As the sky—...
> ... Love is best.'"

Laydon put the book down upon the table. While he read, one of the maids, Zinia, had brought a note to Miss Bedford, and that lady had gone away to answer it. Mrs. Lane knitted on, her lips moving, her back to the table and the hearth. Francie Smythe was sorting silks. "That was a lovely piece," she said unemotionally, and went on dividing orange from lemon. The girl with the menthol pencil was more appreciative. "Once, when I was a little girl I went with my

father and mother to Rome. We went out on the Campagna. I remember now how it was all green and flat and wide as the sea and still, and there were great arches running away — away — and a mist that they said was fever." Her voice sank. She sighed and rubbed her forehead with the menthol. Her eyes closed.

Edgar Laydon rose and came into the circle of firelight. He was moved by his own reading, shaken with the impulse and rhythm of the poem. He stood by the mantel and faced Hagar. She was one of his pupils, she recited well; of the essays, the "compositions," which were produced under his direction, hers were the best; he had told her more than once that her work was good; in short, he was kindly disposed toward her. To this instant that was all; he was scrupulously correct in his attitude toward the young ladies whom he taught. He had for his work a kind of unnecessary scorn; he felt that he ought to be teaching men, or at the very least should hold a chair in some actual college for women. Eglantine was nothing but a Young Ladies' Seminary. He felt quite an enormous gulf between himself and those around him, and, as a weakness will sometimes quaintly do, this feeling kept him steady. Until this moment he was as indifferent to Hagar Ashendyne, as to any one of the fifty whom he taught, and he was indifferent to them all. He had a picture in his mind of the woman whom some day he meant to find and woo, but she was n't in the least like any one at Eglantine.

Now, in an instant, came a change. Hagar's eyes, very quiet and limpid, were upon him. Perhaps, deep down, far distant from her conscious self, she willed and exercised an

ancient power of her sex and charmed him to her; perhaps — in his lifted mood, the great, sensuous swing of the verse still with him, the written cry of passion faintly drumming within his veins — he would have suddenly linked that diffused emotion to whatever presence, young and far from unpleasing, might have risen at this moment to confront him. However that may be, Laydon's eyes and those of Hagar met. Each gaze held the other for a breathless moment, then the lids fell, the heart beat violently, a colour surged over the face and receded, leaving each face pale. A log, burned through, parted, striking the hearth with a sound like the click of a closing trap.

Mrs. Lane, having come to an easy part in the pattern, turned her face to the rest of the room. "Are n't we going to have some more poetry? Read us some more, Mr. Laydon."

The girl with the menthol pencil spoke dreamily. "Is n't there another piece about the Campagna? I can see it plain — green like the sea and arches and tombs and a mist hanging over it, and a road going on — a road going on — a road going on."

CHAPTER VIII

HAGAR AND LAYDON

THIS is what they did. The next day was soft as balm. To Hagar, sitting in the sun on the step of the west porch, came the sound of steps over the fallen leaves of what was called at Eglantine the Syringa Alley — sycamore boughs above and syringa bushes thickly planted and grown tall, making winding walls for a winding path. The red surged over Hagar, her eyes, dark-ringed, half-closed. Laydon, emerging from the alley, came straight toward her, over a space of gravel and wind-brought leaves. It was mid-morning, the place open and sunny, to be viewed from more windows than one, with the servants, moreover, going to and fro on their morning business, apt to pass this gable end. Aunt Dorinda, for instance, the old, turbaned cook, passed, but she saw nothing but one of the teachers stopping to say, "Merry Christmas!" to Miss Hagar. All the servants liked Miss Hagar.

What Laydon said was not "Merry Christmas!" but, "Hagar, Hagar! that was Love came to us last night! I have not slept. I have been like a madman all night! I did not know there was such a force in the world."

"I did not sleep either," answered Hagar. "I did not sleep at all."

"Every one can see us here. Let us walk toward the gate, through the alley."

She rose from the step and went with him. Well in the shelter of the syringa, hidden from the house, he stopped, and laid his hands lightly upon her shoulders, then, as she did not resist, drew her to him. They kissed, they clung together in a long embrace, they uttered love's immemorial words, smothering each with each, then they fell apart; and Hagar first buried her face in her hands, then, uncovering it, broke into tremulous laughter, laughter that had a sobbing note.

"What will they say at Gilead Balm — oh, what will they say at Gilead Balm?"

"Say!" answered Laydon. "They'll say that they wish your happiness! Hagar, how old are you?"

"I'm nearly eighteen."

"And old for your years. And I — I am twenty-eight, and young for my years." Laydon laughed, too. He was giddy with happiness. "Gilead Balm! What a strange name for a place — and you've lived there always —"

"Always."

They were moving now down the alley toward a gate that gave upon the highroad. Near by lay an open field seized upon, at Christmas, by a mob of small boys with squibs and torpedoes and cannon crackers. They had a bonfire, and the wood smoke drifted across, together with the odour of burning powder. The boys were shouting like Liliputian soldiery, and the squibs and giant crackers shook the air as with a continuous elfin bombardment. The nearest church was ringing its bells. Laydon and Hagar came to the gate — not the main but a lesser entrance to Eglantine. No one was in view; hand in hand they leaned against the wooden pal-

ings. Before them stretched the road, an old, country pike going on and on between cedar and locust and thorn until it dropped into the violet distance.

"I wish we were out upon it," said Hagar; "I wish we were out upon it, going on and on through the world, travelling like gipsies!"

"You look like a gipsy," he said. "Have you got gipsy blood in you?"

"No. . . . Yes. Just to go on and on. The open road — and a clear fire at night — and to see all things —"

"Hagar — Why did they call you Hagar?"

"I don't know. My mother named me."

"Hagar, we've got to think a little. . . . It took us so by surprise. . . . We had best, I think, just quietly say nothing to anybody for a while. . . . Don't you think so?"

"I had not thought about it, but I will," said Hagar. She gazed down the road, her brows knit. The Christmas cannonading went on, a continuous miniature tearing and shaking of the air, with a dwarf shouting and laughing, and small coalescing clouds of powder smoke. The road ran, a quiet, sunny streak, past this small bedlam, into the still distance. "I won't tell any one at Eglantine," she said at last, "until Mrs. LeGrand comes back. She will be back in a week. But I'll write to grandmother to-night."

Laydon measured the gate with his hand. "I had rather not tell my mother at once. She is very delicate and nervous, and perhaps she has grown a little selfish in her love for me. Besides, she had set her heart on —" He threw that matter aside, it being a young and attractive kinswoman with money. "I had rather not tell her just now. Then, as to

Mrs. LeGrand. . . . Of course, I suppose, as I am a teacher here, and you are a pupil . . . but there, too, had we not best delay a little? It will make a confusion — things will be said — my position will become an embarrassing one. And you, too, Hagar, — it won't be pleasant for you either. Is n't it better just to keep our own concerns to ourselves for a while? And your people up the river — why not *not* tell them until summer-time? Then, when you go home, — and when I have finished my engagement here, for I don't propose to come back to Eglantine next year, — then you can tell them, and so much better than you could write it! I could follow you to Gilead Balm — we could tell them together. Then we could discuss matters and our future intelligently — and that is impossible at the moment. Let us just quietly keep our happiness to ourselves for a while! Why should the world pry into it?" He seized her hands and pressed his face against them. "Let us be happy and silent."

She looked at him with her candid eyes. "No, we should n't be happy that way. I'll write to grandmother to-night."

They gazed at each other, the gate between them. The strong enchantment held, but a momentary perplexity crossed it, and the never long-laid dust of pain was stirred. "I am not asking anything wrong," said Laydon, a hurt note in his voice. "I only see certain embarrassments — difficulties that may arise. But, darling, darling! it shall be just as you please! 'I'd crowns resign to call you mine' — and so I reckon I can face mother and Mrs. LeGrand and Colonel Ashendyne!" A flush came into his cheek. "I've been so foolish, too, as to — as to pay a little attention to Miss

Bedford. But she is too sensible a woman to think that I meant anything seriously—"

"Did you?"

"Not in the least," said Laydon truthfully. "A man gets lonely, and he craves affection and understanding, and he's in a muddle before he knows it. There isn't anything else there, and I never said a word of *love* to her. Darling, darling! I never loved any one until last night by the fire, and you looked up at me with those wonderful eyes, and I looked down, and our eyes met and held, and it was like a fine flame all over — and now I'm yours till death — and I'll run any gauntlet you tell me to run! If you write to your people to-night, so will I. I'll write to Colonel Ashendyne."

They left the gate and again pursued the syringa alley. The sound of the Christmas bombardment drifted away. When they reached the shadow of the great bushes, he kissed her again. All the air was blue and hazy and the church bells were ringing, ringing. "I haven't any money," said Laydon. "Mother has a very little, but I've never been able, somehow, to lay by. I'll begin now, though, and then, as I told you, I expect next year to have a much better situation. Dr. —— at —— thinks he may get me in there. It would be delightful — a real field at last, the best of surroundings and a tolerable salary. If I were fortunate there, we could marry very soon, darling, darling! But as it is — It is wretched that Eglantine pays so little, and that there is so little recognition here of ability — no career — no opportunity! But just you wait and see — you one bright spot here!"

Hagar gazed at the winding path, strewn with bronze

leaves, and at the syringa bushes, later to be laden with fragrant bloom, and at the great white sycamore boughs against the pallid blue, and at the roof and chimneys of Eglantine, now apparent behind the fretwork of trees. The inner eye saw the house within, the three-years-familiar rooms, her "tower room" — and all the human life, the girls, the teachers, the servants. Bright drops came to her eyes. "I've been unhappy here, too, sometimes. But I could n't stay three years in a place and not love something about it."

"That is because you are a woman," said the lover. "With a man it is different. If a place is n't right, it is n't right. — If I had but five thousand dollars! Then we might marry in a month's time. As it is, we'll have to wait and wait and wait —"

"I am going to work, too," said Hagar. "I am going to try somehow to make money."

He laughed. "You dear gipsy! You just keep your beautiful, large eyes, and those dusky warm waves of hair, and your long slim fingers, and the way you hold yourself, and let 'trying to earn money' go hang! That's my part. Too many women are trying to earn money, anyhow — competing with us. — You've got just to be your beautiful self, and keep on loving me." He drew a long breath. "Jove! I can see you now, in a parlour that's our own at ——, receiving guests — famous guests, maybe, after a while; people who will come distances to see me! For I don't mean to remain unknown. I know I've got ability."

Before they left the alley they settled that both should write that night to Gilead Balm. Laydon found the idea distasteful enough; older and more worldly-wise than the

other, he knew that there would probably ensue a tempest, and he was constitutionally averse to tempests. He was well enough in family, but no great things; he had a good education, but so had others; he could give a good character — already he was running over in mind a list of clergymen, educators, prominent citizens, and Confederate veterans to whom he could refer Colonel Ashendyne. He had some doubt, however, as to whether comparative spotlessness of character would have with Colonel Ashendyne the predominant and overweening value that it should have. Money — he had no means; position — he had as yet an uncertain foothold in the world, and no powerful relatives to push him. Unbounded confidence he had in himself, but the point was to create that confidence in Hagar's people. Of course, they would say that she was too young, and that he had taken advantage. His skirts were clear there; both had truthfully been taken prisoners, fallen into an ambuscade of ancient instinct; there had n't been the slightest premeditation. But how to convey that fact to the old Bourbon up the river? Laydon had once been introduced to Colonel Ashendyne upon one of the latter's rare visits to the neighbouring city and to Eglantine. He remembered stingingly the Colonel's calm and gentlemanly willingness immediately to forget the existence of a teacher of Belles-Lettres in a Young Ladies' School. The letter to Gilead Balm. He did n't want to write it, but he was going to — oh! he was going to. . . . Women were curiously selfish about some things. . . . Mrs. LeGrand, too; he thought that he would write about it to Mrs. LeGrand. He could imagine what she would say, and he did n't want to hear it. He was in love, and he was going to do the honour-

HAGAR AND LAYDON 89

able thing, of course; he had no idea otherwise. But he certainly entertained the wish that Hagar could see how entirely honourable, as well as discreet, would be silence for a while.

Hagar never thought of it in terms of "honour." She had no adequate idea of his reluctance. It might be said that she knew already the arching of Mrs. LeGrand's brows and the lightning and thunder that might issue from Gilead Balm. Grandfather and grandmother, Aunt Serena and Uncle Bob looked upon her as nothing but a child. She was n't a child; she was eighteen. She felt no need to vindicate herself, nor to apologize. She was moving through what was still almost pure bliss, moving with a dreamlike tolerance of difficulties. What did it matter, all those things? They were so little. The air was wine and velvet, colours were at once soft and clear, sound was golden. In the general transfiguration the man by her side appeared much like a demigod. Her wings were fairly caught and held by the honey. It was natural for her to act straightforwardly, and when she must propose that she act so still, it was simply a putting forward, an unveiling of the mass of her nature. She showed herself thus and so, and then went on in her happy dream. Had he been able to make her realize his great magnanimity in giving up his point of view to hers, perhaps she might have striven for magnanimity, too, and acquiesced in a temporary secrecy, perhaps not — on the whole, perhaps not. Had she deeply felt the secrecy to be necessary, had they paced the earth in another time and amid actual dangers, wild beasts could not have torn from her a relation of their case.

But Laydon thought that she was thinking in terms of "honour." Pure women were naturally up in arms at the

suggestion of secrecy. Their delicate minds had at once a vision of deception, desertion, all kinds of horrors. He acknowledged that men had given them reason for the vision; they could not be blamed if they saw it even when an entirely honourable and devoted man was at their feet. He smiled at what he supposed Hagar thought; his warm sense of natural supremacy became rich and deep; he felt like an Eastern king unfolding a generous and noble nature to some suppliant who had reason to doubt those qualities in Eastern kings at large — he experienced a sumptuous, Oriental, Ahasuerus-and-Esther feeling. Poor little girl! If she had any absurd fear like that — He began to be eager to get to the letter to Colonel Ashendyne. He could see his own strong black handwriting on a large sheet of bond paper. *My dear Colonel Ashendyne: — You will doubtless be surprised at the nature and contents of this letter, but I beg of you to —*

The syringa alley ended, and the west wing of the house, beyond which stretched the offices, opened upon them. Zinia, the mulatto maid, and old Daniel, the gardener, watched them from a doorway. "My Lord!" said Zinia. "Dey's walkin' right far apart, but I knows a co'tin' air when I sees it! Miss Sarah better come back here!"

Daniel frowned. He had been born on the Eglantine place and the majesty and honour and glory of Eglantine were his. "Shet yo' mouf, gal! Don't no co'tin' occur at Eglantine. Hit's Christmas an' everybody looks good an' shinin' lak de angels. Dey two jes' been listenin' to de 'lumination an' talkin' jography an' Greek!"

As the two stepped upon the west porch, the door opened

and Miss Bedford came out—Miss Bedford in a very pretty red hood and a Connemara cloak. Miss Bedford had a sharp look. "Where did you two find each other?" she asked; then, without waiting for an answer, "Hagar! Mrs. Lane has been looking for you. She wants you to help her do up parcels for her mission children. I've been tying up things until I am tired, and now I am going to walk down the avenue for a breath of air. Hurry in, dear; she needs you. — Oh, Mr. Laydon! there's a passage in 'The Ring and the Book' that I've been wanting to ask you to explain —"

Hagar went in and tied up parcels in coloured tissue paper. The day went by as in a dream. There was a Christmas dinner, with holly on the table, and little red candles, and in the afternoon she went with Mrs. Lane to a Christmas tree for poor children in the Sunday-School room of a neighbouring church. The tree blazed with an unearthly splendour, the star in the top seemed effulgent, the "Ohs!" and "Ahs!" and laughter of the circling children, fell into a rhythm like sweet, low, distant thunder.

That night she wrote both to her grandmother and her grandfather. When she had made an end of doing so, she knelt upon the braided rug before the fire in her tower room, loosed her dark hair, shook it around her, and sat as in a tent, her arms clasping her knees, her head bowed upon them. "*Carcassonne—Aigues-Mortes. Carcassonne—Aigues-Mortes.* I can't send a letter to father, for I don't know where to address it. Mother — mother — mother! I can't send a letter to you either. . . ."

CHAPTER IX

ROMEO AND JULIET

THAT week a noted actress played Juliet several evenings in succession at the theatre in the neighbouring town. The ladies left adrift at Eglantine read in the morning paper a glowing report of the performance. Miss Bedford said she was going; she never missed an opportunity to see "Romeo and Juliet."

Mr. Laydon, walking in at that moment — they were all in the small book-room — caught the statement. "Why should n't you all go? I have seen her play it once, but I'd like to see it again." He laughed. "I feel reckless and I'm going to get up a theatre-party! Mrs. Lane, won't you go?"

Mrs. Lane shook her head. "My theatre days are over," she said in her gentle, plaintive voice. "Thank you just the same, Mr. Laydon. But the others might like to go."

"Miss Bedford —"

"We ought," said Miss Bedford, "by rights to have Mrs. Lane to chaperon us, but it's Christmas, is n't it? — and everybody's a little mad! Thank you, Mr. Laydon."

Laydon looked at Francie. "Miss Smythe, won't you come, too?" He had made a rapid calculation. Yes, it would cost only so much, — they would go in of course on the street car, — and in order to ask one he would have to ask all.

Yes, Francie would go, though she was sorry that it was

Shakespeare, and just caught herself in time from saying so. "It will be lovely," she said, instead, unemotionally.

Miss Bedford supplied the lacking enthusiasm. "It will be the treat of the winter! Oh, the Balcony Scene, and where she drinks the sleeping-draught, and the tomb—" She moved nearer Laydon as she spoke and managed to convey to him, *sotto voce,* "You must n't be extravagant, you generous man! Don't think that you have to ask these girls just because they are in the room." But she was too late; Laydon was already asking.

"Miss Goldwell, won't you come, too, to see 'Romeo and Juliet'?"

If she did n't have a headache, Miss Goldwell would be glad to,—"Thank you, Mr. Laydon."

"Miss Ashendyne, won't you?"

"Yes, thank you."

"I will go at once," said Laydon, "and get the tickets."

In the end, Lily Goldwell went, and Francie Smythe did not. Francie developed a sore throat that put Mrs. Lane in terror of tonsillitis. Nothing must go wrong—nobody must get ill while dear Mrs. LeGrand was away!—it would be madness for Francie to go out. Where "what Mrs. LeGrand might think" came into it, Mrs. Lane was adamant. Francie sullenly stayed at home. Lily, for a marvel, did n't have a headache, and she said she would take her menthol pencil, in case the music should bring on one.

The four walked down the avenue, beneath the whispering trees. There was no moon, but the stars shone bright, and it was not cold. Mr. Laydon and Miss Bedford went a little in front, and Lily and Hagar followed. They passed

through the big gate and, walking down the road a little way, came to where the road became a street, and, at ten minutes' interval, a street-car jingled up, reversed, and jingled back to town again.

On the street-car Miss Bedford and Mr. Laydon were again together, and Lily and Hagar. Between the two pairs stretched a row of men, several with the evening newspaper. It was too warm in the car, and Lily, murmuring something, took out her menthol pencil. Hagar studied the score of occupants, and the row of advertisements, and the dark night without the windows. The man next her had a newspaper, and now he began to talk to an older man beside him.

"The country's doing pretty well, seems to me."

The other grunted. "Is n't anything doing pretty well. I'm getting to be a Populist."

"Oh, go away! Are you going to the World's Fair?"

"No. There's going to be the biggest panic yet in this country about one year from now."

"Oh, cheer up! You've been living on Homestead."

"If I have, it's poor living."

Across the aisle a woman was talking about the famine in Russia. "We are going to try to get up a bazaar and make a little money to send to get food with. Tolstoy —"

The horse-car jingled, jingled through the night. All the windows were down; it grew hot and close and crowded. The black night without pressed alongside, peered through the clouded glass. Within were a muddy glare and swaying and the mingled breath of people.

Lily sighed. "Don't you ever wish for just a clear No-

thing? No pain, no feeling, no people, no light, no sound, no anything?"

The street-car turned a corner and swayed and jingled into a lighted, business street, where were Christmas windows and upon the pavement a Christmas throng. A drug store — a wine and liquor store — a grocery — a clothing store — a wine and liquor store — a drug store; amber and crimson, green and blue, broken and restless arrived the lights through the filmy glass. Laughter and voices of the crowd came with a distant humming, through which clanged the street-car bell. The car stopped for passengers, then creaked on again. A workman entered, stood for a couple of minutes, touching Hagar's skirt, then, a man opposite rising and leaving the car, sank into the vacant place. Hagar's eyes swept him dreamily; then, she knew not why, she fell to observing him with a puzzled, stealthy gaze. He was certainly young, and yet he did not look so. The lower part of his face was covered by a short soft, dark beard; he had a battered slouch hat pulled down low; the eyes beneath were sombre and the face lined. There was a dinner pail at his feet. He, too, had an evening paper; Hagar saw the headlines of the piece he was reading: "HOMESTEAD"; and underneath, "STRONG HAND OF THE LAW." Outside, topaz and ruby and emerald drifted by the windows of a wine and liquor store.

She knit her brows. Some current in the shoreless sea of mind had been started, but she could not trace its beginning nor where it led. Another minute and the car stopped before the theatre.

Within, Laydon manœuvred, and the end was that if he

had Miss Bedford upon his right, yet he had Hagar upon his left. The orchestra had not yet begun; the house was dim, people entering, those seated having to stand up to let the others pass. Once, when this happened, he leaned toward her until their shoulders touched, until his breath was upon her cheek. He dared so much as to whisper, "If only we were here, just you and I, together!"

Every one was seated now, and she looked at the people with their festal, Christmas air. There was a girl in a box who was like Sylvie, and nearer yet a grey-haired gentleman with a certain vague resemblance to her grandfather. Her thought flashed across the dark country, up the winding, amber-hued river to Gilead Balm. They would have had her letter yesterday. The shimmer and murmur of the filled theatre were all about her, but so was Gilead Balm — she tried to hear what they would be saying there to-night. The music began, and in a moment she was in a colourful dream. The curtain went up, and here was the hot, sunshiny street of Verona and all the heady wine of youth and love.

When the curtain fell and the lights brightened, Miss Bedford, after frantically applauding, claimed Laydon for her own. She had raptures to impart, criticisms to exchange, knowledge to imbibe. Minutes passed ere, during a momentary lapse into her programme, Laydon could bend toward the lady on his left. Did she like it? What did she think of Juliet? — What did she think of Romeo? — Was it not well-staged?

Hagar did not know whether it were well staged or not. She was eighteen years old; she had been very seldom to the theatre; she was moving through a dreamy paradise. She

wanted just to sit still and bring it all back before the inner eye. Despite the fact that he was her lover, she was not sorry when Laydon must turn to the lady on his right. When Lily spoke to her, she said, "Don't let's talk. Let's sit still and see it all again." Lily agreed. She was no chatterbox herself. The music played; the lights in the house were lowered; up, slowly, gently, went the curtain; here was the orchard of the Capulets.

The great concave of the theatre was dim. Laydon's hand sought Hagar's, found it in the semi-darkness, held it throughout the act. She acquiesced; and yet — and yet — She did not wish him to fondle her hand, nor yet, as once or twice he did, to whisper to her. She wished to listen, listen. She was in Verona, not here.

The act closed. The lights went up, Laydon softly withdrew his hand. He applauded loudly, all the house applauded. Hagar hated the clapping, not experienced enough to know how breath-of-life it was to the people behind the curtain. Already the curtain was rising for Juliet to come forth and bow, and then for Juliet to bring forth Romeo, and both to bow. Had she known, she would have applauded, too; she was a kindly child. The curtain was down now, the house rustling. All around was talking; people seemed never to wish to be quiet. Laydon was talking, too, answering Miss Bedford's artful-artless queries, embarking on a commentary upon act and actors. He talked with a conscious brilliance as became a professor of Belles-Lettres, more especially for Hagar's delight, but aware also that the people directly in front and behind were listening. Was Hagar delighted? Very slowly and insidiously, like a slender serpent stealing

into some Happy Valley, there came into her heart a distaste for commentaries. As the valley might be ignorant of the serpent, so neither did she know what was the matter; she was only not so mystically happy as she had been before.

The orchestra came back, there was a murmur of expectation, Laydon ceased to discourse of Bandello, and of Dante's reference to Montague and Capulet. Lily, on the other side of Hagar, complained of the heat and the music. "I like stringed instruments, but those great brass horns make the back of my head hurt so."

Hagar touched her cold, little hand. "Poor Lily! I wish you did n't feel badly all the time! I wish you liked the horns."

The curtain rose, the play rolled on. Mercutio was slain, — Mercutio and Tybalt, — Romeo was banished. The scene changed, and here was the great window of Juliet's room — the rope ladder — the envious East.

> "*Night's candles are burned out and jocund day*
> *Stands tiptoe on the misty mountain-tops;*
> *I must be gone and live, or stay and die —*"

Hagar sat, bent forward, her eyes dark and wide, the wine-red in her cheeks. When the curtain went down she did not move; Laydon, under cover of the loud applause, spoke to her twice before she attended. Her eyes came back from a long way off, her mind turned with difficulty. "Yes? What is it?" Laydon was easily aggrieved. "You are thinking more of this wretched play," he whispered, "than you are of me!"

On rolled the swift events, gorgeous and swift as shadows.

ROMEO AND JULIET

The curtain fell, the curtain rose. The potion was drunk — the wailing was made — Balthasar rode to warn Romeo. There came the last act: the poison — County Paris — the Tomb —

"*Here will I set up my everlasting rest —*"

It was over.... She helped Lily with her red evening cloak, she found Miss Bedford's striped silk bag that Laydon could not find; they all passed out of the house of enchantments. Here was the night, and the night wind, and broken lights and carriages, and a clamour of voices, and at last the clanging street-car with a great freight of talking people. She wanted to sit still and dream it over — and fortunately Laydon was again occupied with Miss Bedford.

"You liked it, did n't you?" asked Lily. "I think that you like things that you imagine better than you like things that you do."

Hagar looked at her with eyes that were yet wide and fixed. "I don't know. If you could be and do all that you can imagine — but you can't — you can't —" she smiled and rubbed her hand across her eyes — "and it's a tragedy."

When they left the street-car and walked toward the Eglantine gates, it was drawing toward midnight. Laydon and Hagar now moved side by side through the darkness. Lily — who said that her head had ached very little, thank you! — exchanged comments on the play with Miss Bedford.

Laydon held the gate open; then, closing it, fell a few feet behind with Hagar. "You enjoyed it?"

"Oh —"

He was again in love. "The plays we'll see together, darling, darling! 'Two souls with but a single thought —'"

"There is no need to walk so fast," said Miss Bedford. "Oh, Mr. Laydon, a briar has caught my skirt — Will you —? Oh, thank you!"

The house showed before them. "The parlour windows are lighted," said Lily. "Mrs. Lane must have company."

Mrs. Lane did have company. She herself opened the front door to them. Mrs. Lane's eyes were red, and she looked frightened. "Wait," she said, and got between the little group and the parlour door. "Lily, you had best go straight upstairs, my dear! Miss Bedford, will you please wait here with me just a minute? Mr. Laydon, Mrs. LeGrand says will you come into the parlour? Hagar, you are to go, too. Your grandfather is here."

Colonel Ashendyne stood between the table and the fire. Mrs. LeGrand was seated upon the sofa, which meant that she sat in state. Mrs. Lane, who came presently stealing in again, sat back from the centre in a meek, small chair, and at intervals wiped her eyes. The culprits stood.

Colonel Argall Ashendyne never lacked words with which to express his meaning — words that bit. Now his well-cut lips opened, and out there came like a scimitar his part of the ensuing conversation.

"Hagar, your letter was read yesterday evening. I immediately telegraphed to Mrs. LeGrand at Idlewood, and she obligingly took this morning's boat. I myself came down on the afternoon train, and got here two hours ago. Now, sir—" he turned on Laydon—"what have you got to say for yourself?"

"I — I—" began Laydon. He drew a breath and his spine

stiffened. "I have to say, sir, that I love your granddaughter, and that I have asked her to marry me."

Mrs. LeGrand, while the colonel's hawk eye dwelt witheringly, spoke from the sofa. "I have no words, Mr. Laydon, in which to express my disapproval of your action, or my disappointment in one whom I had supposed a gentleman. In my absence you have chosen to abuse my confidence and to do a most dishonourable and ungentlemanly thing — a thing which, were it known, might easily bring disrepute upon Eglantine. You will understand, of course, that it terminates your connection with this school —"

"Mrs. LeGrand," said Laydon, "I have done nothing dishonourable."

"You have taken advantage of my absence, sir, to make love to one of my pupils —"

"To an inexperienced child, sir," said the Colonel; — "too young to know better or to tell pinchbeck when she sees it! You should be caned."

"Colonel Ashendyne, if you were a younger man —"

"Bah!" said the Colonel. "I am younger now and more real than you! — Hagar!"

"Yes, grandfather."

"Come here!"

Hagar came. The Colonel laid his hands upon her shoulders, a little roughly, but not too roughly. The two looked each other in the eyes. He was tall and she but of medium height, she was young and he was her elder, he was ancestor and she descendant, he was her supporter and she his dependant, he was grandfather and she was grandchild. Gilead Balm had always inculcated reverence for dominant kin and

family authority. It had been Gilead Balm's grievance, long ago, against her mother that she recognized that so poorly. . . . But Hagar had always seemed to recognize it. "Gipsy," said the Colonel now, "I am not going to be hard upon you. It's the nature of the young to be foolish, and a young girl may be pardoned anything short of the irrecoverable. All that I want you to do is to see that you have been very foolish and to say as much to this — this gentleman. Simply turn round and say to him 'Mr. —' What's his name? — Layton?"

"I wrote to you day before yesterday, Colonel Ashendyne," said Laydon. "You saw my name there —"

"I never got your letter, sir! I got hers. — Hagar! say after me to this gentleman, 'Sir, I was mistaken in my sentiment toward you, and I here and now release you from any fancied engagement between us.' — Say it!"

As he spoke, he wheeled her so that she faced Laydon. She stood, a scarlet in her cheeks, her eyes dark, deep, and angry. "Hagar!" cried Laydon, maddened, too, "are you going to say that?"

"No," answered Hagar. "No, I am not going to say it! I have done nothing wrong nor underhand, and neither have you! Mrs. LeGrand knew that you were coming here, in the evening, to read to us. Why shouldn't you come? Well, one evening you were reading and I was listening, and I was not thinking of you and you were not thinking of me. And then, suddenly, something — Love — came into this room and took us prisoner. We did not ask him here, we did not know anything. . . . But when it happened we knew it, and next morning, out in the open air, we told each other about it.

Nothing could have kept us from doing that, and nothing had a right to keep us from it! Nothing! — And that very night I wrote to you, grandfather — and he wrote. . . . If I am mistaken I am mistaken, but I will find it out for myself!" She twisted herself in the Colonel's grasp until she faced him. "You say that you are real — Well, I am real too! I am as real as you are!"

The Colonel's fine, bony hands closed upon her shoulders until she caught her breath with the pain. The water rushed to her eyes, but she kept it from over-brimming. "Don't cry!" said a voice within her. "Whatever you do, don't cry!" It was like her mother's voice, and she answered instantly. Colonel Ashendyne, his lips white beneath his grey mustache, shook her violently, so violently that, pushed from her footing, she stumbled and sank to her knee.

Laydon came up with clenched fists and the colour gone from his face. "Let her go, damn you! —"

Mrs. Lane uttered a faint cry and Mrs. LeGrand rose from the sofa.

CHAPTER X

GILEAD BALM

THE March winds shook the rusty cedars and tossed the pink peach branches, and carried a fleet of clouds swiftly overhead through the blue aërial sea. They rattled the windows of Gilead Balm and bent the chimney smoke aslant like streamers. The winds were rough but not cold. Now and again they sank into the sunniest of calms, little periods of stillness, small doldrums punctuating the stormiest sentences. Then with a whistle, shriller and shriller, they mounted again, tremendously exhilarated, sweeping earth and sky.

On the ridge back of Gilead Balm the buds of the cucumber tree were swelling, the grass beneath was growing green, the ants were out in the sunshine. Up in the branches a bluebird was exploring building-sites.

Hagar came wandering over the ridge. The wind wrapped her old brown dress about her limbs and blew her dark hair into locks and tendrils. Luna followed her, but Luna in no frolicsome mood. Luna was old, old, and to-day dispirited because Captain Bob had gone to a meeting of Democrats in the neighbouring town and had left her behind. Depression was writ in every line of Luna's body, and an old, experienced weariness and disillusionment in the eye with which she looked askance at a brand-new white butterfly on a brand-new dandelion.

Hagar stood with her back to the cucumber tree and surveyed the scene. The hills, scurried over by the shadows of the driven clouds, the river — the river winding down to the sea, and the ditch where used to be the canal; and away, away, the white plume of a passenger train. She was mad for travel, for wandering, for the open road; all the world sung to her as with a thousand tongues in the books she read. Pictures, cathedrals, statues, cities, snow on mountains, the ocean, deserts, torrid lands, France, Spain, Italy, England — oh, to go, to go! She would have liked to fling herself on the blowing wind and go with it over land and sea.

She looked with hot, sombre eyes at Gilead Balm. It was the home she had always known and she loved it; it was home, — yes, it was home; but it was not so pleasant at home just now. March — and the Colonel had withdrawn her from Eglantine, ordered her home, the first of January! January, February, a part of March — and her grandfather still eaten with a cold anger every time he looked at her, and her grandmother, outraged at her suddenly manifested likeness to Maria and Maria's "ways," almost as bad! Aunt Serena gave her no sympathy; Aunt Serena had become almost violent on the subject. If you were going to rebel and disobey, Aunt Serena told her, if you were going to be forward and almost fast, and rebel and disobey, you need n't look for any sympathy from her! Colonel Ashendyne had been explicit enough back in January. "When you send about his business that second-rate person you've chosen to entangle yourself with, then and not till then will you be 'Gipsy' again to me!"

Hagar put out her arms to the wind. "I want to go away!

I want to go away! I'm tired of it all — tired of living here —"

The wind blew past her with its long cry; then it suddenly sank, and there came almost a half-hour of bright calm, warm stillness, astral gold. Hagar sat down between the roots of the cucumber tree and took her head within her arms. By degrees, in the sunshine, emotion subsided; she began to think and dream. Her mind sent the shuttle far and fast, it touched here and touched there, and in the course of its weaving it touched Eglantine, touched and quit and touched again. Laydon was still at Eglantine. He had been a very satisfactory Professor of Belles-Lettres; Mrs. LeGrand really did not know where, in mid-season, to find such another. He had behaved wretchedly, but the mischief was done, and there was — on consideration — no need to tell the world about it, no especial need, indeed, of proclaiming it at Eglantine or to Eglantine patrons at large. He was not — Mrs. LeGrand did him that justice — he was not at all a "fast" man or likely to give further trouble upon this line. And he was a good teacher, a good talker, in demand for lectures on cultural subjects before local literary societies, popular and pleasing, a creditable figure among the Eglantine faculty. Much of this matter was probably Hagar's fault. She had made eyes at him, little fool! When the Colonel declared his determination, — with no reflections on Eglantine, my dear friend! — to bring to an end his granddaughter's formal edcation, and to take her back to Gilead Balm where this infatuation would soon disappear, — Mrs. LeGrand saw daylight. She had an interview with Colonel Ashendyne. He was profoundly contemptuous of what Mr. Laydon did for a

living or where he did it, of whom he taught or what he taught, so long as there was distance between him and an Ashendyne. "You know — you know, my dear friend, that I have always had in mind Ralph Coltsworth!" She had an interview—concert pitch—with Laydon. She had a smooth, quiet talk with her teachers. She mentioned casually, to one after another of the girls, that Mrs. Ashendyne at Gilead Balm was not as young as she had been, nor as strong, and that Colonel Ashendyne thought that Hagar should be at home with her grandmother. She, Mrs. LeGrand, regretted it, but every girl's duty to her family was paramount. They would miss Hagar sadly, — she was a dear girl and a clever girl, — but it seemed right that she should go. Hagar went and Laydon stayed, and without a word from any principal in the affair, every girl at Eglantine knew that Mr. Laydon had kissed Hagar, and that Hagar had said that she would love him forever, and that Colonel Ashendyne was very angry, and was probably keeping Hagar on bread and water at that instant, and that it was all very romantic.... And then at Eglantine examinations came on, and dreams of Easter holiday, and after that of Commencement, and Mr. Laydon taught with an entire correctness and an impassive attitude toward all young ladies; and Miss Bedford, who had been very bitter at first and had said things, grew amiable again and reopened her Browning. The ripple smoothed out as all things smoothed out at Eglantine. The place resumed its pristine "sweetness." It was believed among the girls that Mr. Laydon and Hagar "corresponded," but it was not certainly known. Mr. Laydon wrapped himself in dignity as in a mantle. As for Hagar, she had always been rather far away.

Up on the ridge to-day, Hagar's mind dwelt somewhat on Eglantine, but not overmuch. It was not precisely Eglantine that she was missing. Was she missing Laydon? Certainly, at this period, she would have answered that she was — though, to be perfectly truthful, she might have added, "But I do not think of that all the time — not nearly all the time." She was unhappy, and on occasions her fancy brooded over that night in the Eglantine parlour when he read of love, and the flames became jewelled and alive, and she saw the turret on the plain, "by the caper overrooted, by the gourd overscored," and suddenly a warmth and light wrapped them both. The warmth and light certainly still dwelt over that scene and that moment. To a lesser extent it abided over and around the next morning, the west porch, the syringa alley. Very strangely, as she was dimly aware, it stretched only thinly over the following days, over even the night of "Romeo and Juliet." There was there a mixed and wavering light, changing, for the hour that immediately followed, — the hour when she faced her grandfather, and he spoke with knives as he was able to do, when he laid his hands upon her and said untrue and unjust things to Laydon, — into an angry glow. That hour was bright and hot like a ruby. How much was love, and how much outraged pride and a burning sense of wrong, she was not skilled to know, nor how much was actual chivalric defence of her partner in iniquity.... The parting interview, when she and Laydon, having stood upon their rights, obtained a strange half-hour in the Eglantine parlour — strange and stiff, with "Of course, if I love you, I'll be faithful," repeated on her part some five times, with, on his part, Byronic fervour, volcanic utterances.

Had he not gone over them to himself afterwards, in his homely, cheerfully commonplace room in the brown cottage outside the Eglantine grounds? They had been fine; from the point of view of Belles-Lettres they could not have been bettered. He felt a glow as he recognized that fact, followed by a mental shot at the great Seat of Learning where he wished to be. "By George! that's the place I'm fitted for! The man they've got isn't in the same class—" ... The parting interview— to the girl on the ridge a cloud seemed to hang over that, a cloud that was here and there rose-flushed, but just as often fading into grey. Hagar drove her thoughts back to the first evening and the jewelled fire; that was a clear, fair memory, innocent, rich and sincere. The others had, so strangely, a certain pain and dulness.

She had a sturdy power of reaction against the melancholy and the painful, and as to-day she could not, somehow, fix her mind unswervingly upon the one clear hour, and the others perplexed and hurt, her mind at last turned with decision from any contemplation whatsoever of the round of events which lay behind her presence here, in March, upon the ridge behind Gilead Balm. Rising, she left the cucumber tree and walked along the crest of the ridge. The wind was not blowing now, the sunshine was very golden, the little leaves were springing. She crossed the ribbon-like plateau to its northern edge, and stood, looking down that slope. It was somewhat heavily wooded, and in shadow. It fell steeply to a handsbreadth of sward, a purling streamlet, sunken boulders, a wide thicket and a wood beyond. Hagar, leaning against a young beech, gazed down the shadowed stillness. Her eyebrows lifted at their inner ends, lines came into her

forehead, wistful markings about her lips. Sometimes when she knew that she was quite alone she spoke aloud to herself. She did this now. "I have n't been here since that day it happened.... Six years ... I wonder if he ran away again, or if he stayed there to the end. I wonder where he is now. Six years ..."

The wind rose and blew fiercely, rattling in the thicket and bending every tree; then it sank again. Hagar leaned against the trunk of the beech and thought and thought. As a child she had been speculative, everywhere and all the time; with youth had come dreams and imaginations, pushing the older intense querying aside. Now of a sudden a leaf was turned. She dreamed and imagined still, but the thinker within her rose a step, gained a foot on the infinite, mounting stair. Hagar began to brood upon the state of the world. " Black and white stripes like a zebra.... How petty to clothe a man — a boy he was then — like that, mark him and brand him, until through life he sees himself striped black and white like a zebra — on his dying bed, maybe, sees himself like that! Vindictive. And the world sees him, too, like that, grotesque and mean and awful, and it cannot cleanse his image in its mind. It is foolish."

The wind roared again up and down the ridge. Hagar shivered and began to move toward the warmer side; then halted, turned, and came back to the beech. "I'll not go away until the sun comes from under that cloud and the wind drops. It's like leaving him alone in the thicket down there, in the cold and shadow." She waited until the sun came out and the wind dropped, then took her hand from the beech tree and went away. Leaving the ridge, she came to the

overseer's house, hesitated a moment, then went and knocked at the kitchen door.

"Come in!" called Mrs. Green, who was sitting by the kitchen table, in the patch of sunlight before the window, sewing together strips of bright cloth and winding them into balls for a rag carpet. "You, Hagar? Come right in! Well, March is surely going out like a lion!"

"It's so windy that the clouds are running like sheep," said Hagar. She took a small, split-bottom rocking-chair, drew it near Mrs. Green, and began to wind carpet rags. "Red and blue and grey — it's going to be a beautiful carpet! Have you heard from Thomasine?"

Mrs. Green rose and took a letter from behind the clock. "Read it. She's been to a theatre and the Eden Musée and Brooklyn Bridge, and she's going to visit the Statue of Liberty."

Hagar read five pages of lined notepaper, all covered with Thomasine's pretty, precise writing. "She's having a good time. . . . I wish I were there, too. I've never seen New York."

"Never mind! You will one day," said Mrs. Green. "Yes, Thomasine's having a good time. Jim was born generous."

"Is she really going to work if he can get her a place?"

"Yes, child, she is. Times seems to me to be gettin' harder right along instead of easier. Girls have got to go out in the world and work nowadays, just the same as boys. I don't know as it will hurt them; anyway, they've got to do it. Food an' clothes don't ask which sect you belong to."

"Thomasine ought to have gone to school. Girls can go to

college now, and Thomasine and I both ought to have gone to college."

"Landsake!" said Mrs. Green. "Ain't you been to college for going on three years?"

But Hagar shook her head. "No. Eglantine was n't exactly a college. I ought to have gone to a different kind of place. Thomasine likes books, too."

"Yes, she likes them, but she don't like them nothing like as much as you do. But Thomasine's a good child and mighty refined. I hope Jim'll take pains to get her a place where they are nice people. He means all right, but there! men don't never quite understand."

"I wish I could earn money," said Hagar. "I wish I could."

Mrs. Green regarded her over her spectacles. "A lot of women have wished that, child. A lot of women have wished it, and then again a lot of women have n't wished it. Some would rather do for themselves an' for others an' some would rather be did for, and that's the world. I've noticed it in men, too."

"It's in my head all the time. I think mother put it there —"

"Yes, I know," said Mrs. Green. "A lot of us have felt that way. But it ain't so easy for women to make money. There's more ways they can't than they can. It's what they call 'Sentiment' fights them. Sentiment don't mind their being industrious, but it draws the line at their getting money for it. It says it ought to be a free gift. It don't grudge — at least it don't grudge much — a little egg and butter money, but anything more — Lord!" She sewed together two strips

of blue flannel. "No, it ain't easy. And a woman kind of gets discouraged. She's put her ambition to sleep so often that now with most of them it seems asleep for keeps. Them that's industrious don't expect to rise or anything to come of it, and them that's lazy gets lazier. It's a funny world — for women. — There's a lot of brown strips in the basket there."

"I'm going to tell you what I've done," said Hagar, winding a red ball. "I've written a fairy story — but I don't suppose it will be taken."

"I always knew you could write," said Mrs. Green. "A fairy story! What's it about?"

"About fairies and a boy and a girl, and a lovely land they found by going neither north nor south nor east nor west, and what they did there. It seemed to me right good," said Hagar wistfully; "but I sent it off a month ago, and I've never heard a word about it."

"Where did you send it? I never did know," said Mrs. Green, "how what people writes gets printed and bound. It don't do it just of itself."

Hagar leaned forward in her rocking-chair. Her cheeks were carmine and her eyes soft and bright. "The 'Young People's Home Magazine' offered three prizes for the three best stories — stories that it could publish. And I thought, 'Why not I as well as another?' — and so I wrote a fairy story and sent it. The first prize is two hundred dollars, and the second prize is one hundred dollars, and the third is fifty dollars. — If I could get even the third prize, I would be happy."

"I should think you would!" exclaimed Mrs. Green.

"Fifty dollars! I don't know as I ever saw fifty dollars all in one lump — exceptin' war money. When are you going to hear?"

"I don't know. I'm afraid I won't ever hear. I'm afraid it was n't good enough — not even good enough for them to write to me and say it would n't do and tell me why."

"Well, I would n't give up hope," said Mrs. Green. "It's my motto to carry hope right spang through the grave." She rose, fed the fire, and filled the tea-kettle, then returned to her rag carpet. "You're lookin' a little thin, child. Don't let them worry you up at the house."

"I'm not," answered Hagar sombrely. The light went out of her eyes. She stitched slowly, drawing her thread through with deliberation.

Mrs. Green again looked over her spectacles. "They're mighty fine folk, the Ashendynes," she said at last. "They've got old blood and pride for a dozen, and the settest heads! Ain't nothin' daunts them, neither Satan nor the Lord. They're goin' to run their own race. — You're more like your mother, but I would n't say you did n't have something of your grandfather in you at times. You've got a dash of Coltsworth, too."

"Have n't I anything of my father at all?"

Mrs. Green, leaning forward into the sunlight, threaded her needle. "I would n't be bitter about my father, if I were you. People can be born without a sense of obligation and responsibility just as they can be born without other senses. I suppose it's there somewhere, only, so many other things are atop, it ain't hardly ever stirred. Your father's right rich in other things."

"He's so poor he couldn't either truly love my mother or truly let her go. — But I didn't mean to talk about him," said Hagar. She laid the ball she had been winding in the basket with the other balls and stood up, stretching her young arms above her head. "Listen to the wind! I wish it would blow me away, neither north nor south nor east nor west!"

"Yes, you are like your mother," said Mrs. Green. "Have you got to go? Then will you take your grandmother's big knitting-needles back to her for me? And don't you want a winesap? — there's a basket of them behind the door."

CHAPTER XI

THE LETTERS

Miss Serena was playing "Silvery Waves." Hagar, kneeling on the hearth-rug, warmed her hands at the fire and studied the illuminated text over the mantel. "Silvery Waves" came to an end, and Miss Serena opened the green music-book at "Santa Anna's March."

"Has Isham gone for the mail?" asked Hagar.

"Yes. He went an hour ago. — You're hoping, I suppose, for a letter from that dreadful man?"

"You know as well as I do," said Hagar, "that I gave my word and he gave his to write only once a month. And he is n't a dreadful man. He's just like everybody else."

"Ha!" said Miss Serena, and brought her hands down upon the opening chord. Hagar, her elbows on her knees, hid her eyes in her hands. Within her consciousness Juliet was speaking as she had spoken that night upon the stage — spoken in the book — spoken in immortal life, youth, love. Not so, she knew with a suddenness and clangour as of a falling city, not so could Juliet have spoken! "Like everybody else" — Was Laydon, then, truly, like everybody else? — A horror of weakness and fickleness came over her. Was there something direfully wrong with her nature, or was it possible for people simply to be mistaken in such a matter? Her head grew tired; she was so unhappy that she wished to creep away and weep and weep. . . . Miss Serena, having

THE LETTERS

marched with Santa Anna, turned a dozen pages and began "The Mocking Bird. With Variations."

Old Miss's step was heard in the hall, very firm and authoritative. In a moment she entered the room, portly, not perceptibly aged, her hair, beneath her cap, hardly more than powdered with grey, still wearing black stuff gowns and white aprons and heelless low shoes over white stockings. Hagar rose from the rug and pushed the big chair toward the fire.

Old Miss dropped into it — no, not "dropped" — lowered herself with dignity. "Has Isham brought the mail?"

"No, not yet."

"I dreamed last night that there was a letter from Medway. Serena!"

"Yes, mother?"

"The next text you paint I want you to do one for me. *Honour thy father and mother that thy days may be long* —"

Miss Serena turned on the piano-stool. "I'll do it right away, mother. It would be lovely in blue and gold. . . . You can't say that I have n't honoured father and mother."

Old Miss had drawn out her knitting and now her needles clicked. "No one honours them as they used to be honoured. No one obeys them as they used to obey. To-day children think that they are wiser than their fathers. They set up to use their own judgment until it's a scandal. . . . It's true you've been better than most, Serena. Taking you year in and year out, you've obeyed the commandment. It's more than many daughters and grand-daughters that I know have done." Her needles clicked again. "Yes, Serena, you have n't given us much trouble. You were easy to make mind from the beginning." She gave the due praise, but her

tone was not without acerbity. It might almost have seemed that such forthright ductility and keeping of the commandment as had been Miss Serena's had its side of annoyance and satiety.

Hagar spoke from the window where she stood, her forehead pressed against the glass. "I see Isham down the road, by the Half-Mile Cedar."

Old Miss turned the heel of the Colonel's sock she was knitting. "Things that from the newspaper and my personal observation happen now in the world could not possibly have occurred when I was young. People defying their betters, women deserting their natural sphere, atheists denying hell and saying that the world wasn't made in six days, young girls talking about independence and their own lives — their own lives! Ha!"

Miss Serena began to play "The Sea in the Shell." "We all know how Hagar came by her disposition, but I must say it is an unfortunate one! When I was her age, no money could have made me act as she has done."

"No money could have made me, either," spoke Hagar at the window.

"Money has nothing to do with it!" said Old Miss. "At least as far as Hagar is concerned, nothing! But fitness, propriety, meekness, and modesty, consultation with those to whom she owes duty, and bowing to what they say — all those have something to do with it! But what could you expect? It was bound to come out some day. From a bush with thorns will come a bush with thorns."

"Here is Isham," said Hagar. "If you've said enough for to-day, grandmother, shall I get the mail?"

THE LETTERS

She brought the bag to her grandmother. When the Colonel was at home, no one else opened the small leather pouch and distributed its contents; when he was away Old Miss performed the ceremony. To-day he had mounted Selim and ridden to the meeting in the neighbouring town. Mrs. Ashendyne opened the bag and sorted the mail. There was no great amount of it, but — "I said so! I dreamed it. My dreams often come true. There it is!" "It" was a square letter, quite thick, addressed in a rather striking hand and bearing a foreign stamp and postmark. It was addressed to the Colonel, and Mrs. Ashendyne never opened the Colonel's letters — not even when they were from Medway. They were not from him very often. The last, and that thin between the fingers, had been in September. This one was so much thicker than that one! Old Miss gazed at it with greedy eyes.

Miss Serena, too, leaving the piano-stool, came to her mother's side and fingered the letter. "He must have had a lot to write about. From Paris. ... I used to want to go to Paris so much!"

"Put it on the mantelpiece," said Old Miss. "It can't be long before the Colonel's home." Even when it was on the mantel-shelf she still sat looking at it with devouring eyes. "I dreamed it was coming — and there it is!" The remainder of the mail waited under her wrinkled hand.

Miss Serena grew mildly impatient. "What else is there, mother? I'm looking for a letter about those embroidery silks. There it is now, I think!" She drew from her mother's lap an envelope with a printed return address in the upper left-hand corner. "No, it is n't it. 'Young People's Home Magazine.' Some advertisement or other — people pay a lot

to tell people about things they don't want! *Miss Hagar Ashendyne.* Here, Hagar! It evidently does n't know that you are grown up — or think you are! There's my letter, mother, — under the 'Dispatch.'"

Hagar went away with the communication from the "Young People's Home Magazine" in her hand. She went upstairs to her own room. It had been her mother's room. She slept in the four-poster bed on which Maria had died, and she curled herself with a book in the corner of the flowered chintz sofa as Maria had done before her. She curled herself here to-day, though with the letter, not with a book. The letter lay upon her knees. She looked at it with a fixed countenance, hardly breathing. She had thought herself out of a deal of the conventional and materialized religious ideas of her world — not out of religion but out of conventional religion. She did not often pray now for rewards or benefits, or hiatuses in the common law, or for a salvation external to her own being. But at this moment the past reasserted itself. Her lips moved. "O God, let it have been taken! O God, let it have been taken! Let me have won the fifty dollars! Let me have won the third prize. O God, let it have been taken!"

At last, her courage at the sticking-point, she opened the envelope, and unfolded the letter within. The typewritten words swam before her eyes, the "Dear Madam," the page or two that followed, the "With Congratulations, we are faithfully yours." There was an enclosure — a cheque. She touched it with trembling fingers. It said: "Pay to Miss Hagar Ashendyne the Sum of Two Hundred Dollars."

An hour later, the dinner-bell sounding, she went down-

stairs. The Colonel and Captain Bob were yet at the meeting of Democrats. There was to be a public dinner; they would not be home before dusk. The three women ate alone, Dilsey waiting. Old Miss was preoccupied; the letter on the parlour mantelpiece filled her mind. "From Paris. In September he was at a place called Dinard." Miss Serena had her mind upon a panel — calla lilies and mignonette — which she was painting for the rectory parlour. As for Hagar, she did not talk much, nowadays, at Gilead Balm. If she were more silent than usual to-day, it passed without notice.

Only once Old Miss remarked upon her appearance. "Hagar, you've got a dazed look about the eyes. Are you feeling badly?"

"No, grandmother."

"You're not to get ill, child. I shall make a bottle of tansy bitters to-morrow morning. We've trouble enough in this family without your losing colour and getting circles round your eyes."

That was love and kindness from Old Miss. The water came into Hagar's eyes. She felt a desire to tell her grandmother and Aunt Serena about the letter, but in another moment it was gone. Her whole inner life was by now secret from them, and this seemed of the inner life. Presently, of course, she would deliberately tell them all; she had thought it out and determined that it would be after supper, before Uncle Bob went to bed and grandfather told her to get the chess-table. It seemed so wonderful a thing to her; she was so awed by it that she could not help the feeling that it would be wonderful to them, too.

In the afternoon she put a cape around her, left the home

hill and went down the lane, skirted a ploughed field, and, crossing the river road, came immediately to the fringe of sycamores and willows upon the river bank. It was warmer and stiller than it had been in the morning, for the voice of the wind there sounded now the voice of the river; the many boughs above were still against the sky. She made for a great sycamore that she had known from childhood; it had a vast protuberant curving root in whose embrace you could sit as in an armchair. She sat there now and looked at the river that went so swiftly by. It was swollen with the spring rains; it made a deep noise, going by to the distant sea. To Hagar its voice to-day was at once solemn and jubilant, strong and stirred from depth to surface. She had with her the letter; how many times she had read it she could not have told. She could have said it by heart, but still she wanted to read it, to touch it, to become aware of meaning under meaning.... She could write, she could tell stories, she could write books.... She could earn money. It was one of the moments of her life: the moment when she knew of her mother's death — the moment when she changed Gilead Balm for Eglantine — the moment by the fire, Christmas eve — this moment. She was but eighteen; the right-angled turns in her road of this life had not been many; this was one and a main one. Suddenly, to herself, her life achieved purpose, direction. It was as though a rudderless boat had been suddenly mended, or a bewildered helmsman had seen the pole star.

She sat in the embrace of the sycamore, her feet lightly resting on the spring earth, her shoulders just touching the pale bark of the tree, her arms folded, her eyes level; poised,

recollected as a young Brahman, conscious of an expanded space, a deeper time. How long she sat there she did not know; the sun slipped lower, touched her knees with gold. She sighed at last, raised her hands and turned her body.

What, perhaps, had roused her was the sound of a horse's hoofs upon the river road. At any rate, she now marked a black horse coming in the distance, down the road, by the speckled sycamores. It came on with a gay sound upon the wind-dried earth, and in its rider she presently recognized her cousin, Ralph Coltsworth.

"What are you doing here?" she asked when he reined in the black horse beside her. "Why are n't you at the University with Blackstone under your arm?"

He dismounted, fastened his horse, and came across to the sycamore root. "It's big enough for two, is n't it?" he asked, and sat down facing her. "You mentioned the University? The University, bless its old heart! does n't appreciate me."

"Ralph! Have you been expelled?"

"Suspended." Hands behind head, he regarded first the blue sky behind the interlaced bare branches, then the tall and great gnarled trunk, then the brown-clad figure of his cousin, enthroned before him. "The suspense," he said, "is exquisite."

"What did you do?"

He grimaced. "I don't remember. Why talk about it? It was n't much. Cakes and ale — *joie de vivre* — chimes at midnight — same old song." He laughed. "I gather that you've been rusticated, too."

Hagar winced. "Don't! ... Let's laugh about other things. You'll break your family's hearts at Hawk Nest."

"Old Miss said in a letter which mother showed me that you were breaking hers. What kind of a fellow is he, Hagar?—Like me?"

Hagar looked at him gravely. "Not in the least. How long are you going to stay at Hawk Nest?"

"Oh, a month! I'm coming to see you every other day."

"Are you?"

"I am. If I could draw I'd like to draw you just as you look now—half marquise, half dryad—sitting before your own front door!"

"Well, you can't draw," said Hagar. "And it's getting cold, and the dryad is going home."

"All right," said Ralph. "I'm going, too. I've come to spend the night."

Leading his horse, he walked beside her. In the green lane, a wintry sunset glory over every slope and distant wood, the house between its black cedars rising before them, he halted a moment. "I have'nt seen you since August when I rode over to tell Gilead Balm good-bye. You've changed. You've 'done growed.'"

"That may be. I've grown to-day."

"Since I came?"

"No. Before you came. For the first time I suppose in your life, grandmother is going to be sorry to see you. She worships you."

"She was sorry to see you, too, was n't she? It's rather nice to be companions out of favour."

"Oh!" cried Hagar. "You are and always were the most provoking twister of the truth! I want to say to you that I do not consider that ours are similar cases! And now, if you

please, that is the last word I am going to say to you on such a matter."

"All right!" said Ralph. "I was curious, of course. But I acknowledge your right to shut me up."

They passed through the home gate, — where a boy took his horse, — and went up the hill together. Dilsey was lighting the lamps. As they entered the hall Miss Serena came out of the library — Miss Serena looking curiously agitated. "Dilsey, has n't Miss Hagar come in yet? . . . Oh, Hagar! I've been searching the place for you — Why, Ralph! Where on earth did you come from? Has the University burned down? Have you got a holiday?"

The library door was ajar. The Colonel's voice made itself heard from within. "Serena! Is that Hagar? Tell her to come here."

The three entered the room together. There was a slight clamour of surprise and greeting from its occupants for Ralph, but it died down in the face, as it were, of things of greater importance.

"What's the matter?" he asked, bringing up at last by Captain Bob in the background.

"A letter from Medway," answered the other. "*Shh!*"

The evenings falling cold, there was a fire upon the hearth. The reading-lamp was lit; all the room was in a glow that caressed the stiff portraits, the old mahogany and horsehair furniture, the bookcases and the books within. In the smaller of the two great chairs by the hearth sat Old Miss, preternaturally straight, her hands folded on the black silk apron which she donned in the evening, her still comely face and head rising from the narrow, very fine embroidered

collar fastened by an oval brooch in which, in a complicated pattern, was wrought the hair of dead Coltsworths and Hardens. Her face wore a look at once softened and fixed. Across from her, in the big chair by the leaf-table, sat Colonel Ashendyne, a little greyer, a little more hawklike of nose, a little sparer in frame as the years went by, but emphatically not a person to whom could be applied the term "old." There breathed from him still an insolent, determined prime, a timelessness, a pictorial quality as of some gallery masterpiece. With the greyish-amber of his yet plentiful hair, his mustache and imperial, the racer set of his head, his well-shaped jaw and long nervous hands, his fine, long, spare figure and his eye in which a certain bladelike keenness and cynicism warred with native sensuousness, he stayed in the memory like such a canvas. His mood always showed through him, though somewhat cloudily like light through a Venetian glass. That it was a mixed and curious mood tonight, Hagar felt the moment she was in the room. She did not always like her grandfather, but she usually understood him. She saw the letter that had rested on the mantelpiece, the letter from Paris, in his hand, and at once there came over her a curious foreboding, she did not know whether of good or evil.

"Sit down," said the Colonel. "I have something to read to you."

For two months and more he had not looked at her without anger in his eyes. To-night the cloud seemed at least partly to have gone by. There was even in the Colonel's tone a touch of blandness, of enjoyment of the situation. She sat down, wondering, her eyes upon the letter. On occa-

sion, when she searched her heart through, she found but a shrivelled love for her father. Except that he had had half-share in giving her life, she really did not know what she had to love him for. Now, however, what power of growth there was in the winter-wrapped root broke the soil. She began to tremble. "What is the matter? Is father ill? Is he coming home?"

"Not immediately," said the Colonel. "No, he is not ill. He appears to be in his usual health and to exhibit his usual good spirits. Your grandmother and I were fortunate in having a son of a disposition so happy that he left all clouds and difficulties, including his own, to other people. At the proper moment he has always been able to find a burden-bearer. No, Medway is well, and apparently happy. He has remarried."

"Remarried!..."

It was the Colonel's intention to read her the letter — indeed, it carried an inclosure for her — as he had already read it, twice, with varying comment, to the others assembled. But he chose to make first, his own introduction. "You've heard of the cat that always falls on its feet? Well, that's your father, Gipsy!" — Even in the whirl of the moment Hagar could not but note that he called her "Gipsy." — "That's Medway! Here's a careless, ungrateful, disobedient son, utterly reckless of his obligations. Is he hanged or struck by lightning? Not he! He goes happily along — Master Lucky-Dog! He makes a disastrous marriage with a penniless remnant of a broken-down family on some lost coast or other and brings her home, and presently there's a child. Does he undertake to support them, stay by his bar-

gain, however poor a one? Not he! He's got a tiny income in his own right, left him by his maternal grandfather — just enough, with care, for one! Off he goes with that in his pocket and a wealthy friend and, from that day to this, we have n't laid eyes on Prince Fortunatus! Well, what happens? Does he come to eating husks with the swine and so at last slink back! Not he! He enjoys life; he's free and footloose; he's put his burden on other folk's backs! Death comes along and unmakes his marriage. His doting mother and his weak father apparently are prepared to charge themselves with the maintenance of his child. Why should he trouble? He does n't — not in the least! He's got just enough in his own right to let him wander, *en garçon*, over creation. If he took the least care of another he could n't wander, and he likes to wander. Ah, I understand Medway, from hair to heel!— What comes of it all? We used to believe in Nemesis, but that, like other beliefs, is going by the board. Is n't he going to suffer? Not at all! He remains the cat that falls, every time, upon its feet. — This, Gipsy, is the letter."

My dear Father and Mother: — As well as I can remember, I was staying at Dinard when I last wrote you. I was there because of the presence in that charming place of a lady whose acquaintance I had made, the previous year, at Aix-les-Bains. From Dinard I followed her, in November, to Nice, and from Nice to Italy. I spent a portion of February as her guest in her villa near Sorrento, and there matters were brought to a conclusion. I proposed marriage and she accepted. We were married a week ago in Rome, in the English church, before a large company, the American Minister giving her away. There were

matters to be arranged with her banker and lawyer in Paris, and so, despite the fact that March is a detestable month in this city, we immediately came on here. Later we shall be in Brittany, and we talk of Norway for the summer.

The lady whom I have married was the widow of —— ——, the noted financier and railroad magnate. She is something under my own age, accomplished, attractive, handsome, and possessed of a boundless good nature and a benevolent heart. We understand each other's nature and expect to be happy together. I need hardly tell you that being who she is, she has extreme wealth. If you read the papers — I do not — you may perhaps recall that ——'s will left his millions to her absolutely without condition. There were no children, To close this matter: — she has been generous to a degree in insisting that certain settlements be made — it leaves me with a personal financial independence and assurance of which, of course, I never dreamed. . . . I have often regretted that I have been able to do so little for you, or for the upkeep of dear old Gilead Balm. This, in the future, may be rectified. I understand that you have had to raise money upon the place, and I wish you would let me know the amount."

The Colonel's eyes darted cold fire. He let the sheet fall for the moment and turned upon Hagar, sitting motionless on the ottoman by the fire. "Damn your father's impertinence, Gipsy!" he said.

Old Miss spoke in a soft and gentle voice. "Why do you call it that, Colonel? Medway always had a better heart than he's ever been given credit for. Why should n't he help now that he can do so? It's greatly to his credit that he should write that way."

"Sarah," said the Colonel, "you are a soft-hearted — mother!"

Captain Bob spoke from beyond the table. Captain Bob did not often speak, nor often with especial weight, but he had been pondering this matter for three quarters of an hour, and he had a certain kind of common sense. "I think Sarah's right. Medway's a curiosity to me, but I've always held that he was born that way. You are, you know; you're born so or you are n't born so. He's pretty consistent. There never was a time when I would n't have said that he would come to the fore just as soon as he did n't have to deny himself. Now the time's come, and here he is. I think Sarah's right. Forgive and forget! If he wants to pay his debts — and God knows he owes you and Sarah a lot — I'd let him. And as to Gipsy there — better late than never! Read her what he says."

"I am going to," said the Colonel sardonically. He read the page that remained, then laid the letter on the table, put his hands behind his head and regarded his granddaughter. "The benevolent parent arrived at last upon the scene — a kindly disposed stepmother with millions — and that teacher of surface culture to young ladies at Eglantine! Among the three you ought to be quite ideally provided for! I hope Medway will like the teacher."

Old Miss came, unexpectedly, to her granddaughter's aid. "Don't worry her, Colonel! I have n't thought her looking well to-day. Give her her letter, and let her go and think it out quietly by herself. — If you like, child, Phœbe shall bring you your supper."

Hagar did like — oh, would like that, thank you, grand-

mother, very much! She took the letter — it was addressed to her in a woman's hand — which her father had enclosed and which her grandfather now held out to her, and went away, feeling somewhat blindly for the door, leaving the others staring after her. Upstairs she lit her lamp and placed it on Maria's table, by Maria's couch. Then, curled there, against the chintz-covered pillows, — they were in a pattern of tulips and roses, — she read the very kind letter which her stepmother had written.

CHAPTER XII

A MEETING

THE New Springs had been so christened about a hundred years before, when a restless pioneer family had moved westward and upward from the Old Springs, thirty miles away, at the foot of the great forest-clad range. The New Springs had been a deer-lick, and apparently, from the number of arrowheads forever being unearthed, a known region to the Indians. Now the Indians were gone, and the deer fast, fast withdrawing. Occasionally buck or doe was shot, but for the most part they were phantoms of the past. So with the bear who used to come down to the corncribs in the lonely clearings. Bear Mountain still rose dark blue, like a wall, and the stark cliff called Bear's Den caught the first ray of the sun, but the bears themselves were seldom seen. They also were phantoms of the past. But the fish stayed in the mountain streams. There were many streams and many fish, — bright, speckled mountain trout, darting and flashing among pools and cascades, now seen in the sunlight, now lurking by fern-crowned rocks, in the shadow of the dark hemlock spruce. The region was Fisherman's Paradise.

It was almost an all-day's climb from the nearest railway station to the New Springs. You took the stage in the first freshness of the morning; you went gaily along for a few miles through a fair grazing country; then the stage began to climb, and it climbed and climbed until you wondered where and

A MEETING

when the thing was going to stop. Every now and then driver and passengers got down and walked. Here it was shady, with wonderful banks of rhododendron, with ferns and overhanging trees, and here it was sunny and hot, with the wood scrub or burned, and the only interesting growth huckleberries and huckleberries and huckleberries, dwarf under the blazing sun, with butterflies flitting over them. Up here you had wonderful views; you saw a sea of mountains, tremendous, motionless waves; the orb as it had wrinkled when man and beast and herb were not. At last, somewhere on the long crest, having been told that you must bring luncheon with you and having provided yourself at the railway station with cold bread and fruit and hard-boiled eggs, you had luncheon. It was eaten near a bubbling spring with a water-trough at which the horses were drinking, and eaten with the most tremendous appetite. By now you were convinced that the air up here was blowing through a champagne bottle. Luncheon over and the horses rested, on went the stage. Quite in the mid-afternoon you began to go down the mountain. Somewhat later, in a turn by a buckwheat field waving white in the summer wind, the driver would point with his whip — "Right down there — there's the New Springs! Be there in an hour now."

It might be "right down there," but still the New Springs was pretty high in the world, away, away above sea level. You always slept at the New Springs under blankets, you nearly always had a fire in the evening; even the heat of the midday sun in the dog days was only a dry, delightful warmth. Hardly anywhere did the stars shine so brightly, the air was so rare and fine.

The New Springs boasted no imposing dwellings. There was a hotel, of faint, old, red brick, with a pillared verandah, and there were half a dozen one-story frame cottages, each with a small porch and growing over it its individual vine. Honeysuckle clambered over one, and hops over another, and a scarlet bean over a third, and so on. There was an ice-cold sulphur spring where the bubbles were always rising, and around it was built a rustic pavilion. Also there existed a much-out-of-repair bowling-alley.

"Yes, there's the New Springs," said the driver, pointing with his whip. "But, Lord! it stopped being new a long time ago."

There were hardly any passengers to-day; only three in fact: two women and a man. All three were young enough to accomplish with enjoyment a great deal of walking up the long mountain. They had laughed and talked together, though of very nothings as became just-met folk. The birds and the bees and butterflies, the flowers, the air, and the view had been the chief subjects of comment. Now, back in the stage for the descent, they held in their hands flowers and ferns and branches covered with ripe huckleberries which they detached from the stems, lifted to their lips and ate. The two women were friends, coming, so they now explained to their fellow-traveller, from a distance to this little out-of-the-way place. The brother of one, it seemed, was a great fisherman and came often. He was not here this year; he was travelling in Palestine; but he had advised his sister, who was a little broken down and wanted a quiet place to work in, to come here. She said, jubilantly, that if the air was always going to be like this she was glad

she had come. It had seemed funny, at first, to think of coming South for the summer — though her friend was half-Southern and didn't mind.

"I'm wondering," said the fellow-traveller, with an effect of gallantry, "what in the world the work can be! The very latest thing, I suppose, in fancy-work — or perhaps you do pastels?"

Elizabeth Eden looked at him with her very candid grey eyes. "I'm doing a book of statistics — women and children in industry."

"And I," said the other, Marie Caton, "I teach English to immigrant girls. We are both Settlement workers."

Laydon prided himself on his ability quickly to shift sail. "Oh!" he said; "a Settlement! That's an idea that hasn't got down to us yet. We are rather lazy, I suppose. — I was reading, though, an excellent article upon Settlements in one of the current magazines only the other day. Ladies, especially, seem to be going in for that kind of work; — of course, it is, when you think of it, only an extension of their historic function as 'loaf-giver.' Charity and Woman — they're almost synonymous."

"That's a magnificent compliment — or meant to be!" said Marie Caton. Her eyes were dancing. "I wonder what you'd say if I said that charity — charity in your sense — is one of woman's worst weaknesses? Thank God Settlements, bad as they are, aren't charity!"

"Look at the view, Marie," said Elizabeth. "And, oh! feel that wind! Isn't it divine?"

"Winds blow from all four points at oncet up here," said the driver. "Ain't many people at the New Springs this

summer. Fish don't bite, or everybody's gone to the World's Fair, or something or other! Ain't more 'n forty people, countin' children."

"What kind of people are they? Do the women fish, too?"

"No, ma'am, not much. It's the husbands and brothers and fathers does the fishing mostly — though there's Mrs. Josslyn. *She* fishes. The others just sit around in rocking-chairs, I reckon, and crochet. Them that has children looks after them, and them that has n't listens to them that has. Then it's a fine air for the health; fine air and fine water. A lot of tired people come. Then there's others get into the habit of meeting friends here. Being on the border, as it were, it's convenient for more states than one. Colonel Ashendyne, for instance, — he comes because General Argyle and Judge Black and he made a pact in the war that if they lived through they'd spend a month together every two years until they died. They've kept it faithful, and because Judge Black's a great fisherman, and General Argyle likes the juleps they make here, and Colonel Ashendyne knew the place when he was a boy, they pitched on the New Springs. When they're here together, they're the three Kings. — Git up, thar, Dandy! — This year the Colonel's got his daughter and granddaughter with him."

Laydon nodded, looking animated and handsome. "I know the Ashendynes. Indeed. — but that is neither here nor there. The Ashendynes," he explained for the benefit of the two foreigners, "are one of our oldest families, with connections everywhere; not wealthy, — we have very little wealth, you know, — but old, very widespread and honoured. A number of them in the past were really famous. It might be

said of the Ashendynes as it was said of an English family —
'All the sons were brave and all the daughters virtuous.'"

"You seem," said Marie Caton, "to have a profound acquaintance with the best literature."

Laydon disclaimed it with a modest shake of the head. "Oh, only so-so! However, literature is my profession. I have a chair of Belles-Lettres."

"That is interesting," said Elizabeth in her friendly voice. "Is it your vacation? Are you a fisherman, too?"

"Oh, I fish a little on occasion! But I am not what you call a great fisherman. And I was never at the New Springs before." He gave a half-boyish, embarrassed laugh. "To tell the truth, I am one of those persons who've come because another person happens to be here —"

"Oh!" said Marie Caton, "I see!" She began presently to hum beneath her breath —

>"Gin a body meet a body,
> Comin' through the rye —"

"Oh, what a rough piece of road!"

"It ain't often mended," said the driver. "They say times is changing, — there was a fellow through here last summer said they was changing so rapid they made you dizzy, — but there ain't much change gotten round to Bear Mountain. I remember that identical rut there when I was just a little shaver. — Look out, now, on that side, and you'll see the New Springs again! We ain't more'n a mile an' a half away now. The ladies often walk up here to see the sunset."

"There's one coming up the road now," said Marie Caton, "In a green gingham and a shady hat."

"That," said the driver, "'ll be Miss Hagar — Colonel Ashendyne's granddaughter. She and me's great friends. Come by here 'most any evenin' and you'll find her sittin' on the big rock there, lookin' away to Kingdom Come."

"Stop a minute," spoke Laydon, "and let me out here. I know Miss Ashendyne. I'll wait here to meet her and walk back to the Springs with her."

He lifted his hat to his fellow-travellers and the stage went on without him. "A nice, clean-looking man," said Elizabeth who was inveterate at finding good; "not very original, but then who is?"

"I can't answer it," said Marie promptly. "Now we'll see the girl! She's coming up straight and light, like a right mountain climber." The stage met and passed Hagar, she and the driver exchanging "Good-evenings!" The stage lumbered on down the slope. "I liked her looks," said Marie. "Now, they're meeting —"

"Don't look back."

"All right, I won't. I'd like such consideration myself. — Betsy, Betsy! You are going to get strong enough at the New Springs to throw every statistic between Canada and Mexico!"

Back beside the big rock at the bend of the road, Hagar and Laydon met. "There isn't any one to see!" he exclaimed, and would have taken her in his arms.

She evaded his grasp, putting out her hand and a light staff which she carried. "No, Mr. Laydon! Wait — wait — " Stepping backward to the rock by the wayside she sat down upon it, behind her all the waves of the Endless Mountains. "I only got your letter yesterday. It had been delayed. If I

had had it in time, I should have written to you not to come."

"I told you in it," smiled Laydon, "that I was not afraid of your grandfather. He can't eat me. The New Springs is as much mine to come to as it is his. I had just three days before I go to —— to see about that opening there. The idea came to me that if I could really see him and talk to him, he might become reconciled. And then, dear little girl! I wanted to see you! I could n't resist —"

As he spoke he moved toward her again. She shook her head and put out again the hand with the staff. "No. That is over.... I came up here to meet you because I wanted to find out — to know — to be certain, at once —"

"To find out — to know — to be certain of what?" He smiled. "That I am just the same? — That I love you still?"

"To be certain," said Hagar, "that I was mistaken.... I have got my certainty."

"I wish," said Laydon, after a pause, "that I knew what you were driving at. There was something in your last month's letter, and for the matter of that in the month before, that struck cold. Have I offended you in any way, Hagar?"

"You have not been to blame," said Hagar. "I don't think either of us was to blame. I think it was an honest mistake. I think we took a passing lightning flash for the sun in heaven.... Mr. Laydon, that evening in the parlour at Eglantine and the morning after, when we walked to the gate, and the road was sunny and lonely and the bells were ringing, oh, then I am sure I loved you —" She drew her

hand across brow and eyes. "Or, if not you, I loved — Love! But after that, oh, steadily after that, it lessened —"

"'Lessened'! — You mean that you are not in love with me as you were?"

"I am not in love with you at all. I was in love with you, or I was in love. I am not now." She struck her staff against the rock. "I almost hope I'll never be in love again!"

Across from a cleared hillside, steep and grassy, came a tinkling of sheep-bells. The sun hung low in the west and the trees cast shadows across the road. A vireo was singing in a walnut tree, a chipmunk ran along a bit of old rail fence. A zephyr brought an odour dank and rich, from the aged forest that hung above.

"I think," said Laydon, "that you are treating me very badly."

"Am I? I am sorry. ... You mustn't think that I haven't been wretched over all this. But it would be treating you badly, indeed, if I were such a coward as to let it go on." She looked at him oddly. "Will you be — Are you much hurt?"

"I — I —" said Laydon. "I do not think you quite conceive what you are saying, nor what such a cool pronunciamento must mean to a man! Hurt? Yes, I am hurt. My pride — my confidence in you — my assurance that I had your heart and that you had put your life in my keeping — the love that I truly felt for you —"

"'Felt.' — You loved me, loving you. Oh," said Hagar, "I feel so old — so old!"

"I loved you sincerely. I imperilled my position for

you — to a certain extent, all my prospects in life. I had delightful visions of the day when we should be finally together — the home you would make — the love and protection I should give you —"

"You are honest," said Hagar, "and I like honesty. If I have done you any wrong at all, if I have made life any harder for you, if I have destroyed any ideals, if I have done you the least harm, I very heartily beg your pardon."

Laydon drew from his pocket a small box and opened it. "I had brought you that —"

Hagar took it in her hand and looked at it. "It is lovely!" she said. "A diamond and a sapphire! And it is n't going to be wasted. You keep it. Sooner or later you'll surely need it. You could n't have bought a prettier one." She looked up with a soft, bright, almost maternal face. "You don't know how much happier I am having faced it, and said it, and had it over with! And you — I don't believe you are so unhappy! Now are you — now are you?"

"You have put me in an absurd position. What am I to say —"

"To people? Nothing — or what you please. I will tell grandfather myself, to-night — and Aunt Serena. I shall tell them that you have behaved extremely well, and that it was all my fault. Or no! I shall tell them that we both found out that we had been mistaken, for I think that that is the truth. And that we have had an explanation, and are now and for always just well-wishers and common friends and nothing more. I am going to try — I think that now maybe I can do it — to get grandfather to treat you properly. There is nobody else here whose business it is, or who knows any-

thing about it — and you have only three days anyway. There are some pleasant people, and you'll meet them. It isn't going to be awkward, indeed, it isn't —'

"By George!" said Laydon, "if you aren't the coolest . . . Of course, if this is the way you feel, it may be wisest not to link my life with — Naturally a man wants entire love, admiration, and confidence —"

"Just so," said Hagar. "And you'll find some one to feel all that. And now let's walk to the New Springs."

CHAPTER XIII

THE NEW SPRINGS

LAYDON's three days spun themselves out to five with a fine smoothness. Colonel Ashendyne's tone was balm itself to what it might have been. Miss Serena was willing to discuss with him "In Memoriam" and the novels of Miss Broughton, and Ralph Coltsworth who was also at the New Springs walked with him over the place. Laydon was keen enough to see that Hagar had appealed to her family, and that Ashendyne breeding had rallied to her support. He was at once provoked and soothed; now conscious only of the injury to his healthy self-love, and now of a vague relief that, young as he still was, and with that wonderful future all to make, he really was not tied down. His very vanity would not agree but that the woman with whom he had thought himself in love must be of a superior type and an undeniable charm, but the same vanity conceded gently that to err was mortal, and that there were as good fish in the sea as ever came out of it, and that he certainly had not been fatally smitten — on the whole, she, poor little thing! had probably suffered the most of the two. Charming as she was, the glamour for him, he conceded, was gone. *He had come off pretty well, after all.*

When the five days were up, he felt positive regret at having to go, and his good-bye to all the Ashendynes was cordial. He had already written to Mrs. LeGrand, and, of course, to

his mother. He went; the stage took him up the mountain....

"For all I could see — and I watched pretty closely — there did n't anything come of it," remarked Marie Caton. "On the whole, I am rather glad. Now you can't hear the rumble of the stage any longer. He's gone out of the picture. — Betsy, stop writing and look at the robin and the chipmunk —"

They had the tiniest cottage to themselves — Elizabeth's brother being an old-timer here, and his letter to the proprietor procuring them great consideration. There were but two rooms in the cottage. Roof and porch, it was sunk in traveller's-joy, and in front sprang a vast walnut tree, and beyond the walnut a span-wide stream purled between mint over a slaty bed. From the porch you looked southward over mountains and mountains, and every evening Antares looked redly back at you. Now it was morning, and wrens and robins and catbirds all were singing.

Elizabeth looked up from the table where she was working. "If I watch chipmunks all morning, I'll never get these textile figures done. — Mrs. Josslyn said at breakfast that it was n't a good day for fishing, and that she might wander by."

"She's coming now. I see her in the distance. I like Molly Josslyn."

"So do I. — We have n't been here a week and yet we talk as though we had known these people always!"

"Well, the fact that quite a number knew your brother made for there being no ice to break. And it would be so absurd not to know one another at the New Springs! as

absurd as if a shipload of people cast on a desert island —
Here she is. Come in, Mrs. Josslyn!"

"Thank you, I don't want a chair," said Molly Josslyn. "You don't mind if I sit on the edge of the porch and dangle my feet, do you? Nor if I take off my hat and roll up my sleeves so that I can feel the air on my arms?"

"Not a bit. Take the hairpins out of your hair and let it fly."

"I wish that I could cut it off!" said Molly viciously. "I will some day! Pretty nearly a whole three-quarters of an hour out of every twenty-four gone in brushing and combing and doing up hair! You have to do it in the morning and the middle of the day and the evening. A twentieth part of your whole waking existence! . . . Oh, me!"

"What a sigh!"

"I've been in rocking-chair-and-gossip land over on the big porch. I've heard everybody — in a petticoat — who wasn't there hanged, drawn, and quartered. Of course, I knew they were eager to get at me, and so I was obliging and came away."

Marie Caton laughed. "Miss Eden here is an optimist of the first water. If you ask her she'll tell you that women are growing beyond that sort of thing — that they don't sting one another half as much as they used to!"

"No, I don't think they do," said Mrs. Josslyn. "I think that's getting apparent nowadays. Speaking for myself, fresh air and out of doors and swinging off by one's self seem to make a body more or less charitable. But some of us have got the habit yet. Gnat or wasp or hornet or snake, on they go!" she laughed. "Over on the porch it was n't

anything but a little cloud of gnats. They were n't really stinging — just getting between your eyes and the blue sky."

"But it is growing better — it is, it is!" said Elizabeth. "I would n't give up that belief for anything."

"No, don't!" said Molly Josslyn. "I like women and like to think well of them."

A strong, rosy blonde, she stood up and stretched her arms above her head. "I wish there were a pool somewhere, deep enough to swim in! I'd like to cross the Hellespont this morning — swim it and swim back. — Christopher is coming to-morrow."

"Christopher?"

"My husband — Christopher Josslyn. They don't," said Mrs. Josslyn, "make them any nicer than Christopher! Christopher was my born mate." And went away with a beamy look, over the grass.

Marie spoke thoughtfully. "Yesterday I heard one of the gnats singing. It sang, 'Yes, rather handsome, but don't you find her dreadfully unfeminine?'"

"Oh, 'feminine'!" said Elizabeth, and went on adding figures.

Marie Caton took a book from the generous number ranged around a jar of Black-eyed Susans on the rustic table in the middle of the porch, but "The chipmunks and the robins get so in the way," she presently dreamily murmured, and then, "You had just as well put up your work. Here's Judge Black and General Argyle!"

Judge Black was sixty-two, rather lean than stout, rather short than tall, clean-shaven, with a good-looking counte-

nance below grizzled, close-clipped hair, with a bald spot at the top like a monk's tonsure. General Argyle was a much larger and taller man, big-framed, wide-girthed, with a well-set head framed about with shaggy white hair. His countenance was rubicund, his voice mellow. He was sixty-seven, in some respects very old, and in others quite young. Usually, at the New Springs, Colonel Ashendyne marched in company, but this morning — "Ashendyne's got some family conference or other on hand. It's a day off for fishing, and nobody seems to have a mind for whist or poker, and the papers have n't come. Argyle and I are floating around like two lost corks or the Babes in the Wood —"

"So I said," said General Argyle richly, "let's stroll over there and say good-morning to Tom Eden's sister and her attractive friend. — No, no; no chairs! We'll sit here on the steps. As soon as Ashendyne appears, we're going after young Coltsworth and have a turn in the bowling-alley. Must exercise! — that's what I'm always telling Black here —"

"As if I did n't exercise," said Judge Black, "more in a day than he does in a week. — What a pretty little porch you've got! Books, flowers, needlework —"

The General surveyed it, too. "It *is* pretty. Woman's touch — woman's touch!"

"That is n't needlework in the basket," said Marie demurely. "It's apples. Will you have one?"

"No, thanks, Mistress Eve — or yes, on second thoughts, I will! What are you reading? — 'The Doll's House.' Ibsen!"

"Yes."

"I do not know," said the Judge, "what young ladies are coming to! I have never had time, nor, I may say, inclination, to read Ibsen myself, but of course I know the kind of thing he's responsible for. And, frankly, I should not permit my daughter to read that book!"

"Oh," said Marie, "I don't think myself it is a book for a child!"

"She's not a child. She's twenty-six. I should dissuade my wife, too, from reading it."

"Then your wife," answered Marie, "would miss an illuminating piece of literature."

Elizabeth came in with her serene voice. "Don't you think, Judge Black, that we all acquire a habit of judging a writer, whom we have n't yet had time to study for ourselves, too much in terms of some review or other, or of the mere unthinking, current talk? I think we all do it. I believe when you read Ibsen you will feel differently about him."

"Not I!" said the Judge. "I have seen extracts enough. I tell you, Miss Eden, the age is reading too much of such decadent stuff—"

"Oh, 'decadent'!"

"And it is read, amazingly, by women. I would rather see my wife or daughter with the old dramatists at their worst in their hands than with stuff like that—! Overturning all our concepts, criticizing supremacies — I beg your pardon, Miss Caton, but if you knew how women, nowadays, amaze me—"

"Stop hectoring, Black," said the General mellowly. "She's not in the dock. Just so that women stay women, they can fill their heads with what stuff they will—"

"Exactly!" said Judge Black. "Do you see them staying women?"

"Women of the past," said Elizabeth.

"That is woman, — the women of the past. There is n't any other. The eternal feminine —"

"I think you are limiting the eternal and denying the universe power to evolve," said Elizabeth. "Why not eternally the man of the past? Why not 'There is n't any other'? Why not 'The eternal masculine'? Why do you change and grow from age to age?"

"I'm not so sure that they do," said Marie *sotto voce*.

"Yes, they do! They grow and become freer always; though I think," said Elizabeth painfully, "that they lag in the way they look at women. — Well, if you grow, being one half, do you suppose that we are not going to grow, being the other half? And if you think that the principle of growth is not in us, still I should n't worry! If we can't grow, we won't grow, and you need n't fash yourselves. On the other hand, if we can, we will — and that is all there is about it. And it would n't do you the least harm to read Ibsen — nor to get another definition of 'decadent.'"

She leaned forward in her chair. "Do you see that strip of blanched grass there? — or rather it was blanched yesterday when that board over there was lying upon it and had lain, I don't know how long! — blanched and bent and sicklied over. Now look! It is getting colour and standing straight — only beginning, but it is beginning — beginning to be on terms with the sun! Well, that grass is woman to-day! The heavy board is being lifted, and that's the change and all the change — and you find it 'pernicious'!"

Glowing-cheeked, she ceased speaking. Judge Black's colour, too, had heightened. "My dear Miss Eden, how did all this begin? I'm the last person in the world to deny to woman a proper freedom. I only ask that it shan't go beyond a certain point — that it shan't threaten the unsettling of a certain divine *status quo* —"

"I doubt if a divine *status quo* is ever unsettled, Judge Black," said Elizabeth. "But there — but there!" She smiled, and she had a very sweet, sunny smile. "I did n't in the least mean to quarrel! Tom will have told you that I sometimes use my tongue, and that's the ancient woman, still, is n't it? You see I care for women — being one — a good deal."

"Let us," said Marie Caton, "talk about fishing."

General Argyle chuckled. "Black does n't think you know anything about fishing. He has to acknowledge that Mrs. Josslyn does — but then he thinks that she's a charming *lusus naturæ*. I like to hear you give it to Black. Pay him back. He's always giving it to me!"

"That's right!" said Black. "Pitch into me! Cover me with obloquy! Poor homeless, friendless sailor with the pole star mysteriously shifted from its place —" . . .

"The homeless, friendless sailor stayed a long time, even with the pole star shifted," remarked Marie, forty minutes later.

"I certainly did n't mean to be rude," murmured Elizabeth, her eyes upon the disappearing guests, now well on their way to the bowling-alley. "They mean you never to resent a thing which they would at once recognize for an impertinence if one of themselves said it to another —"

"Oh, I should n't dub you rude," said the other. "And if he found you uncomfortable for a minute, you made up for it afterwards! You were charming enough, just as charming as if the pole star had never shifted. He went off still in mind the Eastern King."

"Ah," said Elizabeth, "that is where all of us are weak. We say the truth, and then we bring in 'charm' and sandpaper it away again! It's going to take another generation, Marie!"

"Another?" said Marie. "A dozen, more like! — Now I suppose I can read 'The Doll's House' in peace. — No, by all that's fated in this place, here comes another guest!"

This was Ralph Coltsworth, but he made no long tarrying; he was as transient as a butterfly. "Have you ladies seen Hagar Ashendyne? I want her to go to walk with me, and I can't find her anywhere."

"No, we have n't "said Marie. "Judge Black and General Argyle are looking for you to play tenpins."

Ralph smiled back at her. "Let them look! It will do the old codgers good. Do you like this place?"

"Yes, very much. Don't you?"

"Oh, I like it so–so!" said Ralph. "It's a good enough lotus land, but there's a lack somehow of wild, exciting adventure. I've been trying to read on the hotel porch. What do you think they're talking about over there? Fringed doilies!"

"What do you like to do and to talk about?"

"Live things." He laughed, tossed an apple into the air and caught it again. "I want first to make fifty millions, and then I want to spend fifty millions!"

"What an admirable American you are!"

"Am I not? And I vary it with just wanting to be a cowboy with a six-shooter on a Western plain —" He tossed the apple into the air again and, watching it, missed the glimpse of Hagar which the other two received. She appeared around the corner of a neighbouring cottage, her face directed toward the traveller's-joy porch, saw Coltsworth, wheeled and withdrew. He caught the apple, and after gazing meditatively for a moment in the direction of the tenpin-alley, sighed, and said that he supposed after all he might as well go help the General demolish the Army of the Potomac. "That's what he calls the pins when they're set up. He takes the biggest bowl and sends it thundering. I believe he thinks for the moment it is a ball from one of his old twenty-pounders. He sees fire and smells smoke. Sometimes he demolishes the Army of the Potomac and sometimes he does n't; but he never gets discouraged. The next cannon ball will surely do the work!"

When he was gone, and had been gone twenty minutes or more, Hagar reappeared. She came swiftly across the grass, mounted the porch steps, and stood, with a little deprecating shake of her head for the offered chair, by Elizabeth's work-table. "I am not going to stay, thank you! Miss Eden, somebody told me last night that you had written and published books —"

"Only text and reference books — compilations," said Elizabeth. "I only do that kind of unoriginal work."

"Yes, but a book is a book," said Hagar. "What I wondered was if you would n't be good enough to tell me some things. No one in all my connection writes — I don't know

any one to go to. I only want to know plain things — A, B, C's of how to manage —"

"About a manuscript, you mean?"

"Yes. I don't know anything. I've read all kinds of useless things and so little useful! For instance," said Hagar, "is it wrong to write on both sides of the paper?"

CHAPTER XIV

NEW YORK

IN August — the Ashendynes being back at Gilead Balm — the "Young People's Home Magazine" published Hagar's fairy story. Gilead Balm was impressed, but not greatly impressed. It had the aristocratic tradition as to writers; no Ashendyne had ever needed to be one. There had been editor Ashendynes, in the old fiery, early, and mid-century times, but editorship came out naturally from the political stream, and the political, with law, planting, and soldiery, had been the Ashendyne stream. The Ashendyne mind harked back to Early Georgian, even to Stuart times; when you said "writer" it saw something Grub Streetish. In addition, Hagar's was, of course, only a child's story.

The two hundred dollars shrank in impressiveness from being known of after and not before Medway Ashendyne's letter. But to the eyes of her grandmother and her Aunt Serena the two hundred dollars was the impressive, the only really impressive, thing. Her grandmother advised that it be put in bank. Miss Serena said that, when she was Hagar's age, she had had a watch and chain for more than two years. "What would you like to do with it, Gipsy?" asked Captain Bob.

The colour came into Hagar's cheeks. "With one half I want to get my two winter dresses and my coat and hat, and with the other half I want to get books."

"Books!" exclaimed the Ashendynes — the Colonel was not present. "Why, are n't there books enough here?"

"They are not the kind of books I need."

"Nonsense!" said Old Miss. "Get your winter clothes if you wish, — though I am sure that Medway means now to send the Colonel money for you, — but save the rest. It will come in useful some day. Some day, child, you'll be thinking about your marriage clothes."

"Luna and I came over the hill just now with Ralph Coltsworth," remarked Captain Bob cheerfully, apropos of nothing. "He says he's studying hard — means to catch up at the University and be a credit to the family."

Miss Serena was talented in taking offence at small things. She had evolved the watch-and-chain idea and she thought it should have received more consideration. In addition she had the kind of memory that always holds the wrong things. "Books! I suppose you mean a kind of books that we certainly don't have many of here! — French novels and Darwin and the kind of books those two Northern women were reading this summer! Even when you were a child — don't you remember, mother? — you had a perfect talent for getting your hands on debasing literature! I supposed you had outgrown it. I'm sure Mrs. LeGrand never encouraged it. A hundred dollars worth of books! — and I suppose you are to choose them! Well, if I were father, I'd look over the list first."

"Aunt Serena," said Hagar, with a Spanish gravity and courtesy, "there are times when I understand the most violent crimes. ... Yes; I know you don't know what I mean."

That was in August. September passed and part of

October, and then, late in that month, Hagar went to New York.

Medway Ashendyne and his wife were travelling in the East. Next year or the year after, they might, Medway wrote, be in America. In the meantime, Hagar must have advantages. He had not the least idea, he wrote his father, what kind of a person she was. Her letters were formal, toneless and colourless to a degree. He hoped she had not inherited — But whatever she had inherited, she was, of course, his daughter, and he must take care of her, being now in a position properly to do so. His wife suggested, for the moment, a winter in New York, properly chaperoned. The money would be forthcoming (there followed a memorandum of a handsome sum placed in bank to the Colonel's credit). He could, he knew, leave it to his father and mother to see that she *was* properly chaperoned. His wife had thought of making certain suggestions, but upon talking it over together, they had come to the conclusion that, at the moment, at least, it would be wisest not to interfere with the Gilead Balm order and way of life. It was admirably suited, he judged, for a young girl's bringing up — much better than the modern American way of doing things. Only in France — or the Orient — was the *jeune fille* really preserved.

The Colonel wrote to Mrs. LeGrand. Mrs. LeGrand returned one of her long, fluent letters. First of all, congratulations that Hagar had come to her senses about Mr. Laydon, then — "Now as to New York —"

Sylvie was going to New York too, — going to have singing lessons, for she had a very sweet voice, and every one

agreed that it would be a mistake not to give it the best training. The problem of how to manage for Sylvie had received the following solution, and Mrs. LeGrand proffered it as a possible way to manage for Hagar also. There was Powhatan Maine's family in New York — Powhatan himself and Bessie and their widowed daughter, Mrs. Bolt, with her two children. They lived well, "in our quiet, homelike, Southern fashion, of course." Powhatan was a solid lawyer in a solid firm. Sylvie had paid them a visit once before, but of course this year it was a question of her being in New York for months and months. Now, ordinarily, the Maines would not have heard of such a thing, but this disastrous year, with everybody failing, Powhatan had lost heavily in stocks and apparently they were having to economize. At any rate, Bessie was willing, just for this year, to take Sylvie under her wing and to let her pay for her room and board. The Maines' house was a good, big one, and Mrs. LeGrand had very little doubt that, just as a family favour, Bessie would be willing to receive Hagar on similar terms. Bessie would certainly stipulate that the arrangement should be a quiet one, just between themselves, and that Hagar, no less than Sylvie, should be regarded merely as a young friend and connection, visiting her that winter. This understood, Bessie would look after the two as if they were her own. It was fortunate that neither Sylvie nor Hagar was "out," for the Maines were in mourning. But Powhatan and Bessie knew a great many people, and the two girls would probably see company enough. "You remember Bessie, don't you? Good-nature itself! Nothing pleases her so much as having people happy about her." Then, too, there would be

Rachel Bolt. She could take Hagar to the theatre and to concerts and the picture galleries and where not. "The Maines are all members of St. Timothy's — the Bishop's nephew's church, you know." — In fine, Mrs. LeGrand advised that the Ashendynes write at once to Mrs. Maine. It was done and Hagar's winter soon arranged for.

New York! . . . She had dreamed of great cities, but she had never seen one. The night on the sleeping-car — her first night on any sleeping-car — she stayed awake and watched through the window the flying clouds and the moon and stars between, and, underneath, the fugitive landscape. There was a sense of exaltation, of rushing on with the rushing world. Now and again, as the train creaked and swung, and once, as another roared past, there came moments of fascinated terror. Rushing train and rushing world, all galloping wildly through the night, and in front, surely some bottomless precipice! . . . She and Sylvie had a section, and though Hagar had offered to take the upper berth, it had ended in their having it put back and sleeping together. Now Hagar sat up in bed, and looked at the sleeping Sylvie. There was a dim, blended light, coming from the lamp above and the moonlight night without. Sylvie lay, half-uncovered, fast asleep, her hair in glossy braids, her pretty face, shell-tinted, sunk in the pillow, her breast quietly rising and falling. Hagar had an intense, impersonal, abstract passion for beauty wherever and in whatever form it resided. Now, limbs beneath her, her arms nursing each other, she sat and regarded the sleeping Sylvie with a pure, detached admiration. The train roared into a station; she drew the window curtain until it roared out again, then bared the window, and

sat and watched the flying dark woods and the silver surface of some wide water. New York — New York — New York....

Sylvie was a travelled lady. Sylvie had been to New York before. She had been to Florida and New Orleans and Niagara and Saratoga. She could play sweetly, not arrogantly, — Sylvie was not arrogant, except, perhaps, a little when it came to good looks, — the part of guide and mentor to Hagar. In the Jersey City station she kept a reassuring touch upon Hagar's arm down the long platform to the gate. "The New York Ferry has a sign over it. Even if they don't meet us, I know how to manage — Oh, there's Cousin Powhatan!"

It was a pearl-grey morning, going over, with a mist that was almost a fog hanging upon the water and making unearthly and like a mirage the strange sky-line before them. There were not so many huge, tall buildings as there would be in after years, but they were beginning. The mist drifted, opening and closing, and to the mist was added the fairy garlands and pennants of white steam. Out of the luminous haze grew white ferryboats and low barges, and here passed an opalescent shape like a vast moth wing. "A sailboat," said Hagar under her breath. The air was chill and clinging. Sylvie and Captain Powhatan Maine preferred to sit and talk within the cabin, but Hagar remained outside. She stood with her hands lightly touching the rail, her eyes wide. Another sailboat slipped past. She turned and looked along the widening water, oceanward, and in a rift of the grey pearl clouds she seemed to see, at a great distance, a looming woman shape. A salt odour filled her nostrils. "Oh, the sea! I smell the sea!"

The ferryboat glided into its slip, the bell rang, the chains rattled; out resonantly, from the lower deck, passed the great dray horses and heavy wagons; the passengers disembarked; a crowd hurried, in column, toward the Elevated. Half-bewildered, Hagar found herself mounting long flights of steps, passing through a gateway, entering a train, which at once, with a shriek, began to run upon a level with second-story windows. She saw dingy red-brick factory and tenement buildings close, close to her face; fire-escapes and staring windows with squalid or horribly tawdry rooms beyond; on the window-sills spindling, starved plants in ancient, battered tin cans, children's faces, women leaning out, children, children, children — "We have to go quite far uptown," said Captain Maine. "Well, and what do you girls want to see first?"

He was a short, stout, gallant gentleman with a fierce grey mustache. Sylvie talked for both. Hagar nodded her head or commanded a smile when manners seemed to indicate it, but her mind was dealing with a nightmare. "Was this — was this New York?" Once she turned her head toward their escort, but something told her that if, indeed, she asked the absurd question, he would say, "Why, yes! Don't you like it?"

Where were the domes and colonnades? Where the cleanness and fairness — where the order and beauty? Where was the noble, great city? Where were the happy people? She tried to tell herself, first, that all these were there, that this was but a chance ugly street the train was going through ... but they went through it for miles, and she caught glimpses of so many other streets that seemed no better! And then she

tried to tell herself, that, after all, she must have known it would be something like this. She had seen before, on a small scale, in a small city, decrepit buildings and decrepit people of all ages. Poverty, dirt, and disease.... One city would be like another, only larger.... She must have known. But knowing did not seem to have helped — or perhaps she had never really seen, nor thought it out. She was tired and overstrained; a horror came upon her. She looked through a window into a room hung with a ghastly green, torn, and soiled paper. Men and women were working in it, bent over a long table, working haggardly and fast, the shirts of the men, the bodices of the women, open at the throat. Another window — a wretched, blowsy woman and a young man with a bloated, unwholesome face; — another, and an old, old woman with a crying child, whom she struck; — then mere blank windows or windows with starveling geraniums in broken pots; and beneath and around and everywhere voices and heavy wheels, and the train rushing on upon its trestle high in the air. Something black and cold and hopeless rolled over Hagar's soul. It was as though the train were droning, droning, a melancholy text.

"Hagar! What is the matter? You looked as though you were going to faint!"

But Hagar was n't going to faint. She pulled herself together. "No, no! It is n't anything! I was tired, I suppose —"

"Must n't faint in New York," said Captain Maine genially. "You'll get run over if you do."

On went the Elevated, and the walls of windows grew vaguely better — or the shock of surprise was over — or the

armoured being within shouldered away a hampering unhappiness. *New York — New York — New York!* Hope and vision sprang afresh. The windows and the houses in which they were set decidedly bettered. There were distant glimpses of fine buildings, spires of churches, trees that must be in a park. The sun, which had been all morning hidden by clouds, came suddenly forth and flooded the world with October gold. The gulf between what she had dreamed and what she saw perceptibly narrowed, though it was still there and though it still ached. "Here we are!" said Captain Maine, and folded his newspaper. Out of the train upon a platform — then more stairs, this time running downward — then a block or two of walking, in the crisp air, then a very different street from those the train had rushed through and very different houses. "Here we are!" said their host again, and they mounted a brownstone stoop. A coloured maid opened the door — they passed into a narrow reception hall with the Maines' ancestral tall clock standing by the stair and on the opposing walls engravings of Southern generals; thence, through folding doors, into a cool, deep parlour and the embrace of Mrs. Maine.

Mrs. Maine was large and sleepy and quiet and dark, with a nebulous personality. Everybody who knew her said that she was extremely good-natured, while a few added that she was too indolent to be irascible, and a fair number called it native kindliness and adduced a range of respectable incidents. No one ever hinted at intellectuality, and she certainly did not shine in conversation; she was not, apparently, socially ambitious, and nobody could be said to take less trouble — and yet a number of people — chiefly South-

erners dwelling in New York, the more decorative and prosperous of St. Timothy's congregation, and Powhatan Maine's legal associates and acquaintances — exhibited a certain partiality for the Maine house. Powhatan told good war stories and darky stories; almost always there appeared something good to eat, with a Southern name and flavour; and Mrs. Maine was as unobtrusive and comfortable to get on with as the all-pervasive ether. There was nothing riotous nor especially buoyant in the house; it was rather dim and dull and staid; but people who had begun to visit the Maines twenty years before visited still. Perhaps most of them were dim and dull and staid themselves. Others, perhaps, liked the occasional salt of an environment which was not habitually theirs. The house itself was deep and for a New York dwelling wide, cool, high-ceilinged, and dark, with a gleam of white marble mantel-pieces and antiquated crystal chandeliers, with some ancient Virginia furniture and some ebony and walnut abominations of the 'seventies. Everything was a little worn, tending toward shabbiness; but a shabbiness not extreme, as yet only comfortable, though with a glance toward a more helpless old age. There were a fair number of books, some portraits and good, time-yellowed engravings. There were four coloured servants beside the nurse for Mrs. Bolt's children. The children, Charley and Betty, were pudgy, quaint elves of three and five. Charley, the younger, had been blind from birth.

That evening, Rachel Bolt came before bedtime into Hagar's room. "May I sit and talk a little while? Sylvie and mother and father and Dick Dabney, who came in a little while ago, are playing duplicate whist."

"Of course you may. It's such a pleasant room you've given me."

Rachel turned in her chair and regarded it from wall to wall somewhat cynically. "Well, I suppose at the first blush it may seem so. It is, however, rather shabby. We meant to do it over again this year, but times are so tremendously hard that we gave it up with a lot of other things. — What I really came in for was to ask what kind of things and places and people you'd like to see this winter. It's agreed with your grandfather that I'm to take you around."

"It is good of you to be willing to do it —"

"Oh, I'm to be paid for doing it! I'll be spinning my spring outfit and Betty's and Charley's while we gallivant. But I do not mean" — she laughed — "that it is going to be hard or disagreeable work, unless" — she ended coolly — "you want to go to places where I don't want to go."

"To those places," said Hagar seriously, "I will go alone."

"Then," said Rachel, "we will get along very well.... What do you want to do anyhow?"

"I want to feel around for a while. And I'd like to be shown how to go and how to manage, just at first. But after that I hope you won't mind if I just wander about by myself." She lifted her long arms above her head in a gesture, harassed and restless. "I think there are people to whom solitude means as much as food or sleep."

"Do you want me to get up and say good-night?" asked Rachel promptly.

Hagar gave a warm little laugh. "Not yet awhile. I'm not that greedy and sleepy. I strive to be temperate...."

What I want to see first are pictures. I have never seen any — barring those at home and at Eglantine."

"Well, we can go to the Metropolitan to-morrow."

"I should like that. Then I want to hear music. I have never heard any to count."

"There'll be concerts and the opera later. The opera is, of course, very expensive, but I understand that your father wants you to do pretty well what you wish. If you don't mind being high up, we can do a good deal of it reasonably."

"Then let us go high up."

"At the moment there are n't even concerts. We might find an organ recital, and on Sundays there is music in the park."

"Day after to-morrow is Sunday. I'll go and hear that. Then I want to go to the theatre."

"Most of that will come later, too. Are you fond of the theatre?"

"I don't know. That is why I want to go — to find out. I have never seen but three plays."

"What an awfully lucky person! What were they?"

"One — I was a little girl and I went to Richmond for two days — was 'Maria Stuart.'" Janauschek played it. The next was in the small town near where I live. It was rather terribly done, I believe, and it kept me awake for a week afterward. I was fifteen. It was 'The Corsican Brothers.' Then" — said Hagar, "last winter I saw 'Romeo and Juliet.' ... They did n't seem like plays. They seemed like life, — sometimes terrible and sometimes beautiful. I want to go to find out if it is always so."

"It is n't," said Rachel. "You are inexperienced."

"There is a natural history museum here, is n't there?"

"Yes, a large one."

"I want to go there. I want to see malachite and chrysoprase and jade, and the large blue butterflies and the apes up to man and the models of the pterodactyl and dinosaur and a hundred other things."

"Until now," said Rachel, "I have thought that Charley and Betty had the largest possible appetites. What else?"

"Am I tiring you?"

"Not a bit. Besides, it is business. I came in here to get a *catalogue raisonné*. — It's rather curious that you should have such a passion for minerals and species and prehistoric things."

"Is it? Well, I have it," said Hagar. She put her arms again behind and above her head. "If you want to know All, you must live All — though in honour preferring one to the other."

Beside her, on the little table by the hearth, was a paper and pencil. Suddenly she unlocked her hands, bent over and drew a sheet of paper from under the book with which she had covered it on Rachel's entrance. "I was trying to write something when you came in. It is rough and crude, — just the skeleton, — but it's something like what I mean and what I want." She held it out; then, with a deprecating gesture and a shy flush, "If it does n't bore you —"

Rachel took it and read.

> "God that am I,
> I that am God,
> Mass and Motion and Psyche
> Inextricably wound!
> We began not; we end not;

> And a sole purpose have we, —
> Intimately to know
> And exalted to taste,
> In wisdom and beauty
> Perpetually heightening,
> The Absolute, Infinite,
> One Substance Who Is!
> In joy to name
> In wisdom to know
> All flames and all fruits
> From that hearth and that tree!
> To name infinite modes,
> Eternally to name,
> To name as we grow,
> And grow as we name.
> And stars shall arise,
> Beyond stars that we see,
> And self-knowledge shall come,
> To me in God, God in me —"

Rachel put it down. "I'll think that out a little. We've never had any one in the house just like you."

"I thought," said Hagar, " that Sunday morning I would go to the Catholic Cathedral. If you tell me the way I can find it —"

"You are not a Catholic?"

"No. But I have always wanted so to smell incense. —

> "'When from the censer clouds of fragrance roll —'"

"You are rich in differences," said Rachel. "I hope we'll get along well together. I think we will. Is there anything else you can think of at the moment?"

"I want to see the Salvation Army."

"That may be managed, if you are willing to take it in detachments."

"And I want — oh, I want to go somewhere where I can really see the ocean!"

"I'll get father to take us down to Brighton Beach. It isn't too late, this mild weather."

"This morning," said Hagar, "we came through — miles, I think — of places where poor people live. I want to see all that again."

"It isn't very edifying. But we can get under the wing of some association and do a little mild slumming."

"I want to go down there alone and often —"

"That," said Rachel, "is impossible."

"Why?"

"It is not done. Besides, it would be dangerous."

"Dangerous?"

"You might take any disease — or get into any kind of trouble. There are all sorts of traps."

"Why should they set traps?"

"Oh, all kinds of horrors happen. — Just look at the newspapers! A girl — alone — you'd be subjected to insult."

Hagar sighed. "I've always been alone. And I don't see that we are not subjected to insult everywhere. I could never feel more insulted than, sometimes, I have been at home."

Rachel, turning in her chair, darted at her a lightning-like glance of comprehension. "Well, that's true enough, though I never heard it put into words before! It's true. . . . But it remains that with our present conventions, you must have company when you go to see how the other half lives."

"The other half?"

"It's a term: One half of us doesn't know how the other half lives."

"I see," said Hagar. "Well, I'll be glad when I get out of fractions."

Both laughed. A kind of soft, friendly brightness prevailed in the third-floor back bedroom. There was no open fire, but they sat on either side of the little squat table, and the reading-lamp with a yellowy globe did the job of a common luminary. The light reached out to each and linked them together. Rachel Bolt was small and dark and slender. Much of the time she passed for a cynical and rather melancholy young woman; then, occasionally, sheaths parted like opening wings and something showed that was vivid and deep and duskily luminous. The next moment the rift might close, but there had been received an impression of the inward depths. She had been married at eighteen, her first child born a year later. She was now twenty-five, and had been a widow for two years. In worldly wisdom and *savoir faire*, and in several emotional experiences she was well ahead of Hagar, but in other respects the brain ways of the younger in years were deeper and older. Whatever differences, their planes were near enough for a comprehension that, continually deepening, passed before long into the country of lasting friendship.

CHAPTER XV

LOOKING FOR THOMASINE

WHEN Hagar had been ten days in New York, she went early one afternoon to find Thomasine. She had the address, and upon showing it to Rachel the latter had pronounced it "poor but respectable," adding, "Are you sure you ought to go alone?"

"'Ought to go alone?—ought to go alone?'—I am so tired of that phrase 'ought to go alone'!" said Hagar. "At Gilead Balm they said, 'Don't go beyond the Mile-and-a-Half Cedar!' You say yourself that I could n't get lost, and I was brought up with Thomasine, and Jim and his wife are perfectly good people."

Downstairs, as she was passing the parlour doors, Mrs. Maine called to her from within. "Where are you going, dear?" Hagar entered and explained. "That is very nice of you to look her up, but do you think you ought to go alone?" Hagar explained that, too; whereupon Mrs Maine patted her hand and told her to trot along, but always to be careful! As the front door closed after her, her hostess resumed her box of chocolates and the baby sacque she was knitting. "It is n't as though I had promised to give her, or to make Rachel give her, continual chaperonage! To look after her in a general way is all that could possibly be expected. Besides, it's foolish always to be nervous about people!" She took a chocolate cream and began the sleeve. "Medway Ashendyne,

with all those millions, is n't doing very much for her. She could n't dress more plainly if she tried. I wonder what he means to do with her eventually. Perhaps he does n't mean anything — just to let things drift...."

Hagar knew how to orientate herself very well. She took the surface car going in the right direction, and when she had travelled some distance she left it and took a cross-town car. This brought her to the block she wished. Out of the jingling car, across a street of push-carts and drays and hurrying, dodging people, she stood upon the broken and littered pavement a moment to look about her. The houses were tall and dreary; once good, a house to a family, but now not so good, and several families to a house. The corners were occupied by larger buildings, unadorned and jerry-built and ugly, each with a high-sounding name, each containing "flats"; — flats and flats and flats, each with its ground floor occupied by small stores — unprosperous greengrocer, unprosperous butcher, poor chemist, prosperous saloon, and what not. It was a grimy, chilly grey afternoon with more than a hint of the approaching winter. All voices seemed raw and all colours cold. Among the children playing on the pavement and in areaways or on high, broken, entrance steps, there sounded more crying than laughing. Dirty papers were blown up and down; there floated an odour of stale beer; an old-clothes man went by, ringing a bell and crying harshly, "Old clothes! Old clothes! Got any rags?" Hagar stood with contracted brows. She shivered a little. "Why, Thomasine should not live in a place like this!" She looked about her. "Who should?" She had a vision of Thomasine playing ring around-a-rosy, Thomasine looking for four-leaved clovers.

But when she climbed to the third floor of one of the corner buildings, and, standing in the perpetual twilight of the landing-way, rang the bell of a door from which much of the paint had been scarred, she found that Thomasine did not live there.

The door was opened by a gaunt, raw-boned woman. "Thomasine Dale? Did she live with Marietta Green and Jim?"

"Yes. She is Jim's niece."

"Well, she don't live here now."

"May I see Jim or his wife?"

"They don't live here neither."

The door across the landing opened, and a stout woman in a checked apron looked out. "Was you looking for the Greens?"

"Yes, please."

"If you'll come in and set a minute, I'll tell you about them. I've got asthmy, and there's an awful draught comes up those steps."

Hagar sat down in an orange plush rocking-chair and the stout woman, having removed her apron, took the green and purple sofa.

"There now! I meant to mend that carpet!" — and she covered the hole with the sole of her shoe. "I am as fond as I can be of the Greens! Jim's a good man, and if Marietta wa'n't so delicate she'd manage better. The children are nice youngsters, too.... Well, I'm sorry they've gone, but Jim hurt his arm down in the Works and Marietta couldn't seem to get strong again after the last baby, and everybody's cutting wages when they ain't turning men off short, and

Jim's turn come, for all he's always been good and sober and a good workman. First the Works hurt his arm, and then it said that he was n't so useful now; and then it said that it had seen for a long time that it would have to economize, and the men could choose between cut wages or no wages at all, and Jim was one of them it said it to. So he had to take the cut." She began to cough and wheeze and then to pant for breath. "Did you — ever have — the asthmy? I'm — going off — with it — some day. Glass of water? Yes — next room — cup by the sink. . . . Thank you — child! You're real helpful. — What was I saying? Oh, yes — 't was Jim and Marietta and the children and Thomasine who had to economize."

"Where are they gone?" asked Hagar sorrowfully.

"It is n't so awful far from here. I'll give you the address. The car at the corner'll take you there pretty quick. But it ain't nowhere near so nice a neighbourhood or a house as this." She regarded her plush furniture and Nottingham curtains with pride. "Thomasine's an awful nice girl."

"Yes," said Hagar. The tears came into her eyes. "I love Thomasine. I ought n't to have waited so long before coming to find her, but I never thought of all this. It never entered my head."

"She's got an awful good place, for a woman — nine dollars a week. She could have kept a room here, but she's awful fond of Jim and Marietta and the children, and she went with them. I reckon she'll help right sharp this winter — 'less 'n the stores take to cutting too."

On the street-car, the new address in her hand, Hagar

considered Poverty. It was there in person to illustrate, in an opposite row of anæmic, anxious faces and forms none too warmly clad; it was there on the street, going up and down; it was there in the houses that were so gaunt, defaced, and ugly. The very November air, cold and querulous, seemed poor. Her mind was sorting and comparing impressions. She had known, when she came to think of it, a good deal of poverty, and a number of poor people. In the first place, she had been brought up on the tradition of the poverty after the war — but that had been heroic, exalted poverty, in which all shared, and where they kept the amenities. Then, when that had passed, there were the steadygoing poor people in the country — those who had always been poor and apparently always would be so. But it did not seem to hurt so in the country, and certainly it was not so ugly. Often it was not ugly at all. Of course, everybody at home, in a cheerful tone of voice, called the Greens poor people. The Greens were poor, — Car'line and Isham were poor; — she remembered, with a curious vividness, the poor woman on the canal boat, the summer her mother died. She had even heard the Colonel say that he — the Colonel — was poor. Of course, she had seen hosts of poor people. And yet until to-day, or rather, to be more precise, until the morning of the ferry and the Elevated, she had never generalized Poverty, never conceived it abstractly. Poverty! What was Poverty? Why was Poverty? Was it a constant; was it going to last? If so, why? If it was n't going to last, what was going to make things better? It was desirable that things should be better — oh, desirable, desirable! The slave of Beauty and the slave of Righteousness in Hagar's soul rose together and looked upon

the dump-heap and the shards that were thrown upon it. "It should n't be. There is no need and no sense—"

Four or five summers past, visiting with Miss Serena some Coltsworth or Ashendyne house in the country, and exploring, as she always did almost at once, the bookcases, she had come upon — tucked away in the extreme shadow of a shadowy shelf — a copy of William Morris's "News From Nowhere." Hagar had long since come to the conviction that her taste was radically different from that of most Coltsworths and Ashendynes. Where they tucked away, she drew forth. She had read "News From Nowhere" upon that visit. But she had read it hurriedly, amid distractions, and she was much younger then than now. It had left with her chiefly an impression of a certain kind of haunting, other-world beauty. She remembered the boy and the girl in the tobacco-shop, playing merchant, and the cherry trees in the streets, and the cottage of Ellen, and Ellen herself, and the Harvest Home. Why it was written or what it was trying to show, she had not felt then with any clearness. Now, somehow, the book came back to her. "That was what 'News from Nowhere' was trying to show. That people might work, work well and enough, and yet there be for all beauty and comfort and leisure and friendliness. . . . I'll see if I can find that book and I'll read it again."

The car stopped at the street-corner indicated. When she was out upon the pavement, and again stood a moment to look about her, she was frightened. This was the region of the fire-escapes, zig-zagging down the faces of the buildings, the ramshackle buildings. It was the region of the black windows, and the women leaning out, and the wan children.

This street was narrower than the other, grimier and more untidy, more crowded, colder, and the voice of it never died. It rose to a clamour, it sank to a murmur, but it never vanished. Usually it kept a strident midway, idle and fretful as the interminable blown litter of the street. Hagar drew a pained breath. "Thomasine's got no business living here — nor Jim and Marietta and the children either!"

But it seemed, when she mounted a dirty, narrow stair and made enquiries of a person she met atop, — it seemed that they did n't live there. "They moved out a week ago. The man was in some damned Works or other, and it threw him on the scrap-heap with about a thousand more. Then the place where the girl worked thought scrap-heaps were so pretty that it started one, too. Then he heard a report of work to be had over in New Jersey — as if, if this is the frying-pan, that ain't the fire! — and so they left this state. No; they did n't leave any address. Working people's address this year is 'Tramping It. Care of the Unemployed.' Sometimes, it's just plain 'Gone Under.'"

The man looked at Hagar, and Hagar looked at the man. She thought that he had the angriest, gloomiest eyes she had ever seen, and yet they were not wicked eyes. They blazed out of the dark entryway at her, but for all their coal-like glowing they were what she denominated far-away-seeing eyes. They seemed to look through her at something big and black beyond. "Have you seen the evening paper?" he asked abruptly.

"No, I have not. Why?"

"I wanted to see.... This morning's had an account of three Anarchist bits-of-business. A bomb in Barcelona, a

bomb in Milan, and a bomb in Paris. — No, I can't tell you anything more about your friends. Yes, I'm sorry. It's a hard world. But there's a better time coming."

Grieving and bewildered, she came out upon the pavement. Why had n't Thomasine — why had n't Jim let them know? If there was n't anything at home for Jim to do, — and she agreed that there was n't — nor for Thomasine, still they could all have stayed there and waited for a while until Jim's arm and hard times got better. She tried to put them all — there were six — in the overseer's house with Mrs. Green. It would be crowded, but... The overseer's house was her grandfather's; Mrs. Green had had it, rent free, since William Green's death, and most of her cornmeal and flour came from the Colonel's hand. Hagar tried to say to herself that her grandfather would be glad to see Jim and Marietta and Thomasine and the three children there staying with Mrs. Green as long as was necessary; that if it were crowded in the overseer's house her grandmother would be glad to have Thomasine and perhaps one of the children stay in the big house. It would not work. It came to her too, that perhaps Jim and Marietta and Thomasine might not be so fond of coming and sitting down on Mrs. Green and saying, "We've failed." But could n't they work in the country? Jim was a mechanic; he did n't know anything about farming — and the farmers were having a hard time, too. Hagar's head began to ache. Then the travelling expenses — she tried to count those up. If they could n't pay the rent, how could they pay for six to go down to Virginia — and the children's clothes, and the food and everything?... Was there no one who could send them money? Mrs. Green could n't, she

knew — and Thomasine's mother and father were very poor, and Corker was n't doing well, and Maggie was at home nursing their mother whose spine was bad. . . . Gilead Balm had a kindly feeling for the Greens, she knew that. William Green had been a good overseer, and he had fought in the regiment the Colonel led. Her grandfather — if he knew how bad it was, if he could see these places where they had been living, if he could have heard the woman in the check apron and the man with the eyes — he might send Jim twenty-five dollars, he might even send him fifty dollars, though she doubted if he could do that much. She herself had twenty dollars left of that August two hundred. She had been saving it for Christmas presents for Gilead Balm, but now she was going to send it to Thomasine — just as soon as she knew where to send it. She walked on for a little way in a hopeful glow, and then the bottom dropped out of that, too. It would n't go far or do much. It was too small a cloth to wrap a giant in. Jim and Thomasine's unemployment — Jim's injured arm, hurt in the Works, Marietta weak and worn, trying to care for a little baby. . . . Other Mariettas, Jims, Thomasines, thousands and thousands of them. . . . They were willing and wanting to work. They were not lazy. Jim had n't injured his own arm. Apparently there had to be babies. . . . Unemployment, and no one to help when help was needed. . . . It needed a giant. "All of us together could do it — all of us together."

She was cold, even under her warm jacket and with her thick gloves. The street looked horribly cold, but she did not notice many jackets, and no gloves. With all her beauty-loving nature she hated the squalid; nothing so depressed

her. She had not seen it before so verily itself; in the country it was apt to have a draping and setting of beauty; even a pigpen might be environed by blossoming fruit trees. Here squalor environed squalor, ugliness ugliness. On a step before her sat a forlorn little girl of eight or nine, taking care of a large baby wrapped in a shawl. Hagar stopped and spoke.

"Are you cold?" The child shook her head. "Are you hungry?" She shook it still; then suddenly broke forth volubly in a strange tongue. She was telling her something, but what could not be made out. The door behind opened, and Elizabeth Eden came forth. She spoke to the child kindly, in her own language, with a caressing touch upon the shoulder. The little girl nodded, gathered up the baby, and went into the house.

"Miss Eden —"

Elizabeth turned. "What — Why, Miss Ashendyne! Did you drop out of the sky? What on earth are you doing in Omega Street?"

"I came down here to find some people whom I know. I am visiting in New York. Oh, I *am* glad to see you!"

"We can't stand here. The Settlement is just two blocks away. Can't you come with me and have a cup of tea? Where are you staying?"

Hagar told her, adding, "I must be back before dark or they won't let me come out again by myself."

"It is n't quite four. I'll put you on the Elevated in plenty of time. — What people were you looking for?"

Hagar told her as they walked. Elizabeth listened, knew nothing of them, but said gravely that it was a common lot nowadays. "I have seen many hard winters, but this pro-

mises to be one of the worst." She advised writing guardedly to Mrs. Green, until she found out how Thomasine and Jim wrote themselves. "They may not be telling her how bad it is, and if she cannot help, it is right that they should n't. I believe, too, in being hopeful. If they're sturdy, intelligent people, they 'll weather the gale somehow, barring accidents. It's the miserable accidents — the strained arm, your Marietta's illness after the baby — things like that that tip the scales against them. Well, cheer up, child! You may hear that they 've got work and are happy. — This is the Settlement."

Three old residences, stranded long years ago when "fashionable society" moved away, first street by street and at last mile by mile, formed the Settlement. Made one building by archways cut through, grave and plain, with a dignity of good woodwork and polished brass and fit furniture sparely placed, the house had the poise and force of a galleon caught and held intact in the arms of some sargasso sea. All around it were wrecks of many natures, strangled, pinned down, and disintegrating, but it had not disintegrated. One use and custom had left it, but another had passed in with a nobler plan.

Hagar Ashendyne went through the place, wondering, saw the workrooms, the classrooms, the assembly-room, the dwelling-rooms, austere, with a quiet goodness and fairness, of the people who dwelled there and made the heart of the place. "It is not like a convent," she said in a low voice; "at least, I imagine it is not — and yet—"

"Oh, the two ideas have a point of contact!" answered Elizabeth cheerfully. "Only, here, the emphasis is laid on action."

She met several people whom she thought she would like to meet again, and at the last minute came in Marie Caton. It was Marie, who, at five o'clock, put her on the Elevated that would take her home in twenty minutes. Marie had met the Maines — "I'm Southern, too, you know," — and she promised to come to see Hagar, and she said that Hagar and Rachel Bolt must come, some Sunday afternoon, to the Settlement. "That is chiefly when we see our personal friends."

That night Hagar wrote to her grandmother and to Mrs. Green. In four days time she heard from the latter. Yes, Jim and all of them and Thomasine had moved to New Jersey. Times were hard, Jim said, and work was slack, and they thought they could better themselves. Sure enough he had got a right good job. They were living where it was n't so crowded as it was in New York, almost in the country, right by a big mill. There was a row of houses, just alike, Thomasine said, and they were living in one of them. There was n't any yard, but you could walk into the country and see the woods, and Thomasine said the sky was wonderful at night, all red from a furnace. Thomasine had n't got work yet, but she thought that she would. There was a place where they made silk into ribbons, and she thought there'd be a place for her there. Marietta was better, and the children were fine. Mrs. Green sent the address — and Gilead Balm certainly missed Hagar.

Old Miss wrote an explanatory letter. Hagar knew or ought to know that they had little or nothing but the place. The Colonel had been in debt, but Medway had cleared that off, as it was right that he should, now that he was able to do it; right and kind. But as for ready money — country people

never had any ready money, she knew that perfectly well. Medway was now, Old Miss supposed, a rich man, but no one knew exactly how rich, and at any rate it was his money, and living abroad as he did was, of course, expensive. He could n't justly be expected to do much more than he was doing. "As for your having money to give the Greens, you have n't any, child! Medway has told your grandfather that he wants you from now on to have every proper advantage, but that he does not believe in the way young people to-day squander money, nor does he want you to depart from what you have been taught at Gilead Balm. He wants you to remain modest in your wants, as every woman should be. The money he has put in your grandfather's hands for you this year is to pay for this winter in New York and for wherever you go next summer. He never meant it to be diverted to helping people without any claim upon him that are out of employment. Your grandfather won't hear to any such thing as you propose. He says your idea of coming home and using the money you are costing in New York is preposterous. The money is n't your money; it's your father's money, to be used as he, and not as you, direct. . . . Of course, it's a hard year, and of course, there are people suffering. There always are. But Jim's a man and can get work, and Thomasine ought n't to have gone away from home anyhow. They are n't starving, child." — So Old Miss, and more to the same effect, and then, at the end, a postscript. "I had a ten-dollar gold-piece that's been lying by me a long time, and I've taken it to Mary Green and told her to send it to Jim. She seemed surprised, and from what she says and what his letter says, I don't think they are any worse off

than most people. You're young, and your feelings run away with you."

Hagar wrote a long, loving letter to Thomasine, and sent her the twenty dollars. Thomasine returned her effusive, pretty thanks, showed that she was glad, and glad enough to have the help, but insisted that she should regard it as a loan. She acknowledged that Jim and she, and therefore Marietta and the babies, had been pretty hard up. But things were better, she hopefully said. She had a place and Jim had a place. His arm was about well, and on the whole, they liked New Jersey, "though it isn't as interesting, of course, as New York."

CHAPTER XVI

THE MAINES

It was the year of the assassination of Sadi Carnot in France, of the trial of Emma Goldman in New York, of much "Hellish Anarchist Activity." It was a year of growth in the American Federation of Labour. It was a year of Socialist growth. It was a year of strikes — mine strikes, railway strikes, other strikes, Lehigh and Pullman and Cripple Creek. It was the year of the Army of Coxey. It was the year of the Unemployed and of Relief Agencies. It was the year when the phrase "A living wage" received currency.

In the winter of 1894 the Spanish War had not been, the Boer War had not been, the Russo-Japanese War had not been. The war between Japan and China was on the eve of being; people talked of Matabeleland, and Cecil Rhodes was chief in South Africa. Hawaii was in process of being annexed. In the winter of 1894 it was the Wilson Tariff Bill, and Bimetallism, and Mr. Gladstone and Home Rule, and the Mafia in Sicily, and the A.P.A., and the Bicycle, and Queen Liliuokalani, and the Causes of Strikes and of Panics, and Electric Traction, and the romances of Sienkiewicz and "Tess of the D'Urbervilles" and "The Prisoner of Zenda" and "The Heavenly Twins." Mr. Howells was writing "Letters of an Altrurian Traveller"; George Meredith had published "Lord Ormont and his Aminta." Stevenson, at Vailima, was considering "Weir of Hermiston."

THE MAINES

In 1894 occurred the first voting of women in New Zealand. It saw the opening of a Woman's Congress in Berlin. In New York a Woman Suffrage Amendment was strongly advocated before a Constitutional Convention. There was more talk than usual of the Unrest among Women, more editorials than usual upon the phenomenon, more magazine articles. But the bulk of the talk and the editorials and the magazine articles had to do with the business failures and the Unemployed and the Strikes.

The beating of the waves of the year was not loudly heard in the Maines' long, high-ceilinged parlour. The law droned on, bad years with good. Powhatan had speculated and made his little losses. His philosophy this winter was pessimistic, and the household "economized." But the table was still good and plentiful, and the coloured servants, who were fond of him and he of them, smiled and bobbed, and he had not felt it necessary to change his brand of cigars, and the same old people came in the evening. Mrs. Maine never read the newspapers. She rarely read anything, though once in a while she took up an old favourite of her youth, and placidly dipped now into it and now into her box of chocolates. Powhatan kept her supplied with the chocolates. Twice a week, when he came in at five o'clock, he produced out of his overcoat pocket a glazed, white, two-pound box:—
"Chocolates, Bessie! Catch!"

Rachel Bolt was more alert to the world surge, but to her, too, it must come a little muted through the family atmosphere. Her swiftest vibrations were upon other lines, curious inner, personal revolts and rebellions, sometimes consumed below the crust, sometimes breaking forth with a flare and

rain of words as of lava. The family and the people who habitually came to the house were used to Rachel's way of talking; as long as she did nothing *outré*, — and she did not, — it was no more to them than a painted volcano. As for Sylvie — Sylvie was as sweet and likeable as sugar, but not interested in anything outside of the porcelain world-dish that held her. She liked her clothes this winter, and the young men who came to the house, and she dutifully practised her voice, and enjoyed the shops and the plays, and wondered a good deal if she was or was not in love with Jack Carter, who was an interne in one of the hospitals, and who sent her every week six of the new roses called American Beauties. She had other, more distant relatives in New York, people of wealth who presently took her up. She was with them and away from the Maines a good deal, and, on the whole, Hagar saw not much of Sylvie this winter. She and Rachel were more together.

Almost every evening, at the Maines', people came in — old Southern friends, living in New York, or here on business or other occasions, young men and women, fond of Rachel, acceptable fellow-sheep from the fold of St. Timothy, now and then the rector himself, now and then some young man, Southern, with a letter of introduction. Sometimes there were but one or two besides the family, sometimes seven or eight. There was little or no formal entertainment, but this kind of thing always. Each day at dusk Hagar put on one of the two half-festive gowns which, at the last moment, Miss Serena had insisted she must have. Both were simplicity itself, both of some soft, crêpy stuff, one dark bronze and one dark green. They were made with the large puffed sleeves

of the period, and the throat slightly low and square. "Country-made, but somehow just right," Rachel judged. "You are n't any more adorned than the leaf of a tree, and yet you might walk, just as you are, into Cæsar's palace."

Usually by half-past ten visitors were gone, lights downstairs were out. Powhatan and Bessie believed in early to bed and late to rise. Upstairs, in her bedroom on the third floor, Hagar shook out and hung in the closet the bronze or green dress, as the case might be, put on her gown and her red wrapper, braided her hair, pushed the couch well beneath the light, curled herself up on it under the eider-down quilt, and, tablet against knee, began to write.... The Short Story — it was that she dreamed and wrote and polished. Two currents of thought and aspiration ran side by side. "To earn money — to make my own living — to be able to help"; and "To make this Idea, that I think is beautiful, come forth and grow. — To get this thing right — to make this dream show clear — to do it, to do it! — To create!" The latter current was the most powerful. The former would sooner or later accomplish its end; it would turn the millwheel and be content. But the latter — never, never would it be satisfied; never would it say, "It is accomplished." Always there would be the further dream, always the necessity to make that, too, come clear. There were other currents, more or less strong, Desire of Fame, Desire to be Known, Desire to Excel, and others; but the first two were the great currents.

Since March and the fairy story she had written other stories, four or five in all. She had sent them to magazines, and all but one had come back. That one she had sent

immediately after her search for Thomasine. In a month she had word that it was taken, and that, on publication, she would be paid fifty dollars. The letter was like manna, she went about all day with a rapt face. To write — to write — to write stories like Hawthorne, like Poe...

She had been six weeks in New York. That night, when she had worked for an hour over one half-page, and then, the light out, had sat for a long while in the window looking at the winter stars above the city roofs, she could not sleep when she went to bed, but lay, straight and still, half-thinking, half-dreaming. A pageant of impressions, waves of repeated, altered, rearranged contacts drove through her mind. The pictures and marbles of the Metropolitan, the sculptures and casts of sculptures which she cared for more than for the paintings, those of the latter which she loved — the music that she had heard, the plays she had seen, the Park and the slow, interminable afternoon parade of carriages watched from a bench beneath the trees, Fifth Avenue, Broadway, the hurrying crowds, the rush and roar, tramp and clangour, the colour and bravura — Omega Street, the Settlement, a Sunday afternoon there, discussions to which she had listened, a mass meeting of strikers which, Powhatan having taken her downtown to show her the Stock Exchange and Trinity, they had inadvertently fringed, and from which, with epithets of disapproval, he had hurried her away; — uptown once more and the florists' windows and the wheels on the asphalt, a Sunday morning at St. Timothy's with the stained glass and the Bishop's nephew intoning; — again the theatres, a Gilbert and Sullivan opera, the "Merchant of Venice," a play of Pinero's; again the pictures and the statues, the cast

of the great Venus, the cast of Niobe, of the Diana with the hound, of Apollo and Hermes; the pictures, Rembrandts and Vandykes, and certain landscapes, and a form that she liked, firelit and vague, blind Nydia moving through ruining Pompeii, and Bastien LePage's Joan of Arc; then the Park again, and the great trees above the mall, and people, people, people! — all made a vibrating whirl, vast, many-hued, and with strange harmonies. She lay until it passed and sank like the multi-coloured sand of the desert.

When at last she slept, she had a curious dream. She and her mother were alone on an island with palm trees. She was used to being with her mother in dreams. She had for the memory of her mother so passionate a loyalty; the figure of Maria, young, it always seemed to her, as herself, so kept abreast with her inner life that it was but a naturalness that she should be there in the dream mind, too. She was there now, on the island with the palm trees, and the two sat and looked at the sea, which was very blue. Then, right out of the lonely sea, there grew a crowded wharf, with a white steamship and people going to it and coming from it. Her father came from it, dressed in white with a white hat like a helmet, and then suddenly there was no wharf nor ship, but they were in a curious street of low, pale-coloured houses — her father and her mother and herself and the palm trees. "Now we are all going to be happy together," she said; but "No," said her mother, "wait until the procession passes." Then there was a procession, and they were all women, and at first they all had the face and eyes of Bastien LePage's Joan of Arc, but then that faded, and they were simply many women, but each of them carried a blossoming bough. She

saw faces that she knew among them, and she saw women that she thought belonged to the Middle Ages, and Greek women, and Egyptians, and savages. They went by for a long time, and then, with a turn of the hand, the dream changed, and they were all in a courtyard with a well and more palm trees, and people coming and going, and they were eating and drinking, and there was a third woman with them whom her father called Anna. She had a string of jewels, and she tried them, first on Hagar and then on Maria; but Maria had a knife and suddenly she struck at her father with it. She cut him across both wrists and the blood flowed. — Hagar wakened and sat up in bed, shivering. Her father's face was still plain against her eyeballs — bearded and handsome, with red in his cheeks and the hat like a helmet.

During Christmas week Ralph Coltsworth appeared. He had to spend his holidays somewhere, he said. Hawk Nest was dull and he did n't like Gilead Balm without Hagar.

"Ralph, why don't you study?"

"I do study. I'm a star student. Only I don't like the law. I'm going to do a little more convincing myself and the family, and then I'm going to chuck it! I've got a little money to start things with. I want to go in with a broker I know."

"What do you want to do that for?"

"Oh, because! . . . There are chances, if you've got the feeling in your finger tips! . . . Don't you know, Gipsy, that something like that is the career for a man like me? If I had been my father, I could have waved my sword and gone charging down history — and if I'd been my grandfather, I could

have poured out Whig eloquence from every stump in the country and looked Olympian and been carried in procession (I don't like politics now; it's an entirely different thing); — and if I'd been my great-grandfather, I could have filibustered or settled the Southwest; and back of that I could have done almost any old thing — come over with the Adventurers, seized a continent, shared England with the Normans, marauded with the Vikings, whiled through Europe with Attila, done almost anything and come out with a name and my arms full! Now you can't conquer things like that, but, by George, you can corner things!"

"What do you mean ? — That you want to become a rich man?"

"That's what most of those others wanted. Yes, riches and power."

"I was reading the other day a magazine article. It said that the day when any American, if he had energy and ambition, might hope to make a great fortune was past. It said that the Capets and Plantagenets and Hapsburgs were all here; that the dynasties were established and the *entente cordiale* in operation; that young and adventurous Amercans might hope to become captains of mercenaries, or they might go in for being court chaplains, and troubadours."

"Oh, that article had dyspepsia!" said Ralph. "It is n't as easy as it was, that's certain! but it's possible yet, in 1894 — if you've got an opening."

"Have you got one?"

"Elder and Marten would take me in. Marten was an old flame of my mother's, and I got his son Dick out of a scrape

last year. — In ten years, you'll see, Gipsy! I'll send you orchids and pearls!"

"I don't want them, thank you, Ralph."

Ralph took the flower from his buttonhole and began to pluck away its petals. "Gipsy, I was awfully glad, last summer, when you sent that Eglantine fellow about his business."

"Mr. Laydon and I sent each other."

"Well, the road's clear — that's all I want to know! Gipsy —"

"Ralph, it's no use. I'm not going to listen."

"The family has planned this ever since we were infants. When you used to come to Hawk Nest with your big eyes and your blue gingham dress and your white stockings — I knew it somehow even then, even when I teased you so —"

"You certainly teased me. Do you remember the rain barrel?"

"No, I don't. The family has set its heart —"

"Oh, Ralph, family can be such a tyrant! At any rate, ours will have to take its heart off this."

Ralph turned sullen. "Well, the family used to settle it for women."

"Yes, it did — when you came over with William the Conqueror! Do you want to *take* me, regardless — just as you'd take those millions? Well, you may take those millions, but you can't take me!"

"Your father wants it, too. The Colonel showed me a letter —"

Hagar stopped short — they were walking in the Park,

"My father! . . . Do you think I owe my father so great a love and obedience?" She looked before her, steadily, down the vista of vast, leafless trees. "The strongest feeling," she said, "that I have about my father is one of strong curiosity."

CHAPTER XVII

THE SOCIALIST MEETING

THE house was full, said the man at the ticket-window. Nothing to be had, short of almost the back row, under the gallery. Rachel shook her head, and her cousin, Willy Maine, leaving the window, expressed his indignation. "You ought to have told me this afternoon that you wanted to go! Anybody might have known"— Willy was from one of the sleepier villages in one of the sleepiest counties of his native state—"Anybody might have known that in New York you have to get your tickets early! Now we've missed the show!" By now they were out of the swinging doors and down upon the pavement. The night was bright and not especially cold. It was the Lyceum Theatre, and they stood at the intersection of Fourth Avenue and Twenty-third Street.

"It's too late to try anything else," pondered Rachel. "Willy, I'm sorry. But we truly did n't know we could go until the last minute, and I did n't believe it would be crowded."

"It's a beautiful night," said Hagar. "It's light and bright, and there are crowds of people. Why can't we just walk about until bedtime?"

Willy, who was nineteen but a young giant, pursed his lips. "Is it proper for ladies?"

"Oh, I think so," said Rachel absently, "but would it really amuse you, Hagar?"

"Yes, it would. Let us go slowly, Rachel, and look in windows and pretend to be purchasing."

Willy laughed, genially and patronizingly. "I've been along here. There are n't any Paris fashions in these windows."

"I want," said Hagar succinctly, "to saunter through the streets of a great city."

They began to walk, their faces turned downtown, staying chiefly upon the avenue, but now and then diverging into side streets where there were lights and people. By degrees they came into congested, poorer quarters. To Willy, not long removed from a loneliness of tidal creeks, vast stretches of tobacco, slow, solitary sandy roads, all and any of New York was exciting, all a show, a stimulus swallowed without discrimination. That day Rachel had found occasion to rage against a certain closed circle of conventions. The subject had come up at the breakfast table, introduced by a headline in the morning paper, and she had so shocked her family that for once they had acted as though the volcano was real. Mrs. Maine had grown moist and pink, and had said precipitately that in her time a young woman — whether she were married or single, that did n't matter! — would as soon have thought of putting her hand in the fire as of mentioning such things! And Powhatan had as nearly thundered as was in his nature to do. Rachel shrugged her shoulders and desisted, but she had gone about all day with defiance written in her small, sombre face. Now to-night, the street, the broad stripes of blackness, the thin stripes of gold light, the sound of voices and of many footfalls, the faces when the light fell upon them and the brushing by of half-seen forms suited her

raised, angry, and mutinous mood. As for Hagar, the street and its movement simply became herself. She never lost the child's and the poet's power of coalescence.

It was before the days of Waring. The only White Wings upon this avenue had been the snowflakes which a week ago had fallen thickly, which had been dully scraped over the curbing into the gutter, and which now stayed there in irregular, one to three feet in altitude, begrimed Alpine ranges. The cobblestones of the street between, over which the great dray horses ceaselessly passed, were foul enough, while the sidewalks had their own litter of torn scraps of paper, cheap cigar ends, infinitesimal bits of refuse. The day of the weirdness of electric lighting, of the bizarre come-and-go of motion signs was not yet either. Down here there were occasional arc lights, but gas yet reigned in chief. The shops, that were not shops for millionaires, nor even for the Quite Comfortable, all had their winking gaslights. Below them like chequered walls sprang out the variegated show-windows. The wares displayed were usually small in size, slight of value, and high in colour, a kaleidoscopic barbaric display. Above dark doorways the frequent three golden balls showed up well.

Because the night was so mild and windless many people were abroad — people not well-dressed, and yet not quite poverty-stricken in aspect; others who were so, lounging men with hopeless faces, women wandering by, pinched and lost-looking; then again groups or individuals of a fairly prosperous appearance. The flaring gas showed now and again faces that were evidently alien, or there came a snatch of strange jargon. A crowd had gathered at a street corner. A girl

wearing a dark-blue poke bonnet with a red ribbon across it was going from one to the other holding out a tambourine. A few pennies clinked into it. A man standing in the centre of the crowd, raised his arm. "Now, we are going to sing." The women in the bonnets beat upon the tambourines, a man with a drum and another with a cornet gave the opening bars, the women raised shrill, sweet voices, —

> "There is a fountain filled with blood,
> Drawn from Immanuel's veins,
> And sinners, plunged beneath that flood,
> Lose all their guilty stains —"

The hymn ended, a woman lifted both hands and prayed with fervour and a strange, natural eloquence. Then the squad gathered up horn and drum and tambourines, and, drawing a part of the crowd with it, moved up the street to another skirmish ground.

Rachel and Willy and Hagar drifted on. The night was still young, the stars glittering above, the gaslamps making a vista, the footfalls on the pavement murmurous as a stream. The clanging of the street-car bell, the rush of a train on the neighbouring Elevated, the abrupt rise and fall of passing voices — all exercised a fascination. The night was coloured, rhythmic. They came to a building, narrow and plain, with lit windows, as of a hall, on the second floor, and with a clean, fairly lighted stair going up from an open street door. Men and women were entering. A care-worn, stooping, workman-looking man stood by the door with handbills or leaflets which he was giving out. "Socialist Meeting," he said. "Good speaking. The Unemployed and the Strikes. Socialist Meeting. Everybody welcome.

Hagar stopped. "Rachel, I want to go in here. Yes, I do! Come now, be good to me, Rachel! Mr. Maine wants to go, too."

"Socialists!" said Willy. "Those are the people who are blowing up everybody with bombs. I did n't suppose New York would let them hold a meeting! They 're devils!"

But Willy had so well-grown a human curiosity that he was not averse to a glimpse of devils. Perhaps he heard himself, back home in the sleepy county, talking at the village post-office or in the churchyard before church. "Yes, and where else do you think I went? I went to a Socialist Meeting! Bomb-throwers — Socialists and Anarchists, you know!" Rachel, hardly more informed, was ready to-night for anything a little desperate. She would not have taken Hagar where she positively thought she ought not to go, — but if these were desperate people going in, they were, to say the least, pretty quiet and orderly and decent-looking; — and it could do no harm just to slip in and sit on a back seat for a few minutes and look on — just as you might go to mass in a cathedral abroad, disapproving all the time, of course. But Hagar had a book or two in her mind, and in addition the talk that Sunday afternoon at the Settlement.

When they had climbed the stairs and come into the hall, which was a small one, they found that the back seats were all taken. Apparently all seats were taken, but as they stood hesitating, a young man beckoned, and before they knew it they found themselves well down the place, seated near the platform. Rachel looked around a little uneasily. "Crowded, and they all look so intent! It's not going to be easy to get up and leave."

THE SOCIALIST MEETING

The hall was rude enough, and small, the light not brilliant, the platform a few bare boards. Upon it stood a deal table, and three or four chairs. Back of these, fastened against the wall, was a red flag, and on either side of this a strip of canvas with large letters. On one side, UNIVERSAL BROTHERHOOD, and on the other, WORKINGMEN, UNITE! Now standing beside the table, and slowly walking from end to end of the platform, a dark-eyed, well-knit man was speaking, quite conversationally, with a direct appeal, now to this quarter of the hall, now to that. His voice was deep and mellow; he spoke without denunciations, with a quiet reasonableness and conviction. At the moment he was stating a theory, giving the data upon which it was based, weighing it, comparing it with its counter theory. He used phrases — "Economic Determinism" — "Unearned Increment" — "Class-Consciousness" — "Problem of Distribution" — explained clearly what he meant by them, then put them aside. "They are phrases that will serve their ends and pass from speech," he said. "We shall bring in modifiers, we shall make other phrases, and they, too, in their turn, will pass from the tongues of men; but the idea behind them — the idea — the idea and its expression, the intellectual and moral sanction, the thing that is metaphysical and immortal, that will not pass! The very word Socialism may pass, but Socialism itself will be in the blood and bone and marrow of the world that is to be! And this is what is that Socialism." He began to speak in aphorisms, in words from old Wisdom-Religions, and then, for all they were stories of quite modern happenings, in parables — the woe of the world epitomized, a generalization of its needs,

all lines of help synthesized into a world saviour, which, lo! was the world itself. He made an end, stood a moment with kindling eyes, then sat down. After an appreciable silence there came a strange, deep applause, men and women striking fist on palm, striking the bare floor with ill-shod feet.

A small, wiry dark man, sitting on the platform, rose and spoke rapidly for twenty minutes. He had a caustic wit and the power of invective which, if possessed by the other, had not been displayed. Once or twice he evoked a roar of angry laughter. When he had finished, and the applause had subsided, the chairman of the evening stood up and spoke. "As the comrades know, it is our habit to turn the last half-hour into an open meeting. Nearly always there's somebody who's been thinking and studying and wants to say a word as to what he's found — or there's somebody who's got a bit of personal experience that he thinks might help a comrade who's struggling, maybe, through a like pit. Anybody that feels like speaking out, let him do it — or let her do it. Men and women, we're all comrades — and though Socialists are said not to be religious, we're all religious enough to like a good experience meeting —"

He paused, waiting for some one to rise. The first speaker came for a moment to his side. "Mr. Chairman, may I say one word to our comrades, and to any others who may be here? It is this. If 'religious' means world-service and a recognition and a striving toward the ultimate divine in my neighbour as in myself, and in myself as in my neighbour — then I think Socialism may be called religious."

As he moved back to his chair a man arose in the back of

the house and began to speak. After a moment the chairman halted him with a gesture. "It is difficult for the comrades on this side the hall to hear you. Won't you come to the platform?" The man hesitated, then nodded his head; and with a certain deliberateness moved down the aisle, and stepping upon the only slightly raised platform stood facing the gathering. A colour flared in his cheek, and his hands, held somewhat stiffly at his sides, opened and shut. It was evident that he was not an accustomed speaker, and that there was diffidence or doubt of himself and his welcome to be overcome. He began stammering, with nervous hesitation. If anything he *could* say would help by one filing he would say it, though he was n't used — yet — to speaking. He owed a debt and he believed in paying debts — though not the way the world made you pay them.

It was hard to tell how young or old he was. At times he looked boyish; then, when a certain haggard, brooding aspect came upon him, he seemed a middle-aged man. His clothes were poor, but whole and clean, his shirt a grey flannel one. Above the loose collar showed a short, dark beard, well-cut features, and deep-set dark eyes.

Lines came into Hagar's forehead between her eyes. She had seen this man somewhere. Where? She had a trick of holding her mind passive, when the wanted memory would slowly rise, like water from a deep, deep well. Now, after a minute or two, it came. She had seen him in the street-car that night, going from Eglantine to see "Romeo and Juliet." He had been in workman's clothes, he had touched her skirt, standing before her in the car; then he had found a seat, and she had watched him unfold and read a newspaper. Some

vague, uncertain thought that she could not trace had made her regard him at intervals until with Miss Bedford and Lily and Laydon she had left the car. . . .

The man on the platform had shaken off the initial clumsiness of speech and bearing. Like a swimmer, he had needled the wave. He was not clumsy now; he was speaking with short, stripped words, nakedly, with earnestness at white heat. Once he had been dumb and angry, he said, as a maddened dog. He had been through years that had made him so. He had been growing like a wolf. There were times when he wanted to take hold of the world's throat and tear it out. "Do you remember Ishmael in the Bible? — his hand against every man and every man's hand against him? Well, I was growing to feel that way." Then at that point — "and that was perhaps three years ago, and I was down South in a town in my state, trying to get work. I knew how to break rock, and I knew how to make parts of shoes, and I did n't know much besides, except that it was a hard world and I hated it" — at this point chance "or something" had sent him an acquaintance, an educated man, a bookkeeper in the concern where he finally got a job. Out of the acquaintanceship had grown a friendship. "After a while I got to going to his house. He had a wife who helped him lots." The three used to talk together, and the man lent him books and made him read them, and "little by little, he led me on. He was like an old man I knew in the mountains when I was a boy. He showed me that we're all sick and sorry, but that we're growing a principle of health. He showed me how slow we creep up from worm to man, and how now we're fluttering toward something farther on, and how hands of the past

come upon us, and how we yet escape — and the wings strengthen. He showed me how vindictiveness is no use, and how much that is wrong with the world is owing to poor social mechanism and can be changed. He showed me what Brotherliness means, on the road to Unity. He put it in my mind and heart to want to help. He told me I had a good mind. I had always rather liked books, but I'd been where I could n't get any, even if they'd given you time for reading. He made me study things out, and one day I began to think — think for myself — think it out. I've never stopped. Usually now, I'm at night-school nights. I'm learning, and I'm going to keep on, until I make thinking Wisdom." He studied the ceiling a moment, then spoke out with a ring in his voice. "I was a mountain boy. When I was n't out of my teens I got drunk at a dance and played hell-fool and almost killed a man or two. Then the sheriff chased me up to Catamount Gap, and the stuff was still in me and my head hitting the stars, and I shot and shot at the sheriff.... Well, the end of all that playing was that I went to the penitentiary for four years. One thing I want wisdom for is to know how to talk to people about what is called crime and about that great crime, our law courts and penal system. Well, I came out of the penitentiary, and then it was very hard to get work. It was bitter hard. That's another thing I want learning and wisdom for — to talk about that. You see, the penitentiary was n't content with the four years; it followed me always. And then it's hard to get work anyhow. There was n't any use in going back to the mountains. But after a while I got work and kept it. Then, three months ago, I came up here, and I got work here. I'm working on your streets now, and

studying between times.... I'm standing up here to-night to tell you that you've got a flag that draws the unhappy to you, when it happens that they're seeking with the mind. I don't know much about class-consciousness. We did n't have it in the mountains, though, of course, we had it in the penitentiary. But I know that we've got to take the best that was in the past and leave the worst, and go on with the best toward new things. We've got to help others and help ourselves. And it does n't do just to want to help; you've got to have a working theory; you've got to use your mind. You 've got to consider your line of march and mark it out and blast away the rock upon it and go on. And I am willing to be of your construction gang. The man I was talking about thought pretty much that way, too. He said there were a lot of isolated people, here, there, and everywhere, not only those that call themselves working-people, but others, too, and women just as well as men, who were thinking that way — that they might not call themselves Socialists, but that they were blood kin just the same. I don't know why, to-night, but I am thinking of something that happened when I had been a year in the penitentiary, and they had rented a lot of us up the river to make the bed for a railroad. While I was up there, I could n't stand it any longer, and I ran away. They set the dogs on my track and took me, of course, but before they did, I was lying in a thicket, and I had n't had anything to eat for two days and a night. A little girl, about twelve years old, I reckon, came over a hill and down to the stream by the thicket. She gathered flowers and set them around a big rock for a flower doll tea-party. She had two little apple pies and she put those in the middle — and

then she saw me, lying in the thicket. And I was wearing" — the colour flared into his face, then ebbed — "I was wearing stripes.... I don't think she ever thought of being frightened. She gave me both pies, and she sat and talked to me like a friendly human being. I've never forgotten. And when the dogs came, as they did pretty soon, and the men behind them, she lay on the grass and cried and cried as if her heart would break. I've never forgotten. That's what I mean. I don't care what we've done, if we're not fiends incarnate, and very few of us are, we've got to feel toward one another like that. We've got to feel, 'if you are struck, I am struck. If you are wearing stripes, I am wearing stripes.' We've got to feel something more than Brotherhood. We've got to feel identity. And as a part, anyway, of that road seems to me to be named Socialization, I'm willing to be called a Socialist."

He nodded to the audience, and, stepping from the platform, amid a clapping of hands and stamping of feet, did not return to his place in the back of the hall, but sat upon the edge of the stage, his hands clasped around his knee. A German clockmaker and a fiery, dark woman spoke each for a few minutes, and then the meeting ended. There was a noise of rising, of pushing back chairs, a surge of people, in part toward the exit, in part toward the platform. Hagar touched Rachel on the arm. "Wait here for me. I want to speak to that man. — Yes, I know him. Wait here, Rachel."

She made her way to the space before the platform where men and women were pressing about the speakers. The man with the grey flannel shirt was answering a question or two, put by the dark-eyed man who had spoken first. He stood with a certain mountain litheness and lack of tension. A

movement, his answer given, brought him face to face with Hagar. She had taken off her hat, so that it might not trouble the people behind her, and she had it still in her hand. Her dark, soft hair framed her face much as it had done in childhood; she was looking at him with wide, startled eyes.

"I had to come to tell you," she said, "that I am glad you came through. I never forgot you either."

"'Forgot you either!' — " The man stared at her.

"They were apple turnovers," she said; but before she had really spoken there came the flush and light of recognition.

"Oh—h!..." He fell back a step; then, with a reddened cheek and a light in his eyes, put out his hand. She laid hers in it; his fingers closed over hers in a grasp strong enough to give pain.

Then, as their hands dropped, as she fell back a little, the second speaker came between, then others. Suddenly the lights were lowered, people were staying too long. Rachel's hand on Hagar's arm drew her back. "Come, we must go!" Willy, too, was insistent. "It's getting late. Show's over!" The space between her and the boy of the thicket, the figure drawn against the sky of the canal lock, widened, filled with forms in the partial dusk. She was half-drawn, half-pushed by the outgoing stream through the door, out upon the stair, and so down to the street, where now there were fewer lights. The wind had arisen and the air turned colder. "We'll take this cross-town car, and then the Elevated," and while she was still bewildered, they were on the car. The bell clanged, they went on; again, in what seemed the shortest time, they were out in the night, then climbing the long stairs, then through the gate and upon the rushing Elevated. Willy talked

and talked. He was excited. "I thought it was going to be all about bombs! But they talked sense, did n't they?—and there was something in the air that kind of warmed you! Next time I'm in New York I'm going again. Look at the lights streaming off! By Jiminy! New York's great!"

He was not staying at the Maines', but with other kinspeople a few blocks away. He saw the two in at the door, said good-night, and went whistling away. Hagar and Rachel turned off the lowered gas in the hall and went softly upstairs.

As they passed Mrs. Maine's door she asked sleepily from within, "Did you enjoy the play?"

"We did n't go," said Rachel. "We'll tell you about it in the morning."

When the two had said good-night and parted and Hagar, in her own room, kneeling at the window, looked up at the Pleiades, at Aldebaran — only then came the realization that she did not know that man's name, that she had never heard it. In her thoughts he had always been "the boy."

CHAPTER XVIII

A TELEGRAM

THE next day she went down to the Settlement.

Elizabeth was at home. "Yes, I could give you a list of books on Socialism. I read a good deal along those lines myself. I am glad you are interested."

"I am interested," answered Hagar. "I cannot get any of these books now, but I am looking for fifty dollars, and when it comes, I will."

"But I can lend you two or three," said Elizabeth. "Won't you take them — dear Hagar?"

She regarded the younger woman with her steady, friendly eyes, her strong lips just parting in a smile. There was perhaps nine years' difference in their ages, but mentally they came nearer. It was the first time that she had dropped the formal address.

Hagar answered with a warm colour and a tremulous light from brow to chin. "Yes, if you'll be so good — Elizabeth!"

She crossed the floor with the other to the long, low, bookcase. Elizabeth drew out a couple of volumes. "These are good to begin with — and this." She stood a moment in thought, her back to the case, her elbow resting on its polished top and her head upon her hand. On a shelf behind her stood a small bronze Psyche, a photograph of Botticelli's Judith, a drawing of Florence Nightingale. "Hagar," said Elizabeth, "if I give you two or three books upon the

position of woman in the past and to-day, will you read them?"

"I will read anything you give me, Elizabeth."

She took her parcel of books and went back to the Maines'. She read with great rapidity. Her memory was not a verbal one, but her very tissues seemed to absorb the sense of what she read. Much in these books simply formulated for her with clearness what was already in solution in her mind. Here and there she was conscious of lines of difference, of inward criticism, but in the main they but enlarged a content already there, but brought above the threshold, named and fed what she was already thinking. Her mind went back to Eglantine and Roger Michael's talk. "No. It did not begin even here. It was in me. It had been in me a long time, only I did n't know it, or called it other names."

Before these books were finished she got her fifty dollars from the magazine, and the magazine itself was sent her with her story in it. She sat and read the story, and it seemed strange and new in its robe of print. The magazine had provided an illustration — and how strange it was to see her figures (or rather *not* her figures) moving and laughing there! Again and again, after the first time, she opened the magazine and in part or whole read the story and gazed upon the illustration — half a dozen or more times during the first twenty-four hours, then with dwindling frequency day after day, for a week or so. After that her appetite for her own completed work flagged. She laid the magazine away, and it was years before she read that story again. The fifty dollars — She put thirty-five away to go toward her summer clothes and wrote to her grandmother that she had done so.

The remaining fifteen she expended on books, taking starred titles from Elizabeth's list. In January she wrote "The Lame Duck." She sent it to one of the great monthlies. It was accepted, she was paid a fair price, and the monthly gave her to understand that it should like to see *Hagar Ashendyne's* next story.

The letter came as she was leaving the house for a walk in the Park. There was no great distance to go before you came to an entrance, and she often went alone and wandered here and there by herself. The country was in her veins; not to see trees and grass **very** often was very bad. She opened the letter, saw what it was, then walked on in a rosy mist. After a while, out under the branched grey trees, she found a bench, sat down, and read it again and yet again. Her soul passioned to do this thing; to write, to write well, to give out wonderfully, beautifully. A letter that told her it was so, that she was doing that which, with the strongest longing, she longed to do, must be to her golden as a love letter. With it open on her lap, with her eyes on the serene, pearl-grey meadow on the edge of which she sat, she stayed a long time, dreaming. A young man and woman, lovers evidently, slowly passed her bench beneath the trees. She watched them with tranquil eyes. "They're lovers," and she felt a reflex of their bliss. They passed, and she watched as happily the grey spaces where a few sheep stirred, and the edge of trees beyond, dream trees in the mist.

Quite simply she fell to thinking of "the boy." He had been often in her mind since the evening of that meeting; she wondered about him a good deal. She did not know his name; she had no idea where he lived; he might be in New York now,

or he might not be; she might pass him in the street and not know — though, indeed, now she kept a lookout. He did not know her name; she was to him "the little girl" as he was to her "the boy." They might never meet again, but she had a faith that it would not be so. What she felt toward him was but friendliness, concern, and some admiration; but the feeling had a soft glow and pulse. The most marked thing was the consciousness that she knew him truly; reasoning did not come into it; she could have told herself a dozen times how little she did know, and it would have made no difference. It was as though the boy and she had seen each other's essential self through a clear pane of glass.

Her mind did not dwell long upon him to-day. She sat with her hands crossed above the letter, and her eyes, half-veiled, upon the far horizon. To write — to write — to produce, to lead forth, to give birth, to push out and farther on forever, to make a beautiful thing, and always a more beautiful thing — always — always. . . . She was more mind than body as she sat there; she saw her thought-children going up to heaven before her.

There came an impulse to look on beauty that other minds had sent forth. She rose and walked, with her light, rhythmic swiftness, northward toward the Metropolitan. When she passed the turnstile there lacked less than an hour of closing time. She went at once toward the rooms where were the casts. There was hardly a moving figure besides herself; there were only the still, white giants. She entered an alcove where there was a seat drawn before a cast of the tomb of Lorenzo de' Medici. She sat down and gazed upon Michael Angelo's Thinker. After a while her eyes moved to the great figures

of Twilight and Dawn, and then, rising, she crossed to Guliano's Tomb and stood before Day and Night. Presently she left the alcove, and crossing by the models of the Parthenon and of Notre Dame came into the Hall of the Antique and into the presence of the great Venus. Here she stayed until a man came through the place and said it was closing time.

In February she sent to the same monthly "The Mortal." It passed from hand to hand until in due time it reached the editor. He read it, then strolled into the assistant editor's room:—"New star in the sky." But before Hagar could hear from the monthly, another moment in her life was here.

A week after she had mailed this story, she and Rachel were together one evening in the latter's room. It was pouring rain, and there would be no company. Supper was just over,—the Maines clung to supper,—and the children had not been put to bed. Nightgowned, they made excursions and alarms from their nursery into their mother's room and out again and in again. Then Rachel turned out the gas, and they all sat in the light of the coal fire, and first Rachel told a story, and then Betty told one, and then Hagar, and then Charley. They were all stories out of Mother Goose, so no one had to wait long for their turn. Then Hagar had to tell about Bouncing Bet and Creeping Charley, which was a continued story with wonderful adventures, an adventure a night. Then the clock struck eight with a leaden sound, and Mammy appeared in the nursery door. "You carry me!" cried Bouncing Bet, and "You carry me!" cried Creeping Charley. So Rachel took one and Hagar took the other, mounted them like papooses, and in the nursery shot each into the appropriate small, white bed.

Back before the fire, with the lights still out, the two sat for a time in silence. Hagar had a story in mind. She was musing it out, seeing the figures come true in the lit hollows. Rachel had a habit of crooning to herself. She went on now with one of the children's rhymes: —

> " Baa, baa, Black Sheep,
> Have you any wool?"
> "Yes, sir, yes, sir, three bags full —
> One for my master and one for my dame,
> And one for the little boy that lives in the lane!"

Hagar stirred, lifted her arms, and clasped her hands behind her head. "How the rain pours! The winter is nearly over. It has been a wonderful winter."

"I'm glad you've found it so," said Rachel. "You've got a wonder-world of your own, behind your eyes. Everything spins out for good for you sooner or later and somehow or other. You're lucky!"

"Are n't you lucky, too? Have n't you liked this winter?"

'Oh, I've liked it so-so! I've liked you."

"Rachel, I wish you'd be happy. You've got those darling children."

"I am happy where the children touch. And, oh, yes, they touch a long way round! But there's a gap in the circle where you go out lonely and come in lonely."

"That's true of everybody's circle: — mine, yours, everybody's. But you chafe so. You blow the coals with your breath."

"I don't need to blow the coal. It burns without that. . . . Let me tell you, Hagar. There are two kinds of people in the world. The people who are half or maybe two thirds the way

out of the pit and the mire and the slough and the shadow so thick you can cut it! They are rising still, and their garments are getting clean and white, and they can see the wonderful round landscape, and they look at it with calm, wide eyes. They're nearly out; they're more or less spectators. The other kind — they're the poor, dull, infuriated actors. They're still in; they can hardly see even the rim of the pit. The first kind wants to help and does help. It's willing for the others to lay hold of its hands, its skirts, to drag out by. It's willing as an angel, and often the others wouldn't get out at all if it did n't give aid. But it's seen, of course, and it's away beyond.... People like Elizabeth Eden, for instance. ... But the other kind — my kind. — It's all personal with us yet — we're fighting and loving and hating, down here in the muck and turmoil — all of us who are yet devils, and those who are half-devils, and those of us who are just getting vision and finding the stepping-stones — the animal and the half-animal, and those who've only got pointed ears — all resenting and striking out and trampling one another, knowing, some of us, that there are better things and yet not knowing how to get the shining garments; others not caring — Oh, I tell you, life's a bubbling cauldron!"

"I know it is — deep above and deep below. But —"

Rachel rose, went to the window, and stood, brow against the pane, looking out. The rain dashed against the glass; all the street lights were blurred; the gusty wind shook the bare boughs of the one tree upon the block. "You don't know anything about my married life. Well, I'm going to tell you."

She came back to the fire, pushed a footstool upon the hearth, and sat down, crouching close to the flame. "I'm not

yet twenty-six. I was married to Julian Bolt when I was eighteen. I'd known him — or I thought I'd known him — for years. His mother and sisters went in summer to the place in the mountains where we always went. They had money, though less than people supposed. Julian spent two weeks with them each summer. He was older than I, of course, — years older. But he used to row us girls upon the lake, and to play tennis with us, and we thought him wonderful. We called him 'The Prince.' As I got older, he rowed me sometimes alone on the lake, and now and then we went for a walk together. He was good-looking, and he dressed and talked well, and he spent money. I had heard somebody call him 'a man-about-town' — but I did n't know what 'a man-about-town' meant. There were two or three families in the place with daughters out or about to come out, and they made Julian Bolt very welcome. I never heard a father or mother there say a word against him. Mine did n't.

"Well, I came out very early, and the summer after, when I went to Virginia, to the White with my aunt, and that winter when I stayed with some army people at Old Point, he came to both places, and I knew that he came to see me. He told me so.... Of course, though I would have died rather than *say* it, even to myself, of course, I was expecting men to fall in love with me and ask me to marry them — and expecting to choose one, having first, of course, fallen in love with him, and be married in white satin and old lace, and be romantically happy and provided for ever after! Is n't that the thinking rôle for every properly brought-up girl? The funny thing is that I'd rather die than see Betty come upon that treadmill they've built for a girl's mind! ... Well, I was on it all right. ...

"Julian had money, and he spent it recklessly. I did n't see how recklessly; I did n't see anything except that he liked me; for he sent me the most beautiful flowers, the most expensive bon-bons and books and magazines. It was a gay winter. Looking back, it seems to me that everybody was eating and drinking, for to-morrow we die. I knew I must fall in love — that had been suggested to me, suggested for years, just as regularly and powerfully as any hypnotist could do it. The whole world was bent on suggesting it to every young girl. You see, the world's selfish. It wants to live, and it can't live unless the young girl says Yea. And it can't leave it, or it thinks it can't, to Nature working in a certain number in her own good time. It must cheat and beguile and train the girl — every girl — every girl! I tell you, I did n't know any more about marriage than I did about life on the planet Mars! I was packing my trunks for a voyage — and I did n't know where I was going. I did n't know anything about it. No one offered me a Baedeker.... It was orange blossoms and a veil and a ring — and I did n't know what either meant — and felicitations and presents and 'Hear the golden wedding-bells!' and 'They lived happily ever after.' Julian was handsome and lavish and popular, and his family were all right, and if he had been gay he would now settle down; and father and mother were satisfied, and people said I was to be envied.... I married at eighteen. I had n't read much. I did n't know anything. No one told me anything. Maybe the world thinks that if it tells, the young girl would say No.

"We went on a wedding-trip. I suppose sometimes a wedding-trip is n't a mockery. I'm not so bitter as not to know that often it is n't so — that often it is all right. I'm not

A TELEGRAM

denying love, and clean men and considerate. I'm not denying hosts of marriages that without any very high ideal are fit and decent enough. I'm not denying noble lovers — men and women — and noble marriages. I'm only saying that the other kind, the kind that's not fit nor clean nor decent and anything but noble, is so frequent and commonplace that it is rather laughable and altogether sardonic and devilish to kneel down and worship as we do the Institution of Staying Together — Staying Together at any price, even when evidently the only clean thing to do would be to Stay Apart. . . . My wedding-trip lasted four months. I went eighteen, and I came back old as I am now — older than I am now; for I have grown younger these last two years. My marriage was n't the noble kind. It was the kind you could n't make noble. It was n't even the decent, low-order type. It was a sink and a pit and a horror."

She bent and stirred the fire. Outside the gusty wind went by and the rain beat upon the windows. "I know that there are marriages where woman is the ruiner. There are women who are wreckers. They fasten themselves on a man's life and drain it dry. They are devil-fish. They hold him in their arms and break his bones. They're among the worst of us struggling here in the pit. They're wicked women. They may be fewer than wicked men, or they may be equal in number, I don't know. I'm not talking of wicked men or wicked women in that sense. I'm talking of men whom the world does not call wicked, and of a great army of women like myself, an army that stretches round the world and through hundreds of years. . . . An army? It is n't an army. We never had any weapons. We were never taught

to fight. We were never allowed to ask questions. We were told there were no questions to ask. We were young girls, dreaming, dropped into the wolf pack ... and it goes on all the time. It is going on now. It may be going on when Betty grows up — though I'll tell her! You need n't be afraid. I'll tell her. ...

"That wedding trip — that honeymoon. I had married a handsome beast — a cruel one, too. He treated me like a slave, bought for one purpose, wanted for one purpose, kept for one purpose. I was n't enough for him — I found that out very soon. But those others were freer than I. They made him pay them. ... He would have said that he paid me, too; that he supported me. Perhaps it's true. I only know that I am going to have Betty taught to support herself."

"You should have left him."

"We were in Europe. I had n't any money. I was beaten down and stunned. When I tried to write to father and mother, I could n't. They would have said that I was hysterical, and for God's sake to consider the family name! ... I have been a woman slow to develop mentally. What poise I've got, what reading, what knowledge, what everything, has come to me since that time. Then I did n't know how to hold my head up and march out. Then I only wanted to die. ... We came home, and it was to find father with a desperate illness. I could n't tell mother then. I doubt if I could ever have told her. I doubt if it would have done any good if I had. ... We went to live in a house up on the Sound. Julian said his fortune was getting low, and that it would be cheaper there. But he himself came into town and stayed when he wished. He spent a great deal of money. I do not

know what he did with it. He threw away all that he had. . . .
I knew by now that Betty was coming. She was born before
I was nineteen. And Charley was born a year afterward—
born blind, and I knew why. I loved my children. But my
marriage remained what it had always been. When Charley
was nearly a year old, I could n't stand it any longer. If I
could stand it for myself, I saw that I could n't stand it for
them. I could n't let them grow up having that kind of a
mother, the kind that would stand it. . . . Julian went away.
Every two or three months he took all the money he could
lay his hands on and disappeared. I knew that he had dived
into all that goes on here, in some places, in this city. He
would be gone sometimes two weeks, sometimes longer. . . .
Well, this time I took Betty and Charley and came home,
came here — and they tried to persuade me to go back. The
Bishop was here, visiting his nephew, and he came and
tried to persuade me to go back. But I would n't . . . and
there was no need. Within the week Julian was killed in a
fray in a house a mile, I suppose, from where we sit. That
was two years ago."

She rose and moved about the firelit room. "Yes, I've got
the two children, and life's healing over. I don't call myself
unhappy now. At times I'm quite gay — and you don't
know how eerie it feels! But happy or not, Hagar, I'll never
forget — I'll never forget — I'll never forget! They talk
about the end of the century, and about our seeing the beginning of better things. They say the twentieth century will be
an age of clearer Thinking and greater Courage, and they talk
about the coming great Movements. — There's one Movement that I want to see, and that's the Movement to tell the

young girl. If I were the world I would n't *have* my dishonoured life as it gets it now. . . . And now let's talk about something else."

Hagar crossed to her, took her in her arms, and kissed her lips and forehead. "I love you, Rachel. Come, let's look at the rain, how it streams! Listen! Is n't that thunder?"

They stood at the window and looked out upon the slanting lines and the glistening asphalt. The doorbell rang.

"Who on earth can that be?" Rachel went to the door, opened it, and stood listening. "A telegram. Dicey is bringing it up. It's for you, Hagar."

She struck a match and lit the gas. Hagar opened the brown envelope and unfolded the sheet within. The telegram was from Gilead Balm, from her grandfather: —

Cables from physician and Consul at Alexandria. Terrible accident. Yacht on which were Medway and his wife wrecked. His wife drowned, body not recovered. Medway seriously injured. Life not despaired of, but believe it will leave him crippled. Ill in hotel there. Unconscious at present. Every attention. Your grandmother will fret herself ill unless I go. Insists that you accompany me. Have telegraphed for passage on boat sailing Saturday. Arrive in New York Friday morning. Get ready. — Argall Ashendyne.

CHAPTER XIX

ALEXANDRIA

"My master," said the valet, "is fond of Cairo and detests Alexandria. As soon as he is able to be moved, if not sooner, he will wish to be moved."

"He is not able now," said Hagar.

"No, Miss. He is still delirious."

"The doctor says that he is very ill."

"Yes, Miss. But if I may make so bold, I think Mr. Ashendyne will recover. I have lived with him a long time, Miss."

"What is your name?"

"Thomson, Miss."

The Colonel entered. "He did n't know me. Nor would I have known him. He is pretty badly knocked to pieces. — What have you got there? Tea? I want coffee." Thomson moved to the bell, and gave the order to the Arab who appeared with the swiftness of a genie. "Is there anything else, sir?"

"No, not now."

"The English papers are upon the small table, sir." And Thomson glided from the room.

The Colonel looked about him. "Humph! Millionaires fix themselves luxuriously."

"I keep seeing her," said Hagar. "Her body lying drowned there."

The Colonel glanced at her. "Pull yourself together, Gipsy! Whatever you do, don't get morbid."

"I won't," Hagar answered. "I'm like you there, grandfather. I hate it. But it is n't morbidness to think a little of her."

The Arab brought the coffee. "Turkish coffee!" said the Colonel, not without relish in his voice. "I always wanted to taste —" He did so, appreciatively. "Ah, it's good —" He leaned back in the deep wicker chair and gazed upon the latest attendant. "And what may be your name?"

The figure spread its hands and said something unintelligible. "Humph! Comment vous nommez-vous?"

"Mahomét, Monsieur."

"We've come, Gipsy," said the Colonel, "far from old Virginia. Well, I always wanted to travel, but I never could. I had a sense of responsibility."

It struck Hagar with the force of novelty that what he said was true. He had such a sense. There had always been times when she did not like her grandfather, and times when she did. But during the last two weeks, filled with a certain loneliness and strangeness for them both, she had felt nearer to him than ever before. There had chanced to be on the boat few people whom he found congenial. He had been forced to fall back upon his granddaughter's companionship, and in doing so he had made the discovery that the child had a mind. He liked mind. Of old, when he was most sarcastically harsh toward Maria, he had yet grudgingly admitted that she had mind — only, which was the deep damnation, she used it so wrongheadedly! But Gipsy — Gipsy would n't have those notions! The Laydon matter had been just a fool-

ALEXANDRIA

ish girl's affair. She had been obstinate, but she had seen her mistake. As for Ralph — Ralph would get her yet. The Colonel had been careful, in their intercourse during the voyage, to bring forward none of her mother's notions. He found that she knew really an amazing amount of geography and history, that to a certain extent she followed public events, that she knew Byron and could quote Milton, and that though she had no Greek (he had forgotten most of his), she was familiar with translations and could not only give a connected account of the Olympian family, but could follow in their windings the minor myths. The long voyage, the hours when they reclined side by side in their steamer chairs, or with the country need for exercise paced from prow to stern, and from stern to prow, taught him more about his granddaughter than had done the years at Gilead Balm. She told him of the acceptance of "The Lame Duck" and the sending of "The Mortal," and he was indulgent toward her prospects. "There have been women who have done very good work of a certain type. It's limited, but it's good of its kind. As letter-writers they have always excelled. Of course, it is n't necessary for you to write, and in the Old South, at least, we've always rather deprecated that kind of thing for a woman."

The Colonel drank his thick coffee from its little metal cup with undeniable and undenied pleasure. He was not hypocritical, and he never canted. His only son lay in a large bedroom of this luxurious suite, maimed and hardly conscious, and whether he would live or die no one knew. But the Colonel had never wept over Medway in the past and he was not going to weep now. He drank his coffee leisurely, and when

it was done Mahomet took salver and cup away. Rising, the Colonel walked to one of the windows and stood looking out at a bougainvillæa-covered wall, a shaggy eucalyptus tree, and a seated beggar, fearful to the eye. It was afternoon, and they had been in Alexandria since eight o'clock. "I sent a cable to your grandmother. The doctors think he's holding his own, but I don't know. It looks pretty bad. They've got a nurse from a hospital here, — two, in fact, — and that man Thomson is invaluable. . . . I've seen, too, this morning, before they let me into the room, his wife's brother. It seems that he was in London at the time, and came on and has very properly waited here for our arrival. We walked through the Place Mahomet Ali, and he took me to a very good club, where we sat and talked. . . . Her will — it's rather curious. I suppose Medway, if he lives, will be disappointed. And yet, with care, he'll have enough." The Colonel laughed, rather grimly. "We'd think in Virginia, that a million was a good livelihood, but standards are changing, and doubtless he's been feeling many times that amount between his fingers. It occurred to me that they must have quarrelled. It's like a woman to fling off and do a thing like that hastily. Her brother says, however, that he believes they were really happy together. He fancies that she had some feminine scruple or other as to the way her first husband obtained his wealth, — as the world goes, entirely honourable transactions, I believe, — and that she had an idea of 'restoring' it. She made this last will in London, just before they started on this long trip that's ended so. It's been read. There's a string of bequests to servants and so on. She leaves just one million, well invested, to Medway. The rest, and it's an enor-

mous rest, goes into a fund, for erecting model lodging-houses and workmen's dwellings. Philanthropy mad!" said the Colonel. "Her brother's got, I understand, some millions of his own, and he could afford to smile. Also, he's been supposing for a year that it would all go to Medway. Well, that's where Medway is — if he lives. Fifty thousand or so a year," said the Colonel, regarding the beggar, "is not an income to be despised. I should be happy if I saw, each year, in clear money, an eighth as much."

There came a knock at the door and the physician entered. He was an American, a young, fresh-coloured man with an air of strength and capability. He had lunched with the two Ashendynes, and now came in as one at home. He looked graver now than then; there was a plain cloud upon his brow. "I don't believe he can hold out," he said abruptly. "He has a magnificent constitution, and his body is making a splendid fight, but — It may come at any minute with a quick collapse. Of course, I'm not saying that it will be so. But if Miss Ashendyne wishes to see him, or to be with him if it should happen to be the end —"

Hagar turned deadly pale. The Colonel, not usually considerate of her or given to thinking that she needed consideration, was somehow different to-day. "If you'd rather not, Gipsy —? Indeed, I think that you had better not. It is n't as though you had been always with him." He turned to the physician. "She has seen very little of her father since babyhood."

But Hagar had steadied herself and risen from her chair. "Thank you, grandfather, but I would rather go with you."

It was almost sunset, and the splendid western light flooded

the chamber where the sick man lay. He lay low upon the pillows, with only a light covering. There had been, beside injuries to spine and limb, and some internal hurt, a bad blow over the head. This was bandaged; fold after fold of gauze wrapped around forehead and crown. "Oh," thought Hagar, "it is like the white helmet in that dream!" But the features below were not flushed with health; they were grey and drawn. The second physician, standing at the bed-head, lifted his hand from the pulse and moved to the side of the first. "A little stronger." The nurse placed a chair for Hagar. Thomson, at the windows, raised the jalousies higher, and the light evening breeze blew through the room. "It may or it may not be," said the first doctor in a low voice to the Colonel. "If he pulls through to-night, I'll say he wins."

The amber, almost red, light of the sun bathed the bed. When the sun sank, a violet light covered it. When the short twilight was gone, and the large, mild stars shone out, they brought shaded lamps, and the bed lay half in that light and half in the shadow. In the room, through the slow passing hours, hushed, infrequent movements took place, the doctors relieving each other in the watch by the bed, the night nurse arriving, the giving of stimulants, whispered consultations by the window. The adjoining room was prepared for rest and relaxation; there was a table with bread and cold meat and wine. The Colonel came and went, noiseless as a shadow, but a restless shadow. Once or twice during the night his touch upon her shoulder or his hand beckoning from the doorway drew Hagar forth. "You'd better rest, child. Here, drink this wine!" Each time she stayed half an hour

or so, either in the room or out upon the balcony which gave upon a garden, but then she stole back into the bedroom.

She sat in a big chair which she had drawn aside and out of the way. She could, however, see the bed and the figure upon it; not clearly, because the lights were low, but dimly. She rather felt than saw it; it was as though a sixth sense were busy. She sat very still. Her father. . . . Through her mind, automatically, without any conscious willing, drifted words and images that spoke of father and child. It might be a Bible verse, it might be a line from a younger poet, it might be an image from some story or history. Father and child — father and daughter — father and daughter. . . . To sit and see her father die, and to feel no deep sorrow, no rending sense of companionship departing, no abject, suffocating pulsing of a stricken heart, no lifted hope and faith or terror for him, no transcending sense of self-relinquishment, while the loved one flew farther and swifter and higher out of her sight, away from this life's low level. . . . She could not feel any of that. As little as the Colonel did she believe in or practise cant. She knew that she could not feel it thus, and knew why. But there was a great forlornness in sitting there and watching this stranger die.

She tried to strengthen the faint memories that the past held. Was she five or six years old the last time she had seen him? The distinctest image was of underneath the cedars at Gilead Balm. There was a shawl spread upon the grass. Her father was lying on it, his hat tilted over his eyes. There was a book beside him. She had been gathering dandelions, and she came and sat down on the edge of the shawl and opened the book. She thought every book had pictures, but there

were none in that one. Then he had waked up and laughed at her, and said, "Come here!" — It flashed into her consciousness, from where it had lain unrecalled all these years, just what he had said. He had said, "Come here, Miss Ugly, Ill-omened Name!" She had gone, and in playing with her he had accidentally burned her finger with his lighted cigar. And then — it came to her with an effect of warmth and sunshine, and with a feeling of wanting to laugh, with tears in her eyes — he had been beautifully, charmingly shocked and apologetic. He had taken her away and made Old Miss bandage the finger, and then he had shouldered her and carried her into the orchard and broken boughs of apple blossoms for her and told her "Jack and the Beanstalk." ... That was almost all she could remember; or if there were one or two less agreeable things, she would not remember those now. She tried to keep the warmth about her heart; on the whole, aided by human pity for the broken form upon the bed, she succeeded better than she could have dreamed.

The man upon the bed! — Outside the fatherhood, outside the physical relation between them — there he was, a human being with death hovering above. It was easier to think of him just as a fellow-being; she laid hold of that thought and kept it. A fellow-mortal — a fellow-mortal. With a strange sense of relief, she let the images and words and the painful straining for some filial feeling pass from her soul. She did not know why she should feel toward him filially; he had not, like her mother, suffered to give her life; he had probably never thought of her; she had not been to him the concern in the matter. Nor hardly since had he acted parentally toward her. With a wry humour she had

to concede the winter in New York, the summer at the New Springs, but it hardly seemed that the sacrifice could have been great, or that the need for gratitude was extreme. Her soul rose against any hypocrisy. She could not and she would not try to say, "Dear father — dear father!" The vision of her mother rose beside her.... But just to think of him as a human being — she could do that; a man lying there on the knife edge of the present, with the vast, unplumbed gulf before him.... That dream of the blue sea and the palm trees and the low pale-coloured houses returned to mind, but she put it from her somewhat shudderingly. He had looked so abounding in life, so vivid and vital, with the white hat like a helmet!... A fellow-mortal, lying there, helpless and suffering....

At three in the morning the physician in charge, who had been sitting for some time beside the bed, rose and moved away. He nodded his head to his fellow. Hagar caught the satisfaction in the gesture even before, in passing her chair, he paused to say just audibly, "I think your father will recover." A short time passed, and then the Colonel touched her arm. "They think it safe for us to go. He is stronger. Come! They'll call if there is any need, but they don't think there will be."

Going, she stopped for a moment close beside the bed. She had not been this near before. Medway lay there, with his head swathed in bandages, with his lips and chin unshorn, with no colour now in his cheeks, with his eyes closed. Hagar felt the sudden smart of tears between her own lids. The gold thread of the dandelion day tied itself to the natural human pity and awe. Her lips trembled. "Father!" she said, in the

lowest of whispers. Her hand moved falteringly until, for the lightest moment, it rested upon his.

In the outer room the physician joined them. "He'll still have to fight for it, and there may be setbacks. It's going to be a weary, long, painful siege for him, but I don't believe he's going to die. Indeed, I think that, except in the one respect, we'll get him back to being a well man with a long life before him."

"And that respect?"

"I'm afraid, Colonel Ashendyne, that he'll never walk again. If he does, it will be with crutches and with great difficulty."

When, half an hour later, Hagar opened the door of her own room, the dawn was coming. It was a comfortable bedroom, large, cool, and high-pitched, and it, too, had a balcony. The bed invited; she was deadly tired; and yet she doubted if she could sleep. She stood in the middle of the room, her hands over her eyes, then, a little stumblingly, she went out upon the balcony. It was a small place, commanding the east. There was a chair and a little table on which you could rest your arms, and your head upon them, sideways so that you could see the sky. It was just grey light; there were three palm trees rustling, rustling. After a while purple came into the sky, and then pale, pale gold. The wind fell, the palms stood still, the gold widened until all the east was gold. She saw distant, strange, flat roofs, a distant dome and slender towers, all against the pale, pale gold. The air was cool and unearthly still. Her head upon her arm, her face very quiet, her eyes open upon the deepening light, she stayed until the gardeners came into the garden below.

CHAPTER XX

MEDWAY

FIVE days later, Medway, one morning, recognized the Colonel. "Why, my dear father, what are you doing here?... What's it all about?" His feeble voice died away; without waiting for an answer, he lapsed into a kind of semi-consciousness. Out of this, day by day, though, he came more strongly. Directly he appeared to accept, without further curiosity, his father's occasional presence in the room. Another interval, and he began to question the physician and nurses. "Back, eh? — and leg, and this thing on my head. I don't remember. — A kind of crash.... What happened?"

Evasive answers did for a while, but it was evident that they would not do for ever. In the end it was Thomson who told him.

"You did, did you!" exclaimed the doctor in the outer room. "Well, I don't know but what it's just as well!"

"I could n't help it, sir. He pinned me down."

The Colonel spoke. "Just what and how much did you tell him?"

"I told him, sir, about the wreck, and how he got beaten about, and how I fastened him, when he was senseless and we were sinking, to a bit of spar, and how we were picked up with some of the crew about dawn. And about his being brought here, and being very well cared for, and your coming from New York, you and Miss Ashendyne, and that he'd

been wonderful close to dying, but was all right now, and what the date was, and things like that, sir."

"Did he ask for his wife?"

"Yes, sir."

"And you told him?"

"Yes, sir."

The doctor rose. "Well, I'm glad it's done. I'll go see — " and disappeared into the sick-room.

"I think you did well, Thomson," said the Colonel. "When you've got to take a thing, you'd better stand up and take it, and the quicker the better."

"Yes, sir," said Thomson; and adjusted the jalousies, it being now very warm and the glare at times insupportable.

The Colonel, under the guidance of a dragoman of the best, had been shopping, and was in white duck. Hagar, too, had secured from a French shop muslin and nainsook.

Thomson had been concerned for her lack of any maid or female companionship. He had gently broached the subject a week or two before. "Mrs. Ashendyne had an excellent maid, Miss, who was with us on the yacht that night and was saved. But she's of a high-wrought nature, and the shock and cold and everything rather laid her up. She has a brother who is a photographer in Cairo, having married a native woman, and she's gone to stay with him awhile, before she goes back into service. If that hadn't been the case, Miss, you might, if you wished, have taken her on. I think she would have given satisfaction. As it is, Miss, I know some English people with a shop here, and I think through them I could find you some one. She would not be a superior lady's maid like Cécile, but —"

MEDWAY

Hagar had declined the offer. "I never had a maid, thank you, Thomson. I can do for myself very well."

She liked Thomson, and Thomson agreed with the nurse that she was a considerate young lady. Now, having adjusted the blinds, Thomson left the room.

The Colonel paced up and down, his hands behind him. The white duck was becoming; he did not look sixty. Hair, mustache, and imperial were quite grey; except for that he had never aged to Hagar's eyes. His body had the same height and swing, the same fine spareness; his voice kept the same rich inflections, all the way from mellow and golden to the most corroding acid; he dominated, just as she remembered him in her childhood. Not all of his two weeks in Egypt had been spent by Medway's bedside; he had been fairly over Alexandria, and to Meks and Ramleh, and even afield to Abûkir and Rosetta. He had offered to take her with him upon these later excursions, but she had refused. The brother of her father's wife was going with him, and she correctly thought that they would be freer without her. The Colonel acquiesced. "I dare say you'll have chances enough to see things, Gipsy." It was her first intimation that any one had in mind her staying. . . .

Now the Colonel, after pacing awhile, spoke reflectively. "At this rate it won't be long before he's really well enough to talk. I'll have to have several talks with him. Did you gather, Gipsy, that Thomson had told him that he would remain crippled?"

"I do not think he told him that, grandfather."

"That's going to be the shock," said the Colonel. "Well, he'll have to be told! I think Thomson — or the doctor —

had better do it. And then he'll have to learn about that will. Altogether, it may delay his convalescence a little. Of course, I'll stay until he's practically recovered — as far as he can recover."

"Do you think that ... perhaps ... he might like to go home — to go home to Gilead Balm?"

"Not," answered the Colonel, "if I know Medway, and I think I do! To come back, crippled, after all these primrose years — to sleep in his old room, and Maria's — to sit on the porch and listen to Bob and Serena — No!"

That night in her own room Hagar placed two candles on the table, took a sheet of paper and a pencil, and sitting down, made a calculation. The night was warm to oppression; through the windows came the indefinite, hot, thick murmur of the evening city. Hagar sat with bare arms and throat and loosened hair. She wrote her name, *Hagar Ashendyne*, and her age, and then, an inch below, a little table, —

The Prize Story	$200.00
	(*Clothes, books, Thomasine. All spent.*)
The Story in ———'s Magazine	$50.00
	(*Clothes, books. All spent.*)
"The Lame Duck"	$100.00
	(*I have most of it yet.*)
"The Mortal"	$125.00
Total	$475.00

After a pause the pencil moved on. "Many stories in mind, one partly written. The monthly says I can write and will make a name." It paused, then moved again. "To earn a living. To live where life is simple and does n't cost much. If I go on, and I will go on, I could live at Gilead Balm on

what I make, and help keep up the place. If ever I had to live by myself, I could get two or three rooms in a city and live there. Or maybe a small house, and have Thomasine with me. In another year or two years, I can keep myself. I do not want to stay here when grandfather goes. Where there is no love and honour, what is the use? It isn't as though he needed me — he doesn't — or wanted me —"

She laid the pencil down and leaned back in the deep chair. Her eyes grew less troubled; a vague relief and calm came into her face, and she smiled fleetingly. "If he doesn't think he needs me or wants me, — and I don't believe he'll think so, — then there isn't anything surer than that I won't stay." She rose and paced the room. "I shouldn't worry, Hagar!"

Some days after this, she offered one afternoon to relieve the nurse. She had done this before and frequently. Heretofore the service had consisted, since the patient almost always slept through the afternoon, in sitting quietly in the darkened chamber and dreaming her own dreams for an hour or two, when the grateful nurse came back refreshed. To-day she was presently aware that he was awake; that he was lying there with his eyes open, regarding the slow play of light and shadow upon the ceiling. She had found out, on those earlier occasions, that he did not discriminate between her and the usual nurse; when he roused himself to demand water he had looked no farther than the glass held by her hand to his lips. Now, as she felt at once as with a faint electric shock, it was going to be different. He spoke presently. His voice, though halting and much weakened, resembled the Colonel's golden, energetic drawl.

"What time is it?"

"Five o'clock."

"What day of the month?"

She told him. "Alexandria in April!" he said. "What impossible things happen!"

She did not answer, and he fell silent, lying there staring at the ceiling. In a few minutes he asked for water. The glass at his lips, she felt that he looked with curiosity first at the hand which held it, and then at her face. "Water tastes good," he said, "does n't it?"

"Yes, it does." She put down the glass and returned to her seat.

"You are n't," he said, "the nurse I've had."

"No; she will be back presently."

There followed another pregnant silence; then: "A beautiful string of impossibilities. I know the Colonel's here — been here a long time. Now, did I dream it or did Thomson tell me that he'd brought my daughter with him?"

"Thomson told you."

Medway lay quite quiet and relaxed. The cut over the head was nearly healed; there was now but a slight fillet-like white bandage about it. Thomson had trimmed mustache and short pointed beard; the features above were bloodless yet, but no longer sunken and ghastly; the eyes were gathering keenness and intelligence. Ashendynes and Coltsworths were alike good-looking people, and Medway had taken his share. He knew it, prized it, and bestowed upon it a proper care. Hagar wondered — wondered.

He spoke again. "Life's a variorum! I should n't wonder... Hagar!"

"Yes, father?"

"Suppose you come over here, nearer. I want to see how you've 'done growed up.'"

She moved her chair until it rested full in a slant ray of sunlight, coming through the lowered blinds, then sat within the ray, as still almost as if she had been sculptured there.

Five minutes passed. "Haven't you any other name than Hagar?" said Medway. "Are they always going to call you that?"

"Grandfather calls me Gipsy — except when he doesn't like what I do."

"Does that happen often? Are you wilful?"

"I do not know," said Hagar. "I am like my mother."

When she had spoken, she repented it with a pang of fear. He was in no condition, of course, to have waked old, disturbing thoughts.

But Medway had depth on depth of *sang-froid*. "You look like her and you don't look like her," he murmured. "You may be like her within, but you can't be all like her. Blessings and cursings are all mixed in this life. You must be a little bit like me — Gipsy!"

"It is time," said Hagar, "for an egg beaten up in wine."

She gave it to him, standing, grave-eyed, beside the bed. "I do not think you should talk. Shut your eyes and go to sleep."

"Can you read aloud?"

"Yes, but —"

"Can you sing?"

"Not to amount to anything. But I can sing to you very low until you go to sleep, if that's what you mean —"

"All right. Sing!"

She moved from the shaft of light, and began to croon rather than to sing, softly and dreamily, bits of old songs and ballads. In ten minutes he was asleep, and in ten more the nurse returned.

The next afternoon Thomson brought her a message. "Mr. Ashendyne would like you to sit with him awhile, Miss."

She went, and took her chair by the window, the nurse leaving the room. Medway lay dozing, his eyes half-closed. After a while he woke fully and asked who was there.

"It is Hagar, father."

"Sit where you were yesterday."

She obeyed, taking again her place in the slant light. It made a gold crown for her dusky hair, slid to the hollow of her firm young throat, brought forward her slender shoulders, draped in white, and bathed her long hands, folded in her lap.

Medway lay and looked at her, coolly, as long as he pleased. "You are not at all what is called beautiful. We'll dismiss that from mind. But the people who give us our terms are mostly idiots anyhow! Beauty in the eye of the beholder — but what bats are the beholders! No, you have n't beauty, as they say, but there's something left.... I like the way you sit there, Gipsy."

"I am glad that you are pleased, father."

"I could n't deduce you from your letters."

Her eyes met his. "I did not choose that you should."

Again she felt a quiver of pain for what she had said. She was torn between a veritable anger which now and again rose perilously near the surface and a profound pity for his broken body, and for what he would feel when he knew. Her dream of the early winter haunted her. She saw him leaving

that white steamer, coming lightly and jauntily down from it to the shore, robust, with a colour in his cheeks and his white hat like a helmet. She heard again Roger Michael speaking. "We met him at Carcassonne, and afterwards at Aigues-Mortes. He was sketching most wonderfully." She saw him, moving lightly, from stone to stone in old half-ruined cities. The dandelion day and the blossoming orchard came back to her; she felt again beneath her his half-dancing motion as he carried her under the boughs where the bees were humming. Her pity, her comprehension, put the anger down.

Medway was watching her curiously. "You have a most expressive face," he said. "I do not remember you well as a child. How old were you the last time we met?"

"Five or six, I think. The clearest thing I can remember, father, is one day when you were lying under the cedars and I had been gathering dandelions and came to look at a book you had. You played with me, and I accidentally burned my finger on your cigar. Then you were very kind and lovely; you took me to grandmother to have it tied up, and then you carried me on your shoulder through the orchard, and told me 'Jack and the Beanstalk.'"

"By Jove!" said Medway. "Why, I remember that, too! ... First the smell of the cedar and then the apple blossoms.... You were a queer little elf — and you entered into the morals of 'Jack and the Beanstalk' most seriously.... Good lack! Whoever forgets anything! That to come back as soft and vivid!... Well, I thought I had forgotten you clean, Gipsy, but it seems I had n't."

"You must n't talk too much. Shall I sing you to sleep?"

"Yes, sing!"

Just before he dozed off, he spoke again, drowsily. "Have you heard them say how many days it will be before I am on my feet again?"

"No."

"I will want to show you and the Colonel —" But she had begun to croon "Swanee River," and he went to sleep with his sentence unfinished.

The next day he spoke of his drowned wife. It came as a casual remark, but with propriety. "Anna was a good woman. There could hardly have been a more amiable one. She had experience and tact; she was utterly unexacting. She had her interests and I had mine; we lived and let live. . . . I cannot yet understand how she happened to have been the one —"

"She sent me her picture," said Hagar. "I thought it very handsome, and a good face, too. And the two or three letters I had from her — I have kept them."

"She was a good woman," repeated Medway. "You rarely see a tolerant woman — she was one. Her brother has told me about her will. It is true that I expected, perhaps, a fuller confidence. But it was her money — she had a right to do as she pleased. I knew that she had some unfortunate idea or other as to the origin of her wealth — but I did not conceive that her mind made so much of it. . . . However, I refuse to be troubled on that score. Her disposition of matters leaves me comfortable enough. I am not worrying over it. I never worry, Gipsy!"

After lying for three minutes he spoke with his inimitable liquid drawl. "When I think of all the years out of which I have squeezed enjoyment on the pettiest income — going

here and going there — every nook of Europe, much of Asia and Africa — just managing to keep Thomson and myself — knowing every in and out, every rank and grade and caste, palace and hovel, château and garret, camp and atelier, knowing pictures, music, scenery, strange people and strange adventures, knowing my own kind and welcome among them — now basking like a lizard, now in action as though a tarantula had bit me — everywhere, desert and sea and city — and all on next to nothing! — making drawings when I had to (I did that one year in southern France; Carcassonne, Aigues-Mortes, Nîmes, and so forth), but usually fortunate in friends . . . it seems that I might be able to manage on fifty thousand a year . . . resume at the old house."

It was another week before he was told. He was growing impatient and suspicious. . . . The doctor did it, Thomson flunking for the first time in his existence. The doctor, having done it, came out of the room, drew a long breath, and accepted coffee from Mahomet with rather a shaking hand.

"Well?" demanded the Colonel. "Well?"

"He's perfectly game," said the doctor, "but I should say he's hard hit. However," — he drank the coffee, — "there's one thing that a considerable experience with human nature has taught me, and that is, Colonel, that your born hedonist — and it's no disparagement to Mr. Ashendyne to call him that; quite the reverse — your born hedonist will remain hedonist still, though the heavens fall. He'll twist back to the pleasant. He's going through pretty bitter waters at the moment, but he'll get life somehow on the pleasurable plane again. All the same," mused the doctor, "he's undoubtedly suffering at present."

"I won't go in," said the Colonel. "Better fight such things out alone!"

The other nodded. "Yes, I suppose so."

But a little later Hagar went in. She waited an hour or two in her own room, sitting before a window, gazing with unseeing eyes. The heat swam and dazzled above countless flat, pale, parapetted roofs of countless houses. Palm and pepper and acacia and eucalyptus drooped in the airless day; there sounded a drone of voices; a great bird sailed slowly on stretched wings far overhead in a sky like brass. She turned and went to her father's room.

Outside she met Thomson. "Are you going in, Miss? I'm glad of that. Mr. Ashendyne is n't one of these people whom their own company suffices —"

Hagar raised sombre eyes. "I thought that my father had always been sufficient to himself —"

"Not in trouble, Miss."

He knocked at the door for her. Medway's voice answered, strangely jerky, quick, and harsh. "What is it? Come in!"

Thomson opened the door. "It's Miss Hagar, sir," then closed it upon her and glided away down the corridor.

Medway was lying well up upon his pillows, staring at the light upon the wall. He had sent away the nurse. He did not speak, and Hagar, moving quietly, went here and there in the large room, that was as large as an audience chamber. At the windows she drew the jalousies yet closer, making a rich twilight in the room. There were flowers on a table, and she brought fresh water and filled the bowl in which they lived. There were books in a small case, and, kneeling before it, she

read over their titles, and taking one from the shelf went softly through it, looking at the pictures.

At last, with it still in her hand, she came to her accustomed seat near the bed. "It's a bad day for you," she said simply. "I am very sorry."

"Do you object to my swearing?"

"Not especially, if it helps you."

"It won't — I'll put it off.... Oh—h..." He turned his head and shoulders as best he could, until his face was buried in the pillows. The bed shook with his heavy, gasping sobs....

It did not last. Ashendynes were not apt long to indulge in that kind of thing. Medway pulled a good oar out of it. The room very soon became perfectly still again. When the silence was broken, he asked her what she was reading, and then if she had seen anything of the city. Presently he told her to sing. He thought he might sleep; he hadn't slept much last night. "I must have had a presentiment of this damned thing — Go on and sing!" She crooned "Dixie" and "Swanee River" and "Annie Laurie," but it was of no use. He could not sleep. "Of all things to come to me, this —!... Why, I should like to be out in the desert this minute, with a caravan.... O God!"

She brought him cool water. "I'm sorry — I'm sorry!" she said.

As she put down the glass, he held her by the sleeve. A twisted smile, half-wretched, half with a glint of cheer, crossed his face. "Do you know, Gipsy, I could grow right fond of you."

CHAPTER XXI

AT ROGER MICHAEL'S

On an early April afternoon in the year 1902 a man and woman were crossing, with much leisureliness, Trafalgar Square.

"We won't get run over! It is n't like Paris."

"Are n't you tired, Molly? Don't you want a hansom?"

"Tired? No! What could make me tired a day like this? I want to go stroke the lions."

They gravely went and did so. "Poor old British Lion! — Listen!"

News was being cried. "*Details of fight at Bushman's Kop!*"

Christopher Josslyn left the lions, ran across and got a paper, then returned. "A small affair!" he said. "How interminably the thing drags out!"

"But they'll have peace directly now."

"Yes — but it's Poor old Lion, just the same —"

They moved from the four in stone, striking across to Pall Mall. "There was a halcyon time in England, fifty years or so ago, when, if you'll believe what men wrote, it was seriously held that no civilized man would ever again encroach upon a weaker brother's rights! Æons were at hand of universal education, stained glass, and ascension lilies. At any rate æons of brotherhood. Under the kindly control of the great Elder Brother England. And they had some reason — it looked for an illusory moment that way. I always try to

remember that — and moments like that in every land's history — at moments such as these. Why does n't that moment carry on over? There's something deeply, fundamentally wrong."

He looked along the crowded street. Men were buying papers — that seemed their chief employment. *Delarey — Kitchener — Report of fight at Hartz River.*

"Not far from a billion dollars expended on this war — and those East Side streets we went through yesterday — Concentration Camps — and the Coronation — this reactionary Administration with its Corn Laws and Coercion Laws and wretched Education Bill, and so on — and the Coronation talk — and Piccadilly last night after nine —"

"Oh," said Molly sharply. "That's the sting that I feel! It's women and children who are suffering in those Concentration Camps, I suppose — and it's women's sons who are lying on the battlefields — and it's women just as well as men who are paying the taxes — and it's women, too, in those horrible slums, wretched and hopeless — and bad legislation falls on women just as hardly as on men — but the other! There we've got the tragedy mostly to ourselves — and there's no greater tragedy below the stars!" She dashed a bright drop from her eyes. "I'll never forget that girl, last night, on the Embankment — thin and painted and that hollow laugh. . . . I wish women would wake up!"

"Women and men," said the other. "They're waking, but it's slow, it's slow, it's slow."

The softened, softened English sunlight bathed the broad street, the buildings, the wheeled traffic, the people going up and down. The two Americans, here at last at the latter end

of their six months abroad, delighted in the tender light, in the soft afternoon sky with a few sailing clouds, in the street sights and sounds, in the English speech. They strolled rather than walked; even at times they dawdled rather than strolled. They developed a tendency to stand before shop-windows. So strong and handsome a pair were they that they attracted some attention. Thirty-five and thirty-two, both tall, both well-made, lithe, active, both aglow with health; she a magnificent rosy blonde, he blue-eyed, but with nut-brown hair; both dressed with an unconventional simplicity, fitness, and comfort; both interested as children and happy in each other's company — those who observed them did not call them "Promise-Bearers"; and yet, in a way, that was what they were. There were three children at home with as splendid a grandmother. A University had sent Christopher to make an investigation, and the children had said, "You go, too, mother! It'll be splendid. You need a rest!" and Christopher had said, "Molly, you need another honeymoon."

The English weather was uncommonly good. As they came to Green Park a barrel-organ was playing. Spring was full at hand; you read it everywhere.

Two men passed, talking. "Yes, to confer at Klerksdorp, with Steyn and Botha and De Wet. Peace presently, and none too soon!"

"I should think not. I'm done with wars."

"Little Annie Rooney," played the barrel-organ.

"There is more than one way for societies to survive," said Christopher, "and some day men will find it out. You can survive by being a better duellist and for a longer time

than the other fellow — and you can survive by being the better toiler, also with persistence — or you can survive by being the better thinker, in an endless, ascending scale. Each plane makes the lower largely unnecessary, is, indeed, the lower moved up, become more merciful and wiser. Survive — to live over — to outlive. The true survivor — would n't you like to see him — see her — see *us*, Molly?"

"Yes," said Molly soberly. "We are a long way off."

Christopher assented. "True enough. And, thank Heaven! the true survivor will always vanish toward the truer yet. But I don't know — it seems to me — the twentieth century might catch a faint far glimpse of our lineaments! I am madly, wildly, rashly optimistic for the twentieth century — even when I remember how optimistic they were fifty years ago! Who could help being optimistic on such an afternoon? Look at the gold on the green!"

The barrel-organ played an old, gay dance.

"Do you suppose," said Molly, "that, in Merry England, the milkmaids and shepherdesses danced about a maypole at thirty-two? For that's just exactly what I should like to do this minute! How absurd to be able to climb the Matterhorn, and then not to be let go out there and dance on that smooth bit of green!"

"You might try it. Only I would n't answer for the conduct of the policeman by the tree. And if you're arrested, we can't dine to-night with Roger Michael."

Roger Michael lived in a small, red, Georgian house in Chelsea. Her grandparents had lived here, and her parents, and she had been born here, nearer fifty than forty years ago. It had descended to her, and she lived here still. She had an

old housekeeper and a beautiful cat, and two orphan children who were almost the happiest children in that part of the world. She always kept children in the house. There were a couple of others whom she had raised and who were out in the world, doing well, and when the two now with her were no longer children she would find another two. She did not believe in orphan asylums. She herself had never married.

She remembered George Eliot, and she had known the Rossettis, and more slightly the Carlyles. Now in her small, distinguished house, with its atmosphere of plain living and high thinking, fragrant and sunny with kindliness and good will, she set her table often for her friends and drew them together in her simple, old-fashioned, book-overflowing drawing-room. Her friends were scholars, writing and thinking people, and simply good people, and any one who was in trouble and came to her, and many reformers. She was herself of old, reforming stock, and she served humanity in all those ways. She had met and liked the Josslyns when she was in America years before, and when they wrote and told her they were in London she promptly named this evening for them to come to Chelsea.

They found besides Roger Michael a scientific man of name asked to meet Christopher, a writer of plays, a writer of essays, a noted Fabian, and as noted a woman reformer. The seventh guest was a little late. When she came, it was Hagar Ashendyne.

"What an unexpected pleasure!" said the Josslyns, and meant every word of it. "How long since that summer at the New Springs? Almost nine years! And you've grown a great, famous woman —"

AT ROGER MICHAEL'S

"Not so very great, and not so very famous," said Hagar Ashendyne. "But I'm fortunate enough — to-night! You're a wind from home — you mountain-climbing, divine couple! The Bear's Den! Do you remember the day we climbed there?"

"Yes!" said Molly; "and Judge Black waiting at the foot. Oh, I am glad to see you! We did not dream you were in London."

"We — my father and I — have been here only a little while. All winter we were in Algeria. Then, suddenly, he wanted to see the Leonardos in the National."

Her voice, which was very rich and soft, made musical notes of her words. She was subtly, indescribably, transfigured and magnified. She looked a great woman. While she turned to greet others in the room, one or two of whom seemed acquaintances of more or less old standing, Molly and Christopher were alike engaged in drawing rapidly into mind what they knew of this countrywoman. They knew what the world knew — that she was a writer of short stories whose work would probably live; that her work was fabulously in demand; that it had a metaphysical value as well as a clutching interest. They knew that she was a world-wanderer, sailing here and there over the globe with a father whose insatiable zest for life crutches and wheelchair could not put under. It was their impression that she had not been in America more than once or twice in a number of years. They read everything she published; they knew what could be known that way. They had that one summer's impression and memory. She was there still; she was that Hagar Ashendyne also, but evolved, enriched. . . .

Roger Michael never had large dinner-parties, and the talk was oftenest general. The fare that she spread was very simple; it was enough and good; it gained that recognition, and then the attention went elsewhere. The eight at the round table were, through a long range, harmoniously minded; half, at least, were old friends and comrades, and the other half came easily to a meeting-place. Thought, become articulate with less difficulty than usual, wove with ductileness across and across the table. There sounded a fair deal of laughter. They were all workers here, and, necessarily, toward many issues, serious-minded enough. But they could talk shop, and one another's shop, and shop of the world at large, with humour and quick appreciation of the merrier aspects of the workroom. At first, naturally, in a time of public excitement, they talked the war in Africa, and the sick longing the country now felt for peace, and the general public foreboding, undefined but very real, that had taken the place of the old, too-mellow complacency; but then, as naturally in this company, the talk went to underlying, slow, hesitant movements, evolutionary forces just "a-borning"; roads that people such as these were blazing, and athwart which each reactionary swing of the pendulum brought landslides and floods enough, mountains of obstruction, gulfs of not-yet-ness. But the roadmakers, the pioneers, had the pioneer temper; they were spinning ropes, shouldering picks, stating to themselves and one another that gulfs had been crossed before and mountains removed, and that, on the whole, it was healthful exercise. They were incurably hopeful, though at quite long range, as reformers have to be.

The Fabian told a mirth-provoking anecdote of a Tory candidate. The scientific man, who possessed an imagination and was a member of the Society for Psychical Research, gave a brief account of Thomson's new Theory of Corpuscles, and hazarded the prediction that the next quarter-century would see remarkable things. "We'll know more about radiation — gravity — the infinitely little and the infinitely big. And then — my hobby. There's a curious increase of interest in the question of a Fourth Dimension. It's a strange age, and it's going to be stranger still — or merely beautifully simple and homecoming, I don't know which. Science and mysticism are fairly within hailing distance of each other." The talk went to Christopher's investigation, and then to mountain-climbing, and Cecil Rhodes's Will, and Marconi's astonishing feat of receiving in Newfoundland wireless signals from a station on the English coast, and M. Santos-Dumont's flight in a veritable airship. The writer of essays, who was a woman and an earnest and loving one, had recently published a paper upon a term that had hardly as yet come into general use — *Eugenics;* an article as earnest and loving as herself. Roger Michael had liked it greatly, and so had others at the table. Now they made the writer go over a point or two, which she did quietly, elaborating what she had first said.

Only the writer of plays — his last one being at the moment in the hands of the censor — chose to be strangely, deeply, desperately pessimistic. "I am going," he said, "to quote Huxley — not that I could n't say it as well myself. Says Huxley, 'I know of no study which is so unutterably saddening as that of the evolution of humanity.... Out of

the darkness of prehistoric ages man emerges with the mark of his lowly origin strong upon him. He is a brute, more intelligent than other brutes; a blind prey to impulses which, as often as not, lead him to destruction; a victim to endless illusions which make his mental existence a terror and a burthen and fill his physical life with barren toil and battle. He attains a certain degree of comfort and develops a more or less workable theory of life . . . and then for thousands of years struggles with varying fortunes, attended by infinite wickedness, bloodshed, and misery, to maintain himself at that point against the greed and ambition of his fellow-men. He makes a point of killing and otherwise persecuting all those who first try to get him to move on; and when he has moved a step farther, foolishly confers *post-mortem* deification on his victims. He exactly repeats the process with all who want him to move a step yet farther.' — That," said the writer of plays, "is what happens to brains, aspiration, and altruism in combination — rack and thumbscrews and auto-da-fés, and maybe in five hundred years or a thousand a picture skied by the Royal Academy — 'Giordano Bruno going to the Stake,' 'Galileo Recanting,' 'Joan of Arc before her Judges.' My own theory of the world is that it is standing on its head. Naturally it resents the presence of people whose heads are in the clouds. Naturally it finds them rather ridiculous and contrary to all the proprieties, and violently to be pulled down. Moral: keep your brains close to safety and the creeping herb."

"I think that you worry," said the Fabian, "much too much about that play. I don't believe there's the slightest prospect that he'll think it fit to be produced."

AT ROGER MICHAEL'S

The woman reformer was talking with Molly. "Yes; it's a long struggle. We've been at it since the 'fifties — just as you have been in America. A long, long time. The Movement in both countries is a grey-haired woman of almost sixty years. We've needed what they say we have — patience. Sometimes I think we've been too patient. You younger women have got to come in and take hold and give what perhaps the older type could n't give — organization and wider knowledge and modern courage. We've given the old-time courage all right, and you'll have to have the patience and staying qualities, too; — but there's needed now a higher heart and a freer step than we could give in that world that we're coming out of."

"I think that I've always thought it right," said Molly, "but I've never really come out and said so, or become identified in any way. — Of course, it is n't thinking so very positively if you have n't done that —"

"It is like that with almost every one. Diffused thought — and then, suddenly one day, something happens or another mind touches yours, and out of the mist there gathers form, determination, action. You're all right, my dear! Only, I hope when you go home you will speak out, join some organization — That is the simple, right thing that every one can do. Concerted effort is the effort that tells today."

"Are you speaking," asked Hagar Ashendyne, "of the Suffrage Movement?"

They were back in the drawing-room, all gathered more or less closely around a light fire upon the hearth, kindled for the comfort of Americans who always found England "so

cold." It softened and brightened all the room, quaint and old-fashioned, where, for a hundred years, distinguished quiet people had come and gone.

"Yes," said the older women. "Are you interested?"

"Yes, of course —"

She had not spoken much at dinner, but had sat, a pearl of listeners, deep, soft eyes upon each discourser in turn. There was in the minds of all an interest and curiosity regarding her. Her work was very good. She had personality to an extraordinary degree.

Now she spoke in a voice that had a little of the Ashendyne golden drawl. "I have been — in the last eight years — oh, all over! Europe, yes; but more especially, it seems to me, looking back, the Orient. Egypt, all North Africa, Turkey and Persia, Japan and India. Yes, and Europe, too; Greece and Italy and Spain, the mid-Continent and the North. Around the world — a little of Spanish America, a little of the Islands. Sometimes long in one place, sometimes only a few days.... Everywhere it was always the same.... The Social Organism with a shrivelled side."

The writer of plays was in a mood to take issue with his every deepest conviction; also to say banal things. "But are n't American women the freest in the world?"

Hagar Ashendyne did not answer. She sat in a deep armchair, her elbow upon the arm, her chin in her hand, her eyes dreaming upon the fire....

But Christopher entered the lists. "'Freest' — 'freest'! Yes, perhaps they are. The Italian woman is freer than the Oriental woman, and the German woman is freer than the Italian, and the English woman is freer than the

German, and the American is freer than the English! But what have they to do with 'freer' and 'freest'? It is a question of being free!"

"Free politically?"

"Free in all human ways, politically being one. I do not see how a man can endure to say to a woman, 'You are less free than I am, but be satisfied! you are so much freer than that wretch over there!'"

Hagar rose. Her eyes chanced to meet those of the man who had talked physics and mysticism. "We shan't," she said, "get into the Fourth Dimension while we have a shrivelled side. We can't limp into that, you know." She crossed the room and stood before a portrait hung above a sofa. "Roger Michael, come tell me about this Quaker lady!"

She left before ten, pleading an early rising for work that must be done. And Molly and Christopher would come to see her? She might be a month in London.

Christopher and the Fabian saw her into her cab, and she gave each her hand and was driven away. "That," said the Fabian, as they turned back to the house, "is a woman one could die for."

It was a long way to the hotel where the Ashendynes were staying. A mild, dark, blurred night; street lights, houses with lights and darkened houses, forms on the pavement that moved briskly, forms that idled, forms that went with stealthiness; passing vehicles, the horses' hoofs, the roll of the wheels, the onward, unfolding ribbon of the night. The air came in at the lowered window, soft and cool, with a hint now of rain. Hagar was dreaming of Gilead Balm. Up

over the threshold had peered a childhood evening, and she and Thomasine and Maggie and Corker and Mary Magazine played ring-around-a-rosy, over the dewy grass until the pink in the west was ashes of roses and the fireflies were out.

CHAPTER XXII

HAGAR IN LONDON

"I HAVE been re-reading Humboldt," said Medway Ashendyne. "What do you say, Gipsy, to risking a South American Revolution? Venezuela — Colombia — Sail from New York in September — and if you wanted ten days at Gilead Balm —"

Their drawing-room looked pleasantly out over gardens; indeed, so closely came the trees, there was a green and shimmering light in the room. It was May, and the sounds of the London streets floated pleasantly in at the open windows with the pleasant morning breeze. The waiter had taken away Medway's breakfast paraphernalia. Hagar had breakfasted much earlier. Thomson stood at the back of the room arranging upon a small table, which presently would be moved within reach of Medway's hand, smoking apparatus, papers, magazines, and what not. That eight-years-past prolonged sojourn and convalescence in Egypt had produced a liking for Mahomet, and Medway had annexed him as he annexed all possible things that he liked and that could serve him. Mahomet, speaking English now, but still in the costume of the East, had just brought in a pannier of flowers. They were all over the room, in tall vases. "Too many," said Hagar's eyes; but Medway who, when he was in search of the rarefied pleasure of adventure and novelty in strange and barbarous places, could be as ascetic as a red Indian on the

warpath, loved, when he rocked in the trough of the waves, to rock in a bower.

"Cartagena would be our port. There's a railroad, I believe, to Calamar. Then up the Magdalena by some kind of a steamboat to Giradot. Then get to Bogotá as best we might. There's an interesting life there, eight thousand feet above the sea, with schools and letters, and governments in and governments out, and cool mountain water running downwards through the city, and the houses built low because of the earthquakes. Let us go up the Magdalena and across to Bogotá, Gipsy!"

He sat in the wheel-chair he had himself designed, a wonderfully light and graceful affair, — considering, — with wonderful places alongside and beneath for wonderful things. His crutches were there, slung alongside, ready to his hand, and wicker detachable receptacles for writing-things and sketching-block and pencils and the book he was reading and so forth. Where he travelled now, the wheel-chair must travel. He was good with crutches for a hundred paces or two; then he must sit down and gather force for the next hundred. He suffered at times — not at all constantly — a good deal of pain. But with all of this understood, he yet looked a vigorous person, — fresh, hale, well-favoured, with not a grey hair, — a young man still.

"Bogotá," he said, "An archiepiscopal see — universities, libraries, and a botanic garden. Shut-in and in-growing meridional culture, tempered by revolutions. By all means let us go to Bogotá, Gipsy!"

Hagar smiled, sat without speaking, waiting, her eyes upon Thomson putting the last touches to the table, and

Mahomet thrusting long-stemmed irises into the vases, the faces of both discreetly masking whatever interest they might feel in the proposed itinerary.

When, after another minute or two, they were gone from the room, "Were you waiting for them to go? Why, who keeps anything from Thomson? He knows my innermost soul. I told him this morning I was thinking of South America."

Hagar rose, and with her hands behind her head, began slowly to pace the large room. "Bogota *qua* Bogotá is all right. You've the surest instinct, of course, when it comes to matching your mood with your place. You're a marvel there, as you are in so many ways, father! And Thomson and Mahomet would like it, too, I think."

"Do you mean that you won't like it?"

"No. I should like it very much. But I am not going, father."

Medway made an impatient movement, "We have had this before —"

"Yes, but not so determinedly. . . . Why not agree that the battle is over? It *is* over."

"And you rest the conqueror?"

"In this — yes."

"I could see," said Medway, "some point in it if the existence you lead with me made the fulfilment of your undoubted talent — your genius, perhaps — impossible. But you write wherever we go. You work steadily."

"Yes," said Hagar, "but the work by which you live is not all of life."

"It seems to me that you have touched life at a good many points in these eight years."

"Being with you," said Hagar, "has been a liberal education." She laughed with soft, deliberate merriment, but she meant what she said. From a slender green vase she took an iris, and coming to the wheel-chair knelt down and drew the long stalk through the appropriate buttonhole. "You must have as large a bouquet as that!" she said. "Yes, a university and a training-ship! I can never be sufficiently grateful!"

They both laughed. "Well, you've paid your way!" he said; "literally and metaphorically. I suppose two gratitudes cancel each other —"

"Leaving an understanding friendship." She grew graver. "A good deal of love, too. I want you to realize that." She laughed again. "I do not always approve you, you know, but, thank God! I can love without always approving!"

Medway nodded. "I like a tolerant woman."

She rose and stood, regarding him with a twisted smile, affectionate and pitying. "I think that you are a fearfully selfish man — to quote Stevenson, quoted by Henley, 'an unconscious, easy, selfish person.' And I think that, of your own brand, you have grit and pluck and stamina for twenty men. There's no malice or envy in you, and you're intellectually honest, and you can be the best company in the world. I am very fond of you."

"Are n't you the selfish person not to be willing to go to Bogotá?"

"Perhaps — perhaps —" said Hagar Ashendyne, "but I am not willing."

"What is it that you do want?"

"That is the first time you have asked me that. . . . Wandering is good, but it is not good for all of life. I want to

return to my own country and to live there. I want to grow in my native forest and serve in my own place."

"To live at Gilead Balm with Bob and Serena?"

"No; I do not mean that precisely." Hagar pushed back her heavy hair. "I have n't thought it out perfectly. But it has grown to be wrong to me, personally, to wander, wander forever like this — irresponsible, brushing life with moth wings. . . . If I saw any end to it . . . but I do not —"

"And you wish to cut the painter? This comes," said Medway, "of the damned modern independence of women. If you could n't write — could n't earn — you 'd trot along quietly enough! The pivotal mistake was letting women learn the alphabet."

"I could always have taken a position as housemaid," said Hagar serenely. "You can't make me angry, and so get the best of me. And you like me better, knowing the alphabet, and there's no use in your denying it. . . . If only you would conceive that it were possible for you to return to America, to take a house, to *live* there. And still you could travel — sometimes with me, sometimes without me — travel often if you pleased and far and wide. . . . Would it be so distasteful?"

"Profoundly so," said Medway. "It is idle to talk of it. I should be bored to extinction. — What is your alternative?"

"I shall be glad to spend three months out of every year with you."

"Is that your last word?"

"Yes."

"Suppose you do not begin the arrangement until next year? Then we can still go to Bogotá."

"Are you so wild to go to Bogotá?"

"All life," said Medway, "is based upon compromise."

Hagar, pacing to and fro, in her soft dull-green cotton with its fine deep collar of valenciennes, stopped now before the purple irises and now before the white. "Had I not appeared by your bedside in Alexandria, eight years ago, had I not been at hand during that convalescence for you to grow a little fond of, you would have, all these years, taken Thomson and Mahomet and gone to every place where we have gone, just the same, — just the same, — and with, I hardly doubt, just as full enjoyment. If you had not liked me, you would, with the entirest equanimity, have bidden me good-bye and seen me return with grandfather to Gilead Balm, and you would have travelled on, finding and making friends, acquaintances, and servants as you do to so remarkable a degree, missing not one station or event. If I died to-day, you would do every proper thing — and in the autumn proceed to Bogotá."

"Granting all that," said Medway, "it remains that I find and have found in the past a pleasure in your company. — I am going to remind you again, Gipsy, that all life is compromise."

Hagar, at the window, in the green and shimmering light like the bottom of the sea, leaned her forehead against the sash and looked across into the leafy gardens. Children were there, playing and calling. A young girl passed, carrying smart bandboxes; then an old woman, stooping, using a cane, with her a great dog and a young woman in the dress of a nurse. The soft rumble and crying of the city droned in together with a bee that made for the nearest flower. Hagar

turned. "I will go with you for another year, father, but after that, I will go home."

"No end of things," said Medway, "can happen in a year. I never cross a bridge that's three hundred and sixty-five days away. — I'd advise you, if you have n't already done so, to read Humboldt."

He had a luncheon engagement, and at twelve vanished, Thomson and Mahomet in attendance. This drawing-room, his large chamber and bath, an adjoining room with its own entrance for Thomson, quarters somewhere for Mahomet, were his; he paid for them. Hagar had two rooms, her bedroom, and a much smaller drawing-room. They were hers; she paid for them. After the first two years she had assumed utterly her own support. Medway had shrugged. "As you choose —"

Now, in her own rooms, she wrote through the early afternoon, then, rising, weighted the sheets of manuscript with a jade Buddha, put on a street dress, and went out into the divine, mild May weather. She knew people in London; she had acquaintances, engagements; but to-day was free. She walked a long way, the air was so sweet, and at last she found herself before Westminster Abbey. After a moment's hesitation she went in. The great, crowded place was empty, almost, of the living; a few tourist figures flitted vaguely. She moved slowly, over the dust of the dead, between the dull, encumbering marbles, until she reached a corner that she liked. Sitting here, her head a little thrown back against the stone, her soul opened the gates of Quiet. Rose and purple light sifted down from the great windows; all about was the dim thought of dead kings and queens, soldiers, poets, men of

the state. In the organ loft some one touched the organ keys. A few chords were sounded, then the vibration ceased.

Hagar sat very still, her eyes closed. Her soul was searching, searching, not tumultuously, but quietly, quietly. It touched the past, here and there, and lighted it up; days and nights, dreams, ambitions, aspirations. Some dreams, some ambitions were in the way of fulfilment. Medway Ashendyne was within her; she, too, knew *Wanderlust* — "for to admire an' for to see." She had wandered and had seen. She would always love to wander, crave for to see and to admire. . . . To write — to earn — to write. . . . Her lips curved into the slightest smile. The old days and nights when she had wondered, wondered if that would ever come to pass, if it ever *could* come to pass! It had come to pass. To do better work, and always better work — that was a continuing impulse; but it was still and steady now, not fevered. . . . Her mind swept with wider wings. To know, to learn, to gain in content and in fineness, to gather being, knowledge, wisdom, bliss — to gather, and then from her granary to give the increase, that was the containing, the undying desire. She had a strange passion for the future, for all that might become. She was sensitive to the wild and scattered motion within the Whole, atom colliding with atom, blind-man's-buff — all looking for the outlet into freedom, power, glory; all groping, beating the air with unclutching hands, missing the outlet, it was perhaps so small. She thought of an expression of George Meredith's, "To see the lynx that sees the light." To see it — to follow — to help find the opening. . . . What was needed was direction, and then unity of movement, the atoms in one stream, resistless. That, when the lightning bolt

went across the sky, was what happened; corpuscles streaming freely, going side by side, not face against face, not energy dashing itself endlessly against energy. It was all one, physical and psychic; power lay in community of understanding.... Public Opinion, community of understanding, minds moving in a like direction, power resulting, power to accomplish mighty and mightier things.... Then do your best to ennoble Public Opinion. Do not think whether your best is little or great; do your best....

She opened her eyes upon the light sifting down from the rose windows. It was shortening, the shaft; evening was at hand in the church of the great dead. Many who lay there had had within them a lynx that saw the light and had tried to bring the mass of their being to follow; many had ennobled the world-mind, one this way and one that; each had brought to the vast granary his handful of wheat. Ruby and amethyst, the light lay athwart the pillars like an ethereal stair. The organist touched the organ again. A verger came down the aisle; it was closing time. Hagar rose and went out into what sunshine lay over London.

CHAPTER XXIII

BY THE SEA

But after all they did not go to Bogotá. That autumn a revolution flared up in Colombia. Medway considered the matter, but finally shrugged and shook his head. His point gained and Bogotá prepared for, he gave the idea up "for this time" with entire nonchalance. But they were in New York by now, and something must be done. He went with Hagar to Gilead Balm for two weeks — going home for the second time in eight years. The first time had been perhaps two years after his accident. Old Miss had cried out so to him to come, had so passionately besought him to let her see him again, and Hagar had so steadfastly supported her claim, that at last he gave in and went. He spent two months at Gilead Balm, and he had been gracious and considerate to all the family with an extra touch for his mother. But when he went away he evidently considered that he had done all that mortal could ask, and though Old Miss continued to write to him every three months, and though she always said, "And when are you coming home?" she never so urged the matter again.

Now he went with Hagar down through the late autumn country to his birthplace, and stayed for a fortnight, as unruffled, debonair, and dominant as before. The Colonel and Old Miss had each of them years enough now; as age is counted they were old. But each came of a long-lived stock,

and they held their own to a marvel. Hagar could see the difference the years had made, but there was no overwhelming difference. The Colonel did not ride so far, and Old Miss, though she jealously guarded her key-basket and abated authority not a jot, was less active than of old. She had grown rather deaf, and Medway avoided much conversation with her. Captain Bob was more broken; he looked older than the elder brother. Luna was dead long ago, and he had another hound, Lisa. He was fond of Lisa and Lisa of him, but Lisa was not Luna, and he was very faithful to Luna's memory and always telling stories of her intelligence and exploits. Miss Serena had changed very little. Mrs. Green was dead, and the overseer's house at the moment stood empty. Car'line was dead, too, but Mary Magazine kept house for Isham. Hagar walked down to the ferry, and she and Mary Magazine talked about the old flower dolls and the hayloft, and the cavern by the spring. She walked by herself upon the ridge, and sat under the cucumber tree, and went to the north side, and, leaning against the beech, which had grown to be a good-sized tree, looked down the long slope to the hollow and streamlet, the sunken boulder and thicket.

The two weeks passed. Indian summer held throughout November. "This dreamy place makes you disinclined to vigorous planning," said Medway. "I think, Gipsy, that we will drift on down through Florida, and cross to Cuba."

This year there were evidently cross-winds. At Palm Beach, Medway came upon an old acquaintance, associate of ancient days in Paris, an artist with whom he had rambled through Fontainebleau forest and drunk good wine in

Barbizon. For years each had been to the other a thin memory; now, almost with violence, the attraction renewed itself. But the artist was not going to Cuba; he was going to the Bahamas. He had a commission to paint a portrait, and his subject, who was a Chicago multi-millionaire, had elected to winter at Nassau and to give the sittings there. Commissions evidently did not come every day to the artist, who was post-post-impressionist, and he was quite willing to go to Nassau, jubilantly so, in fact. He said that, for once, light was going to be thrown upon the multi-millionaire.

Medway strove to persuade him to forfeit the commission and go to Cuba; and he was even, it was evident, prepared to make the proceeding no financial loss. But the artist stated explicitly that he had a sense of honour and could not leave the Chicagoan in the lurch; besides he wanted to paint that portrait. "Come and see me do it, old fellow! I'm going to take a reasonable small house with a garden, knock out partitions and make a studio. One commission leads to another:— Light on the whole bunch. — Oh, I'm told that you've got a million, too! How the devil did you get into that galley?" In the end, rather than part with the old companion, Medway exchanged Cuba for the Bahamas.

Thomson found a house that he thought would answer. Hagar went with him to see it, and agreed that it would. Both spoke entirely with reference to Medway. Back at the great hotel, she explained its advantages. "There's a pleasing, tangled garden, palms and orange trees and hibiscus, and a high garden wall. The verandahs, upper and lower, are wide. You get the air, and you have, besides the town, a

BY THE SEA

great sweep of this turquoise sea. There's only a short, quiet, easy street between the house and Mr. Greer's studio. I think that it will answer."

It answered very well as Medway granted. He and Greer were much together. The Chicagoan, when he arrived, proved to be a good fellow, too, earnest in his endeavour to play blotting-paper to culture. Greer gathered from the hotel several congenial Americans. Medway, who always had the best of letters, provided an Englishman or two from the more or less stationary Government set. The studio became practically his and Greer's in common; they were extraordinarily good talkers and they rolled wonderful cigarettes and Mahomet made *café fort*. A violinist of some note was stopping at the hotel, and he and his violin added themselves to the company. When a traveller who knew Lhasa, Bangkok, and Baalbek, Knossos and Kairwan and Kandy, was joined to the others, it became evident that Medway had made his circle and found the winter's entertainment.

He had never made greatly too large demand upon Hagar's hours. He was full of resources, supple in turning from person to person of all his varied acquaintance in varied lands, moderately appreciative, too, of the value of solitude. On her side she would have stood, had there been need, for time to herself. It was to her the very breath of life. But there was never extreme need. She was within call when he wanted to turn to her, and that was sufficient. But this winter, it was evident, she would have her days to a greater extent than usual in her own hand. There was never any accounting to him for her days apart from him; almost from the first there had obtained that relation of personal liberty. To do

him justice he felt no desire to exact such an accounting, and had he tried to do so he would have failed.

Hagar saw that she was going to have time, time this winter; and, what she liked, they would be long enough in one place to allow her to work with advantage. There would be visitors, invitations — already they had begun: — Medway would wish to give, now and then, a garden-party, a dinner-party. But life would by no means run to an exchange of visits and entertainments. Father and daughter had alike, in this direction, the art of sufficient but not too much. Anything beyond a certain, not-great amount wearied and exasperated him, wearied and saddened her. All that would be kept in bounds. Hagar, pacing the garden, saw quiet days, surcharged with light.

She was thinking out her half-year's work. A volume of stories, eight or ten in all — such a subject and such a subject; such or such an incident, situation, value; such a man, such a woman. She knew that her work was good, that it was counted very good, counted to her for name and fame. All that was something to her; rather, it was much to her; but only positively so, not relatively. It could by no means fill her universe. For years she had taken now this, now that filament-like value and with skill and power had enlarged, coloured, and arranged it so that her great audience might also see; and she had done, she thought, service thereby; had, in her place, served beauty and knowledge. But the hunger grew to serve more fully. Knowledge, knowledge — wisdom, wisdom — action. . . .

Hagar moved to a stone seat that commanded an opening in the garden wall. She looked out, down and over a short,

steep, dazzling white street and a swarm of low, pale-coloured, chimneyless houses, with the green between of tropic trees, to the surf upon the coral shore and the opaque, marvellous blue of the surrounding sea. The creative passion was upon her, but it moved nowadays as it had moved with many an idealist-realist before.... To mould living material, to deal with the objective, to deal with the living world, not the world of bright-hued shadows; to see the living world lighten to the dawn, see the dull hues brighten, see the beautyless become beauty and beauty grow vivid, to see all the world lift, lift toward the golden day, to see the race become the over-race.... She would have died for that and died to help. She laid her arms along the stone and her head upon them. "And yet I do not help, or not with all that is in me. I sit here to one side and spin fancies."

She rose, and put on a shady hat, and going out into the dazzling white street moved down it, and then by another across for some distance to the white road by the sea. Her back to the town, she walked on. A few scattered palms, the sea-wall; then where it ended, an edging tangle of the hard green leaves of the sea-grape; outside of that, low fantastically worn coral rock and the white dash and spray of the water. Though the sun was high and the sky intense and cloudless, a wind blew always; the air was dry and the day not too warm. There was hardly anyone upon the road. She met a cluster of negro children and talked with them a little. A surrey, of the type that waited on the street near the great hotels, passed her, driven sleepily by a sleepy negro, within it a large man in white. When it was gone in a little cloud of white dust there was only the long road, and the

unyielding monotonous green of the sea-grape, and the water thundering in an undertone. Hagar turned aside, broke through the grape, and came down to the edge of the surf. There was a rock hollowed until it made a rude chair. She sat down and looked out to sea. On one hand, across the harbour mouth, rose from a finger-narrow sliver of land, a squat white lighthouse; but turn a little and look away and there was only the open sea, unimaginably blue, azure as the sky. The soft wind blew, the surf broke in low thunder. Hagar, her chin upon her hand, sat for a long time, very still.

"How good is man's life, the mere living—"

It seemed true enough, sitting there in the sunshine, in the heart of so rich a beauty. She agreed. How good it was, how good it often was! — only, only.... The line was true, perhaps, of all at some time, of some at all times — though she doubted that — but never of all at all times. It was true of a host at very few times; it was never so true of any as it might be.

"How good is man's life, the mere living! — how fit to employ
All the heart and the soul and the senses forever in joy!"

Who felt that? — Not even the poets immemorial who so sang — sang often in sadness of heart! They felt only the promise that the future cast before her.

Association of ideas was so strong and quick within her that she was apt to call up images, not singly, but in series and sequences. Her mind swept away from the West Indian sea. She saw her mother at Gilead Balm, beating her wings against invisible bars; the woman on the packet-boat, racked with anxiety, her child in her arms, begging her way to her

BY THE SEA

sick mate; the figure of the convict at the lock, Thomasine in the silk mill, Omega Street.... She thought of Rachel and her married life, of things which she had heard at the Settlement, and the pain in Elizabeth Eden's eyes as she told them. She thought of Eglantine and its insidious sapping, sapping ... of Miss Serena and her stunted, small industries and too-obedient soul. She thought of Miss Bedford, and of Francie Smythe, and of Mrs. LeGrand. She seemed again to hear Mrs. LeGrand upon Roger Michael. She thought of the Bishop and the day he passed sentence upon a child for reading a great book. She saw the thicket back of the ridge, and dogs set by a human being upon a human being. She saw winter streets in New York, and the light shining on the three balls of the pawnbrokers, and a bread-line, and men and women huddled on park benches while the wind shook the leafless trees. She saw Wall Street and St. Timothy's. Her mind passed overseas. Russia — three summers before they had been there. Medway, though he laughed at her, had agreed to a stepping aside which she proposed. She wished to see Tolstoy. It was always easy to him to arrange such things, and it had ended in their being invited for two days to Yásnaya Polyána. She saw again the old man and heard his slow words. *Non-resistance* — but his mind, through his pen, was not non-resistant! It acted, it scourged, it fought, it strove to build and to clear the ground that it might build. He deceived himself, the tremendous old man. He thought himself quietist as Lao-Tzu, but there in that bare, small study he cried, *Allah! Allah!* and fought like a Mohammedan. Russia and the burden of Russia ... the world and the burden of the world. She thought of the East, and

now her mind entered Zenanas — of India, and it was the child marriages; of Turkey, Egypt, Algeria, Morocco, and it was the veiled women, proclaimed without souls. She saw the eunuchs at the gate. Away to Europe — and she saw that concept grading away, but never quite gone, never quite gone. Woman as mind undying, self-authoritative and unrelated, the arbiter of her own destiny, the definer of her own powers, with an equal goal and right-of-way — few were the earthly places where that ray fell!

"How good is man's life, the mere living —"

"With vast modifications and withdrawals, with dross and alloy," said Hagar. "But it might be — O, God, it might be! Lift all desire and you lift the whole. Lift the present — steady, steady! — and know that one day the future will blossom. And a woman's work is now with women. Solidarity — unification — woman at last for woman."

CHAPTER XXIV

DENNY GAYDE

A FEW days after this she grew tired one morning of working. At ten o'clock she put away paper and pencil, pen and ink, letters and manuscript, and went out, first into the garden, and then through the gate in the wall into the high white light of the street and the pale-coloured town. Few were abroad in this section; she gave a friendly nod to those she met, but they were not many — an old negress carrying chickens, a few slow wagons, a priest, a young girl and boy, white-clad, with tennis rackets; two or three others. The street swam in light, the blue vault above sprang intense, there was just enough air to keep away languor. She turned into the grounds of the old, closed Royal Victoria Hotel. Here was shade and greater freshness. She sat down on the rock coping of the driveway; then, as there was no one about, lay down upon it pillowing her head on her arms. Above her was a tall, tall tree, and between the branches the deep and vivid blue. It seemed so near, it was as though with a little upward effort you might touch a sapphire roof. Between the leaves the sun scattered gold sequins. They lay upon her white skirt, the hat she had discarded, her arms, her hair. She looked sideways watching a chameleon, burnished and slender, upon the wall below her. It saw her at last and with a jerk of its head scuttled away. Hagar laughed, sat up and stretched her arms. Some neighbouring, one-storey house,

buried in foliage, possessed a parrot or cockatoo. She watched it now, on some hidden perch, a vivid splash of colour in the enfolding green, dancing about, chattering and screaming. Some curious, exotic fragrance came to her; she could not trace its source. "It's a morning for the gods!" she said, and walked slowly by winding paths downward through the garden to the street. Before her, seen through foliage, rose the curiously shaped building with a history where now was lodged the public library. She had visited it several times; she liked the place, which had a quaintness, and liked the way the air blew in through its deep windows; and where books were she was at home. She crossed the white street, entered and went up the stair past dusty casts, pieces of coral and sea-curios, and into the round room where English and American papers and magazines were spread upon a table. From this centre sprang, like short spokes, alcoves made by the book-stacks. Each of these divisions had its chair or two and its open window. The air came in coolly, deliciously. There were the librarian and two or three people standing or seated about the central table, — no one else in the cool, quiet place. Hagar, too, stood by the table for a while, turning over the January magazines, looking at the table of contents or glancing at some article or illustration. Catholicism versus Ultramontanism — Why Ireland is Disloyal — Drama of the Future — The Coal Strike and its Lessons — Labour and the Trusts — Labour and Capital — Municipalization of Public Services — The Battleship of the Future — The War against Disease — Tschaikowsky and Tolstoy — Mankind in the Making — Mendel's Law — The Advancement of Woman — The Woman who

Toils — Variation in Man and Woman — Genesis of the Æsthetic Categories — New Metaphysical Movement — Inversion of Ideas as to the Structure of the Universe — The World and the Individual. — After a while she left these and the table and moved to one of the alcoves. It was not a day somehow for magazines. The rows of books! Her gaze lingered with fondness upon them — this familiar title, this loved old friend and that. Finally she drew forth a volume of Keats, and with it sat down in the sweet air from the window.

> "No, no! go not to Lethe, neither twist
> Wolf'sbane, tight-rooted, for its poisonous wine —"

An hour passed. A man, who had come into the room a few minutes before, was standing, looking about him — evidently the first time he had been in the building.

The librarian joined him. "It's a pleasant old place, is n't it?" she said politely.

"It certainly is," answered the man. "But it's so curious with that narrow stair and these deep-set windows."

"Yes. You see it's the old jail. Once they kept men here instead of books."

There was a pause. Then the man said, "This is the nobler use, don't you think?"

"Oh," said the librarian; "but of course they were wicked men — that is, most of them. There was n't anything else to do with them."

"I see," said the man. He looked about him. "Well, it's sweet and clean and useful now at last!"

Some one called the librarian and she went away. The man moved on with slow steps from alcove to alcove. Hagar,

from her recess, watched him, fascinated. Her book had fallen upon the floor. With half of her mind she was again in a poor hall in New York on a winter night.... Five or six people entered the library together. They came between her and the man she was following with her eyes. When at last they moved from before her alcove, she saw him leaving the place. Before she could hastily rise and come out into the wider space he was out of the room upon the landing — he was going downstairs. She caught up the book from the floor, thrust it hurriedly into its place, and with a light and rapid step followed. He was at the foot of the stair when she reached the head.

"Oh," she called, "will you stop — will you wait?"

He stopped short, turned. She was halfway down the stair, which was not long. "I beg your pardon. Was it to me you were speaking?"

"Yes!" She came up with him — they stood together in the light-washed doorway. "I — You do not remember me." She put up her hand and took off her wide hat of straw and lace. "Do you, now?"

He gazed. "No — Yes! Wait.... Oh—h! You are the little girl again!"

They both laughed with pure pleasure. A soft, bright swirl of feeling enfolded the ancient doorway.

"Oh," she said, "I have so often thought of you!"

"Not oftener than I have thought of you.... You've always been like a quaint, bright picture and a piece of music in my mind. — I don't know your name."

"Hagar Ashendyne. — And I don't know yours."

"Denny Gayde.... I tried to find you in the crowd that

night — the night of the meeting, you remember — but you were gone."

"Yes. And for weeks after that night I used to think that perhaps I might meet you on the street any day. And then I went away."

The sun was dazzling where they stood. People, too, were coming down the stairs behind them.

"Let us go somewhere where we can talk," said Hagar; "the gardens over there — have you time?"

"I'm here on a holiday. I came yesterday. I don't know a soul and I was lonely. I've all the time there is."

They crossed the street, passed under an arch of blossoming vines, and entered the Royal Victoria's garden — deserted, cool, and silent as when Hagar had quitted it earlier in the morning. Built high above the ground, about the vast trunk of a vast silk-cotton tree was a square, railed platform reached by a flight of steps. A bench ran around it; it was a cool and airy perch, chequered with shadows of leaf and twig and with a sight of the azure sea. The two mounted the steps, and moving around the trunk to a well-shaded angle, sat down. No one at all seemed near; for solitude it was much like a tree house which, shipwrecked, they might have built on a desert island.

"Life's the most curious thing!" said Gayde.

"Is n't it? 'Curiouser and curiouser!' said Alice. "I was twelve years old that summer we shared the apple turnovers."

"We didn't share them. You gave me all. — I was nineteen."

"And then — how many years? — Nine, is n't it? — that night at that Socialist meeting, when you spoke —"

"What were you doing there? I asked about you — I got to know well many of the people who were there that night — but no one could identify you. And though I kept you in mind, and looked for you, too, I could never find you again."

"I was spending the winter in New York. That night we had missed the theatre. We walked down Fourth Avenue and across — we were seeing New York at night. A crowd was going into that hall, and we went in too —"

"I see."

"Not until I got home that night did I remember that I did not know your name.... And in a month I was upon the ocean, and I have been in America very little in all the years since. I am here this winter with my father.... And you?"

She regarded him with dark eyes, simple and serious and interested as the eyes with which as a child she had regarded him above her flower dolls. He was not hungry and haggard and fear-ridden as then, nor was he as he had been the night of the Socialist meeting, somewhat embarrassed and stumbling, strong, but piteous, too.... He was a little thin and worn, and looked as though he had been ill, she noted, but he was quiet, at ease, and assured. There needed no elaborate process in telling her things; to intuition she added a considerable knowledge of the world and of ways and means; to heart, intellect. One could do much in nine years; she knew that from personal experience. This man had added to native strength education, experience, poise, and significance. She might have said culture, only she had grown to dislike the word. He had not, evidently, attained to wealth as wealth is counted. In a region where the male visitor, though he might arrive in winter garments, promptly sloughed them

off for fine white flannels, he had not followed custom. It was true that he was not wearing a winter suit, but what was probably a last summer's one. It was not white — only a grey, light-weight business suit, ready-made and somewhat worn. His straw hat looked new. He was clean-shaven. His face was at once the face of the boy in the thicket, and the face of the workman talking out of bitter experience to other workmen, and a new face, too, — a judging face, ascetic rather than not, with eyes that carried a passion for something vaster than the flesh. "And you?" asked Hagar again.

But he had fallen into a brown study. "*Hagar Ashendyne* — You can't be — do you mean that you are — Hagar Ashendyne, the writer?"

"Yes, Hagar Ashendyne, the writer." She smiled. "It never occurred to me that you might read what I have written. Have you?"

"Yes, I have read what you have written — read it and cared for it greatly.... Well, all life's a strange encounter!"

"And that's true enough. And now will you tell me about yourself?"

His eyes smiled back at her. "Let me see — what is there to tell? That night in New York.... Well, after that night ... I was fortunate in the work I got, and I rose from grade to grade. I studied hard, every moment I could get. I read and read and read. I became secretary to a certain Socialist organization. I have been for some years a Socialist organizer, lecturer, and occasional writer. In the summer I am to take the editorship of a Socialist paper. Behold the short and simple annals of the poor!"

"How long are you going to be in Nassau?"

"A whole month. These last two years have been years of exacting, constant work, and there's a prospect of the same continuing. I thought I'd got my second wind — and then I came down suddenly. The doctor said that if I wanted to do the paper justice — and I do — I'd have to give it an editor who could sleep. So he and Rose packed me off."

"Rose?"

"My wife — Rose Darragh."

He spoke as though she would know the name. Indeed, it seemed to have for her some association; but it wavered like a dream; she could not fix it. She seemed to feel how long she had been away from America — out of touch — not knowing things, events, trendings. "Nine years," she said again, uncertainly; "so much happens in nine years."

"Yes," he said. "Personal life changes rapidly to-day — with everything more flexible, with horizons growing wider — and the age follows and changes and changes — changes and mounts. We are in for a great century. I'm glad to be alive!"

"Yes, I am, too." Presently she looked at her watch. It was luncheon-time. Would he not take it with her father and herself? No; he would not do that to-day; but leaving the great tree and the garden they walked together to the house. At the gate in the wall she said, "Come to see me here to-morrow morning, if you will. I should like you to come and go as you please."

"Thank you," he said, then, with emphasis, "*friend*. . . . That is what, when I was nineteen and afterwards, I called you in my mind."

"It's a good word — 'friend.' Let us use it still,"

"With all the will in the world. You are wonderful to me — Hagar Ashendyne."

"I am glad to have found you again, Denny Gayde."

That night, suddenly, before she slept, she placed the name Rose Darragh.... A feminist — A Socialist agitator and leader — a writer of vigorous prose — sociology — economics.... She seemed to see her picture in some magazine of current life — a face rich, alert, and daring, rising on a strong throat from a blouse like a peasant's.

CHAPTER XXV

HAGAR AND DENNY

THE afternoon sun yet made a dazzle of the white road. Infrequent trees cast infrequent shadows. It was warm, but not too warm, with an endless low wind. The tide was going out; there spread an expanse of iridescent shallows, and beyond a line of water so blue that it was unearthly. There was a tonic smell of salt and marsh. The wheels of the surrey, the horse's hoofs, brought a pleasant, monotonous, rhythmic sense of sound and motion.

"That is the shell house," said Hagar, breaking a long silence; "that small, small house with the boat behind. There you can buy throngs of things that come out of the sea — coral and sponges and purple sea-fans and wonderful shells."

"I walked out here last week. There's a sick child I know — a little cripple. I am going to take her a great box of the prettiest shells. She'll lie there and play with them in her dingy corner of the dingy room where all the others work, and maybe they'll bring her a little of all this.... God knows!"

The wheels went on. They passed the small house with a great lump of coral on one side of the door, and a tall purple sea-fan upon the other.

"I sometimes think," said Hagar, "that the trouble with me is that I am too general. My own sharp inner struggle was for intellectual and spiritual freedom. I had to think

away from concepts with which the atmosphere in which I was raised was saturated. I had to think away from creeds and dogmas and affirmations made for me by my ancestors. I had to think away from the idea of a sacrosanct Past and the virtue of Immobility; — not the true idea of the mighty Past as our present body which we are to lift and ennoble, and not Immobility as the supreme refusal to be diverted from that purpose, — but the Past, that is made up of steps forward, set and stubborn against another step, and Immobility blind to any virtue in Change. I had to think away from a concept of woman that the future can surely only sadly laugh at. I had to think away from Sanctions and Authorities and Taboos and Divine Rights — and when I had done so, I had to go back with the lamp of wider knowledge, deeper feeling, and find how organic and on the whole virtuous in its day was each husk and shell. The trouble was that in love with the lesser we would keep out the stronger day ... and there was everywhere a sickness of conflict. I had to think away from my own dogmatisms and intolerances. I'm still engaged in doing that. ... What has come of it all is a certain universal feeling. ... I'm not explaining very well what I mean, but — though I want to be able to do it — it is difficult for me to drive the lightning in a narrow track to a definite end. It's playing over everything."

"I see what you mean. You're more the philosopher than the crusader. Well, we need philosophers, too! ... I'm more, I think, the type that is sharpened to a point, that couches its lance for one Promised Land, which it believes is the key to many another. But I hold that it is better to move full-orbed, if you can."

"I do not know — I do not know," said Hagar. "I try to plunge with my whole mind into some political or social theory, but I fail. Even the slow drawing-up of the submerged capacities in woman, even the helping in that,—which is greater than would be the discovery of Atlantis, which is greater than almost anything else, — cannot bring the ends together. Name everything and there is so much besides!"

"There is such a thing," said Denny, "as going to the stake for what you know to be partial, only factors, scaffoldings, stairs to mount by. . . . Stairs and scaffoldings are necessary; therefore, die for them if need be."

"I agree there," answered Hagar.

The surrey had left the sight of the sea. The pale road stretched straight before them, going on until it touched the cobalt sky. On either hand stood growing walls, dense and thorny as those about the Sleeping Beauty's palace — all manner of trees, silver palm and thatch palm, tamarind, poison-wood and plum, ink-berry and jack-bush, bound all together with smilax and many another vine. At long intervals occurred an opening, a ragged space and a hut or cabin, with an odour, too languid-sweet, of orange blossoms, and a vision of black children. The walls closed in again sombrely. The road would have been a little dreary but for the sky and the sun and the jewel-fine air.

"I suppose," said Hagar, "that there is a certain Brahmin-like attitude to be overcome. I suppose that to take wallet and staff and go with the mass upon the day's march, encouraging, lifting, helping, pointing forward, bearing with the others, is a nobler thing than to run ahead upon your own path and cry back to the throng, 'Why are you not here as

well?' I suppose that... and yet there are times when I am Nietzschean, too. I can be opposites."

"Yes; that is what bewilders," said Denny. "To include contradictories and irreconcilables — to be both centripetal and centrifugal — to be in one brain Socialist and Individualist!... But the greatest among mankind have found themselves able. They have been farthest ahead, and yet they have always seemed to be in the midst."

The sun sank low, the white road grew pallid. "Better turn presently," said Hagar.

"When we get to that palm. How wonderful it stands against the sky! — I never thought that I should see palm trees."

When they came to it, the negro driver turned the horse. Roll of wheel and slow thud of hoofs they went dreamily back toward Nassau. The walls on either hand were darkening; the sky was putting on a splendid dress.

"Years and years now I have been away," said Hagar. "In the spring I am going home."

"Home to — to Gilead Balm?"

"At first, yes, I think... then, I do not know. I have been away so long. There are people in New York I want to see — old friends — women. Do you chance to know Elizabeth Eden?"

"Yes, I know her. She's one of the blessed." After a moment he said abruptly, "I want you to know Rose Darragh."

"Yes, I want to," said Hagar simply.

They came before long to the shell house. "Let us stop and get some shells."

Inside they had the place, save for the merchant of shells, to themselves. Right and left and all around were strewn the pearl and pink and purply spoils. All the sunset tints were here, and the beauty of delicate form — grotesqueries, too; nature in queer moods. It was pleasant to run the hands through the myriad small shells heaped in baskets, to weigh the sea-cushions and sea-stars and golden seafeathers, to admire rose coral and brain coral and finger coral, and hold the conch shells to the ear. Through the open door, too, came the smell and murmur of the near-by sea, and on the floor lay one last splash of sunlight. "Give me a shell," said Hagar, "and I will give you one. Then each of us will have something to remember the other by."

They gravely picked them out, and it took some minutes to do it. Then in turn each crossed to the merchant in his corner and paid the purchase price, then came back to the light in the doorway.

Denny held out a delicate, translucent, rosy shell. "It won't hold my gratitude," he said. "You'll never know.... I used to see you in the moonlight, between me and the bars. ... Somebody had cried for me, ... wept passionately. It helped to keep me human. I've always seen you with a light about you. This is your shell."

"Thank you. I shall keep your kind gift always," said Hagar. She spoke in a child's lyric voice, quaintly and properly, so precisely as she might have spoken at twelve years old that, startled herself, she laughed, and Denny, with a catch in his voice, laughed too. "Oh," she cried with something like a sob, "sixteen years to slip from one like that!" She held out a small purple shell. "This is yours, Denny

Gayde.... And I've thought of you often, and wished you well. If I did you, unknowing, a service, so you, unknowing, have done me a service, too. That summer morning, long ago — it shocked me awake. The world since then has been different always, more pitiful and nearer. Here's your shell. It won't hold my gratitude and well-wishing either."

They passed out between the coral and the sea-fans, entered the surrey, and it drove on. Now they were back by the sea. The tide was far out, the expanse of shallows vaster. The salt pools had been fired by the torch of the sky; they lay in reds and purples, wonderful. The smell of the sea impregnated the air and there blew a whispering wind. The town began to appear, straggling out to meet them, low chimneyless houses of the poorer sort. Men and women were out in the twilight, and children calling to one another and playing. The vivid lights had faded from sky and from wet sand and rock, shoal and lagoon, but colour was left, though it was the ghost of itself. It swam in the air, it gleamed from the earth. Warmth was there, too, and languor, and the melancholy of the gathering night. A dreamlike quality came into things — the children's voices sounded faint and far; only there were waves of some faint odour, coming now it seemed from gardens.... Now they were in the town and the sea was shut away.

"One half of my fairy month is gone."

"You are sleeping better?"

"Yes — much better.... Where shall we go to-morrow?"

"Leave it to to-morrow. Look at the star ... oh, beauty!"

When to-morrow was here they walked inland to Fort Fincastle, and then to the Queen's Staircase. Negro children

raced after them with some sweet-smelling yellow flower in their hands. "Penny, Boss!—Penny, Boss!—Penny, Boss!" When they were gone, and when two surreys filled with white-dressed hotel people vanished likewise, they had the Queen's Staircase to themselves. Broad-stepped, cut in the living rock, it plunged downward to the green bottom of the seventy-foot deep ancient quarry. Trees overhung it and yellow flowers, and there was a rich, green light like the bottom of the sea. Denny and Hagar sat upon a step a quarter of the way down.

"I do not know why," said Denny, "there should be so deadly a fear of upheaval. All growth comes with upheaval — surely all spiritual growth comes so. Growth by accretion means little. Growth from within comes with upheaval—what you have been transformed or discarded. A little higher, a little finer breaks the sod and grows forth so. The deadly fear should be of down-sinking — from the stagnant grow-no-farther-than-our-fathers-grew down — down.... Of course, the Woman Movement means upheaval and great upheaval — but that is a poor reason for condemnation.... As far as its political aspect is concerned, most open-minded men, Socialists and others, with whom I come into contact, admit the right and the need. Unless a man is very stupid he can see what a farce it is to talk of a democracy — government of the people, for the people, by the people — when one out of every two human beings is notoriously living under an aristocracy. And, of course, we who want an associative gain of livelihood, no less than an associative form of government, stand for her equality there.... But to me there is something other than all that in this upheaval. I cannot

express it. I do not know what it is, unless it is some faint, supernal promise.... It is as though the Spirit were again working upon the face of the waters." He paused, gazing upward at the sky above the wall of rock. "We are in for a deep change."

"Yes, I think so. A lift of mind and a change of heart, on which to base a chance for a deep change, indeed. A richer, deeper life.... Oh, there will be dross enough for a time, tares, detritus, heat and dust and wounds of conflict, Babel, cries and counter-cries! and some will think they lose...."

"They'll only think so for a while. Nothing can be lost."

"No — only transmuted.... But I hate the tumult and the shouting while the people are yet bewildered. If that's the Brahmin in me, I am going to sacrifice him. I am going where the battle is."

"I do not doubt that."

More white-suited people appeared, at their heels the black children. "Penny, Boss! — Penny, Boss! — Penny, Boss!" Hagar and Denny rose and walked back to town through the warm, fragrant ways. He left her at Greer's studio — she had promised to come look at the portrait. As they stood a moment in the verandah, Medway's golden drawl was heard from within. "Well, I've known a good many philosophers — but none that were irreducible. Every heroic, every transcendental treads at last the same pavement. 'I love and seek the street called pleasure. I abhor and avoid the street called pain.' Therefore the *summum bonum* —" The door opened to Hagar. She smiled and waved her hand, and the studio swallowed her up.

Some days after this they drove one afternoon over the

Blue Hills to the southern beach. Long white road — long white road — and on either hand pine and scrub, pine and scrub, and over all a vault of sky achingly blue. It was a lonely road, a road untravelled to-day, and the wind shook in the palmetto scrub. Small grey birds flitted before them, or cheeped from the tangled wood. It was a day for silence and they stayed silent so long that the negro driving, who was afraid of silence, broke it himself. He told them about things, and when they awoke and genially answered, he was happy and talked on to himself until they, too, were talking, when he lapsed into silence and contentment. The wind blew, the scrub rustled, the sky was sapphire — oh, sapphire!

When they came after a good while to the South Beach, they left the surrey and the horse and the driver, in the shade of the trees that fringed the beach, and walked slowly a long way, over the firm sand. It stretched, a silver shore; the sun was westering, the great sea making a hoarse, profound murmur. They walked in silence, thinking their own thoughts. Before them, half-sunken in the sand, lay an old boat. When they came to it, they sat down upon its shattered, sun-dried boards, with the sand at their feet and the grave evening light stealing up and Mother Ocean speaking, speaking. . . .

"In the last analysis it is," said Hagar, "a metaphysical adventure — a love-quest if you will. There is a passion of the mind, there is the questing soul, there is the desire that will have union with nothing less than the whole. I will think freely, and largely, and doing that, under pain of being false, I must act freely and largely, live freely and largely. Nor must I think one thing and speak another, nor must I be

silent when silence betrays the whole.... And so woman no less than man comes into the open."

"There is something that broods in this time," said Denny. "I do not know what it will hatch. But something vaster, something nobler..."

Hagar let the warm sand stream through her fingers. "Oh, how blue is the sea.... Æons and æons and æons ago, when slowly, slowly life drew itself forth from such a sea as this into upper air — when Amphibian began to know two elements, how much richer was life for Amphibian, how great was the gain!... When, after æons and æons, there was all manner of warm-blooded life in woods like these behind us, or in richer woods ... and one day, dimly, dimly, some primate thought, and her children and grandchildren a little, little more consciously thought, and it spread.... To that tribe how strange a dawn! 'We are growing away from the four-footed — we are growing away from our sister the gibbon and our brother the chimpanzee — we are growing — we are changing — we feel the heavens over us and a strange new life within us — we are passing out, we are coming in — we need a new word....' And at last they called themselves *human* — æons ago...."

"And now?"

"And now, on the human plane, it seems to me that we may be immediately above that region." She took a pointed piece of driftwood and drew upon the sand. "Here is the human plane — and here above it is another plane." She drew a diagonal line between. "And that is a stairway of growth from one to the other. And we are turning from this plane — the lower plane — and coming upon that stairway,

and down it, to meet us, pours like a morning wind, like the first light in the sky, a hint of what may be. Like that ancestral tribe, we are growing, we are changing — we feel a strange new life within us — we are passing out, we are coming in — we need a new word."

"What would it be?"

"I do not know.... After a while, an age hence maybe, when the light is stronger, we will coin it. Now there is only intuition of the change.... There is something in a translation I was reading of one of the Upanishads, 'But he who discerns all creatures in his Self and his Self in all creatures, has no disquiet.... What delusion, what grief can be with him in whom all creatures have become the very self of the thinker, discerning their oneness?... He has spread around a thing, bright, bodiless, taking no hurt, sinewless, pure, unsmitten by evil'... That might come after a long, long time, after change upon change."

The great sea murmured on, a wild white bird flew across the round of vision, melted into the sunset.

"And each change is greater by geometrical progression than was the one before?"

"Not the change itself, but that into which the change leads us. Each time we depart at right angles.... Yes, I think so."

"And the movement of women toward freedom of field and toward self-recognition — no less than the general movement toward socialization — is part of the change?"

"All things are part of it.... Yes, it is part."

She rose from the sand. "The sun is setting." They walked back to the surrey and took the homeward road. As

they came over the Blue Hills it was first dusk; the town lay, grey-pearl, before them, and above it swam the moon, full and opaline. "How many days have you now?"

"Just seven."

"Have you heard from Rose Darragh?"

"Yes. She's been doing her work and mine, too. She begs me to stay another two weeks, but I must not. There is no need — I am perfectly well again — it would only be selfish enjoyment."

"I wish it were possible — but if it's not, it's not.... Oh, how large the moon is! You can almost see it a globe — it is like a beautiful, lighted Japanese lantern."

"Where will we go to-morrow afternoon?"

"We cannot go anywhere to-morrow afternoon, for, alas! I have to go to a garden-party at Government House. But the next day we might go to Old Fort. What is that fragrance — those strange lilies? Look now at the Japanese lantern!"

They went to Old Fort and came back in the warm evening light, driving close to the sounding sea. "Five days now," said Denny. "Well, I have been so happy."

That night Hagar could not sleep. She rose at last from the bed and paced her moon-flooded room. All the long windows were wide; the night air came in and brought a sighing of the trees. After a while she stepped out upon the gallery that ran along the face of the house. Medway's room was down stairs and away from this front; she had the long silvered pathway to herself. She paced it slowly, up and down, wooing calm. Each time she reached the end of the gallery, she paused a moment and looked across the sleeping town that lay for the most part below this house and garden,

to where she could guess the roof of the small, inexpensive, half hotel, half boarding-house where Denny bided. When after a time she discovered that she was doing this, she shook herself away from the action. "No, Hagar, no!"

Going to the other end of the gallery, she found there a low chair and sat down, leaning her head against the railing. It was the middle of the night. Something in the place and in the balm of the air brought back to her those days and nights in Alexandria, so long ago. There, too, she had had to make choice.... "I could love him here and now — love him — love him in the old immemorial way.... Well, I will not!" She put her elbows on her knees, her chin in her hands. "*Rose Darragh — Rose Darragh — Rose Darragh*" — it struck through her mind, slow and heavily vibrant, like a deep and melancholy music. She rose and paced the gallery again, but when she came to the farther end, she turned without pause or look over the moonlit town.

"*Rose Darragh — Rose Darragh*" — she made it rhythmic, breathing deeply and quietly, saying the name inwardly, deeply, but without passion now, saying it like a comrade's name. "*Rose Darragh — Rose Darragh — Rose Darragh —*"

Calm came at last, repose of mind, victory. She sat down again, leaned her arms upon the railing, and followed with her eyes the lonely, silver moon. Work was in the world, the all-friend Work; and Beauty was in the world, the all-friend Beauty; and one good put out of reach, mind and spirit must make another and were equal to the task. "Rose Darragh — Rose Darragh! — not if I could would I hurt you," said Hagar; and took her attention from that matter and put it first upon the stars, and then upon some lines of Shelley's

that she loved, and then upon the story she had in hand. It was not well to go to bed thinking of a story, and when at last she left the gallery and laid herself straight upon the cool linen, she stilled the waves of the mind-stuff and let the barque of attention drift whither it would. At last she seemed in a deep forest long ago and far away, and there she went to sleep with a feeling of violets under her hand.

Five days, and Denny left Nassau. "It's not saying good-bye. In May, when you come to New York —"

"Yes, in May I'll see you and Rose Darragh. Until May, then —"

Denny and she clasped hands, both hands. "Thank God for friends!" he said with the odd little laugh that she liked, with the catch in the voice at the end of it as though he had started to laugh and then Life had come in. His eyes were misty. He brushed his hand across them. "You are dancing before me," he said apologetically.

She laughed herself. "And you are dancing before me! Good-bye, good-bye, Denny Gayde! Let's be friends always."

From the garden she watched the Miami steam slowly down the narrow harbour, and, passing the lighthouse, turn to the open sea. She watched it until it was but a black speck with a dark feather of smoke, and then until the feather and all had melted into the sky. "Well," she said, "there's work and beauty and high cheer, and Time that smooths away most violences!"

But she did not see Denny and Rose Darragh in May. That evening at dinner Medway was more than usually good company. He had a high colour; his hair and curling beard had

been cut just the length that was most becoming; he looked superbly handsome. Often he affected Hagar as would a very fine canvas, some portrait by Titian. To-night was one of these nights.

Greer dined with them, and he was urging Medway as he had urged before to let him paint him. "Fortune's smiling on us both — on you as well as me. Neither of us may have such a chance again! Let me — ah, let me!"

"What should I do with it when it was done, and if I liked it — which you know, Greer, is not dead certain? You can't hang portraits in a nomad's tent, and I haven't a soul in the world to give it to, — my mother would like a coloured photograph of me, but she wouldn't like Greer's picture, — unless Gipsy will take it when she sets up her own establishment —"

"I will take it with thanks," said Hagar. "Let Mr. Greer do it."

Medway said he would consider it. Dinner went off gaily with stories and badinage. Afterwards the traveller from the Colonial came in, and then the violinist. He played for them — played rhapsodies and fantasias. It was after eleven when the three guests departed. Greer's gay voice could be heard down the street —

> "'A Saint-Blaise, à la Zuecca,
> Vous étiez, vous étiez bien aise
> A Saint-Blaise.
> A Saint Blaise, à la Zuecca
> Nous étions bien là —'"

Thomson appeared, with Mahomet behind him to put out the lights.

"Good-night — sleep right!" said Medway. "Pleasant fellows, are n't they?"

Toward daylight she was awakened by a knock at her door, followed by Thomson's voice. "Mr. Ashendyne has had some kind of a stroke, Miss Hagar—" She sprang up, threw on a kimono, opened the door, and ran downstairs with Thomson. "I heard him breathing heavily — I've waked Mahomet and sent the black boy for the doctor—"

It was paralysis. And after months of Nassau, she took him back to the mainland and northward by slow stages, not to Gilead Balm, for he made always "No!" with his head and eyes to that, and not to New York for he seemed impatient of that, too; but at last to Washington. There she and Thomson found a pleasant residence to let on a tree-embowered avenue, and there they moved him, and there she stayed with him two years and read a vast number of books aloud, and between the readings cultivated a sunny talkativeness. At the end of the two years there came a second stroke which killed him.

CHAPTER XXVI

GILEAD BALM

It's a foolish piece of idealism," said Ralph. "But she's had her way so long I suppose it's impossible now to check her."

The Colonel's irritation exploded. White-haired, hawk-nosed and eyed, a little stooped now, a good deal shrunken in his black, old-fashioned, aristocratic clothes, he lifted a bloodless hand and made emphasis with a long forefinger. "Precisely so! One world mistake lay in ever giving property unqualifiedly into a woman's hands, and another in ever encouraging occupations outside the household, and so breeding this independent attitude — an attitude which I for one find the most intolerable feature of this intolerable latter age! I opposed the Married Woman's Property Act in this state, but the people were infatuated and passed it. Married or single, the principle is the same. It is folly to give woman control of any considerable sum of money —"

Mrs. LeGrand, entering the Gilead Balm library, caught the last three sentences. She smiled on the two gentlemen and took her seat upon the sofa. "Money and women are you talking about? Where money comes in," said Mrs. LeGrand, "I always act under advice. Women know very little about finance, and their judgment is rarely to be trusted."

"Just so, my dear friend! It is not in the least," spoke the Colonel, "that I am acquisitive or that it will make any

great difference to me personally if Medway's wealth stays in the family or no. What I am commenting upon is the folly of giving a woman power to do so foolish a thing."

"Hagar always *could* do foolish things," said Miss Serena, looking up from her Mexican drawnwork.

"I don't quite understand yet," said Mrs. LeGrand. "Mrs. Ashendyne was telling me in the big room yesterday evening, and then some one came in — dear Medway's will left her without proviso all that he had —"

"As was quite proper," said Ralph, "the Colonel to the contrary. Well, the principal comes to considerably over a million dollars — the cool million his second wife left him by her will and the settlement she had already made upon their marriage. The investment is gilt-edged. Altogether it would make Hagar not an extremely rich woman as riches are counted nowadays, but — yes, certainly for the South — a very rich woman. But now comes in your feminine tender conscience —"

"Hagar refuses to put on black," said Miss Serena. "I don't see that she's got a tender conscience —"

"The entire amount — everything that came from the fortune — she turns back to the fund which the second wife established for workingmen's housing. She states that she agrees with her stepmother's views as to how the fortune was made, and that she does not care to be a beneficiary. She says that her stepmother had evidently given thought to the matter and preferred that form of "restitution" and that her only duty is simply to return this million and more to the fund already erected, and from which it was diverted for Cousin Medway's benefit."

"Duty!" exclaimed Mrs. LeGrand. "I don't see where 'duty' comes in. Her 'duty' is to see that her father was wise for her. If he was content there's surely no reason why she should not be so!"

"Hagar," said Miss Serena, "never could see proper distinctions between people. I don't see that working-people are housed so badly —"

Ralph laughed mirthlessly. "Yes, they are, Cousin Serena! Scarcely any of them have tiled bathrooms and the best type of porcelain-lined tub, and very few have libraries that'll accommodate more than a thousand volumes, and quite a number do without nurseries papered with scenes from Mother Goose. And as they're all for that kind of housing, they're preparing to move in — just a little preliminary ousting of a few people with more brains and money and in they go! — cuckoos laying their eggs in abler folks' nests! This is the age of the cuckoo."

"How absurd," said Miss Serena. "Gilead Balm has n't a tiled bathroom, nor an extremely large library, and when I was a child the nursery wasn't papered at all. But we are perfectly comfortable at Gilead Balm. It's a heinous sin — discontent with your lot in life."

"Do you mean," asked Mrs. LeGrand, "that, against your counsel and advice, Hagar is really going headstrongly on to do this silly thing?"

"Apparently so. She is," said the Colonel, "of age. There again was a mistake — to let women come of age. Perpetual minors —"

Mrs. LeGrand laughed. "Colonel, you are not very gallant!"

The Colonel turned to her. "Oh, my dear friend, you're not the modern, unwomanly type that professes to see something degrading in the subordination that God and Nature have decreed for woman! Gallant! That's just what I am. Knights and gallantry were for the type that's vanishing, though" — he bowed to Mrs. LeGrand, who had not a little of her old beauty left — "though here and there is left a shining example!"

Mrs. LeGrand used her fan. "Oh, Colonel, there are many of us who like the old ways best."

Ralph drummed with his fingers upon the table. "To come back to Hagar —"

Hagar herself entered the room.

She was dressed in white; she was a little thin and pale, for the last weeks had been trying ones. Habitually she had a glancing way of ranging from an appearance of youth almost girlish to a noble look of young maturity. To-day she looked her thirty-one years, but looked them regally.

Once the Colonel would not have hesitated to hector her, Miss Serena peevishly to blame what she could not understand, Mrs. LeGrand to attempt smoothly to put her down. All that seemed impossible now. There was about her the glamour of successful work, of a known person. Mrs. LeGrand had recently purchased a "Who's Who," and had found her there. *Ashendyne, Hagar, author; b. Gilead Balm, in Virginia,* and so on. From various chronicles of the realm of contemporary literature she had gathered that Hagar's name would be found in yet more exclusive lists than "Who's Who." Of course, all in the room had read much of what she had written, and equally, of course, each of the four had, for

temperamental reasons, spokenly or unspokenly depreciated it. But all knew that she had — though they could not see the justice of her having — that standing in the world. Mrs. LeGrand always, with patrons, smoothly brought it in that she had been a pupil at Eglantine. None of them knew how much she made by her writing; it was to be supposed it was something, seeing that she was coolly throwing away a million dollars. There was likewise the glamour of much absence in foreign lands; the undefined feeling that here were novelties of experience and adventure, ground with which she was familiar and they were not. Of experience and adventure in psychical lands they took no account. But it was undeniable that her knowing Europe and Asia and Africa added to the already considerable difficulty in properly expressing to Hagar how criminally foolish she was being. Added to that, there was something in herself that prevented it.

Ralph spoke first. "We were talking, Hagar, about your idea of what to do with Cousin Medway's money. Here are only kinspeople and old friends, and we all wish that you would n't do it, and think that there'll come a day when you'll be sorry —"

The Colonel, leaning back in his chair, stroked his white imperial. "I should never have said, Gipsy, that you were the sentimental, beggar-tending kind —"

Hagar's kindly eyes that had travelled from her cousin to her grandfather, now went on to Mrs. LeGrand. "And you?" they seemed to say.

"Why could n't you," said Mrs. LeGrand, "do both? Why couldn't you give a handsome donation — give a really large amount to this charity? And then why not feel that

you had, so to speak, the rest in trust, and give liberally, so much a year, to all kinds of worthy enterprises? I don't believe the most benevolent heart could find anything to complain of in that —"

Hagar's eyes went to Miss Serena.

"You ought to take advice," said Miss Serena. "How can you know that your judgment is good?"

Hagar gave her eyes to all in company. "It is right that you should say what you think. We are all too bound together for one not to be ready to listen and give weight to what the others think. But having done it, our own judgment has to determine at last, has n't it? It seems to me that it is right to do what I am doing — what I have done, for it is practically accomplished. I saw all necessary lawyers and people last week in New York. Of course, I hope that you'll come to see it as I do, but if you do not, still I'll hope that you'll believe that I am right in doing what I hold to be right. And now don't let's talk of that any more."

"What I want to know," said Miss Serena, "is how you're going to live, if you don't take your dead father's support —"

Hagar looked at her in surprise. "Live? Why, live as I have lived for years — upon what I earn."

"I did n't suppose you could do that. — What *do* you earn?"

"It depends. Some years more, some years less. I have published a good deal and there is a continuing sale. England and America together, I am good for something more than ten thousand a year."

Miss Serena stared at her. A film seemed to come over her eyes, the muscles of her face slightly worked. "Somewhere

about thirty years ago," she said painfully, "I thought I'd write a book. I'd thought of a pretty story. I wrote to a printing and publishing company in Richmond about it, but they wrote back that I'd have to *pay* to have it printed."

That night in her bedroom, plethoric with small products of needle, crochet-needle, and paint-box, Miss Serena drew down the shades of all four windows preparatory to undressing. She was upstairs, there was a thick screen of cedars and no house or hill or person who could possibly command her windows, but she would have been horribly uneasy with undrawn shades. Ready for bed, she always blew out the lamp before she again bared the windows.

Some one knocked at the door. "Who is it?" called Miss Serena, her hand upon her dress-waist.

"It's Hagar. May I come in?"

It seemed that Hagar just wanted to talk. And she talked, with charm, of twenty things. Mostly of happenings about the old place. She asked about the latest panel of garden lilies and cat-tails, and she took the wonderfully embroidered pincushion from the bureau and admired it. "I think that I'm going to have an apartment in New York this winter, and if I do, won't you make me a pincushion? And, Aunt Serena, you must come sometimes to see me."

"You'll be marrying. You ought to marry Ralph."

"Even so, you could come to see me, couldn't you? But I am not going to marry Ralph."

Miss Serena stiffened. "The whole family wants you to — " She was upon family authority, and the wooing had to be done all over again. . . .

"I saw Thomasine in New York. She's going to live with me as my secretary. You know that she has been a typewriter and stenographer for a long time, and they say she is an excellent one. She has been studying, too, other things at night, after her long hours. She is as pretty and sweet as ever. When you come, the three of us will do wonderful things together —"

Miss Serena's bosom swelled. "I wonder when Ashendynes and Dales and Greens began to 'do things' — by which I suppose you mean going to theatres and concerts and stores and such things — together! The bottom rail's on top with a vengeance in these days! But your mother before you had no sense of blood."

Hagar sat silent, with a feeling of despair. Then she began again, her subject the flower garden, and then, at last — "Aunt Serena, tell me about the story *you* wanted to write...."

Ralph — Ralph was too insistent, she thought. He found her the next morning, under the old sycamore by the river, and he proceeded again to be insistent.

She stopped him impatiently. "Ralph, do you wish still to be friends, or do you wish me to put you one side of the Equator and myself on the other? I can do it."

"The Equator's an imaginary line."

"You'll find that an imaginary line can change you into a stranger."

"Hagar, I'm used to getting what I set my heart and brain upon."

"So was a gentleman named Napoleon Bonaparte. He got it — up to a certain limit."

"I don't believe you are in earnest. I don't believe you have ever really considered — And I intend one day to make you see —"

"See what? See my enormous advantage in marrying you? Oh, you — man!"

"See that you love me."

"How, you mean, can I help it? Oh, you — featherless biped!"

Ralph broke in two the bit of stick in his hands with a snapping sound. "I'm mad for you, and I'd like to pay you out —"

"You are more remotely ancestral than almost any man I know! — Come, come! let us stop this and talk as cousins and old playmates. There's Wall Street left, and who is going to be President, and what are you going to do with Hawk Nest."

"What I wanted to do with Hawk Nest was to fix it up for you."

"Oh, Ralph, Ralph! I should laugh at you, but I feel more like crying. The pattern is so criss-cross!" She rose from beneath the sycamore. "I'm going back to the house now."

He walked beside her. "Do you remember once I told you I was going to make a great fortune, and you made light of it? Well, I'm a wealthy man to-day and I shall be a much wealthier one. It grows now automatically. And that I would be powerful. Well, I am powerful to-day, and that, too, grows.

"Oh, Ralph, I wish you well! And if we don't define wealth and power alike, still your definition is your definition.

And if that's your heart's desire, and I think it is, be happy in your heart's desire — until it changes, and then be happier in the change!"

"I have told you what is my heart's desire."

"I will *not* go back to that. Look! the sumach is turning red."

"Yes, it is very pretty.... You didn't see Sylvie Maine — Sylvie Carter — when you were in New York?"

"No. I haven't seen Sylvie since that one first winter there. I wrote to her when I heard of Jack Carter's death."

"That has been three years ago now. She is a very beautiful woman and much sought after. I saw a good deal of her last winter.... Yes, that sumach is getting red. Autumn's coming.... Hagar! I'm not in the least going to give up."

"Ralph, I'm going to advise you to use your business acumen and recognize an unprofitable enterprise when you see it.... Look at the painted ladies on that thistle!"

"I'm old-fashioned enough to believe that a man can *make* a woman love him —"

"Are you? Be so good as to let me know when you succeed. — I warn you that the Equator is getting ready to drop between."

When they passed the cedars and came to the porch steps, it was to find Old Miss sitting in the large chair, her white-stockinged feet firmly planted, her key-basket beside her, and her knitting-needles glinting.

"Did you have a pleasant walk?" she asked, and looked at them with a certain massive eagerness.

"Ask Hagar, ma'am. She may have," answered Ralph;

and took himself into the house. They heard his rather heavy footfall upon the stair.

Hagar sat down on the porch step. "Ralph has, doubtless, a great many good qualities, but he is spoiled."

Now Old Miss had a favourite project or projects, and that was matings between Coltsworths and Ashendynes. Every few years for perhaps two centuries such matings had occurred. Many had occurred in her day. With great intensity she wanted and had wanted for years to see a match made between her granddaughter and so promising, nay, so accomplishing, a Coltsworth as Ralph. She was proud of Ralph — proud of his appearance, of his ability to get on in the world and make money and restore Hawk Nest, of his judgment and knowledge of public affairs which seemed to her extraordinary. She wanted him to marry Hagar, and characteristically she refused to admit the possibility of defeat. But Ralph was no longer quite a young man — he ought to have been married years ago. As for Hagar — Old Miss loved her granddaughter, but she had very little patience with her. She was not patient with women generally. She thought that, on the whole, women were a poor lot — *witness Maria*. Maria lived for Old Miss, lived on one side in space of her own, core of an atmosphere of smouldering, dull resentment. If Maria had been different, Medway would have lived at home. If Maria had known her duty, there would have been a brood of grandchildren to match with broods of Coltsworths and others of rank just under the first. If Maria had been different, this one grandchild wouldn't be throwing a million dollars away and failing to love her cousin! If Maria hadn't been a wilful piece, Hagar

might have escaped being a wilful piece. Old Miss loved her granddaughter, but that was what she was calling her now in her mind — a wilful piece.

Factors that counted with the others at Gilead Balm, Hagar's very actual detachment and independence, name and prestige and personality, failed to count with Old Miss.

Such things counted in other cases; they counted in Ralph's case. But Hagar was of the younger, therefore rightfully subordinate, generation, and she was female. Ralph was of the younger generation, also, and as a boy, while Old Miss spoiled him when he came to Gilead Balm, she expected to rule him, too. But Ralph had crossed the Rubicon. As soon as he grew from young boy to man, some mysterious force placed him without trouble of his own in the conquering superior class whose dicta must be accepted and whose judgment must be deferred to. The halo appeared about his head. He came up equal with and passed ahead of old Miss, elder generation to the contrary. But Hagar — Hagar was yet in the class that was young and couldn't know; she was in the class of the "poor lot." She was a wilful piece.

"I do not see that Ralph is spoiled," said Old Miss. "He receives a natural recognition of his ability and success in life. He is a very successful man, a very able man. He is giving new weight to the family name. There was a piece in the paper the other day that said the state ought to be proud of Ralph. I cut it out," said Old Miss, "and put it in my scrapbook. I'll show it to you. You ought to read it. I don't see why you aren't proud of your cousin."

"I hope I may be.—What are you knitting, grandmother?"

"Any woman might be happy to have Ralph propose to

her. And any woman but your mother's daughter might have some care for family happiness and advantage —"

"Oh, grandmother, would my unhappiness in truth advantage the family?"

"Unhappiness! There's no need for unhappiness. That's your mother again! Ralph is a splendid man. You ought to feel flattered. I don't believe in marrying without love, certainly not without respect; but when you see it is your duty and make your mind submissive you can manage easily enough to feel both. That's the trouble with you as it was with your mother before you. You don't see your duty and you don't make your mind submissive. I've no patience with you."

"Grandmother," said Hagar, "did you ever realize that you yourself only make your mind submissive when it comes into relation with men, or with ideas advanced by men? I have never seen you humble-minded with a woman."

Old Miss appeared to take this as a startling proposition, and to consider it for a moment; then, "I don't know what you mean."

"I mean that outraged nature must be itself somewhere — else there's annihilation."

Old Miss's needles clicked. "I don't pretend to be 'literary,' or to understand literary talk. What Moses and St. Paul said and the way we've always done in Virginia is good enough for me. You're perverse and rebellious as Maria was before you. It's simple obstinacy, your not caring for Ralph — and as for throwing away Medway's million dollars, there ought to be a law to keep you from doing it! — Are you going upstairs? My scrapbook is on the fourth shelf of the big closet. Get it and read that piece about Ralph."

CHAPTER XXVII

A DIFFERENCE OF OPINION

BUT the great Gilead Balm explosion came three days later.

It was nearly sunset, and they were all upon the wide, front porch — the Colonel, Old Miss, Miss Serena, Captain Bob, Mrs. LeGrand, Hagar. Ralph was not there, he had ridden to Hawk Nest, but would return to-night. It had been a beautiful, early September day, the sky high and blue, the air all sunny vigour. Gilead Balm sat and enjoyed the cool, golden, winey afternoon, the shadows lengthening over the hills, the swallows overhead, the tinkle of the cow-bells. It was not one of your families that were always chattering. The porch held rather silent than otherwise. Mrs. LeGrand could, indeed, keep up a smooth, slow flow of talk, but Mrs. LeGrand had been packing to return to Englantine which would "open" in another week, and she was somewhat fatigued. The Colonel, pending the arrival of yesterday's newspaper, was reviewing that of the day before yesterday. Captain Bob and Lisa communed together. Old Miss knitted. Miss Serena ran a strawberry emery bag through and through with her embroidery needle. Hagar had a book, but she was not reading. It lay face down in her lap; she was hardly thinking; she was dreaming with her eyes upon a vast pearly, cumulus cloud, coming up between the spires of the cedars. A mulatto boy appeared with the mail-bag. "Ha!" said the Colonel, and stretched out his hand.

There was a small table beside him. He opened the bag and turned the contents out upon this, then began to sort them. No one — it was a Gilead Balm way — claimed letter or paper until the Colonel had made as many little heaps as there were individuals and had placed every jot and tittle of mail accruing, ending by shaking out the empty bag. He did all this to-day. Captain Bob had only a county paper — no letters for Old Miss — a good deal of forwarded mail for Mrs. LeGrand — the Colonel's own — letters and papers for Hagar. The Colonel handled each piece, glanced at the superscription, put it in the proper heap. He shook out the bag; then, gathering up Mrs. LeGrand's mail, gave it to her with a smile and a small courtly bow. Miss Serena rose, work in hand, and took hers from the table. Lisa walked gravely up, then returned to Captain Bob with the county paper in her mouth. The Colonel's shrunken long fingers took up Hagar's rather large amount and held it out to her. "Here, Gipsy"— the last time for many a day that he called her Gipsy. A letter slipped from the packet to the floor. Bending, the Colonel picked it up, and in doing so for the first time regarded the printing on the upper left-hand corner — *Return in five days to the —— Equal Suffrage League.* The envelope turned in his hand. On its reverse, across the flap, was boldly stamped — VOTES FOR WOMEN.

Colonel Argall Ashendyne straightened himself with a jerk. "Hagar! — What is that? How do you happen to get letters like that? — Answer!"

His granddaughter, who had risen to take her mail, regarded first the letter and then the Colonel with some astonishment. "What do you mean, grandfather? The letter's

A DIFFERENCE OF OPINION

from my friend, Elizabeth Eden. I wonder if you don't remember her, that summer long ago at the New Springs?"

The Colonel's forefinger stabbed the three words on the back of the envelope. "You don't have friends and correspondents who are working for *that?*"

"Why not? I propose presently actively to work for it myself."

Apoplectic silence on the part of the Colonel. The suddenly arisen storm darted an electric feeler from one to the other upon the porch.

"What's the matter?" demanded Captain Bob. "Something's the matter!"

Old Miss, who had not clearly caught the Colonel's words, yet felt the tension and put in an authoritative foot. "What have you done now, Hagar? Who's been writing to you? What is it, Colonel?"

Ralph, in his riding-clothes, coming through the hall from the back where he had just dismounted, felt the sultry hush. "What's happened? What's the matter, Hagar?"

"Get me a glass of water, Serena!" breathed the Colonel. He still held the letter.

"My dear friend, let me fan you!" exclaimed Mrs. LeGrand, and moved to where she could see the offending epistle. "VOTES FOR — oh, Hagar, you surely aren't one of *those* women!"

Miss Serena, who had flown for the water, returned. The Colonel drank and the blood receded from his face. The physical shock passed, there could be seen gathering the mental lightning. Miss Serena, too, read over his shoulder "VOTES — ... Oh, *Hagar!*"

Hagar laughed — a cool, gay, rippling sound. "Why, how round-eyed you all are! It is n't murder and forgery. Is the word 'rebellion' so strange to you? May I have my letter, grandfather?"

The Colonel released the letter, but not the situation. "Either you retire from such a position and such activities, or you cease to be granddaughter of mine —"

Old Miss, enlightened by an aside from Mrs. LeGrand, came into action. "She does n't mean that she's friends with those brazen women who want to be men? What's that? She says she's going to work with them? I don't believe it! I don't believe that even of Maria's daughter. Going around speaking and screaming and tying themselves to Houses of Parliament and interrupting policemen! If I believed it, I don't think I'd ever speak to her again in this life! Women Righters and Abolitionists! — doing their best to drench the country with blood, kill our people and bring the carpet-baggers upon us! Wearing bloomers and cutting their hair short and speaking in town-halls and wanting to change the marriage service! — Yes, they do wear bloomers! I saw one doing it in New York in 1885, when I was there with your grandfather. And she had short hair —"

Mrs. LeGrand, as the principal of a School for Young Ladies, always recognized her responsibility to truth. She stood up for veracity. "Dear Mrs. Ashendyne, it is not just like that now. There are a great many more suffragists now — so many that society has agreed not to ostracize them. Some of them are pretty and dress well and have a good position. I was at a tea in Baltimore and there were several there. I've even heard women in Virginia — women

A DIFFERENCE OF OPINION

that you'd think ought to know better — say that they believed in it and that sooner or later we'd have a movement here. Of course, you don't hear that kind of talk, but I can assure you there's a good deal of it. Of course, I myself think it is perfectly dreadful. Woman's place is the home. And we can surely trust *everything* to the chivalry of our Southern men. I am sure Hagar has only to think a little — The whole thing seems to me so — so — so *vulgar!*"

Miss Serena broke out passionately. "It's against the Bible! I don't see how any *religious* woman —"

Hagar, who had gone back to her chair, turned her eyes toward Captain Bob.

"Confound it, Gipsy! What do you want to put your feet on the table and smoke cigars for?"

Hagar looked at Ralph.

He was gazing at her with eyes that were burning and yet sullen and angry. "Women, I suppose, have got to have follies and fads to amuse themselves with. At any rate, they have them. Suffrage or bridge, it does n't much matter, so long as it's not let really to interfere. If it begins to do that, we'll have to put a stop to it. Woman, I take it, was made for man, and she'll have to continue to recognize that fact. Good Lord! It seems to me that if we give her our love and pay her bills, she might be satisfied!"

All having spoken, Hagar spoke. "I should like, if I may, to tell you quietly and reasonably why —" her eyes were upon her grandfather.

"I wish to hear neither your excuses nor your reasons," said the Colonel. "I want to hear a retraction and a promise."

Hagar turned slightly, "Grandmother —"

"Don't," said Old Miss, "talk to me! When you're wrong, you're wrong, and that's all there is to it! Maria used to try to explain, and then she stopped and I was glad of it."

Hagar leaned back in her chair and regarded the circle of her relatives. She felt for a moment more like Maria than Hagar. She felt trapped. Then she realized that she was not trapped, and she smiled. Thanks to the evolving whole, thanks to the years and to her eternal self pacing now through a larger moment than those moments of old, she was not by position Maria, she was not by position Miss Serena. Before her, quiet and fair, opened her Fourth Dimension. Inner freedom, ability to work, personal independence, courage and sense of humour and a sanguine mind, breadth and height of vision, tenderness and hope, her waiting friends, Elizabeth, Marie, Rachel, Molly and Christopher, Denny, Rose Darragh, many another — her work, the story now hovering in her brain, what other and different work might rise above the horizon — the passion to help, help largely, lift without thinking if it were or were not her share of the weight — the universe of the mind, the growing spirit and the wings of the morning . . . there was her land of escape, real as the hills of Gilead Balm. She crossed the border with ease; she was not trapped. Even now her subtle self was serenely over. And the Hagar Ashendyne appearing to others upon this porch was not chained there, was not riveted to Gilead Balm. Next week, indeed, she would be gone.

A tenderness came over Hagar for her people. All her childhood was surrounded by them; they were dear, deep among the roots of things. She wanted to talk to them; she

A DIFFERENCE OF OPINION 319

longed that they should understand. "If you'd listen," she said, "perhaps you'd see it a little differently —"

The Colonel spoke with harshness. "There is no need to see it diffcrently. It is you who should see it differently."

"It comes of the kind of things you've always read!" cried Miss Serena. "Books that I wouldn't touch!"

"Yes, Maria was always reading, too," said Old Miss. For her it *was* less Hagar than Maria sitting there. . . .

"If it was anything we didn't know, we would, of course, listen to you, Hagar dear," said Mrs. LeGrand. "I should be glad to listen anyhow, just as I listened to those two women in Baltimore. But I must say their arguments sounded to me very foolish. Ladies in the South certainly don't need to come into contact with the horrors they talked about. And I cannot consider the discussion of such subjects delicate. I should certainly consider it disastrous if my girls at Eglantine gained any such knowledge. To talk about their being white slaves and things like that — it was nauseating!"

"Would you listen, Ralph?" asked Hagar.

"I'll listen to you, Hagar, on any other subject but this."

Mrs. LeGrand's voice came in again. She was fluttering her fan. "All these theories that you women are advancing now-a-days — if they *paid*, if you stood to gain anything by them, if by advancing them you didn't, so it seems to me, always come out at the little end of the horn — people ridiculing you, society raising its eyebrows, men afraid to marry you —! My dear Hagar, men, collectively speaking — men don't want women to exhibit mind in all directions. They don't object to their showing it in certain directions, but

when it comes to women showing it all around the circle they do object, and from my point of view quite properly! Men naturally require a certain complaisance and deference from women. There's no need to overdo it, but a certain amount of physical and mental dependence they certainly do want! Well, what's the use of a woman quarrelling with the world as it's made? Between doing without independent thinking and doing without an establishment and someone to provide for you —! So you see," said Mrs. LeGrand, smoothly argumentative, "what's the use of stirring up the bottoms of things? And it isn't as though we weren't really fond of the men. We are. I've always been fonder of a man, every time, than of a woman. I must confess I can't see any reason at all for all this strenuous crying out against good old usage! Of course a woman with considerable mental power may find it a little limiting, but there are a lot of women, I assure you, who never think of it. If there's a little humbug and if some women suffer, why those things are in the dish, that's all! The dish isn't all poisoned, and a woman who knows what she is about can pick and choose and turn everything to account. I wouldn't know what to do," said Mrs. LeGrand, "with the dish that people like you would set before us. All this crying out about evolution and development and higher forms doesn't touch me in the least! I like the forms we've got. Perhaps they're imperfect, but the thing is, I feel at home with imperfection."

She leaned back, in good humour. Hagar had given her an opportunity to express herself very well. "Don't you, too," she asked, "feel at home with the dear old imperfection?"

Hagar met her eyes. "No," she said.

Mrs. LeGrand shrugged. "Oh, well!" she said, "I suppose each will fight for the place that is home."

Hagar looked beyond her, to her kindred. "You're all opponents," she said. "Alike you worship God as Man, and you worship a static God, never to be questioned nor surpassed. You have shut an iron door upon yourselves. . . . One day you who shut it, you alone — you will open it, you alone. But I see that the day is somewhat far."

She rose. "I was going anyhow you know, grandfather, in four days. But I can take the morning train if you'd rather?"

But Colonel Ashendyne said stiffly that if she had forgotten her duty, he had not his, and that the hospitality of Gilead Balm would be hers, of course, for the four days.

Hagar listened to him, and then she looked once more around the circle. A smile hovered on her lips and in her eyes. It broadened, became warm and sweet. "I'll accept for a time the partial estrangement, but I don't ever mean that it shall be complete! It takes two to make an estrangement." She went up to her grandmother and kissed her, then said that she was going for a walk. — "No, Ralph, you are not coming with me!"

She went down the porch steps, and moved away in the evening glow. The black cedars swallowed her up; then upon the other side, beyond the gate, she was seen mounting the hill to the right. The sun was down, but the hilltop rested against rose-suffused air, and above it swam the evening star.

Ralph spoke with a certain grim fury. "I wish the old times were back! Then a man could do what he wished! Then

you didn't feel yourself caught in a net like a cobweb that you couldn't break —"

Mrs. LeGrand again opened her fan. "I am very fond, of course, of dear Hagar, but I must say that she seems to me intensely unwomanly!"

CHAPTER XXVIII

NEW YORK AGAIN

IT seemed strange to be back at the Maines', staying a fortnight with Rachel while the apartment was being looked for. Nothing had been moved in that house; it was all just the same, only the tone of time was deeper, the furniture more worn, the prints yellower. She asked for and was given the third-floor back room again, though, indeed, Mrs. Maine protested that now that she was famous! . . . Bessie had changed as little as the house. More grey hairs, somewhat more flesh, a great many more pounds of chocolate creams to her credit — that seemed all. She was still amiable, sleepily agreeable, comely, and lazy. Powhatan, except to grow greyer and leaner, had not altered either. The old servants held on. With some inevitable variations the same people came in the evenings — the Bishop's nephew and the St. Timothy people, and Powhatan's downtown acquaintances, and chance visitors from the other side of Mason and Dixon's.

She noticed a slight difference in the cast of talk. They all seemed uneasily aware that the world was moving. Mostly they disapproved and foreboded. She cast her mind back to that winter of '93–'94. It had been the terrible winter of unemployment, strikes, widespread discontent. She remembered clearly how Powhatan had declaimed then against "upsetters" and what the country was coming to. But now she

heard him and the Bishop's nephew agree that anti-Christ and ruin were modern inventions. They sighed for the halcyon past. "Even ten or twelve years ago, sir, men were content enough!"

Rachel — Rachel had not sat still. Rachel had climbed. She was the old Rachel, but sweetened and broadened. There was left something of her old manner; she had her broodings that to the casual eye seemed half-sullen; at the end of long silences she might flare out, send at table or elsewhere a flaming, unexpected arrow, but her old ways were like old clothes, kept half-negligently, worn from habit, while all the time a fairer, more lately woven garment was in the wardrobe. She looked no older; she was slight and brown and somehow velvety. Hagar called her a pansy. She was no longer tragic, or tragedy had become but a dim background, a remembered cloud. And she was the strong, sane, and actual comrade of her children.

Betty and Charley.... Charley was blind. Charley and Betty had changed, changed more than anybody. Betty stood a frank, straight young Diana, what she said and did ringing true. Charley was the student. He had his shelves of Braille, and his mother's eyes and voice were his at call. Just now they were doing general history together — that was what Charley wanted, to be a historian. Charley and Betty claimed Hagar for their own. There were her Christmas letters every year — wonderful letters — and her Christmas gifts, small choice things from every land. They worshipped her, too, with frankness because she had "done something" — because her name counted. Oh, they were very ambitious, Betty and Charley; filled with ideas, glori-

NEW YORK AGAIN

ous for the new time, ready to push the world with vigour! "Oh," cried Hagar, "don't they make you feel timid, cautious, and conservative?"

She watched with interest to see what effect the two had upon Powhatan and Bessie. She was forced to the conclusion that they had very little. They angered Powhatan sometimes, and he would strike the table and deplore the days of silent reverence. But he was desperately proud of Betty's looks, and he had an odd, sneaking pity and fondness for Charley, and Hagar gathered that he would have sadly missed them out of the house. As for Bessie, she only gave her sleepy smile, and said that all children talked foolishly, but that you didn't have to listen.

Upstairs, at bedtime, now in Rachel's room, now in Hagar's the two talked together. Daytime, they looked for Hagar's apartment. They found it at last, high in air, overlooking the great city; roofs and roofs and roofs at a hundred levels; curling streamers of white steam like tossed plumes against the blue sky, bright pennants floating from towering hotel or department store; a clock below a church spire, with a gilt weather-cock far above; blurs of occasional trees seen in some hollow opening; streets far below them, crossing, crossing — percolating rivulets of manikins that were people; roofs and roofs and roofs, and a low perpetual, multitudinous voice; and the sky over all, high and clear and exhilarating the day they found the place. "I am going to utter a bromide," said Hagar. "How marvellous is modern life!"

They went over it again. "Thomasine's room, and a guest-room, and my room, and a fine room for Mary Magazine who is coming — Isham having remarried — to look

after us, and two baths and a great big library-study-drawing-room, and a little room for what we please, and plenty of closets, and a quiet and good café away up on the roof — Rachel, it's fine!" They sat on a window-seat and Rachel produced a pencil and notebook, and together they tinted the walls and laid rugs and hung pictures and ran bookshelves around and furnished the apartment. "There! that's quiet and perfect and not expensive. As Thomson would say, 'It's quite *comme il faut*, Miss!'"

"Where is Thomson?"

"Mr. Greer, the artist, has taken him over. He wrote me that he was making thousands, throwing the light on millionaires, and especially millionairesses, and that he wanted Thomson, oh, so badly! He's the type that Thomson likes, and so he joined him two months ago at Newport. Dear old Thomson! Mahomet has gone back to Alexandria."

They looked around the big room. "Soft lights at night and all those twinkling stars out there. It's going to be a dear home."

"You'll have people coming about you. Your own sort—"

Hagar laughed. "What is my sort? Everybody's my sort."

"Writers — artists —"

Hagar pondered the mantel-shelf with a view to what should go above it. "I don't know many of them. I know more of them abroad than here. We're a very isolated kind of craftspeople — each of us more or less on a little Robinson Crusoe island of our own. It may be different in New York, I don't know.... We could do a good deal if we'd put our heads together and push the same wheel."

The apartment was not to be furnished in a day. They

worked at it in a restful and leisurely manner, and in the midst of operations, Hagar went to see the Josslyns who had a house up on the Sound.

That afternoon she and the Josslyns walked by the water and watched the white sails gliding by the green and rocky shore, then in the evening sat by a wood fire with cider and apples. Monday to Friday the children were in town at their grandmother's, going to school; Friday afternoon they entered the big living-room like a west wind and danced about with their mother. A little later the whole family would go into town; Christopher had had a course of lectures to write and he was doing it better here. The fire crackled and blazed; at night through the open windows came in a dim sound of waves, with passing lights of boats, and the fragrance of the salt sea, beloved by Hagar. On Monday, when the children had gone, she drove with Molly deep into the sweet countryside, and the two talked as the quiet old horse jogged along. ... Molly had taken the advice of the woman at Roger Michael's dinner-party three years and more ago. She was an active member of a suffrage organization, deeply interested, beginning to speak. "I'm a good out-of-doors sort. My voice carries and I don't have to strain it. Of course, we're just beginning out-of-doors speaking. I have n't half the intellect I wish I had, but I can give them good, plain doctrine. It's so common-sense, after all! And Christopher helps so much. ... Oh, Hagar, when you're truly mated, it's *heaven!*"

Molly could tell much of the practical working, of the everyday effort and propaganda. "In two weeks we'll be back in town, and then if you'll let me take you here and there — And when we get back to the house I'll show you

what I have of the literature we use, — pamphlets, leaflets, and so on, — from John Stuart Mill down to an article Christopher wrote the other day. We broadcast a great amount of it in every state, but if we were rich we could make use of a thousand times more. But we're not rich — whether that's to our damnation or our salvation! We have to make devotion do instead. Then there are the books that help us, and they are coming out constantly now. And every now and then we gain a bit of the press. A number of the magazines help no end. And, of course, we speak and have meetings and work quietly, each among her own acquaintance. It's to educate — educate — educate! We're just at the beginning of things. There were the early stages and the heroic women who blazed the trail. They're all going, — Miss Anthony died last March, — and their time is merging into our time, and now the trail's a roadway and there are thousands on it, and still we're just at the beginning —"

Molly could tell, too, something of the personality of the women eminent in the movement. "The really eminent to-day are not always those whose names the reporters catch, and *vice versa.* And while the papers talk of 'leaders,' I do not think that, in the man's sense, they are leaders at all. We do not hurrah for any woman as the men do for Mr. Roosevelt or Mr. Bryan. The movement goes without high priests and autocrats and personifications. We have n't, I suppose, the Big Chief tradition. Perhaps woman's individualism has a value after all. It's like religion when it really is personal; your idea of good remains your idea of good; it does n't take on a human form. Or perhaps we're merely tired of crooking the knee. I don't know. The fact remains."

NEW YORK AGAIN

They jogged along by country roads and orchards. "It's the most worth-*while* thing!" said Molly. "Nobody can explain it, but every one who takes hold of it *deep* feels it. I heard a woman say the other day that it was like going out of a close room into ozone and wind and the blue lift of the sky. She said she felt as though she had wings! Discouragements? Cartloads of them! But somehow they don't matter. Nor do mistakes. Of course we make them — but the next time we do better."

The witching autumn week with the Josslyns over, Hagar went back to town, and, as she had promised, to the Settlement for three days.

The Settlement! The first day she had seen it came back clearly; the harsh, biting day and the search for Thomasine, and Omega Street, and then how wonderful the old house had seemed to her, going over it with Elizabeth. It was shrunken now, of course, in size and marvel, but it was still a grave and pleasant place of fine uses. She had visited it before during this month, and she had marked certain changes. A few of the people in residence years before were here yet, others were gone, others of later years had come in. But it was not only people; others changes appeared. She found exhibited a deep skepticism of certain Danaïdes' labours still favoured or tolerated so many years ago. The policies of the place were bolder and larger; every one was at once more radical and more serene.

Marie Caton met her. "Elizabeth has a committee meeting, and then she speaks to-night at Cooper Union: *Women in the Sweated Trades*. I have n't had you to myself hardly ever! Now I'm going to."

"Can't I go to Cooper Union to-night?"

"Oh, yes! I'm going, too. It's an important meeting. But I've got you for a whole two hours, and nowadays that's a long and restful sojourn together! Get your things off and we'll take possession of Elizabeth's sitting-room."

In Elizabeth's room, with her books, with the Psyche and the Botticelli Judith and the Mona Lisa and the drawing of the Sphinx, they talked of twenty things, finally of the Settlement's specific activities, old ones carried on, new ones embarked in; then, "But more and more you get drawn — or I get drawn — into the ocean of China Awake."

"China Awake?"

"Women Awake. It's an ocean all right, with an ocean's possibilities."

"I don't think it's women only who are waking, Marie. Women and men, all of us —"

"I agree," said Marie. "But it was n't just natural sleepy-headedness with women. They've been drugged — given knock-out drops, so to speak. They have a long way to wake up."

Hagar mused, her eyes upon the drawing. "Yes, a good, long way.... There must have been a lot of pristine strength."

"Well, it's coming out. All kinds of things are coming out with an accent on qualities they did n't think she had."

"Yes. The world *is* rather in the position of the hen with the duckling —"

"The kind of thing we read and hear at this place emphasizes, of course, the economic and sociological side. It's to be the Century of Fair Distribution, of Social Organization, of

Humanism — *ergo*, Woman Also. Which, of course, is all right, but I'd put an infinite plus to that."

"And Elizabeth?"

"Oh, Elizabeth is a saint! What she thinks of is the sweated woman and the little children, and the girl who goes under — most often is pushed under. It's what we see down here; it's the starved bodies and minds, the slow dying of fatigue, the monstrous wrong of the Things Withheld that's moving her. Of course, we all think of that. How can any thinking woman not think of that? She wants the vote to use as a lever, and so do I, and so do you. . . . But behind all that, in the place where I myself live," said Marie, with sudden passion, "I am fighting to be myself! I am fighting for that same right for the other woman! I am fighting for plain recognition of an equal humanity!"

There was a crowd that night at Cooper Union. Elizabeth spoke; a grave, strong talk, followed with attention, clapped with sincerity. After her there spoke an A. F. of L. man. "Women have got to unionize. They've got to learn to keep step. They've got to learn that the good of one is wrapped up in the good of all. They've got to learn to strike. They've got to learn to strike not only for themselves, but for the others. They've got to get off their little, just-standing-room islands, and think in terms of continents. They've got to get an idea of solidarity —"

When he had taken his seat came an announcement, made with evident satisfaction. "We did not know it until a few minutes ago. We thought she was still in the West — but we are so fortunate as to have with us to-night — Rose Darragh!" Applause broke forth at once.

CHAPTER XXIX

ROSE DARRAGH

Rose Darragh's short speech, at once caustic and passionate, ended — the meeting ended. Hagar waited below the platform.

Rose Darragh, at last shaking off the crowd, came toward her. "I've been looking at you. I seem, somehow, to know you —"

"And I you. And not — which is strange to me — not through another."

"Is your name Hagar Ashendyne?"

Hagar nodded. "We can't talk well here —"

"I'm in New York for two weeks. Denny's in Chicago and I join him there. Let me see — where can we meet? Will you come to my flat?"

"Yes; and in a few days I shall have my own rooms. I want to see you there, too, Rose Darragh."

"I'll come. This is my address. Will you come to-morrow at four?"

Hagar went. Denny had written that the two lived "handy to their work," and it was apparent that they did. The flat had the dignity of Spartan simplicity. In it Rose Darragh moved with the fire of the ruby.

"Denny had to go about the paper. Oh, it's doing well, the paper! It's Denny's idol. He serves in the temple day and night, and when the idol asks it, he'll give his heart's

blood. . . . You liked Denny very much, did n't you? — in Nassau, three years ago?"

"Yes, I did." They were sitting in the plain, bare room, attractive, for it was so clean, the late autumn sunlight streaming in at the curtainless windows. "Yes, I did. I liked him so well that . . . I had somewhat of a fight with myself. . . . I am telling you that," said Hagar, "because I want your friendship. It is over now, nor do I think it will come again."

Rose Darragh gave her a swift look from heel to head. "That's strength. I like strength. . . . All right! I'm not afraid."

They sat in silence for a moment; then, "I wish you'd tell me," said Hagar, "about your work."

A very few days after this she took possession of the apartment, and at once made it a home. There was a housewarming with Rachel and Betty and Charley and Elizabeth and Marie and the Josslyns, and two pleasant gentlemen, her publishers, and a fellow-writer or two whom she was by way of knowing and liking, and an artist, and an old scholar and philosopher whom she had known abroad and loved and honoured. And there was Thomasine, a little worn and faded, but with happiness stealing over her, and Mary Magazine busy with the cakes and ale. There could n't have been a better housewarming.

Thomasine — Thomasine began to bloom afresh. Factory and department store and business school and office lay behind her — each a stage upon a somewhat dull and dusty and ambuscade-beset road of life. Business school and office, training for mind and fingers alike, a resulting "place" with a

fair-dealing firm — all that was Hagar's helping, a matter of the last six or seven years. And now Hagar had come back and had made Thomasine an offer, and Thomasine closed with it very simply and gladly. She had from the beginning worked hard and as best she could and had given good value for her pay; and now she was going still to do all that, but to do it with a singing heart and her hunger for beauty and fitness fed. The colour came back into her cheeks; she began to take on a sprite-like beauty. She brought seriously into conversation one day the fact that she had always been good at finding four-leafed clovers. . . . Jim and Marietta were doing fairly, still over in New Jersey. "Fairly" meant a poor house which Marietta did her best to keep clean, and two of the children working, and the city for summer and winter, and Jim's pay envelope neither larger nor heavier, but the cost of living both. But Jim had his "job," and Marietta was not so ailing as she used to be, and the two children brought in a little, and Thomasine helped each month; so they might be said to be doing much better than many others. There was even talk of being able one day to get — the whole family being fond of music — one of the cheaper phonographs.

Hagar and Thomasine worked through the mornings, Hagar thinking, remembering, creating; Thomasine taking from her the labour of record; caring also for her letters and the keeping of accounts and all small, recurring business. And Thomasine loved to do any shopping that arose to be done, — which was well, for Hagar hated shopping, — and loved to keep the apartment "just so." The two lived in quiet, harmonious intercourse, together in working hours, but

when working hours were over, each going freely her individual way. Thomasine, too, had friends. She wrote to Jim and Marietta and to Maggie at home, taking care of the mother with the spine, that she had n't been so happy since they used to go to grandmother's at Gilead Balm. . . .

Rose Darragh — Rose Darragh had not been at Hagar's housewarming. She was speaking that night in Newark. But some days afterwards she came — came late one afternoon with the statement that she had the evening free. She and Thomasine and Hagar dined in the café together, but Thomasine hurried through her dinner, for she was going to the theatre with a fellow-stenographer with whom she had worked for two years downtown, and who was "such a nice girl," and with the stenographer's brother, who looked like a nice brother. Hagar and Rose Darragh, left at table, sipped their coffee.

A quality of Rose Darragh's came out. She observed and deduced, to the amusement of herself and of others, with the swiftness and accuracy of M. Dupin or of Mr. Sherlock Holmes. They had a small corner table commanding the long, bright room. "Twenty tables," she said. "Men and women and a fair number of children. Not proportionately so large a number as once there would have been, and that is well, the bawlers of race-suicide to the contrary! — I'm interested in the women just now. Man's had the centre of the stage for so long! — and, of course, we know that this is the Century of the Child — see cotton-mills, glass-works, and canneries. But Woman — Woman's just coming out of the wings. . . . There's rather an interesting collection here to-night? Do you know any of them?"

"I have spoken casually to several. I have been here, you know, only the shortest time."

"There's a woman over there who has a wonderful face — brooding and wise. . . . A teacher is n't she? I should say she was not married."

"Yes; she is a teacher, and single."

"There's a woman who is a nurse."

"Yes. There's a sick child in that family. But she is not in uniform to-night."

"I know her all the same. She's a good nurse. There are those who are and those who are n't. But she's got strength and poise and knows what she is about and is kind. — Those two women over there —"

"Yes. What do you make of them?"

"There's such a glitter of diamonds you can't see the women. Poor things! — to be beings of a single element — to live in a world of pure carbon — to be the hardest thing there is, and yet be so brittle too! . . . The woman next them is good ordinary: nothing remarkable, and yet pleasant enough. The worst that can be said of her is that she does n't discriminate. If the broth lacks salt, she never knows it."

"And the two over there with the stout man?"

Rose Darragh gazed a moment with eyes slightly narrowed. "Oh, those!" she said. "Those are our adapted women — perilously near adapted, at any rate. That's a sucking wife and daughter. Take your premise that in the divine order of things the male opens the folds of his being, surrounds, encloses, 'shelters' and 'protects' and 'provides for' your female in season and out of season, when there is need, and when there is certainly none, and your further premise that

the female is willing and ruthlessly logical — and behold the supremely natural conclusion! . . . Daughters of the horse leech — and perfectly respectable members of society as constituted! Faugh! — with their mouths glued to that fat man's pocket. He looks haggard, and at the moment he's probably grinding the faces of no end of men and women, — not because he's got a bad heart and really wants to, — but because he's got to 'provide' for those two perfectly strong and healthy persons in jewelry and orchids! He's cowed by tradition into accepting the monstrous position, and he's weak enough to let them define what is 'provision.' He's got to keep filling and filling the pocket because they suck so fast."

"Do you think they can change?"

"They can be forced to change. They don't want to change, any more than the copepod wants to change. And logically, while he persists in his present attitude, the man can't ask them to change. He can't keep his cake and eat it too." She drank her coffee. "That very stout gentleman who is being driven to bankruptcy, or to ways that are queer, is just the kind to strike the table with his fist and violently to assure you that God meant Woman, lovely Woman! to be dependent upon Man, and that it is with deep regret that he sees woman crowding into industry and beating at the doors of the professions — Woman, Wife and Mother, God bless her! Do you notice how they always put Wife first? If the Association Opposed to the Extension of the Franchise to Women asked him to-night for a contribution, they'd probably get it."

"How numerous do you think are those women?"

"The copepods? Numerous enough, pity 't is! But not so numerous as, given the System, you might fairly expect: numerous positively, but not relatively. And a lot of them have simply succumbed to environmental pressure. Given a generation or two of rational training and a nobler ideal of what befits a human being, and the copepod will yet succour herself. . . . Denny and I see more of the other kind. The drudges outnumber the copepods, and neither need be. . . . There's a girl over there I like — the one with the braided hair. Many of the young girls of to-day are rather wonderful. It's going to be interesting to see what they'll do when they're older, and what their daughters will do. She's got a fine head — mathematics, I should think."

They went down together.

In the large and comfortable half study, half drawing-room with the shaded lights, with the sea-like sound of the city without the windows, with the books and pictures, they walked a little to and fro together, and at last paused before a window and looked forth — the firmament studded with lights above and the city studded with lights below. "There's a noble word called Work," said Rose Darragh, "and we have degraded it into Toil, on the one hand, and it has a strong enemy called False Ideals, on the other. What I ask of Life is that I may be one of the helpers to save Work from Toil and False Ideals."

They watched the lights in silence, then turned back to the soft glowing room. When each had taken a deep chair on either side of the great library table, they still kept silent. Rose Darragh sat erect, lithe, strong, embrowned, a wine red in her cheeks. As in the picture that Hagar remembered, her

strong throat rose clear from a blouse of the simplest make, only a soft dark silk instead of wool in honour of the evening. Her skirt was of dark cheviot. She wore no stays, it was evident, and needed none. Her hair, of a warm chestnut, wavy and bright, was cut to about the length worn by Byron and Keats and Shelley.... To a marked extent she was interest-provoking; there was felt a powerful nature, rich and indomitable.

Presently she spoke. "Denny will be home next week. Don't you want me to take you one day to see the shrine where he keeps his idol and watch him providing acceptable sacrifice? It's rich — the editorial room of 'Onward!'"

"Yes, I should like it very much."

"Then we'll go down some morning soon. There's a place near the temple where they give you a decent omelette and cheese. We'll all three go there for luncheon.... Denny's fine."

"I'm very sure of that."

"Yes, warp and woof, he's sincere — and that's what I worship, sincerity! And he's able. He strikes more narrowly than I do, but he strikes deep. We've lived and worked together now eight years. We've seen hard times together. We've nearly starved together. We've made a name and come out together. And, bigger than our own fates, we've seen our Cause bludgeoned and seen it lift its bleeding head. We've known together impersonal sorrow and joy, humbling and pride, fear and faith, despair and hope. Denny and I are the best friends. We've been lovers in the flesh, but there's something better than that between us." She turned square to the light and Hagar. "That's the truest truth, and yet I

want to tell you that I think you've always been to him a kind of unearthly and spiritual romance. He's kept you lifted, moving above him in the clouds, beckoning, with a light about you. And I want to tell you that I have not grudged that —"

"I spoke to you as I did the other day," said Hagar, "because, somehow, I had that impulse. It was not necessary that I should do so; that of which I spoke had long passed." She rose and walked slowly back and forth in the room. "When I bethought myself, that month in Nassau, of where I — not he — was drifting . . . I was able then to leave that current, and leave it not to reënter. That was three years ago. I beg you to believe that that temptation, if it was a temptation, is far behind me. My soul will not return that way, cannot return that way. . . . And now I simply want to be friends."

"I'll meet you there. I like you too much not to want to. You seem to me one of those rare ones who find their lamp and refuge in themselves."

"And I like you, extraordinarily. I should like to work with you."

"There is nothing," said Rose Darragh, "any easier to arrange than that."

CHAPTER XXX

AN OLD ACQUAINTANCE

IN the year 1910, a certain large gathering of suffragists occurring in New York, permission was sought and obtained for speaking in Union Square. Here and there, beneath the trees, sprang temporary tribunes sheathed with bunting the colour of gold; above them banners and banneroles of the same hue, black-lettered, VOTES FOR WOMEN. From each tribune now a woman was speaking, now a man. About speakers and tribunes pressed the crowd, good-natured, commenting, earnest in places. Each speaker had about ten minutes; time up, he or she stepped down; another took position. Sometimes the crowd laughed at a good story or at a barbed shaft skilfully shot; sometimes it applauded; sometimes it indulged in questions. Its units continually shifted; one or more speakers at this stand listened to, it went roaming for pastures new and brought up before the next tribune, whose crowd, roaming in its turn, filled the just vacated spaces. It was a still, pearl-grey mid-afternoon, the pale-brown leaves falling from the trees, the roar of the city softened, the square's frontier lines of tall buildings withdrawn, a little blurred, made looming and poetic. All was a picture, lightly shifting with gleams of gold and a woman's voice, earnest, lilting. The crowd increased until there was a great crowd. VOTES FOR WOMEN — VOTES FOR WOMEN — said the banners and the banneroles.

A man and a woman, leaving a taxicab on the Broadway facet of the Square, stood a moment upon the pavement. "What a crowd!" said the man. "There is speaking of some kind." He stopped a boy. "What is going on?"

"Suffragettes! Women speaking. Want ter vote. Ain't got no husbands. — *I* would n't let 'em! Say, ain't they gettin' too big for their places?" The boy stuck out his tongue and went away.

"Young hoodlum!" exclaimed the man with disgust.

"Let us stay and hear them for a while. I never have."

"All right! — I'll pay the cab." He came back to her, and they moved across and under the trees. "Are you interested?"

"I think I am. I have n't made up my mind. We're so far South that as a movement it's all as yet only a rather distant sound. How do you feel about it?"

"Why, I think it's an honest proposition. I've never seen why not. We're all human together, are n't we? But building bridges for South American Governments has kept me, too, a little out of earshot. I see what the papers say, and they're saying a good deal."

"Ours chiefly confine themselves to being scandalized by the English Militants."

"Then your papers are very foolish. Who ever supposed there were n't Jacobins in every historic struggle for liberty? Sometimes they help and sometimes they hinder, and sometimes they do both at once. It's rather superficial to see only the 'left,' and not the movement of which it is the 'left.'"

They came beneath the trees upon the fringe of the crowd about one of the gold-swathed stands. This was an attentive

crowd, not restless but listening, slanted forward. The man from the taxicab touched a young workman upon the arm. "Who is it speaking?" The other turned a pale, tense face. "It's one that can hold them. It's Rose Darragh, speaking for the working-women."

The two made their way to where they could see and hear. Rose Darragh, speaking with a lifted irony and passion, sent her last Parthian arrow, paused a moment, then cried with a vibrant voice, "Give the working-woman a vote!" and stepped back and down from the stand. "By George!" breathed the man from the cab. The crowd applauded — for such a meeting applauded loudly.

The young man to whom the two had appealed cried out also. "Give the working-woman a vote! She's working dumb and driven under your factory laws! Give her the vote!"

A large, bald-headed, stubborn-jawed man who had been making *sotto-voce* remarks, turned with anger. "And have them striking at the polls as well as striking in the shop! Doubling the ignorant vote and getting into the way of business! You'd better listen to what I tell you! Woman's place is at home — damn her!"

The man next him was a clergyman. "I agree with you, sir, that woman's place is the home, but I object to your expletive!"

The bald-headed man was willing to be placatory. "Well, Reverend, if we're only two words apart — Are you going to stay here? I'm not! I don't believe in encouraging them —"

"I believe you to be right there, sir. Woman's Sphere —" they went off together.

The man from the cab, John Fay by name, with his sister-in-law, Lily Fay, who had been Lily Goldwell, moved still nearer the front. They could see Rose Darragh pausing for a moment beside the stand before she went away to another tribune. A woman dressed in wood-brown spoke to her laughing; then, a hand on her shoulder, mounted to the platform.

Two women behind Lily Fay whispered together excitedly, "Hagar Ashendyne?"

"Yes. I did n't know she was going to speak to-day — but she and Rose Darragh often do speak together. They're great friends.... Somebody ought to tell them who she is — Oh! they know —"

"*Shh!*"

"Oh, she's holding them —"

Lily Fay clutched her companion's arm. "Hagar Ashendyne! I went to school with her —"

"The writer?"

"Yes. How strange it seems.... Oh, listen!"

Hagar's voice came to them, silver clear as a swinging bell. "Men and women — I am going to tell you why a woman like myself finds herself to-day under a mental and moral compulsion consciously to further what is called the Woman Movement —"

She spoke for ten minutes. When she ended and stepped from the platform, there followed a moment of silence, then applause broke forth. A dark-eyed, breathless girl, a lettered ribbon across her coat, caught her hand. "Hurry! We're waiting for you at the next stand. Rose Darragh is just through — " The two hastened away together, lithe and

free beneath the falling brown leaves. A Columbia man was speaking well for the Men's League, but a good proportion of the crowd, John and Lily Fay among them, followed the wood-brown skirt.

They followed from stand to stand during the next hour, at the end of which time speaking was over for that day. The crowd broke up; the speakers, after some cheerful talk among themselves, gathered together their banners and pennants and went their several ways; committees looked after the taking-down of the stands.

Lily went over to Hagar Ashendyne standing with Rose Darragh and Molly Josslyn, talking to a little group of friendly people. "I'm Lily Goldwell. Do you remember?"

Hagar put her arms about her. "Oh, Lily, how is your head? Have you got that menthol pencil still?"

"My head got better and I threw it away. Oh, Hagar, you are a sight for sair een! . . . Yes, I'm Lily Fay, now. I'm on my way to England to join my husband. The boat sails next week. I'm at the———. This is my brother-in-law, John Fay."

"I've got to be at Carnegie Hall to-night," said Hagar. "And I have something to do to-morrow through the day — but the evening's free. Won't you come to dinner with me — both of you? Yes, I want you, want you bad! Come early — come at six."

To-morrow was the serenest autumn day. Lily and John Fay walked from their hotel through a twilight tinted like a shell. When they came to the apartment house and were carried up, up, and left the elevator and rang at the door before them and it opened and they were admitted by a tidy coloured maid, it was to find themselves a little in advance

of their hostess. Mary Magazine explained with slow, soft courtesy. "Miss Hagar cert'n'y meant to be home er long time befo' you come, she cert'n'y did. But there's er big strike goin' on — er lot of sewing-women — an' she went with Miss Elizabeth Eden early this mahnin', an' erwhile ago she telephone if you got heah first, you must 'scuse her anyhow an' make yo'selves at home 'cause she'll be heah presently. She had," Mary Magazine explained further, "to send Miss Thomasine to see somebody for her in Boston, so there is n't anybody to entertain you twel she comes. If you'll just make yo'selves comfortable —" and Mary Magazine smiled slowly and disappeared.

The large room had not greatly altered in appearance since Rachel and Hagar first arranged it, three years ago. There were more books, a few more prints, more signed photographs, a somewhat richer tone of time. It was a good room, quiet and fine, not lacking an air of nobility. A great bough of red autumn leaves flamed at one end like a stained-glass window. A door opening into a small room showed a typewriter and a desk piled with work. The two visitors, with fifteen minutes of sole possession before them, strolled to the windows and admired the far-flung, grandiose view, twilight beginning to be starred with the city lights; then turned back to the room and its strong charm.

"We've lived through the revolution, I think," said John Fay. "The senses move more slowly than the event. We're just taking it in, and we call it all to make. But it's really made."

"I see what you mean. But they — but we — have all this monstrous amount of hard work yet —"

"Yes. Introducing the revolution to the slow-minded. But I gather it's being done." He moved about the room, looking at the photographs. "Artists and thinkers and world-builders, men and women. . . . Those years down there around the Equator, I could at least take the magazines, and I got each twelvemonth a box of books. I know all these people. I used to feel quite intimate with them, down there building bridges. . . . Building bridges is great work. I believe in it thoroughly and quite enjoy doing it. . . . And these are bridge-builders, too, and I had a fraternal feeling. I've cut their pictures, men and women, from the magazines and stuck them up in my hut and said good-morning and good-evening to them." He had the pleasantest, humorous eyes, and now they twinkled. "Sometimes I like them so well that I really kow-towed to them. And I've laid a platonic sprig of flowers before more than one of these women's pictures. Perhaps I'd better not tell her so, but there was a picture of Hagar Ashendyne — "

The door opened and Hagar entered. She wore the wood-brown dress of yesterday — she was somewhat pale, with circles under her eyes. "Ah, I am sorry!" she said, "but I could not help it. The strike . . . and they send the girls to the Island. Two or three of us went to the court — oh, the snaky, blind thing we call Justice!" Her eyes filled. "Pardon! but if you had been there — " She caught herself up, dashed the moisture from her eyes and said — and looked — that she was glad to see them. "We'll put the things away that make your heart ache! I'll go and change, and we'll eat our dinner and have a pleasant, pleasant time!"

In a very little while she was back, dressed in white, ame-

thysts in an old and curious setting about her throat. They had been Maria's, and to-night she looked like Maria, lines of the haunted mind about her mouth and between her eyes. Only it was not her personal fate that troubled her, but a wider haunting. At dinner, in the café at the corner table, she told them, when they asked her, a little of where she had been and what she had done during the day, told them of this pitiful case and of that. Then after a moment's silence she said resolutely, "Don't let us talk about these things any more. Let us talk about happy things. Talk to me about yourself, Lily!"

"There is n't much to tell," said Lily; "I've been quite terribly sheltered. For years I was ill, and then I grew better. I've travelled a little, and I like Maeterlinck and Vedanta and Bergson, and I play the violin not so badly, and Robert, my husband, is very good to me. I have n't grown much, I am afraid, since I was at Eglantine. But more and more continually I want to grow. Do you remember, at Eglantine —"

Dinner was not long. They came down to the grave and fair room with the scarlet autumn leaves and the books, and here Mary Magazine gave them coffee. They sat in their deep chairs and drank it slowly. The talk dropped; they sat in a thoughtful mood. John Fay had a long and easy figure, a bronzed, clean-shaven, humorous face and sea-blue eyes. Lily was slender as a willow wand, with colourless, strong features. Her eyes were dreamy — Hagar remembered how she sat and looked into the fire when they read poetry. Like the faintest, faraway strain of a music not altogether welcome, a line went through her mind, —

> "Where the quiet-coloured end of evening smiles
> Miles and miles —"

Hagar, with her odd, pensive, enigmatical face, drove the strain back to the limbo whence it came. She and Lily talked of the girls so long ago at Eglantine, of Sylvie and Francie and all the rest, the living and the dead, and the scattered fates. Neither had ever been back to the school, but she could tell Lily of Mrs. LeGrand's health and prosperity. "You don't like her," said Lily. "I was so ill and homesick, I did n't have energy one way or the other, but she was very smooth, I remember that, ... and we were all to marry, and only to marry — marry money and social position — especially social position." They talked of the teachers. "I liked Miss Gage," said Hagar, "and Mrs. Lane was a gentle, sweet woman. Do you remember M. Morel?"

"Yes, and Mr. Laydon."

"Yes, and Mr. Laydon."

Lily started. "Oh, Hagar, I had forgotten that! But perhaps there was nothing in it —"

Hagar laughed. "If you meant that at eighteen I sincerely thought I loved Mr. Laydon — and that he, as sincerely, I do believe, thought that he loved me — yes, there was that in it! But we found out with fair promptness that it was false fire. — I have not seen nor heard of him for many years. He taught at Eglantine for a while, and then he went, I believe, to some Western school. . . . Lily, Lily! I have had a long life!"

"I have had as long a one in years," said Lily. "But yours has been the fuller. You have a wonderful life."

"We all have wonderful lives," answered Hagar. "One is rich after this fashion, one after that."

The bell rang. In another moment Denny Gayde came into the big room. The six years since the Nassau month had wrought little outer change. He was still somewhat thin and worn, with a face at once keen and quiet, a little stern, with eyes that saw away, away — He was more light than heat, but there was warmth, too, and it glowed and deepened all around "Onward!" When he said the name of his paper, it was as though he caressed it. He was like a lighthouse-keeper whose whole being had become bent, on a wreck-strewn shore, to tending and heightening the light, to sending the rays streaming across the reefs.

CHAPTER XXXI

JOHN FAY

"Denny," said Hagar, "ask Mary Magazine to give you a coffee-cup." Denny came back with it and she filled it from the silver urn. "Rose went to Brooklyn to-night?"

"Yes. — I was to have spoken down on Omega Street, but at the last moment Harding came in and I sent him instead. 'Onward!' 's got the strongest kind of stuff this week, and there are some finishing touches — I'm going back to the office in an hour or two. Rose said that she asked you for that poem, and that you said you would give it, and she thought you might have it ready. I've got a telling place for it —"

"Drink your coffee and talk to the others while I copy it out," said Hagar. She rose and went to the desk in the smaller room. When she came back, Lily was dreaming with her eyes upon the forest bough, and the two men sat discussing Syndicalism. She laid a folded piece of paper upon the table beside Denny's hand. "There are only three verses."

He opened the paper and read them. "Thank you, Hagar! You've struck it home."

He refolded the paper and was about to put it in his pocket when John Fay held out his hand. "May n't I see it, too?" He looked at Hagar.

"Yes, of course, if you wish."

Fay read it, held the paper in his hand for a moment, then

gave it back to Denny. "I wish I could write like that," he said.

His tone was so oddly humble that Hagar laughed. "I wish that I could build great bridges across deep rivers!" she said.

They sat and talked, and the poem gave leadings to their talk, though they did not speak of the poem. At first it was Fay, answering Hagar's questions, telling of the struggle of muscle and brain with the physical earth, of mountain-piercing, river-spanning, harbour-making. He was thirty-nine; he had been engineering, building in strange and desert places since he was a boy; he had a host of memories of struggles, now desperate and picturesque, now patient and drudging, grapples of mind with matter, first-hand encounters with solids and liquids and gases. He had had to manage men in order to manage these; he had had to know how to manage men. Born with an enquiring mind, he learned as he went along his governments and peoples, their customs, institutions, motor-faiths, strengths and weaknesses; also he knew the natural history of places, and loved Mother Earth and a good part of her progeny. He had also a defined, quizzical humour which saved the day for him when it grew too strenuous. He talked well, with a certain drawling fitness of phrase which brought Medway into Hagar's mind, but not unpleasantly. There had been much in Medway which she had liked.

Fay was no monopolist. The talk went from one to another, and Denny drew more into it. He had been listening attentively to Fay. "It's your work," he said, "and it's tremendous and basic work. You've been doing it through

the ages ever since it first occurred to us that we could lengthen an arm with a stick and crack a nut — or an enemy's head — with a stone. It's tremendous and basic still. And the people who work under your direction, and atom by atom give you power?"

"Why, one day," said Fay, "they'll work as artists. A far day, doubtless, and there are degrees in artists; but I see no other conclusion. And to give the artist component in the mass of humanity a chance to strengthen and come out is, I take it, the tremendous and basic work to which we've all got to devote the next century or two."

"Oh, you're all right!" said Denny.

Hagar smiled. "My old 'News from Nowhere' —"

"But with a difference," said Denny. "Morris's was an over-simplified dream."

"Yes; we are more complex and flowing than that. But it was lovely. Do you remember the harvest home, and the masons, so absorbed and happy in their building . . . like children, and yet conscious artists, buoyant, free —"

Fay looked at her. "What," he said, "is *your* vision of the country that is coming?"

Her candid eyes met his. "I have no clear vision," she said. "Visions, too, are flowing. The vision of to-day is not that of yesterday and to-morrow's may be different yet. Moreover, I don't want to fix a vision, to mount it like a butterfly and keep it with the life gone out. We've done too much of that all along the way behind us. Vision grows, and who wishes to say 'Lo, the beautiful End!' There is no End. I do not wish a rigid mind, posturing before one altar-piece. Pictures dissolve and altars are portable."

"Yes," said Denny, "but —"

"Lily says she reads Vedanta. Well, it is the Yogi's *Neti — neti!* Almost your only possible definition as yet is, 'Not this — not this!' The country that is coming — It is not capitalism, though capitalism is among its ancestors. It is not war, though in the past it warred. It is not ecclesiasticism, though ecclesiasticism, too, was an inn on its road. It is not sex-aristocracy, though that, too, is behind it; it is not preoccupation with sex at all. It is not sectionalism, nor nationalism, nor imperialism. It is not racial arrogance. It is not arrogance at all. It is not exploitation. It is not hatred. It is not selfishness. It is not lust. It is not bigotry. It is not ignorance, or pride in ignorance. — *Neti, neti!* ... It is beauty — and truth. ... And always greater. ... And it comes by knowledge, out of which grows understanding, and by courage, out of which come great actions."

She ceased to speak, and leaned back in her chair, her hand at the amethysts about her throat. Fay kept his eyes upon her. He was conscious of a resurgence of a morning of a couple of years before when he had cut from a magazine a page bearing a half-tone portrait and had pinned it above his book-shelf. HAGAR ASHENDYNE had said the legend below. The rustle of the palms outside his hut came to him, and the mist of early morning above the waters.

The clock on Hagar's mantel-shelf struck ten with a silvery stroke.

Denny started. "I've got to go — work's calling!"

"I had rather hear you say, at ten o'clock, that sleep was calling," said Hagar. "You're working too hard, Rose says so, and I say so." She looked at him with friendliness deep

and tender, soft and bright. "Almost Denny's only fault is that he makes his work his god rather than his servant. At times he's perilously near offering it a human sacrifice. Why will you, Denny?"

"There's so much to do and so few are doing it," said Denny. His eyes were upon the great forest bough, but he seemed to be looking beyond it, down long, long vistas. "I don't know that I worship work. But I want every prisoner of wrong to rebel. And there's no time to waste when you have to pass the word along to so many cells. Sometimes I feel, too, like sitting down and playing, but when I do, I always begin after a little to hear the chains." He laughed. "And I like you and Rose preaching *dolce far niente!* If ever there were two who had the power of work —!"

"All the same," said Hagar, "go to bed before two o'clock, won't you?"

He shook hands around and was gone. "What a wonderful face!" said Lily; and Fay nodded. "A kind of worn, warrior angel —"

Hagar took Lily's hand and kissed it. "You've defined Denny to a nicety! 'A kind of worn, warrior angel' — I like that! . . . No, don't go! It is n't late."

"We'll stay, then, just one other half-hour. And now," said Lily, "tell me about yourself. We see your name, of course, and what the papers think you are doing. But you yourself —"

"But I myself?" said Hagar. "Ah, if you'll tell me, I'll tell you!" The great bough of red leaves against the wall was repeated in miniature by a spray upon the table, resting in a piece of cloudy Venetian glass. Hagar took it from the vase

and sat studying it, colour and line. She sat at ease in the deep chair, her long, slender limbs composed, her head thrown back against green-bronze, an arm bent and raised, the wine-red spray in her hand. "What," she said, "does a man or woman do in a dusty day's march of every great transit? About that is what I and many others have been doing, in this age as in other ages. Millions of minds to reach with a statement that for reasons of weight the column must surmount such a hill and again such a hill, the line of march lying truly on higher levels. The statement did not originate with the messengers of this or any other age; it is social, and the inner urge would send the marchers somehow on, but there is needed interpreting, clarifying, articulation — hence the office that we fill, though we fill it as yet, I know, weakly enough! So it means a preoccupation with communication — ways and means of reaching minds. And that, lacking a developed telepathy, means the spoken and the written word. And that means, seeing we have such great numbers to reach, a continuing endeavour to reach people in congregation. And that means arrangement, going from place to place, much time that you sigh for consumed, some weariness, a great number of petty happenings — and a vast insight into life and the way it is lived and the beings who live it! It means contacts with reality and a feeding the springs of humour and an acquaintance with the truly astonishing forest of human motives. And there is organization work and correspondence, and much of what might be called drudgery unless you can put the glow about it. . . . And there is the weaving all the time of the web of unity. The human family, and the dying-out before love and understanding of

invidious distinctions. The world one home, and men one man, though of an infinite variety, and women one woman, though of an infinite variety, and children one child, and the open road before the three. And back of the three, Oneness. The Great Pulse — out, the Many; in, the One. . . . So I with others speak and write and go about and work."

When the clock struck again, Lily and John Fay said good-night. Lily was to come once more before her boat sailed.

Hagar looked at Fay. "You are going to England, too?"

He hesitated. "I've said so —"

"He's just built a great bridge," said Lily, "and he has n't really taken a holiday for years. Robert and I want him just as long as he will travel with us."

When they were gone, Hagar went to the window and looked out far and wide upon the city settling to its rest. Here, to-night, would be deep repose, here fevered tossing, here perhaps no sleep at all. There would be death chambers and birth chambers — a many of each. And spiritual death chambers and spiritual birth chambers and the trodden middle rooms, minds that cried, "Light, more light!" and minds that said, "We see as it is." . . . And over all, the suns so far away they were but glittering points. Hagar's gaze moved across the heavens from host to host. "Ah, if you were hieroglyphics, and we could find the key —"

She came back to the lamplit table; Thomasine away, Mary Magazine asleep — the place was alone with her. She had been tired, but she did not feel so now. She sat down, put her arms above her head and her eyes upon the forest bough, and began to think. . . . She thought visually with

colour and light and form, luminous images parting the mist, rising in the great "interior sphere." She sat there till the clock struck twelve, then she rose, put out the lights, opened every window. In the east, above the roofs, glittered Orion, with Aldebaran red and mighty and the glimmering Pleiades. Hagar stood and gazed. She lifted her eyes toward the zenith — Capella and Algol and the street whose dust is stars between. Her lips moved, she raised her hand. "All hail!" she said; then turning from the window opened the door that led into her bedroom. It was a white and fair and simple place. As she undressed, she was thinking of the October woods at Gilead Balm.

Three days later, at the hotel, Lily and John Fay had a short but momentous conversation. "*Do* you want to go, John? I don't want you to go if you don't want to go, you know."

"That's what I came to talk to you about," said Fay. "I have my stateroom. The boat sails day after to-morrow. I've written to men I know in London and in Paris. I want to see them. They're men I've worked with. I want to see Robert. I even want to keep on seeing you, Lily! I've been about as eager as a boy for that run over Europe with the two of you. And I don't want to disappoint you and Robert, if it is the least disappointment. But —"

"I don't know that she'll ever marry," said Lily. "She'll not, unless she finds some one alike to strengthen and be strengthened by. A lot of the reasons for which women used to marry are out of court with her. Even what we call love — she won't feel it now for anything less than something that matches her."

JOHN FAY

Fay walked across the floor, stood at the window a moment, then came back. "I won't fence," he said. "It's simple truth, however you divined it. And I'm going to stay. I don't match her, but I've never proposed to stop growing."

CHAPTER XXXII

RALPH

FAY stayed. Lily's farewell note to Hagar merely said that after all he was not sailing with her and that she hoped Hagar would let him be among her friends. He made a good friend. Fay himself wrote to her, stating that he would be much in New York that autumn and winter and asking if he might come to see her. She answered yes, but that she herself was often away; he would have to take the chance of not finding her. He came, and she was away, came again, and she was away; then she wrote and asked him to dine with her on such an evening. He went, and it was an evening to mark with a white stone, to keep a lamp burning before in the mind. He asked how he could find out where she would be, since it was evident that she was speaking here and there. She nodded; she was working hard that autumn, oftenest in company with Rose Darragh, but often, too, with Elizabeth Eden and Marie Caton, with Rachel and Molly Josslyn. She showed him a list of meetings.

He thanked her and copied it down. "I see that your book will presently be out."

"Yes. I hope that you will like it."

"I think that I shall. How hard you work!"

"Not harder than others. The secret is to learn concentration and to fill all the interstices with the balm of leisure. And to work with love of the World to Be."

That November, together with Rose Darragh and Denny and Elizabeth, she was often speaking in the poor and crowded sections of the great city. Sometimes they talked to the people in dim, small halls, sometimes in larger, brighter places, sometimes there were street meetings. She grew aware that often Fay was present. Sometimes, when the meeting was over, he joined her; it began to be no infrequent thing his going uptown upon the car with her. She began to wonder. . . . Once in a street meeting she saw him near her as she spoke. It was a good crowd and interested. As she brought her brief, straight talk to a conclusion, Elizabeth whispered to her, "Lucien could n't come. Is there any one else who could speak?" Hagar's eyes met John Fay's. "We lack a speaker," she said. "Could n't you — won't you?" He nodded, stepped upon the box, and made a good speech. His drawling, telling periods, his smiling, sea-blue eyes, a story that he told and a blow or two out from the shoulder caught the fancy and then the good-will of the crowd.

An old woman, Irish, wrinkled, her hands on her hips, called out to him. "Be yez the new man? If yez are, I loike yez foine!"

He laughed at and with her. "Do you? Then you'll have to become a new woman to match me!"

The November dusk was closing in when the crowd dispersed. Elizabeth with the other woman speaker faced toward the Settlement. "Can't you come with me, Hagar?"

"No, not to-night. There are letters and letters —"

Fay asked if he might go uptown with her.

She nodded. "Yes, if you like. Good-night, Elizabeth — good-night, Mary Ware; good-night, good-night!"

They took a surface car. She sat for a minute with her eyes shut.

"Are you very tired?"

She smiled. "No, I am not tired. After all, why should it fatigue more than standing in cathedrals, walking through art galleries? But I was thinking of something. . . . Let us sit quietly for a while."

The minutes went by. At last she spoke. "I liked what you said, and the way you said it. Thank you."

"You do not need to thank me. Had I been less convinced, I might have spoken because you asked me to. As it is, I was willing to serve the truth."

"Ah, good! . . ."

There was another silence; then she began to speak of the light and thunder of the city about them, and then of a book she was reading. When they left the car it was dark — they walked westward together.

"Have you heard from Lily?"

"Yes. She and Robert are going first to the Riviera, then to Sicily."

"Both are very lovely. Why do you not change your mind and go?"

"I like it better here."

The evening was dark, clear and windy, with the stars trooping out.

"When," asked Hagar, "are you going to build another bridge?"

He pondered it. "I've been building for a long time and I'm going to build for another long time. Do you grudge me this half-year in between?"

"I do not. I was only wondering —" She broke off and began to talk about the Josslyns whom, it had turned out, he knew and liked. Two weeks ago she had dined there with him, and Christopher had taken occasion to tell her that John Fay was about the rightest all right he knew. . . . She had not really needed the telling. She had a good deal of insight herself.

They came to the great arched door of the apartment house, and there she told Fay good-night. When he was gone, she stood for a moment in the paved lobby with its palm or two, her eyes upon the clear darkness without; then she turned to the elevator.

Upstairs, within her own doors, Thomasine met her. "Oh, Hagar! It's Mr. Ralph —"

"Ralph!"

Ralph had been abroad, and she had not seen him for a long time.

"Yes!" said Thomasine. "His boat came in yesterday evening. And awhile ago he telephoned to ask you if he might come to dinner with you, and I did n't know what to say, and I told him you would n't be in till late; and he said did I think you'd mind his coming, and I did n't know what to say, so I said, 'No,' I could n't think so; and he asked what time you dined — and it's nearly seven now —"

"Well, you could n't say anything else," said Hagar. "Only I devoutly hope —" She moved toward her own room. "I'll dress quickly."

"And don't you think," said Thomasine, "that I'd better not dine with you —"

"I think just the contrary," answered Hagar, and vanished.

Ralph came. He was the Ralph of three years ago, of that last autumn week at Gilead Balm, only with certain things accentuated. He was richer, he had more and more a name in finance; his state was now loudly and perpetually proud of him. There was an indefinable hardening. . . . He was very handsome, Thomasine thought; he looked tremendously Somebody. He had been around the world — his physician had sent him off because of a threatened breaking-down. Apparently that had been staved off, pushed at least into a closet to stay there a few years. He talked well, with vigorous, clipped sentences, of Australia and China and India. Hagar, sitting opposite him in a filmy black gown, kept the talk upon travel. She had not seen him for eighteen months, and before then, for a long while, their meetings had been casual, cold and stiff enough, with upon his side an absurd hauteur. The eighteen months had at least dissipated that. . . . Dinner over, they went for coffee back to the apartment, and Thomasine determinedly disappeared. Old Gilead Balm talk was in Thomasine's mind. Ralph Coltsworth and Hagar Ashendyne were to mate — Old Miss had somehow kept that in the air, even so long, long ago.

In the grave and restful room with its shaded lights Hagar poured a cup of coffee for her cousin and gave it to him.

Taking it, he took for a moment also her two hands, long, slender, and very finely made. "Ringless!" he said.

Hagar, withdrawing them, poured her own coffee. "I have never cared to wear jewels. A necklace and an old brooch or two of my mother's are almost the only things I have."

Ralph looked about the room. The bough of flaming maple

was gone and in its place rested a great branch of cone-bearing white pine.

Her eyes followed his. "I can see the forest through it. Do you remember the great pine above the spring?"

His gaze still roamed. "And you call this home?"

"Yes, it is home."

"Without a man?"

She smiled. "Do you think there can be no home without a man?"

He drank his coffee; then, putting down the cup, rose and moved about the deep and wide place. She watched him from her armchair, long and slim as Diana in her black robe. He looked at the walls with their rows of cabined thought and the pictures above, at the great library table with its tokens of work, and then, standing before the wide, clear windows, at the multitudinous lights of the world without. A sound as of a distant sea came through the glass. "And without a child?"

Her clear voice sounded behind him. "You are mistaken," she said. "My work is my child. One human being serves and expresses in one way and one in another, and I think it is not the office which is higher or lower, but only the mind with which the office is performed. Did I ever meet a man whom I loved and who was my comrade, and who loved me and saw in me his comrade, my home would probably open to that man. And we two might say, 'Now in cleanliness and joy and awe will we bring a child into our home.' . . . I think that would be a happy thing to happen. But if it does not happen, none the less will I have my earthly home as I have my unearthly, and be happy in it, and none the less will I do world-work and rejoice in the doing. And if it happened, it

would be but added bliss — it would be by no means all the bliss, or all the world, nor should it be. We grow larger than that. . . . And now, having answered your question, come! let us sit down and talk about what you are doing and when you are going down to Hawk Nest. I had a letter from Gilead Balm last week — from Aunt Serena."

He came and sat down. "The last time I was at Gilead Balm — two years and a half ago — they said they had ceased to write to you."

"They have begun again," said Hagar calmly. "Dear Ralph, we live in the twentieth century. You yourself are here to-night, eating my bread and salt."

"Have you been to Gilead Balm?"

"Yes, I went last summer, and again the summer before. Not for long, for a little while. Grandfather and grandmother and Aunt Serena said some hard things, but I think they enjoyed saying them, and I could ramble over the old place, and, indeed, I think, though they would never have said so, that they were glad to have me there. I will not quarrel. They are so feeble — the Colonel and Old Miss. I do not think they can live many years longer."

"Are you going again this summer?"

"Yes."

They talked again of his journey and recovered health, of New York, of the political and financial condition of the country; or rather he gave his view upon this and she sat studying him, her fine, long hands folded in her lap. What with question and remark she kept him for a long time upon general topics, or upon his increasing part in the subtle machinery behind so much that made general talk; — but at last, skil-

fully as she fenced, he came back to personal life and to his resentment of all her attitude. . . . He had thought that time and absence had cured his passion for her. Even a month ago he had told himself that there was left only family interest, old boyish memories. He disapproved intensely of the way she thought of things; she was not at all the wife for him. Sylvie Carter was — he would go to see Sylvie just as soon as he reached New York. . . . And then, upon the boat, coming over, it was of Hagar that he dreamed all the time. Like a gathering thunderstorm it was all coming back. Landing in New York he had only thought of her, all last night and to-day. It was an obsession, he told himself that — he could see that once he had her, possessed her, owned her, he would fight her through life . . . or she would fight him . . . and all the same the obsession had him, whirling him like a leaf in storm.

He spoke with a suddenness startling to himself. "What is between us is all this fog of damnable ideas that has arisen in the last twenty years! If it was n't for that you would marry me."

Hagar took the jade Buddha from the table and weighed it in her hands. "Oh, give me patience —" she murmured.

He rose and began to pace the floor. The physical, the passionate side of him was in storm. He was not for nothing a Coltsworth. Coltsworths were dominating people, they were masterful. They wished to prevail, body and point of view, point of view, perhaps, no less than body. They were not content to have their scheme of life and to allow another a like liberty; their scheme must lie upon and smother under the other's. They wished submissiveness of mind — the other

person's mind. They wished it in their relations with men — Ralph himself preferred subservient officials, subservient secretaries, subservient boards, subservient legislators. He preferred men to listen in the club, he liked a deferential murmur from his acquaintance. He had followers whom he called friends. A certain number of these truly admired him; he was to them feudal and splendid. He was a Coltsworth and Coltsworths liked to dominate the minds and fortunes of men. When it came to collective womankind, they might have said that they had really never considered the question — naturally men dominated women. To them God was male. They would have agreed with the Kentucky editor that the feminist movement was an audacious attempt to change the sex of Deity.... The thing that angered the Coltsworths through and through was Revolt. Political, economic, intellectual, spiritual — Revolt was Revolt, whatever adjective went before! Rage boiled up in the mind of the master. And when the revolted was not perturbed, or anxious or fluttered, but stood aloof and was aloof, when the revolt was successful, when the rebellion had become revolution and the new flag was up and the citadel impregnable — the sense of wrath and injury overflowed like the waves of Phlegethon. It overflowed now with Ralph.

He turned from the window. "All this rebellion of women is unthinkable!"

Hagar looked at him somewhat dreamily. "However, it has occurred."

"Things can't change like that —"

"The answer to that is that they have changed."

She sat and smiled at him, quite eluding him, a long way

RALPH

off. "Do you think that only mind in man rebels? Mind in woman does it too. And it comes about that there are always more rebels, men and women. We are quite numerous to-day.... But there are women who do not rebel, as there are men. There are many women who will grant you your every premise, who are horrified in company with you, horrified at us others.... Why do you not wish to mate among your own kind?"

"I wish to mate with *you!*"

She shook her head. "That you cannot do.... There is being drawn a line. Some men and women are on one side of it, and some men and women are on the other side of it. There is taking place a sorting-out.... In the things that make the difference you are where you were when Troy fell. I cannot go back, down all those slopes of Time."

"I am afire for you."

"You wake in me no answering fire." She rose. "I will talk about much with you, but I will talk no longer about love. You may take your choice. Stay and talk as my old playmate and cousin, or say good-night and good-bye."

"If I go," said Ralph hoarsely, "I shall not come again — I shall not ask you again —"

"Ralph, Ralph! do you think I shall weep for that?... You *do* think that I shall weep for that!... You are mad!"

"By God!" said Ralph, and quivered, "I wish that we were together in a dark wood — I wish that you were in a captured city, and I was coming through the broken gate —" Suddenly he crossed the few feet between them, caught and crushed her in his arms, bruising her lips with his. "Just be a woman — you dark, rich thing with wings —"

Hagar had a physical strength for which he was unprepared. Exerting it, she freed herself, and in the same instant and as deliberately as swiftly, struck him across the face with her open hand. "Good-bye, to you!" she said in a thrilling voice.

They stared at each other for a moment across space. Then Hagar said quietly. "You had better go, Ralph . . ."

He went. When the door had closed behind him, she stood very still for a few moments, her eyes upon the pine bough. The excess of colour slowly ebbed from her face, the anger died in her eyes. "Oh, all of us poor, struggling souls!" she said. Obeying some inner impulse she first lowered, then extinguished the lights in the room and moved to one of the windows. She threw up the sash and the keen, autumnal night streamed in upon her. The window-seat was low and broad. She sat there with her head thrown back against the frame, and let the night and the high, starry heaven and the moving air absorb and lift her. It was very clear and there seemed depths on depths above. Hyades and Pleiades, and the Charioteer, and Andromeda Bound, and Perseus climbing the steep sky. "We are all bound and limited — we are all on the lower slopes of Time — down in the fens with the lower nature. It is only a question of more or less — Aspiration born and strengthening, or Aspiration yet in the womb. Then what room for anger because another is where I have been — because another, coming upward, rests awhile in the dungeon that was also mine, perhaps it was yesterday, perhaps it was ages ago? . . . Where I am to-day will seem dungeon enough to that which one day I shall be. . . . And so with him, and so with us all . . ."

A month after this she found among her letters one morning four smoothly ecstatic pages from Sylvie Carter. Ralph had asked Sylvie to marry him, and Sylvie had said Yes. Sylvie wrote that she expected to be very happy, and that she was going to do her best to make Ralph so, too. The next day brought a half-page from Ralph. It stated that something Hagar had said had set him to thinking. She had said that there was being a line drawn and that some men and some women were finding themselves together on either side. He thought there was truth in it, and that, after all, one should marry within one's class; otherwise a perpetual clash of opinions, fatal to love. There followed a terse announcement of his engagement to Sylvie, and he signed himself, "Your affectionate cousin, Ralph Coltsworth."

But it was Old Miss whose letter was wholly aggrieved and indignant. . . .

CHAPTER XXXIII

GILEAD BALM

THE second letter from Old Miss came in February. The Colonel had suddenly failed and taken to his bed. Old Miss believed that he would get up again, — there was, she said, no reason why he should n't, — but in the mean time there he lay. He was a little wandering in his mind, and he had taken to thinking that Hagar was in the house, and a little girl still, and demanding to see her. Old Miss suggested that she should come to Gilead Balm.

She went at once. On the train, thundering south through a snowy night, she lay awake until half of her journey was over. Scenes and moments, occurrences of the outer and inner life, went by her mind like some endless, shifting tapestry. Childhood, girlhood, womanhood, work and play, the daily, material task and the inner lift, lift, and ever-strengthening knowledge of the impalpable — that last was not tapestry; it was height and breadth and depth, and something more. The old, wide travel came back to her; shifting gleams of Eastern cities, deserts, time-broken temples, mountains, vineyards, haunted groves, endless surrounding, azure, murmuring seas. . . . Medway, white-clothed and helmeted, in his rolling chair. . . . The whistle shrieked; the train stopped with a jar at some lighted station, then, regathering its forces, rushed and roared on through the February night. Now it was the last three years and more: they passed in

panorama before her. Stages and stairways and scaffoldings by which the world-spirit might mount an inch: ferments and leavens: voices telling of democracy and fair play and care for your neighbour's freedom as for your own, your woman-neighbour and your man-neighbour. Through her mind ran all the enormous detail of the work being pursued over all the country; countless meetings, speeches, appeals, talks to a dozen gathered together or to two or three; letters and letters and letters, press and magazine utterances, organization, the difficult raising of money, legislative work, petitions, canvassing; drudgery in myriad detail, letters and letters, voice and pen. . . . And all the opposition — blind bigotry to be met, and a maniac fear of change, inertia, tradition, habit, the dead past's hand, cold and heavy — and all the interested opposition, the things whose book the movement did not suit — and all the lethargy of womankind itself. . . . And in the very camp, in the huge, chaotic movement itself, as in all the past's vast human movements, recurring frictions, antagonisms, small jealousies, flags set up by individuals, pacifications and smoothings, bringing compatibles together, keeping incompatibles apart. . . . A contending with outer oppositions and inner weaknesses, resisting discouragement, fighting cynicism, acknowledging the vast road to travel, keeping on. . . . She knew nothing that was at once so weak and so mighty as the Woman Movement. One who was deep within it might feel at times a vast weariness, impatience, and despair . . . but deep within it you never left it. Here you dealt with clay that was so cold and lumpish it seemed that no generous idea could germinate within; here you dealt with stuff so friable,

light, and disintegrative that the thought would come that it were better to cast it to the winds . . . but you did not; you comforted your soul with the very much that was noble, and you hoped for the other that was not yet noble, and you went on — went on. It was all you yourself — you had within you the intractable clay and the stuff light as chaff, inconsequent; but you went on transmuting, lifting. . . . There was no other hope, no other course, deep down no other wish. So with the Woman Movement. . . . Another station. Hagar looked out at the lights and the hurrying forms; then, as the train roared into the white countryside, at what could be seen of the fields and hills and storm-bent trees. She was thinking now of Gilead Balm and her childhood and her mother. She seemed to lie again, close beside Maria, on the big, chintz-covered sofa. At last she slept, lying so.

Captain Bob and Lisa met her at the station, three miles from Gilead Balm. Captain Bob had a doleful mien. "Oh, yes, the Colonel's better — but I don't think he's so much better. He's getting old — and Lisa and I are getting old, too, aren't we old girl? — old like Luna and going away pretty soon like Luna. Well, Gipsy, you're looking natural — No, it's been an open winter down here — not much snow." He put her in the carriage, and they drove slowly to Gilead Balm, over the heavy country road.

Old Miss was well; Serena was well; Captain Bob himself had had rheumatism, but he was better. — The Colonel didn't look badly; it was only that he didn't seem to want to get out of bed, and that every little while he set the clock back and rambled on about things and people — "It's creepy to hear him," said Captain Bob. "He thinks young Dr. Bude

is old Dr. Bude, and he thinks that Maria is alive, and that she won't let you come into the room. And then it'll change like that, and he's just as much himself as he ever was — more so, in fact. — Hi, Li-sa! let that rooster alone —"

The house cedars showed over the brown hills. "Dr. Bude wanted Old Miss to get a trained nurse because somebody's got more or less to watch at night. But Old Miss would n't hear to it. She don't approve of women training for nurses, so she's got young Phœbe and Isham's second wife — and I think myself," said Captain Bob, "that I would n't want a young white woman that I could n't order round."

Red brick and brown fields and the black-green of many cedars — here was Gilead Balm, looking just as it used to look of a February. The air was cold and still, the day a grey one, the smoke from the chimneys moving upward sluggishly. Miss Serena came down the porch steps and greeted Hagar as she stepped from the carriage.

"Yes, your old room. Did you have a tiresome journey? — Is your trunk coming? Then I'll send it up as soon as they bring it. Young Phœbe, you take Miss Hagar's bag up to her room. The fire's lighted, Hagar, and Mimy shall make you a cup of coffee. We're glad to see you."

The old room, her mother's and her own! Hagar had not been in it in winter-time for a long while. When Phœbe was gone, she sat in the winged chair by the fire and regarded the familiar wall-paper and the old, carved wardrobe and the four-poster bed and the sofa where Maria had lain, and, between the dimity curtains at the windows, the winter landscape. The fire was bright and danced in the old mahogany; the old chintz covers were upon the chair and sofa — the

old pattern, only the hues faded. Hagar rose, took off her travelling dress, bathed and put on a dark, silken dressing-gown. She took the pins from her hair and let it stream; it was like Maria's. She stood for a moment, her eyes upon the pallid day, the rusty cedars without the window, then she went to the chintz sofa and lay down in the firelight, piling the pillows behind her head, taking, half-consciously, the posture that oftenest in her memory she saw Maria take. Her mother was present with her; there came an expression into her face that was her mother's. Old Miss knocked at the door, and entered without waiting for the "Come in!"

Hagar rose and embraced her grandmother; then Old Miss sat down in the winged chair and her granddaughter went back to the sofa. The two gazed at each other. Hagar did not know that she looked to-day like Maria, and Old Miss did not examine the springs and sources of a mounting anger and sense of injury. She sat very straight, with her knitting in her hand, wearing a cap upon her smoothly parted hair, in which there were yet strands of brown, wearing a black stuff skirt and low-heeled shoes over white stockings; comely yet, and as ever, authoritative.

"I am so very sorry about grandfather," said Hagar. "Uncle Bob thinks he is better—"

"Yes, he is better. He will be well presently. I should not," said Old Miss coldly, "have written asking you to come but that Dr. Bude advised it."

"I was very glad to come."

"Dr. Bude is by no means the man his father was. The age is degenerate. And so"— said Old Miss —"Sylvie Maine has taken the prize right from under your hand."

"Oh!" said Hagar. The corners of her lips rose; her look that had been rather still and brooding broke into sunshine. "If you call it that! — I hope that Ralph and Sylvie will be very happy."

"They will probably be extraordinarily happy. She is not one of your new women. I detest," said Old Miss grimly, "your new women."

Silence. Hagar lay back against the pillows and she looked more and more to Old Miss like Maria. Old Miss's needles clicked.

"When may I see grandfather?" asked Hagar, and she kept her voice friendly and quiet.

"He is sleeping now. When he wakes up, if he asks for you you may go in. I wouldn't stay long. — And what have you been doing this winter?"

"Various things, grandmother. Thomasine and I have been working pretty hard. Thomasine sent her regards to every one at Gilead Balm."

"If you hadn't thrown away Medway's million dollars you wouldn't have had to work," said Old Miss. "Maria was perfectly spendthrift, and of course you take after her. — What kind of work do you mean you have been doing?"

"I have been writing, of course. And then other work connected with movements in which I am interested."

Old Miss's needles clicked again! "Unsexing women and unsettling the minds of working-people. I saw a piece in a paper. Preposterous! But it's just what Maria would have liked to have done."

Silence again; then Hagar leaned across and took up her

grandmother's work. "What is it? An afghan? It's lovely soft wool."

"When," asked Old Miss, "are you going to marry — and whom?"

"I do not know, grandmother, that I am going to marry, or whom."

"You should have married Ralph. . . . All these years have you had any other offers?"

"Yes, grandmother."

"While you were with Medway?"

"Yes, grandmother."

"Have you had any since you set up in this remarkable way for yourself?"

Hagar laughed. "No, grandmother — unless you except Ralph."

"Ha!" said Old Miss in grim triumph; "I knew you would n't!"

Miss Serena came to the door. "Father's awake and he wants to see Hagar."

But when Hagar went down and into the big room and up to the great bed, the Colonel declared her to be Maria, grew excited, and said that she should n't keep his grandchild from him. "I tell you, woman, Medway and I are going to use authority! The child's Medway's — Medway's next of kin by every law in the land! He can take her from you, and, by God! he shall do it!"

"Father," said Miss Serena, "this is Hagar, grown up."

But the Colonel grew violently angry. "You are all lying! — a man's family conspiring against him! That woman's my daughter-in-law — my son's wife, dependent

on me for her bread and shelter and setting up her will against mine! And now she's all for keeping from me my grandchild — she's hiding Gipsy in closets and under the stairs — You have no right. It's not your child, it's Medway's child! That's law. You ought to be whipped!"

"Grandfather," said Hagar, "do you remember Alexandria and the mosques and the Place Mahomet Ali?"

"Why, exactly," said the Colonel. "Well, Gipsy, we always wanted to travel, did n't we? That dragoman seems to know his business — we're going down to Cairo to-day and out to see the pyramids. Want to come along?"

Day followed day at Gilead Balm. Sometimes the Colonel's mind wandered over the seas of creation, with the pilot asleep at the helm; sometimes the pilot suddenly awoke, though it was not apt to be for long. It was eerie when the pilot awoke; when he suddenly sat there, gaunt, with a parchment face and beak-like nose and straying white hair, and in a cool, drawling voice asked intelligent questions about the hour and the season and the plantation happenings.

At such times, if Hagar were not already in the room, he demanded to see her. She came, sat by him in the great chair, offered to read to him. He was not infrequently willing for her to do this. She read both prose and verse to him this winter. Sometimes he did not wish her to read; he wanted to talk. When this was the case — the pilot being awake — it was her life away from Gilead Balm that he oftenest chose to comment upon. That he knew the content of her life hardly at all mattered, as little to the Colonel as it mattered to Old Miss and Miss Serena. They were going to let fly their arrows; if there was no target in the direction in which they

shot, at least they were in sublime ignorance of the fact. Hagar let them talk. Not only the Colonel — Gilead Balm was dying. . . . In the middle of a sarcastic sentence the pilot would drop asleep again; in a moment the barque was at the mercy of every wandering wind. Hagar became Maria and he gibbered at her.

Young Dr. Bude came and went. February grew old and passed into March; March, cold and sunny, with high winds, wheeled by; April came with tender light, with Judas trees and bloodroot, and the white cherry trees in a mist of bloom; and still the Colonel lay there, and now the pilot waked and now the pilot slept.

May came. Dr. Bude stayed in the house. One evening at dusk the Colonel suddenly opened his eyes upon his family gathered about his bed. Old Miss was sitting, upright and still, in the great chair at the bed-head. Miss Serena had a low chair at the foot, and Captain Bob was near, his old, grey head buried in his hands. There was also an Ashendyne close kinsman, and a Coltsworth — not Ralph. Dr. Bude waited in the background. Hagar stood behind Miss Serena.

Colonel Argall Ashendyne looked out from his pillow. "Wasn't the Canal good enough? Who wants their Railroad — damn them! And after the Railroad there'll be something else. . . . Public Schools, too! . . . This country's getting too damnably democratic!" His eyes closed, his face seemed to sink together. Dr. Bude came from the hearth and, bending over, laid his finger upon the pulse. The Colonel again opened his eyes. They were fastened now on Hagar, standing behind Miss Serena. "Well, Gipsy!" he said with cheerfulness, "It's a pretty comfortable boat, eh? We'll make the

voyage before we know it." His hands touched the bed. "Steamer chairs! I don't think I was ever in one before. Lean back and see the wide ocean stretch before you! The wide ocean . . . the wide ocean . . .

"'Roll on, thou deep and dark blue ocean, roll!'

That's Byron, you know, Gipsy. . . . The wide ocean . . ."

His eyes glazed. He sank back. Dr. Bude touched the wrist again; then, straightening himself, turned and spoke to Old Miss.

CHAPTER XXXIV

BRITTANY

"She has n't had a holiday for nearly four years," said Molly. "I'm glad she's gone for this summer. She would n't take Thomasine — she said she wanted to be all, all alone, just for three months. Then she would come back to work."

"Brittany —"

"Yes. A little place on the coast that she knew. She said she wanted the sea. I thought perhaps that she had written to you —"

"Not since May," said John Fay. "There was a proposed extension of a piece of work of mine in the West. I was called out there to see about it, and I had to go. I was kept for weeks. I tried to get back, but I could n't — I was in honour bound. Then when I came her boat had sailed. And now I —"

He measured the table with his fingers. "Do you think she would hate me if I turned up in that place in Brittany?"

Molly considered it. "She's a reasonable being. Brittany is n't for the benefit of just one person."

"Ah, but you see I should want to talk to her."

Molly pondered that, too. "Well, I should try, I think. If she does n't want to talk she will tell you so. . . ."

Hagar's village was a small village, a grey patch of time-worn houses, set like a lichen against a cliff with a heath above. Before it ran a great and far stretch of brown sands.

BRITTANY

There was a tiny harbour where the fishing-boats came in, and all beyond the thundering sea. The place boasted a small inn, but she did not stay there. The widow of the curé had to let a clean large room, overlooking a windy garden, and the widow and her one servant set a table with simple, well-cooked fare. Hagar stayed here, though most of the time, indeed, she stayed out upon the brown, shell-strewn, far-stretching sands.

She walked for miles, or, down with the women at evening, she watched the boats come one by one to haven, or, far from the village, beneath some dune-like heap of sand, she sat with her hands about her knees and watched the shifting colour of the sea. She had a book with her; sometimes she read in it, and sometimes it lay unopened. All the colours went over the sea, the surf murmured, the sea-birds flew, the salt wind bent the sparse grass at the top of the dune. On such an afternoon, after long, motionless dreaming, she changed her posture, turning her eyes toward the distant village. A man was walking toward her, over the firm sand. She watched him at first dreamily, then, suddenly, with a quickened breath. While the distance between them was yet great, she knew it to be Fay.

He came up to her and held out his hand. She put hers in it. "Did I startle you?" he said. "If you don't want me, I will go away."

"I thought you were bridge-building in the West."

"I could get away at last. I crossed the Atlantic because I wanted to see you. Do you mind, very much?"

"Do I mind seeing you here, in Brittany? No, I do not know that I mind that. . . . Sit down and tell me about

America. America has seemed so far away, these still, still days . . . farther away than the sun and the moon."

Long and clean-limbed, with his sea-blue eyes and quizzical look, Fay threw himself down upon the sand beside her. They talked that day of people at home, of the work he had been doing and of her long absence at Gilead Balm. She made him see the place — the old man who had died — and Old Miss and Miss Serena and Captain Bob and the servants and Lisa.

"They are going to live on there?"

"Yes. Just as they have done, until they, too, die. . . . Oh, Gilead Balm!"

Late in the afternoon, the sun making a red path across the waters, and the red-sailed boats growing larger, coming toward the land, they walked back to the village together. He left her at the door of the curé's house. He himself was staying at the inn. She did not ask him how long he would stay, or if he was on his way to other, larger places. The situation accepted itself.

There followed some days of wandering together, through the little grey town, or over the green headland to a country beyond of pine trees and Druid stones, or, in the evening light, along the sands. They found a sailboat, with an old, hale boatman, for hire, and they went out in this boat. Sometimes the wind carried them along, swift as a leaf; sometimes they went as in a sea-revery, so dreamily. The boatman knew all the legends of the sea; he told them stories of the King of Ys and the false Ahés, and then he talked of the Pardons of his youth. Sometimes they skirted the coast, sometimes they went so far out that the land was but an

eastward-lying shadow. The next day, perhaps, they wandered inland, over the heath among dolmens and menhirs, or, seated on old wreckage upon the sands, the dark blue sea before them, now they talked and now they kept company with silence. They talked little rather than much. The place was taciturn, and her mood made for quiet.

It was not until the fourth day that he told her for what he had come. "But you know for what I came."

"Yes, I know."

"If you could —"

"I want," said Hagar, "more time. Will you let it all rest for a little longer? I don't think I could tell you truly to-day."

"As long as you wish," he said, "if only, in the end —"

Two days after this they went out in the afternoon in the boat. It had been a warm day, with murk in the air. At the little landing-place Fay, after a glance at the dim, hot arch of the sky, asked the boatman if bad weather might be brewing. But the Breton was positive.

"Nothing to-day — nothing to-day! To-morrow, perhaps, m'sieu."

They went sailing far out, until the land sunk from sight. An hour or two passed, pleasantly, pleasantly. Then suddenly the wind, where they were, dropped like a stone. They lay for an hour with flapping sail and watched the blue sky grow pallid and then darken. A puff of wind, hot and heavy, lifted the hair from their brows. It increased; the sky darkened yet more; with an appalling might and swiftness the worst storm of the half-year burst upon them. The wind blew a hurricane; the sea rose; suddenly the mast went.

Fay and the Breton battled with the wreckage, cut it loose — the boat righted. But she had shipped water and her timbers were straining and creaking. The wind was whipping her away to the open sea, and the waves, continually mounting, battered her side. There was a perceptible list. Night was oncoming, and the fury above increasing.

Hagar braided her long hair that the wind had loosened from its fastening. "We are in danger," she said to Fay.

"Yes. Can you swim?"

"Yes. But there would be no long swimming in this sea."

They sat in the darkness of the storm. When the lightnings flashed each had a vision of the other's face, tense and still. There was nothing that could be done. The sailor, who was hardy enough, now muttered prayers and now objurgations upon the faithless weather. He tried to assure his passengers that not St. Anne herself could have foreseen what was going to occur that afternoon. Certainly Jean Gouillou had not. "That's understood," said Hagar, smiling at him in a flash of lightning; and, "Just do your best now," said Fay.

The wild storm continued. Wind and wave tossed and drove the helpless boat. Now it laboured in the black trough of the waves, now it staggered upon the summits; and always it laboured more heavily, and always it was more laggard in rising. The Breton and Fay took turns in bailing the water out. It was now, save for the lightning, dark night. At last it was seen — though still they worked on — that there was little use in bailing. The boat grew heavier, more distressed. The sea was running high.

"Some wave will swamp us?"

"Yes. It is a matter of time — and not long time, I think."

Hagar put out her hands to him. "Then I will tell you now —"

He took her hands. "Is it your answer?"

"Yes, my dear. . . . Yes, my dear."

They bent toward each other — their lips met. "Now, whether we live or whether we die —"

The wild storm continued. The slow sands of the night ran on, and still the boat lived, though always more weakly, with the end more certainly before her. The Breton crossed himself and prayed. Hagar and Fay sat close together, hand in hand. After midnight the storm suddenly decreased in force. The lightning and thunder ceased, the clouds began to part. In another hour there would be a sky all stars. The wind that had been so loud and wild sank to a lingering, steady moaning. There was left the tumultuous, lifted sea, and the boat sunken now almost to her gunwales.

Fay spoke in a low voice. "Are you afraid of death?"

"No. . . . You cannot kill life."

"It will not be painful, going as we shall go — if it is to happen. And to go together —"

"I am glad that we are going together — seeing that we are to go."

"Do you believe that — when it is over — we shall be together still?"

"Consciously together?"

"Yes."

"I do not know. No one knows. No one can know — yet. But I have faith that we shall persist, and that intelligently. I do not think that we shall forget or ignore our old selves.

And if we wish to be together — and we do wish it — then I think we may have power to compass it."

"It has sometimes seemed to me," said Fay, "that After Death may prove to be just Life with something like fourth dimensional powers. All this life a memory as of childhood, and a power and freedom and scope undreamed of now —"

"It is possible. All things are possible — save extinction. — I think, too, it will be higher, more spiritual. . . . At any rate, I do not fear. I feel awe as before something unknown and high."

"And I the same."

Off in the east the stars were paling, there was coming a vague and mournful grey. The boat was sinking. The two men had torn away the thwarts and with a piece of rope lashed them together. It would be little more than a straw to cling to, in the turbulent wide ocean, miles from land. All were cold and numbed with the wind and the rain and the sea.

Purple streaks came into the east, a chill and solemn lift to all the sea and air and the roofless ether. Hagar and Fay looked at the violet light, at the extreme and ghostly calm of the fields of dawn. "It is coming now," said Fay, and put his arm around her. The boat sank.

The three, clinging to the frail raft they had provided, were swung from wave to wave beneath the glowing dawn. . . . The wind was stilled now, the water, under the rising sun, smoothed itself out. They drifted, drifted; and now the sun was an hour high. . . . "Look! look!" cried the Breton, and they looked and saw a red sail coming toward them.

A day or two later Hagar and Fay met at the gate of the curé's widow, and climbing through the grey town came out upon the heath above. It was a high, clear afternoon, with a marvellous blue sky. They walked until they came to a circle of stones, raised there in the immemorial, dark past. When they had wandered among them for a while, they rested, leaning against the greatest menhir, looking out over the grey-green, far-stretching heath to a line of sapphire sea. "It grows like a dream," said Hagar. "Death, life — life, death. . . . I think we are growing into something that transcends both . . . as we have known both."

"Hagar, do you love me?"

"Yes, I love you. . . . It's a quiet love, but it's deep."

They sat down in the warm grass by the huge stone, and now they talked and now they were silent and content. Little by little they laid their plans.

"Let us go to London. I will go to Roger Michael's. We will marry quietly there."

"Lily and Robert will want to come from Scotland."

"Well, we'll let them." Hagar laughed, a musical, sweet laugh. "Thomson is in London with Mr. Greer. Dear old Thomson! I think he'll have to come."

"Could n't we have," said Fay, "a month in some old, green, still, English country place?"

"With roses to the eaves and a sunken lane to wander in and at night a cricket chirping on the hearth. . . . We'll try."

"And in October sail for home."

"And in October sail for home."

She looked at him with eyes that smiled and yet were

grave. "You're aware that you're marrying a working-woman, who intends to continue to work?"

"I'm aware."

Her candid eyes continued to meet his. "I wish a child. While it needs me and when it needs me, I shall be there."

His hand closed over hers. "Is it as though I did not know that —"

She kissed him on the lips. "And you're aware that I shall work on through life for the fairer social order? And that, generally speaking, the Woman Movement has me for keeps?"

"I'm aware. I'm going to help you."

"South America —"

"I'm not wedded," said Fay, "to South American governments. There are a plenty of bridges to be built in the United States."

The grey-green silent heath stretched away to the shining sea. The grasses waved around and between the grey altars of the past, and the sky vaulted all, azure and splendid. Two sea-birds passed overhead with a long, clarion cry. Two butterflies hung poised upon a thistle beside them. The salt wind blew from the sea as it had blown against man and woman when these stones were raised. They sat and talked until the sun was low in the west, and then, hand in hand, walked back toward the village.

THE END